Politics of Memory

Routledge Studies in Cultural History

1 **The Politics of Information in Early Modern Europe**
Edited by Brendan Dooley and Sabrina Baron

2 **The Insanity of Place/ The Place of Insanity**
Essays on the History of Psychiatry
Andrew Scull

3 **Film, History, and Cultural Citizenship**
Sites of Production
Edited by Tina Mai Chen and David S. Churchill

4 **Genre and Cinema**
Ireland and Transnationalism
Edited by Brian McIlroy

5 **Histories of Postmodernism**
Edited by Mark Bevir, Jill Hargis, and Sara Rushing

6 **Africa after Modernism**
Transitions in Literature, Media, and Philosophy
Michael Janis

7 **Rethinking Race, Politics, and Poetics**
C. L. R. James' Critique of Modernity
Brett St Louis

8 **Making British Culture**
English Readers and the Scottish Enlightenment, 1740–1830
David Allan

9 **Empires and Boundaries**
Rethinking Race, Class, and Gender in Colonial Settings
Edited by Harald Fischer-Tiné and Susanne Gehrmann

10 **Tobacco in Russian History and Culture**
From the Seventeenth Century to the Present
Edited by Matthew P. Romaniello and Tricia Starks

11 **History of Islam in German Thought**
From Leibniz to Nietzsche
Ian Almond

12 **Israeli-Palestinian Conflict in the Francophone World**
Edited by Nathalie Debrauwere-Miller

13 **History of Participatory Media**
Politics and Publics, 1750–2000
Edited by Anders Ekström, Solveig Jülich, Frans Lundgren and Per Wisselgren

14 **Living in the City**
Urban Institutions in the Low Countries, 1200–2010
Edited by Leo Lucassen and Wim Willems

15 **Historical Disasters in Context**
Science, Religion, and Politics
Edited by Andrea Janku, Gerrit J. Schenk and Franz Mauelshagen

16 **Migration, Ethnicity, and Mental Health**
International Perspectives, 1840–2010
Edited by Angela McCarthy and Catharine Coleborne

17 **Politics of Memory**
Making Slavery Visible in the Public Space
Edited by Ana Lucia Araujo

Politics of Memory
Making Slavery Visible in the Public Space

Edited by Ana Lucia Araujo

Routledge
Taylor & Francis Group
NEW YORK LONDON

First published 2012
by Routledge
711 Third Avenue, New York, NY 10017

Simultaneously published in the UK
by Routledge
2 Park Square, Milton Park, Abingdon, Oxon OX14 4RN

*Routledge is an imprint of the Taylor & Francis Group,
an informa business*

© 2012 Taylor & Francis

The right of Ana Lucia Araujo to be identified as the author of the editorial material, and of the authors for their individual chapters, has been asserted in accordance with sections 77 and 78 of the Copyright, Designs and Patents Act 1988.

All rights reserved. No part of this book may be reprinted or reproduced or utilised in any form or by any electronic, mechanical, or other means, now known or hereafter invented, including photocopying and recording, or in any information storage or retrieval system, without permission in writing from the publishers.

Trademark Notice: Product or corporate names may be trademarks or registered trademarks, and are used only for identification and explanation without intent to infringe.

Library of Congress Cataloging-in-Publication Data
Politics of memory : making slavery visible in the public space / edited by
 Ana Lucia Araujo.
 p. cm. — (Routledge studies in cultural history ; 17)
 Includes bibliographical references and index.
 1. Slavery—Historiography—Social aspects. 2. Slave trade—
Historiography—Social aspects. 3. Slavery—Musems. 4. Slave
trade—Museums. 5. Collective memory. I. Araujo, Ana Lucia.
 HT871.P65 2012
 306.3'62072'2—dc23
 2011046232

ISBN13: 978-0-415-52692-0 (hbk)
ISBN13: 978-0-203-11907-5 (ebk)

Typeset in Sabon
by IBT Global.

Printed and bound in the United States of America on sustainably sourced paper by IBT Global.

Contents

List of Figures ix

Acknowledgments xi

Introduction 1
ANA LUCIA ARAUJO

PART I
Slavery and Slave Trade in National Narratives

1 Transnational Memory of Slave Merchants: Making the Perpetrators Visible in the Public Space 15
ANA LUCIA ARAUJO

2 Reasons for Silence: Tracing the Legacy of Internal Slavery and Slave Trade in Contemporary Gambia 35
ALICE BELLAGAMBA

3 With or Without Roots: Conflicting Memories of Slavery and Indentured Labor in the Mauritian Public Space 54
MATHIEU CLAVEYROLAS

4 Smoldering Memories and Burning Questions: The Politics of Remembering Sally Bassett and Slavery in Bermuda 71
QUITO SWAN

5 Making Slavery Visible (Again): The Nineteenth-Century Roots of a Revisionist Recovery in New England 92
MARGOT MINARDI

6 Teaching and Commemorating Slavery and Abolition in France: From Organized Forgetfulness to Historical Debates 106
NELLY SCHMIDT

7 Commemorating a Guilty Past: The Politics of Memory in the French Former Slave Trade Cities 124
RENAUD HOURCADE

8 The Challenge of Memorializing Slavery in North Carolina: The Unsung Founders Memorial and the North Carolina Freedom Monument Project 141
RENÉE ATER

PART II
Slavery and Slave Trade in the Museum

9 Museums and Slavery in Britain: The Bicentenary of 1807 159
GEOFFREY CUBITT

10 Museums and Sensitive Histories: The International Slavery Museum 178
RICHARD BENJAMIN

11 The Art of Memory: São Paulo's AfroBrazil Museum 197
KIMBERLY CLEVELAND

12 Afro-Brazilian Heritage and Slavery in Rio de Janeiro Community Museums 213
FRANCINE SAILLANT AND PEDRO SIMONARD

13 Exhibiting Slavery at the New-York Historical Society 232
KATHLEEN HULSER

14 Museums and the Story of Slavery: The Challenge of Language 252
REGINA FADEN

Contributors 267
Bibliography 271
Index 291

Figures

1.1	Statue of Joaquim Pereira Marinho at Santa Casa da Misericórdia, Salvador (Bahia, Brazil).	24
1.2	Statue of Robert Milligan in front of the Museum of Docklands, London, United Kingdom.	28
4.1	Spirit of Freedom. Hamilton, Bermuda.	72
4.2	Map of Bermuda, Library of Congress General Map Collection.	76
4.3	Children in stockades. St. George's Square, Bermuda.	83
8.1	Do-So Huh, Unsung Founders Memorial, bronze and granite, McCorkle Place, University of North Carolina at Chapel Hill, 2005.	143
8.2	Schematic drawing of the North Carolina Freedom Monument Project, Raleigh, prepared by Juan Logan, Lyneise Williams, and David Swanson, June 2008.	144
10.1	Ku Klux Klan display, International Slavery Museum, *Legacy Gallery*.	189
10.2	Niger ankle bracelet, International Slavery Museum, *Legacy Gallery*.	192
13.1	Free Negro Plots in Washington Square.	236
13.2	Merchant's House Installation. Exhibit *Slavery in New York*, New-York Historical Society, 2005.	238
13.3	Liberty/Liberté, Fred Wilson. Exhibit *Legacies: Contemporary Artists Reflect on Slavery*, New-York Historical Society, 2006.	243
14.1	Mark Twain and John Lewis at Quarry Farm, Elmira, New York, July, 1903.	254
14.2	Historical Interpreter and Visitor at the Godiah Spray Plantation, Historic St. Mary's City, 2007.	261

Acknowledgments

This book is based on selected papers presented in the multisession workshop "Politics of Memory: Making Slavery Visible in the Public Space," held during the 125th American Historical Association Meeting in January 2011 in Boston, Massachusetts. I am indebted to to David Lowenthal and Peter H. Wood for their insightful comments. I am also grateful to Bogumil Jewsiewicki and to the other two anonymous reviewers for their suggestions and criticism. I thank the authors who agreed to participate in this venture, who always answered in a timely manner my queries, and from whom I learned a lot during our fruitful exchanges. Particular thanks are owed to Dr. Joseph E. Reidy, Associate Provost of Howard University. With his support and the help of Mr. Rohinton Tengra, I was able to receive a generous summer grant from the Provost's Office, which allowed me to finish editing this book. I also thank Dr. James A. Donaldson, Dean of the College of Arts and Sciences of Howard University. The College provided me with funds to participate in the American Historical Association Meeting in Boston. I also thank Alhaji Conteh, PhD student in the Department of History at Howard University, who assisted me in proofreading some chapters of this book. I am especially grateful to Laura Stearns, my editor, and to Stacy Noto, editorial assistant, at Routledge. They closely assisted me during the various stages of the manuscript's preparation, always answering patiently my numerous questions. Finally, I thank my husband Alain Belanger. His love, patience, kindness, and enthusiastic support encouraged me to start and to finish this project on time.

Introduction

Ana Lucia Araujo

This book examines the resurgence of the memory of slavery in the public space of various former slave societies in Europe, Africa, and the Americas. The idea of public memory developed in the book is closely associated with Maurice Halbwachs's notion of collective memory, a mode of memory carried out by social groups and societies within specific social frameworks.[1] Collective memory becomes public when it is transformed into a political instrument to build, assert, and reinforce identities of these groups. In other words, collective memory is not related to individual recollection of personal experiences and events but is about the way the past of a group is lived again in the present—the way a group associates its common remembrances with historical events or with a set of historical events. Although collective memory is characterized by continuity, it is not homogenous but conflictual, rather resembling a mosaic composed of various zones corresponding to the ways the past is remembered by individuals and groups. However, in societies marked by traumatic events like the Atlantic slave trade and in which transmission of past experiences was interrupted, collective memory gives way to historical memory that to some extent can be "crystallized" in more permanent forms, including museums, monuments, and memorials, in processes that have been defined as memorialization and heritagization. This mode of memory is no longer characterized by a continuous flow or transmission of experiences but instead is the common way societies or groups in a specific society recover, re-create, and represent their past to themselves and to others in the public sphere, regardless of whether the individuals involved in memorialization and heritagization actually lived or participated in the events they collectively remember. Engaged in recovering their common past, individuals and groups rebuild and reinforce their identities by asserting what distinguishes them from others in the same society or by stating what makes their society different from other societies.

Examining the collective and public memories of slavery is a complex task because the Atlantic slave trade and slavery lasted more than three centuries, encompassing and affecting directly or indirectly several regions of the globe. These memories are plural, scattered, and change over time,

constituting several layers. As a result, in a specific nation, the collective memory of slavery can be that of the dominant group—descendants of slavers, slave merchants, slave owners, or in some cases the ethnic or racial group representing those who largely benefited from the slave trade and slavery—and remain hegemonic for a long period. In this context, the memories of the subaltern groups—descendants of slaves or the victimized groups who because of the color of their skin, their ethnic origin, their religion, or social position are associated with the victims—continue to exist in various states. In one state, the memory is repressed, and social actors live in a condition close to amnesia, in which silence and forgetfulness predominate. In a second state, the memory of victims is alive, but because the social actors who carry these memories remain in a subaltern position, a place of social exclusion, these memories are rarely expressed in the public arena. In a third state, international, national, and local events and initiatives help the victims, for whom their past is very much alive, to start conveying their memories in the public arena. In this context, bringing the past to the present or reenacting the past in the present is a process that can encompass collective healing. Nevertheless, the resurgence of the memory of slavery—conveyed by the descendants of the victims or by the groups who have been historically associated with these victims—also creates competition between the memories of the descendants of victims and perpetrators. Through this competition the memory of the victimized groups can eventually conquer the public space, allowing these groups to make their past officially recognized and to formulate demands to redress inherited social, economic, and racial inequalities.

Regarding the memory of the Atlantic slave trade and slavery, the three states here described appeared at different moments in various former slave societies. However, until recent years, in most European, African, and American societies, the traces of more than three centuries of slave trade and slavery remained concealed in the public space. With the end of the Second World War and the unveiling of the horrors of the Holocaust, the wounds of the slave past started to slowly emerge. The end of colonial rule in Africa and the US civil rights movement fueled the battle against racism and racial inequalities led by the populations of African descent in the Caribbean, South America, and Europe. This new context helped to foster cultural assertion and demands for official recognition of the contributions of the populations of African descent to the building of societies in Europe and the Americas, which largely benefited from slavery and the slave trade. In some cases, the emergence of the memory of slavery was followed by public "apologies." Pope John Paul II, President Bill Clinton, and Great Britain's Prime Minister Tony Blair were among the public personalities who publicly expressed their sorrow for slavery and the Atlantic slave trade. In other cases, the resurgence of the memory of slavery was followed by claims for financial compensation, and social and historical actors frequently expressed the need to remember the traumatic past in the public

sphere through public commemoration, museums, monuments, festivals, and holidays.

Although the memory and the legacies of slavery and the slave trade were deeply embedded in former slave societies—including Brazil, the United States, France, Britain, Colombia, Cuba, and several other countries—governments historically had not officially recognized the participation of their nations in the trade of human beings. In these societies that largely benefited from a slave workforce, most descendants of the perpetrators continued to occupy prominent social, economic, and political positions, which they would not risk by accurately recalling past moral transgressions of their societies. Because in former slave societies most descendants of enslaved persons continued to be socially and economically excluded, slave ancestry was (and in several cases still is) a heavy stigma. Due to this social configuration, in both urban and rural areas, historical sites of slavery and the slave trade often remained unnoticed, and monuments and memorials built to honor the contribution of black men and women and of the victims of the Atlantic slave trade were very rare. In addition, official institutions like museums and their permanent and temporary exhibitions often ignored or avoided the topic "slavery," which was usually presented as one of the various components of maritime history and labor history.

Slavery very gradually left this "wounded" condition that kept it concealed and started to become visible in local and global spheres.[2] During the 1990s, globalization, the development of the Internet and other technologies of information, and the growing accessibility of overseas travel to some extent contributed to the development of a phenomenon of homogenization among nations and groups and helped at the same time to establish connections among the populations of African descent from various areas of the world.[3] But as a form of response to globalization, cultural and human diversity—and the emphasis on specific identities—were brought to light. As part of this process, slavery, the slave trade, and other crimes against humanity as well as genocides, among which the Holocaust received the largest attention, were fully incorporated to the memorialization and heritagization phenomena. The resurgence of the memory of slavery was marked by initiatives aiming at preserving and promoting historical sites that memorialized slavery and the slave trade, and this was followed by a growing interest in the search for one's genealogical "roots." In addition, all sorts of commemorative activities such as festivals and anniversaries contributed to the broad process that led the populations of African descent to voice identity claims and highlight particular aspects of their history, including cultural and religious traditions. Groups organized by the African diaspora were eventually successful in emphasizing the crucial role of Africans in the building of Europe and the Americas. However, because the development and success of these various efforts depended on the ability and the political weight of the various groups involved, the speed with which official recognition of the slave past and of the populations of

African descent's contribution to former slave societies were incorporated into national narratives varied significantly from region to region.

In the United States the memory of slavery became popular in the public sphere particularly through the early publication of slave narratives and of novels about slavery. The memory of slavery was also raised in the public consciousness by the broadcasting of television series such as Alex Haley's *Roots*, which became very popular around the world. However, despite the importance of the US civil rights movement, and despite its various branches—which inspired black cultural assertion, the fight against racism in other parts of the Americas, and the struggle against apartheid in South Africa—the public recognition of this past was not expressed by the creation of permanent institutions and landmarks remembering US slavery. The initiative to build a national museum of African American History in the Washington, DC, National Mall is actually very recent.[4] Until the 1990s, only a very few monuments, museums, and memorials related to slavery and black history were scattered around the country, and most of these were small initiatives developed by specific groups. Actually, despite the great financial resources of the United States and the country's plethora of well-established museums and numerous monuments honoring its historical heroes, the first important projects highlighting the memory of the Atlantic slave trade and slavery in the public space were developed in West African countries. Since the middle of the 1960s, in countries such as Ghana, Senegal, and the Republic of Benin, national governments and UNESCO played an important role in fostering initiatives aimed at preserving and promoting historical sites such as slave-trade castles and fortresses that served as slave depots. In addition, in 1992, following the commemoration activities of the 500th anniversary of Columbus's arrival in the Americas, important and visible initiatives were developed in West African countries to highlight the involvement of these regions in the Atlantic slave trade. The construction of Western-like public monuments and memorials was sponsored by local governments and supported by some European countries (including France, Italy, and Germany) and by UNESCO, which sponsored and created some of these initiatives under the umbrella of The Slave Route project, launched in 1994. However, it is important to underline that, unlike European and North American countries, most West African countries were not familiar with Western museum traditions or with the tradition of creating permanent memorials and monuments to remember the past in the public space. For most West African governments and elites, the main goal of these projects was promoting cultural tourism in regions that were seriously in need of economic development. Though they attracted tourists, these initiatives failed in addressing the importance of the Muslim slave trade and of local slavery, and they were not always successful in creating local awareness about the slave past of West Africa. In this context of commodification of slavery and slave trade, the number of African American and Caribbean tourists who traveled to West African countries not only to research their

family roots but also to visit places of remembrance of the Atlantic slave trade and slavery increased. Even though family and private memories of slavery remained alive in the United States, because they were not officially recognized and displayed in the public landscape, African Americans today must travel to Africa to address and face the slaving past.[5]

Slavery remained invisible in the public space of other important former slave societies as well. Unlike West Africa, West Central African countries did not witness a significant number of public initiatives aimed at highlighting the region's important role during the period of the Atlantic slave trade. In former slave ports such as Luanda and Benguela in modern Angola, no monuments or memorials honor the victims of the slave trade. In 1997, following the wave launched by UNESCO's Slave Route project, Angola unveiled its National Museum of Slavery. Created by the National Institute of Cultural Heritage, this very modest museum is located 15 miles from Luanda, far from the gaze of the city's inhabitants.

In Brazil—Angola's counterpart in the slave trade in the South Atlantic region and the largest slave society in the Americas—since the 1960s African cultural heritage gained visibility in states like Bahia and Rio de Janeiro.[6] Nevertheless, most initiatives celebrating the country's African roots and the tragedy of the slave trade and slavery were limited to particular occasions, especially in the period of Carnival.[7] Indeed, despite the strong resurgence of the Brazilian black movement in the 1980s, public venues highlighting the country's slaving past remained very scarce until the end of the 1990s.[8] However, at the turn of the twenty-first century, international pressure and the actions of Afro-Brazilian organized groups began to rapidly change this situation.

In Europe, England was the first country to explicitly acknowledge in the public sphere its deep involvement in the Atlantic slave trade. The first British initiatives aimed at memorializing the slave trade started in the middle of the 1990s, even though most venues were launched at the turn of the present century with the intent of preparing the commemoration activities of the 2007 bicentennial of the abolition of British slave trade.[9] As a result of the pressure from organized black British social groups—most of them composed of individuals born in former British colonies in the West Indies, which largely relied on slave labor, and who remain economically and socially excluded—former slave ports like Bristol and later Liverpool publicly recognized their role in the Atlantic slave trade by agreeing to display this uncomfortable part of their past in their urban landscapes.[10]

France's slaving past gradually resurged in 1998, after England's did, during the commemoration activities of the 150th anniversary of the second abolition of slavery in the French colonies. In response to the pressures from French Caribbean communities of African descent, the French Parliament passed Law number 2001–434 of May 2001 (the Taubira Law), which recognized slavery and the slave trade as crimes against humanity. The passing of the Taubira Law was followed by a series of

events and debates dealing with the question of the place of slaving and colonial pasts in the public life of France. In 2005, police violence against teenagers of African descent in a suburb of Paris fueled a series of riots in several French cities. That same year Article Four of the Law 2005–158 of February 23, 2005, which proposed recognizing the positive role of French colonization, was an object of great controversy and was eventually withdrawn by President Jacques Chirac. Also in 2005, the Committee for the Memory of Slavery was created in France. The Committee ended by proposing May 10 to be the official national day of commemoration of the abolition of slavery in Metropolitan France. In the years that followed, several other initiatives attempting to adapt and redress French national narrative on slavery and the Atlantic slave trade were developed, including proposals to change the French school curriculum, the creation of national commemoration activities, the unveiling of monuments, and the creation and display of permanent and temporary exhibitions about slavery and the slave trade.[11]

The fourteen chapters of this book explore how the memories of the descendants of the enslaved and the descendants of the slavers are shaped and displayed in the public space not only in former slave societies in the Americas but also in the regions that provided captives to the former American colonies and European metropoles. Through the analysis of national narratives, life stories, museum exhibitions, monuments, and memorials, the volume aims at understanding the political stakes involved in the phenomenon of memorialization and heritagization of slavery and the slave trade. What the various chapters of this book show is that the resurgence of the public memory of slavery and the Atlantic slave trade, which twenty years ago could be barely observed, especially in North America, is gradually becoming a transnational phenomenon now encompassing Europe, Africa, and Latin America.

The book is divided into two parts. *Part I: Slavery and Slave Trade in National Narratives* consists of eight chapters that shed light on the difficulties faced by African, European, and American nations when dealing with their slaving pasts. The chapters discuss how various countries gradually incorporated slavery and the Atlantic slave trade in their national narratives and how public debates eventually led governments to give visibility to these crimes against humanity in the public space.

The first chapter, "Transnational Memory of Slave Merchants: Making the Perpetrators Visible in the Public Space," examines the public memory of three slave merchants who were deeply involved in the Atlantic slave trade in Brazil, in the present-day Republic of Benin, and in England: Francisco Félix de Souza (1754–1849), Joaquim Pereira Marinho (1816–1887), and Robert Milligan (1746–1809). The chapter shows that although official initiatives promoting the memory of slavery are receiving greater attention, slave traders continue to occupy a prominent place in public landmarks of countries like Brazil, Benin, and England.

In Chapter 2, "Public Memories, Silenced Pasts: Following the Inner Legacy of Slavery in the Contemporary Gambia," Alice Bellagamba shows that West African nations such as Gambia were successful in giving visibility to the region's involvement in the Atlantic slave trade. However, the past of local slavery and slave trade remains a difficult subject around which there are more silences than answers. Based on long-term fieldwork research in Gambia, Bellagamba's chapter explores present social and economic legacies of slavery and discusses the various reasons for these silences.

In the third chapter, Mathieu Claveyrolas shows how the Republic of Mauritius quickly adhered to the international initiatives promoting slavery in the public space. The chapter discusses the conflicting communal memories of the descendants of Indian indentured servants who arrived in the country after 1835 and the descendants of enslaved Africans who were deported to the island earlier, during the French rule. By discussing the appropriation of Mauritian public space through the construction of monuments and the preservation of historical sites, Claveyrolas argues that the global phenomenon of commemoration of the memory of slavery is an instrument allowing identity positioning and resistance in the Mauritian political arena.

Bermuda was one of the latest countries to adhere to the phenomenon of memorialization of slavery and the slave trade in the British Caribbean. In Chapter 4, "Smoldering Memories and Burning Questions: The Politics of Remembering Sally Bassett and Slavery in Bermuda," Quito Swan examines the debates around the construction of a monument representing Sally Bassett, an enslaved woman who was burned alive in the eighteenth century after being accused of poisoning the masters of her enslaved granddaughter. By revisiting the history of slavery in Bermuda and the myth of benign slavery, Swan shows in this provocative chapter that the political stakes involved in the process of making slavery visible in Bermuda reveal contemporary issues of power, race, racism, and colonialism.

In Chapter 5, "Making Slavery Visible (Again): The Nineteenth-Century Roots of a Revisionist Recovery in New England," Margot Minardi explores the history of the memory of slavery in New England. She argues that in New England the collective memory of slavery is closely associated with the nostalgia for the racial order that followed the post-Emancipation period, which was marked by close relationships between freedmen and freedwomen with their former masters and white elites. By examining this nostalgia, Minardi argues that the processes of remembering and forgetting slavery could convey the same racial ideology.

In the sixth chapter, Nelly Schmidt examines the construction of the public memory of slavery in the French Caribbean colonies. She argues that since 1848, colonial authorities developed policies of social control in order to support public order, to prevent social disputes, and to protect economic activity, all of which resulted in neglecting and forgetting the French slaving past. As part of this process of manipulating history that

8 Ana Lucia Araujo

Schmidt provocatively defines as "organized forgetfulness," the construction of myths played a crucial role. From the nineteenth century until now, several commemoration activities supported this mythmaking. Schmidt explains that because historians have not yet established an efficient connection between the results of their investigations and the various means of teaching and disseminating knowledge, a long period of transition marked by contradictory and ambiguous debates still persists in France.

In Chapter 7, "Commemorating a Guilty Past: The Politics of Memory in the French Former Slave Trade Cities," Renaud Hourcade examines the resurgence of the slaving past in two former French slave ports: Bordeaux and Nantes. By discussing the influence of local memory entrepreneurs and the changes in French national memory of slavery, Hourcade argues that the local politics of memory have produced a specific understanding of the past in which a racialization approach was rejected in favor of an inclusive narrative focusing on the local community's changing identities.

In Chapter 8, Renée Ater dicusses one monument and the project of a memorial, both located in North Carolina, a US state where important debates on the meaning of slavery and its relations to Civil War events, and the Confederate past, are in progress. Ater examines the Unsung Founders Memorial, situated on the campus of the University of North Carolina at Chapel Hill, and the North Carolina Freedom Monument Project, planned to be unveiled in downtown Raleigh as a "site of memory." By exploring the visual forms of the memorials and the debates around their construction, Ater seeks to understand how the various social actors and institutions involved in the development of these two initiatives have sought to remember slavery in the public spaces of the campus and the city.

Part II: Slavery and Slave Trade in the Museum is composed of six chapters discussing how slavery has gradually occupied a place in museums of England, Brazil, and the United States. The authors evaluate the challenges associated with conveying the experience of the victims of enslavement and examine the different approaches employed by several national and community museums when displaying slavery and the Atlantic slave trade in permanent and temporary exhibitions.

In Chapter 9, Geoffrey Cubitt examines the initiatives developed by British museums to mark the 2007 bicentenary of the Slave Trade Act in Britain. Cubitt shows how museums sought to educate predominantly middle-class white audiences and create awareness of the country's slaving past and how slavery contributed to British history. The chapter also discusses how museums involved the black community in the various activities, by attempting to persuade black groups that henceforth museums were willing to take into account a diversity of voices and to recognize a variety of histories. Examining these various and competing priorities, Cubitt explores the approaches developed by museums to deal with various topics, including abolitionism and resistance, slavery's local and regional significance, and its contemporary legacies.

In Chapter 10, Richard Benjamin examines the case of the International Slavery Museum (ISM), which opened in Liverpool in 2007. Benjamin, the head of the ISM, discusses a number of challenging issues and concerns faced by the museum when developing collection policies and programming initiatives involving sensitive histories, such as slavery. By examining a number of examples taken from exhibitions and other initiatives developed in the museum, the chapter shows how the museum seeks to increase public understanding of slavery, the Atlantic slave trade, and its legacies.

In her chapter, "The Art of Memory: São Paulo's AfroBrazil Museum," Kimberly Cleveland examines São Paulo's AfroBrazil Museum, one of the only Brazilian institutions dedicated to presenting the history of the country's African and Afro-Brazilian populations. Cleveland discusses the obstacles faced by the museum in a country that still resists examining its slavery past. By analyzing the various strategies developed by the museum to teach black history, the chapter explores the complex dialogue between art and racial politics developed in the AfroBrasil Museum.

Chapter 12, "Afro-Brazilian Heritage and Slavery in Rio de Janeiro Community Museums," studies the presence of the memory of slavery in the national museums in Rio de Janeiro (Brazil). The authors, Francine Saillant and Pedro Simonard, discuss the place of Afro-Brazilian culture in the heritage policies developed by the federal government, as well as in the state and the city of Rio de Janeiro. By considering the weak presence of slavery in national museums, the chapter examines the presence of slavery and Afro-Brazilian culture in three community museums. The conclusion suggests a growing visibility of the memory of slavery in the city of Rio de Janeiro resulting from the recent political incentives and community dynamism.

Chapter 13, "Exhibiting Slavery at the New-York Historical Society," by Kathleen Hulser, analyzes several initiatives focusing on Northern slavery and its legacies transformed the New-York Historical Society at the outset of the twenty-first century. Hulser, a public historian and senior curator of history in the New-York Historical Society, argues that in general these projects were possible because of the changes provoked by the US civil rights movement and that, in particular, they resulted from the rediscovery and preservation of the African Burial Ground in New York City. She shows that the initial concern with the forgotten history of slavery and prejudice was transformed into a project focusing on historical justice and the memory of slavery. In the context of these changes, the New-York Historical Society contributed to make the slavery past and racial prejudice visible in the public space.

In the fourteenth chapter, "Museums and the Story of Slavery: The Challenge of Language," Regina Faden discusses how two US museums have taken the challenge of discussing race and the legacy of slavery. Faden insists that race and slavery are difficult topics to address in museums because of the reluctance of some North Americans to engage with

these aspects of US history. She explains this process can be complicated by language—both its meanings and its vagaries. To support her arguments, Faden first examines the Mark Twain Boyhood Home & Museum (Hannibal, Missouri), at which she served as executive director for four years. This institution is studied as an example of a museum that struggles with nineteenth-century racial language. In addition, she also examines the case of Historic St. Mary's City (St. Mary's City, Maryland)—where she presently serves as executive director—to show how language of the past can obscure the broad history of slavery.

Through the analysis of various initiatives such as public monuments, memorials, museums, exhibitions, festivals, and commemoration activities, this book seeks the answers to numerous questions, including the following: How is the public memory of the slave trade and slavery shaped, displayed, and reconstructed in the public arena? What political stakes encompassed the emergence of the public memory of slavery in national and transnational spaces? How were slavery and the slave trade integrated or not in national narratives? What aspects characterized the presence or the absence of slavery and the slave trade in public urban spaces of various regions of the Americas, Europe, and Africa? What problems accompanied the appropriation of the public sphere? Taking the transnational rise of the memory of slavery in the last twenty years as a point of departure, this edited book aims at understanding the political stakes involved in the phenomenon that is slowly making the slave trade and slavery more visible in the public space.

NOTES

1. On collective memory and memory social frameworks, see Halbwachs's pioneer works: Maurice Halbwachs, *Les cadres sociaux de la mémoire* (Paris: F. Alcan, 1925). For a distinction between collective memory and historical memory see Maurice Halbwachs, *La mémoire collective* (Paris: Presses Universitaires de France, 1950), Chapter 2. About collective memory in the context of nation-states see Paul Connerton, *How Societies Remember* (New York: Cambridge University Press, 1989).
2. I take the notion of "wounded memory" from Paul Ricoeur, *Memory, History, Forgetting* (Chicago: University of Chicago Press, 2006).
3. See Ana Lucia Araujo, "Welcome the Diaspora: Slavery Heritage Tourism and the Public Memory of the Atlantic Slave Trade," *Ethnologies* 32, no. 2 (2010): 145–178.
4. The museum is an old demand of African American organized groups, and its completion is expected in 2015. The museum will be part of the Smithsonian Institution and will be located on five acres at Constitution Avenue between 14th and 15th streets NW.
5. Sandra Richards, "What Is to Be Remembered? Tourism to Ghana's Slave Castle Dungeons," *Theatre Journal* 57, no. 4 (2005): 620.
6. See Ana Lucia Araujo, *Public Memory of Slavery: Victims and Perpetrators in the South Atlantic* (Amherst, NY: Cambria Press, 2010), especially Chapter 5.

7. See Ana Lucia Araujo, "Slavery, Royalty and Racism: Representations of Africa in Brazilian Carnaval," *Ethnologies* 31, no. 2 (2010): 131–167.
8. See Myrian Sepúlveda dos Santos, "The Repressed Memory of Brazilian Slavery," *International Journal of Cultural Studies* 11, no 2 (2008): 157–175.
9. A large number of recent publications have focused on British public memory of slavery and the 2007 bicentenary, among them see Laurajane Smith, Geoff Cubitt, Ross Wilson, and Kalliopi Fouseki, eds. *Representing Enslavement and Abolition in Museums* (New York and London: Routledge, 2011), and Elizabeth Kowaleski Wallace, *The British Slave Trade and Public Memory* (New York: Columbia University Press, 2006).
10. About Bristol, see Christine Chivallon, "Bristol and the Eruption of Memory: Making the Slave-Trading Past Visible," *Social & Cultural Geography* 2, no. 3 (2001): 347–363, and Madge Dresser, "Remembering Slavery and Abolition in Bristol," *Slavery and Abolition* 30, no. 2 (2009): 223–246.
11. About the public memory of slavery in France and the French Caribbean, see Christopher L. Miller, *The French Atlantic Triangle: Literature and Culture of the Slave Trade* (Durham: Duke University Press, 2008); Christine Chivallon, "Resurgence of the Memory of Slavery in France: Issues and Significations of a Public and Academic Debate," in *Living History: Encountering the Memory of the Heirs of Slavery*, ed. Ana Lucia Araujo (Newcastle: Cambridge Scholars Publishing, 2009), 83–97; and Catherine A. Reinhardt, *Claims to Memory: Beyond Slavery and Emancipation in the French Caribbean* (New York, Oxford: Berghahn Books, 2006).

Part I

Slavery and Slave Trade in National Narratives

1 Transnational Memory of Slave Merchants
Making the Perpetrators Visible in the Public Space

Ana Lucia Araujo

Over the last twenty years the public memory of the Atlantic slave trade and slavery emerged as a global phenomenon in various Atlantic centers in the Americas, Europe, and Africa. Places of remembrance of the Atlantic slave trade, such as memorials, museums, and monuments, very often emphasizing victimhood, depict naked and starving black bodies packed in slave ships. In Gorée Island, Cape Coast, Elmina, and Ouidah, these traumatic journeys are represented by gates and doors of no-return that mark the transition to confinement, forced migration, and forced labor. However, official initiatives, most of them led by UNESCO, also had unexpected outcomes. In Brazil, Benin, and England, memorialization of slavery has also helped rehabilitate the memory of the perpetrators of crimes against humanity. By considering this complex context, this chapter examines the public memory of three slave merchants who were deeply in involved in the Atlantic slave trade in three different societies located in three different continents (Brazil, present-day Republic of Benin, and England): Francisco Félix de Souza (1754–1849), Joaquim Pereira Marinho (1816–1887), and Robert Milligan (1746–1809). This chapter seeks to explain how despite the official international projects aimed at promoting the memory of the victims of the Atlantic slave trade, the memory of these perpetrators continues to occupy a prominent place in the public space. Although these three individuals plied their slave-trade activities in three different continents, several elements of their public memory remain very similar. Indeed, in Brazil, England, or Benin, these three slave merchants are almost never depicted as perpetrators, but rather as benefactors and great businessmen. This chapter sheds light on the public representations of these slave merchants and how these three societies, which were deeply involved in the Atlantic slave trade, dealt with the memory of the victims and the memory of the perpetrators in the public space.

TRANSNATIONAL MEMORY OF SLAVE MERCHANTS

The rise of the memory of slavery not only allowed the descendants of the victims to occupy the public space to promote the heritage of their ancestors and to formulate demands to redress past wrongs, but also offered

the opportunity to the descendants of perpetrators and other auxiliaries in the slave-trade business to give their own point of view about the slave past of their families. Depending on the context, the public memory of the perpetrators and their descendants acquired political and even religious contours. In some countries, by expressing regret and addressing public apologies for the errors of their ancestors, the families of the perpetrators are also acquiring public visibility. In other countries, despite the construction of new monuments and memorials honoring the victims of the Atlantic slave trade, numerous public statues honoring individuals highly involved in the slave trade business remain intact and unquestioned.

Francisco Félix de Souza (1754–1849)

In 1727 the West African Kingdom of Dahomey seized Ouidah, the capital of the Kingdom of Hueda, gaining access to the coast. Over the years Ouidah became the second most important African slaving port after Luanda (Angola). Most enslaved men and women embarked in Ouidah were sent to Bahia, in Brazil. During the eighteenth century, numerous Brazilian and Portuguese slave merchants settled in Ouidah, where in 1721, the Portuguese founded the fortress São João Batista da Ajuda.[1]

The Brazilian slave merchant Francisco Félix Souza settled in the Bight of Benin in the early nineteenth century and soon became one of the most prosperous slave merchants of the region. By that time, the Dahomean King Adandozan (r. 1797–1818) and de Souza had a disagreement related to the Atlantic slave trade. Adandozan sent the slave merchant to prison, where he had contact with Prince Gakpe, who was Adandozan's half-brother. De Souza contracted a blood pact with the prince and helped him to organize a coup d'état. In 1818, Adandozan was deposed, and Prince Gakpe was enthroned and became King Gezo. To reward de Souza, the new king conferred upon him the position of his commercial intermediary in Ouidah. Eventually, de Souza's nickname "Chacha" became the title of the highest representative of the de Souzas. After the death of de Souza, the first Chacha, the King of Dahomey selected and nominated his successor, and today the family chooses the Chacha.

During the first half of the nineteenth century, de Souza became not only one of the most important slave merchants in the Bight of Benin, but also a legendary figure who is still part of the collective memory of Republic of Benin (former Kingdom of Dahomey). Since 1835, de Souza helped former slave returnees from Brazil to settle in Ouidah. Paradoxically, some of these returnees soon became prosperous slave merchants as well, and together with the slave traders already established in the Bight of Benin, they formed an Afro-Luso-Brazilian community. The existence of descendants of former slave merchants and former slave returnees—some of whom were followed by their former slaves and who became slave merchants once established in West Africa—reinforces the plural memories of slavery in the region.[2] This complex configuration sometimes makes it difficult to distinguish who were the victims and who were the perpetrators.[3]

Like other slave merchants of his time, de Souza continued making a profit from the Atlantic slave trade after 1815, when the Anglo-Portuguese treaty had already declared illegal the slave trade from West Africa, including the Bight of Benin. Although at the time of his death in 1849 de Souza had significant debts with King Gezo, as well as with Brazilian and Cuban merchants, he was one of the wealthiest slave merchants in West Africa, his fortune essentially made in the illegal slave trade business. Today the de Souzas still keep economic and political power not only in Benin, but also in other West African countries.

In the early 1990s, several public initiatives aiming at commemorating and memorializing the slave past were developed in the Republic of Benin. These various official projects such as the UNESCO's Slave Route project and the Vodun festival *Ouidah 92* left important marks in Ouidah's public space. As part of the Vodun festival held in February 1993, a Slaves' Route displaying one hundred monuments and memorials was unveiled in Ouidah and became a place of pilgrimage visited each year by several thousands of tourists from Benin and abroad. Although some monuments and memorials were placed along the route to mark actual historical sites, other statues do not indicate any specific point of reference but rather emphasize the idea of continuity. Most of these statues represent Vodun deities, and many others depict enchained and kneeling enslaved men and women.[4]

Nevertheless, the first station of the Slaves' Route in Ouidah is not dedicated to the victims of the Atlantic slave trade, but honors a perpetrator: Francisco Félix de Souza.[5] The station is named *Place des enchères* (Auctions Square) or *Place Chacha*.[6] This square is located in the Adjido quarter, behind the de Souza family compound, which is the location of de Souza's old house, still occupied by the head of the family, Honoré Feliciano Julião de Souza (Chacha VIII). The *Place des enchères* is also located in the same zone in which a slave market existed in the past. However, the sculpture created by the Beninese artist Cyprien Tokoudagba that marks the square represents an amazon of Dahomey's army, a female warrior with naked breasts and horns. At first sight, the public memory of slavery underscored in this monument is not related to the Brazilian slave merchant, instead it refers to his partner, King Gezo (r. 1818–1858). Just as his predecessors did, Gezo waged military campaigns annually against neighboring kingdoms: most of these war prisoners were sold and sent into slavery in the Americas. Upon the cement base of the monument at the *Place des enchères*, one reads: "In this place and under this tree were held public slave auctions during which the slaves who would be embarked to the Americas were exchanged for shoddy goods." In 1999, six years after the festival "Ouidah 92," another commemorative plaque displaying "Place Chacha" was placed next to the monument, associating the statue of the amazon and the square with de Souza.

In 1993, when the statue representing the Amazon was unveiled, de Souza's old house was almost abandoned. In 1995, when Chacha VIII was appointed, he decided to restore Francisco Félix de Souza's house and to build a new four-story "palace" at the same place where his old residence

was located. The new imposing building, situated behind the *Place Chacha*, symbolizes the power of the de Souza family, which still persists today.

Also in the de Souza compound there is a memorial to honor the Francisco Félix de Souza. Although it has existed for many years, it became accessible to the public only in the 1990s, when the Chacha VIII was appointed. Despite de Souza's slave trade activities, his descendants are proud of their ancestor, and over the past few years the members of the family have been making efforts to rehabilitate his memory, depicting him not as a slave trader but as a great entrepreneur.[7]

During a visit to the memorial, family members emphasized the de Souzas' bonds with Brazil, and justified the merchant's activities by insisting that slave trading was indeed a legal activity at the time, even though de Souza and his sons continued trading in slaves years after its prohibition. According to the family's point of view, de Souza contributed to the development of Africa by introducing new goods and new crops to the region, including the oil palm tree. Among others, in a speech during a ceremony held in the family compound, the spokesman of Chacha VIII, stated that the late Francisco Félix de Souza "spent without count his strength and his wealth in favor of the weak against the strong, the oppressed against the oppressor."[8]

Inside the memorial, Francisco Félix de Souza's old bedroom is still intact. In it one finds not only his original Brazilian wood bed, freshly made each day as if he were alive, but also his tomb. The room reinforces the idea that he remains among his family members and has become a major symbol of the family's original connection with Brazil and reveals the political influence still exerted by the de Souza family over the Afro-Luso-Brazilian community and other communities in Ouidah. This sanctification of de Souza increases the family's authority, which reaches beyond the political, economic, and family arenas to also gain a religious dimension.

De Souza's reputation as a generous man started when he was still alive. According to some descendants of slaves who were owned by de Souza, he was not perceived negatively by his slaves, but rather seen as a benevolent man.[9] Indeed, to British travelers of the nineteenth century, such as Frederick Forbes, de Souza's values differed from those of the indigenous population, and he was also opposed to human sacrifice.[10] John Duncan, for instance, reported that de Souza was benevolent to his slaves.[11] According to some travelers de Souza considered himself a great philanthropist, "on the grounds of having saved the lives of the slaves whom he purchased for export," consequently preventing them from being sacrificed.[12] Among the members of the family and the local population there is also a belief that de Souza used to buy all the members of a family in order to prevent their being separated and sent into slavery to the Americas.[13] Thus, as part of the memorialization process, de Souza's public memory is reconstructed according to moral values belonging to the present. He is depicted as concerned with human rights and disposed to liberate his slaves.

In Brazil, a country that imported the majority of the slaves sold by de Souza, recent movie and television documentaries highlighting the

connections between Brazil and Benin have given visibility to the de Souza family. Moreover, with the growing interest in the slave past and the emergence of a tourism industry relying on the memory of the Atlantic slave trade, an increasing number of African Americans who visit Ouidah are intrigued about the history of the legendary Brazilian slave merchant, who was depicted in Bruce Chatwin's novel *The Vice-Roy of Ouidah* and Werner Herzog's film *Cobra Verde*.[14] However, unlike other large tourist sites associated with the Atlantic slave trade, such as the Elmina or the Cape Coast Castles in Ghana or the House of Slaves on Gorée Island in Senegal, a visit to Singbomey and to a memorial honoring a perpetrator makes sense only if it is accompanied by the narration developed by the members of the family. Intentionally or not, as the point of departure of Ouidah's Slaves' Route is the *Place Chacha*, the UNESCO initiatives including "Ouidah 92" and The Slave Route project, which were intended to remember the victims of the Atlantic slave trade, indirectly helped to promote the memory of a perpetrator.

At least in the public sphere the memories of the victims and the perpetrators apparently coexist harmoniously. However, at a private level, there are persisting differences between the descendants of slave merchants and slave owners, and the descendants of those who were enslaved and remained in the region. Slave ancestry remains a source of shame, and most descendants of men and women who were locally kept under enslavement remain silent about this aspect of the past of their families, even though among the local population several marks—including their names, where they live, and their activities—reveal their slave origins.[15] The local population is aware that families of powerful individuals like de Souza, who were deeply involved in the Atlantic slave trade as merchants or auxiliaries, are still economically and politically important. Although the official initiatives helped to bring to light forgotten elements of the Atlantic slave past of the region, the public memory of the perpetrators was not radically transformed. On the contrary, the statue of the *Place Chacha*, along with the statues honoring the *voduns* of the slaver kings of Dahomey, which were placed along the Slaves' Route, are not only helping to renew the memory of those who led the slave trade in the region, but the development of slave-trade tourism is also offering new economic and political opportunities for these wealthy families.[16]

Joaquim Pereira Marinho (1816–1887)

On November 7, 1831, after the signature of several treaties between Brazil and England, the Law Feijó outlawed the Atlantic slave trade to Brazil. In theory, enslaved Africans who entered the country after 1831 were considered legally free. However, the illegal slave trade continued until 1850, when the Law Eusébio de Queirós eventually abolished it. Brazil not only imported the largest number of enslaved Africans, more than five million individuals, during the Atlantic slave trade, it was also the last country to abolish slavery. Despite the importance of the Luso-Brazilian slave trade,

few initiatives aimed at making the memory and the heritage of the Atlantic slave trade visible in the public space were developed in Brazil.

The state of Bahia imported about 1.5 million enslaved Africans, almost one-third of the total Brazilian slave imports. Although in Bahia—the Brazilian state with the largest population of African descent (70 percent)—African roots are publicly celebrated, few projects underscore its slave past. The first public monument addressing the issue of slavery erected in Salvador is not a statue honoring a slave or a person of African descent, but rather a monument in bronze and granite celebrating the white abolitionist poet Castro Alves (1847–1871), author of several abolitionist poems, including "The Slave Ship," and who became known as the "slaves' poet." Unveiled in July 1923, the monument has since 1971 contained the poet's mortal remains. It consists of huge column on which lies a full-body statue of Castro Alves. At the monument's base are two groups of figures. The first group, which leans against the column, consists of a flying angel rising up a young enslaved woman. The second group, placed at the base of the monument, is formed by an enslaved man and a black woman. Despite the presence of enslaved characters, the anonymous black women and the black man play only the supporting roles in this homage to the abolitionist poet.

Every year, Salvador receives millions of tourists, including a growing number of African American tourists, especially during the period of its famous carnival.[17] The city's slogan "Salvador: capital of joy" is confirmed by tourists who visit its historic center and are often approached by very young street children selling souvenirs or asking for money and who tirelessly repeat "smile you are in Bahia." As the second-largest slave port in Brazil, Salvador has numerous historical sites associated with slavery and the Atlantic slave trade, but this past is not acknowledged in the public space. In 1985, when Pelourinho—a Salvador's neighborhood located in the city's historic center where criminals as well as enslaved men and women were publicly punished—was added to the World Heritage List, the UNESCO's official document only highlighted its "colonial" architectural features, with no mention to slavery. The history of slavery is often evacuated from these sites, which do not contain a plaque or any other kind of sign indicating its role during the Atlantic slave trade, even though for the attentive observer the shadows of slavery are visible everywhere in the streets, buildings, and churches, several of which accommodated Catholic brotherhoods, such as the Blacks of the Rosary Church, that gathered together enslaved men and women, free and freed blacks.

In 1998, eight impressive 22-foot-tall statues representing various *orixás* (Afro-Brazilian deities) were placed in the "Tororó Dam" ("Dique do Tororó), an artificial lagoon in Salvador.[18] For the first time African religious heritage was praised in a permanent place in the public space. Since then, other monuments have focused on the public memory of slavery and Afro-Brazilian historical figures. In November 2004, four busts honoring four Afro-Brazilian men were unveiled at Praça da Piedade in Salvador, which was the stage for the events that followed the so-called Conspiracy of the Tailors or Buzios Revolt in 1798. The conspirators, mainly free-born Afro-Brazilians, former

slaves, and slaves, promised freedom to slaves and equality among all citizens, including blacks and mulattos. The busts pay homage to four men who were condemned to death because of their participation in the revolt: Manuel Faustino dos Santos Lira (1775–1799), the freedman Lucas Dantas do Amorim Torres (1774–1799), the freemen Luiz Gonzaga das Virgens e Veiga (1762–1799), and João de Deus do Nascimento (1771–1799). Since 2009, the Bahian deputy Luiz Alberto (Workers' Party) proposed law number 5819/2009, which would mandate inclusion of these four black leaders in the Book of National Heroes. However, only on May 30, 2008, did Salvador unveil its monument honoring Zumbi, the leader of the largest Brazilian runaway slave community. The full-body bronze statue on a square granite base represents Zumbi as a warrior holding a spear. Despite these initiatives, just as in several other former Atlantic slave ports, the public memory of those wealthy individuals who largely benefited from the trade in human beings remains almost intact in Salvador. Actually, except for historians and black activists, most people are not aware of how prominent men honored in monuments and statues all over the city were actually slave merchants and owners of numerous slaves.

Among these prominent men is the slave merchant Joaquim Pereira Marinho (1816–1887), who was born in Portugal and moved to Bahia in 1828. Of modest origin, his parents were farmers, who died when he was still a child, and his oldest brother, a vicar who prepared him for a religious career, may have raised him.[19] Indeed, in order to avoid the military service, at his arrival in Bahia it is likely he declared being younger than he actually was. At the time, he registered at the Portuguese consulate as a *marítimo* (maritime worker), but one of his obituaries indicates he was a *caixeiro* (shop assistant) in a textile shop, a position he probably occupied later.[20] As for other Portuguese immigrants, his activities as a maritime worker probably helped him to quickly become a prosperous slave merchant.[21]

Although it is hard to establish the exact year that Marinho started his career as a slave merchant, his activities began when the Brazilian slave trade was outlawed. Like de Souza, he was among those who made important profits with the illegal slave trade. Actually, by 1831 Marinho's boss Francisco Antonio de Souza Paranhos moved to Rio Grande do Sul, after being accused of killing someone. To reward his young employee for helping him to hide and escape from Bahia, Paranhos invited Marinho to join him in Rio Grande do Sul. In April 1835 Marinho, along with two slaves, were listed as passengers of the brigantine *Princeza* that sailed to Rio Grande do Sul. As Ximenes points out, the presence of the two slaves indicates an improvement in his financial situation.[22] Despite the lack of evidence, it is likely that by 1835 he was already involved in the commerce of human beings, probably through the port of Montevideo, a common route at the time of the illegal slave trade. From Rio Grande do Sul, Marinho traveled to Luanda, where he is said to have sealed significant commercial relations with Angola's greatest Central African woman slave merchant, Ana Joaquina dos Santos Silva (1779–1859), even though the slave trade in the Portuguese dominions was banned in 1836.[23] Also during this

trip, Marinho established connections with the infamous Brazilian slave trader Domingos José Martins, alias "Dominguinhos da 'Costa,'" also known as Domingo Martinez. By 1838 Dominguinhos was established in Lagos, and Marinho became his attorney-in-fact in Salvador.[24] By the end of 1839, he was back to Salvador. Between 1839 and 1850, according to *The Trans-Atlantic Slave Trade Database: Voyages*, Marinho's slave ships *Destemida, Três Amigos, Baiano, Teodora Teodósia, Maria, Andorinha, Vivo, Mosca, Moquim, Espanto, Rosita, Esperança, Terceira Andorinha, Nova Andorinha, Bomfim,* and *Cátita* made at least thirty-three voyages between Bahia and the Bight of Benin. Despite the ban of the Atlantic slave trade, the British Navy captured only some of these vessels. For example, the brigantine *Três Amigos* left Bahia to the port of Lagos (Onim).[25] There 1,400 enslaved persons were embarked. On March 9, 1846, the same vessel arrived in Bahia carrying 1,350 Africans.[26] The *Trans-Atlantic Slave Trade Database* indicates that between 1848 and 1849, the yacht *Andorinha* made five voyages between Bahia and African coasts, and was captured by the British Navy only on its sixth voyage in May 1849.[27] According to Pierre Verger, between October 17, 1846, and August 23, 1849, this same vessel made ten voyages to Africa, and disembarked 3,800 Africans in the port of Salvador.[28] If some contemporary observers negatively perceive slave merchants such as Marinho and de Souza as adventurous smugglers because their illegal activities involved risks, others see them as the men who provided the nation with a slave workforce necessary to the country's prosperity. Marinho's involvement in the illegal slave trade allowed him to quickly build his wealth and invest the profit in other business activities. The passing of the Law Eusébio de Queirós in 1850 did not prevent Marinho from continuing the trade in human beings. In 1858, he created the *Companhia União Africana* to develop legal trade with Africa; however, thanks to his connections with Cuba—where the slave trade stopped only in 1866—the company also traded in slaves. In addition to his various commercial operations, especially the trade of *charque* (salted meat), Marinho business ventures also included real estate investments and usury activities such as lending money and supplying credit to other merchants.

Still, during his life, Marinho was engaged in fighting against the dissemination of a public negative image of himself that resulted from his slave-trade activities, considered by some contemporary observers as immoral and illicit.[29] Marinho and his supporters responded to each one of these accusations by enumerating the numerous occasions the slave merchant helped the province of Bahia, either by leading initiatives to help the victims of a drought, or by providing financial support to build sidewalks in the streets of Corredor da Vitória, a wealthy neighborhood where he owned several properties.[30]

Despite Marinho's reputation as a prominent slave merchant, his public memory as a benefactor is still visible in Salvador's public space. Indeed, in 1847 he was admitted as member of the Santa Casa da Misericórdia (Holy House of Mercy), a sodality and charity institution created in Portugal at

the end of the fifteenth century that since 1549 provided health assistance to Bahian patients in financial need.[31] By joining the members of Bahian elite in this charity institution, which also admitted as members several other slave merchants, Marinho continued developing the image of a benefactor.[32] As Ximenes points out, his name appeared for the first time in the institution meetings minutes in 1860, and then only in 1881, when he was elected provider of the institution, a position occupied by individuals of great political importance that conferred on him significant powers with the president of the province and the city council.[33] In this position, kept until his death, he was able to definitely consolidate his image as a benefactor. After he received the titles of baron and viscount, on March 7, 1881, he was granted the title of count by King Luís of Portugal. On October 31, 1889, his son Joaquim Elísio Pereira Marinho (1841–1914), who had received the title of baron ten years earlier, was granted the title of Viscount of Guaí. Moreover, even in his own will of 1887, Pereira Marinho depicts himself as generous and righteous man, dissociating his wealth from any illegal and inhuman activity:

> [. . .] have done this will by my spontaneous will and with clear conscience to pass to the eternal life without never doing evil to my fellow creatures, and with the conviction that the wealth I leave was amassed by my perseverant work with savings and honesty and honor in my commercial transactions, never renouncing to doing good to my fellow creatures [. . .]."[34]

On July 30, 1893, some years after Count Marinho's death, a statue honoring him was erected at Largo de Nazaré, in front of the Hospital Santa Isabel of Santa Casa de Misericórdia inaugurated that same year (Figure 1.1). The full-body marble statue, measuring 6 feet tall and standing on a 3-foot-tall pedestal, symbolizes charity. The statue depicts Marinho as a businessman distinctively dressed and wearing a long beard. In his left hand he holds a scroll, probably the plan of the new hospital building. At his right side, a standing girl and boy express their gratitude by offering him a bunch of flowers. On the statue's pedestal, a plaque reads: "Tribute to the Memory of the Worthy Ex Provider Count Pereira Marinho, Resolution of April 26, 1887, recognizing his relevant services offered to the Casa da Santa Mizericordia."[35] In this case, the public memory of Pereira Marinho is the memory of the benefactor, the righteous businessman, and not of the slave merchant who benefited from the contraband of African women, men, and children. Some steps from Praça da Sé, where the statue of Zumbi was unveiled in 2008, and from the monument honoring the abolitionist poet Castro Alves, the Museum of the Santa Casa da Misericórdia (opened in 2006), hangs an impressive full-body oil portrait of Marinho, represented as a distinguished entrepreneur and benevolent man. As in other sites related to the Atlantic slave trade in the "capital of joy," nothing indicates that the "charity" he did was stained by the blood and the suffering of those men, women, and children who crossed the Atlantic Ocean enchained in the hold of his numerous slave ships.

Figure 1.1 Statue of Joaquim Pereira Marinho at Santa Casa da Misericórdia, Salvador (Bahia, Brazil). Photograph by Ana Lucia Araujo, 2009.

Robert Milligan (1746–1809)

Since the 1990s, England started publicly recognizing its slave-trading past by promoting its slave-trade heritage and developing cultural tourism in its former slave ports such as Liverpool, London, and Bristol.[36] During 2007 and 2008, the bicentenary of the abolition of the British slave trade was widely celebrated in Europe and the Americas with conferences, films, documentaries, publications, monuments, and exhibitions. London hosted several exhibitions discussing the English participation in the Atlantic slave trade. From February 20 to June 17, 2007, the Victoria and Albert Museum hosted the exhibition *Uncomfortable Truths: The Shadow of Slave Trade on Contemporary Art*; from March 17 to July 22, 2007, the National Portrait Gallery organized the exhibition *Portraits, People, and Abolition*; the Westminster Hall showed the exhibit *The British Slave Trade: Abolition, Parliament and People* from May 23 to September 23, 2007. Still in London, on November 30, 2007, the National Maritime Museum opened the exhibition *Atlantic Worlds*. In Bristol, the British Empire and Commonwealth Museum showed the exhibition *Breaking the Chains: The Fight to End Slavery*, from April 23, 2007, to April 23, 2009. In Hull, the William Wilberforce House was reopened on March 25, 2007. On August 23, 2007, Slavery Remembrance Day in Britain, the International Slavery Museum was opened in Liverpool.[37]

Since the 1980s, when a project to transform the West India Docks into Canary Wharf was developed, the Museum of London was working on an initiative to create the Museum of Docklands. The new museum, which aimed to tell the 2,000-year-old story of the Thames River, would essentially show objects from the collections of the Port of London Authority and the Museum of London. Located at West India Docks, in an 1802 former sugar warehouse that was used to store goods from the Caribbean plantations, the building of the Museum of London Docklands is part of the material heritage of the Atlantic slave trade. However, as Georgie Wemyss explained, between the 1990s until the museum opened in 2003, the museum's press releases and publicity material did not mention the Atlantic slave trade. Instead, it emphasized the architectural value of the warehouses, praising them as "great monuments of European Commercial Power."[38]

The Museum of London Docklands consists of twelve permanent galleries. The first, titled *No 1 Warehouse*, is situated in the museum's external area. The other galleries, located inside the building, cover the whole history of *London's River, Port, and People*, including the following themes: Thames Highway and Trade Expansion, Trade Expansion, The Rhineback Panorama, City and River, Sailortown, First Port of Empire, Warehouse of the World, Docklands at War, New Port, New City, and Mudlarks.

With the approaching of the commemorations of the bicentennial of the British abolition of the slave trade, the mercantile and maritime discourse

of the Museum of London Docklands was slowly modified. On November 10, 2007, the museum opened a permanent gallery named *London, Sugar and Slavery: Revealing Our City's Untold History,* which discusses London's involvement in the Atlantic slave trade. The implementation of the permanent gallery was funded by several organizations, such as the Heritage Lottery Fund, and evolved from debates and discussions with various African-Caribbean organizations such as the Tower Hamlets African Caribbean Mental Health Organisation (THACMHO). The huge new gallery displays accounts, film, music, paintings, maps, interactive displays containing illustrations and text, as well as 140 objects explaining the history of the Atlantic slave trade and London's role in it.

As part of the gallery *London, Sugar and Slavery,* the Museum of London Docklands produced a walking-tour guide highlighting various neighboring landmarks associated with the British slave trade. A first longer itinerary starts at the museum, and the proposed first stop is the Guildhall, in Gresham Street, the headquarters of the Corporation of London, which during the eighteenth and nineteenth centuries included shareholders of the Royal African Company. The proposed walking-tour guide mentions the life-statue of Sir William Beckford (1709–1770), located at the east end of the south wall in Guildhall. Beckford, who owned more than 20,000 acres of plantations in Jamaica, was twice lord mayor of London and was also a member of the Parliament for the city of London. Following London's "slaving route," the next landmark is the South Sea House building that housed the SSC (South Sea Company), which was crucial for the city's role in the Atlantic slave trade. From 1713 to 1736, the SSC sent 115 slave voyages to West African coasts.[39] The itinerary includes several other landmarks: the African House, site of the Royal African Company, which was located in Leadenhall Street and had the monopoly of the slave trade on African west coast; the Lloyd's of London Royal Exchange, which originated from the Edward Lloyd's Coffee House in 1688 and insured slave-trade vessels; the East India House, which housed the East India Company in Leadenhall Street that traded in slaves and goods for the Atlantic slave trade; the Jamaica Coffee House in St. Michael's Alley that not only served as meeting place for slave merchants but also as a place to advertise slave sales and reward announcements for the recapture of runaway slaves.

A second, and shorter, walk around the region of the docklands is also proposed in the printable guide. The walk starts at the site where the dock basins and warehouses of the West India Dock were located. According to the guide, it was the "first enclosed dock built on the Thames for the purpose of cargo handling," constituting a "physical manifestation of London's corner of the Triangle trade," and was used for at least twenty-two slave vessels between 1802 and 1807.[40] The second landmark located close to the Museum of London Docklands is the Hibbert Gate, a replica of the gate of the West India Dock. Above the gate there is also a replica of the *Hibberts,* a slave vessel that traded from the dock to Jamaica and was

named after the slave merchant and slave owner George Hibbert, whose portrait is displayed in the gallery *London, Sugar, and Slavery*. The third landmark indicated in the guide is the West India Dock foundation stone dated July 12, 1800, and containing a plaque that reads:

Of this Range of BUILDINGS
Constructed together with the Adjacent Docks. At the Expence [sic]
 of public spirited Individuals.
Under the Sanction of a provident Legislature.
And with the liberal Co-operation of the Corporate Body of the
 CITY of LONDON.
For the distinct Purpose
Of complete SECURITY and ample ACCOMODATION
(hitherto not afforded)
To the SHIPPRHING and PRODUCE of the WEST INDIES at this
 wealthy PORT.
THE FIRST STONE WAS LAID
On Saturday the Twelfth Day of July A. D. 1800,
BY THE CONCURRING HANDS OF
THE RIGHT HONOURABLE LORD LOUGHBOROUGH.
LORD HIGH CHANCELLOR OF GREAT BRITAIN
THE RIGHT HONOURABLE WILLIAM PITT
FIRST LORD COMMISSIONER OF HIS MAJESTY'S TREASURY AND
 CHANCELLOR OF HIS MAJESTY'S EXCHEQUER.
GEORGE HIBBERT ESQ. THE CHAIRMAN AND ROBERT MILLIGAN.
 ESQ. THE DEPUTY
CHAIRMAN *OF THE WEST INDIA DOCK COMPANY*
The two former conspicuous in the Band Of those illustrious
 Statesmen.
Who in either House of Parliament have been zealous to promote.
The two latter distinguished among those chosen to direct
AN UNDERTAKING
Which under the favour of GOD, shall contribute
STABILITY, INCREASE and ORNAMENT
TO
BRITISH COMMERCE

In addition to the plaque, two other landmarks are emphasized. The first is the building of the Museum of London Docklands, the only of the nine warehouses that originally housed the West India Dock Company. Another landmark is the statue of Robert Milligan (Figure 1.2), described in the printable guide as the son of a plantation-owning family in the Caribbean, who was a member of the Committee of West India Merchants and Planters that raised funds to build the West India Docks, without any mention of the Atlantic slave trade.

Figure 1.2 Statue of Robert Milligan in front of the Museum of Docklands, London, United Kingdom. Photograph by Ana Lucia Araujo, 2010.

After Robert Milligan's death in 1809, the West India Dock Company commissioned a full-body bronze statue to honor its creator. The statue—made by Richard Westmacott in 1810–1812, stands about 6 feet tall and cost £1,400—is a portrait of Milligan standing, wearing a doubled-breasted frock coat and cravat. His left arm is leaning on a column, his right arm is extended, and with his right hand he is holding a scroll. The bronze plaque on the pedestal below the statue shows a helmeted warrior seated on the head of a lion and holding a spear in his right hand. A female figure, holding a scepter with her right hand and surrounded by three cherubim, is greeting the warrior. This allegory represents Mercury, patron saint of the commerce, and the female figure is Britannia receiving him.[41] In the background of this scene there is a sailing vessel. The plaque with embossed letters on rear of the pedestal reads:

TO PERPETUATE ON THIS SPOT
THE MEMORY OF
ROBERT MILLIGAN
MERCHANT OF LONDON,
TO WHOSE GENIUS, PERSEVERANCE AND
GUARDIAN CARE
THE SURROUNDING GREAT
WORK PRINCIPALLY OWES
IT'S [SIC] DESIGN,
ACCOMPLISHMENT AND REGULATION.
THE DIRECTORS AND PROPRIETORS,
DEPRIVED BY HIS DEATH
ON 21ST MAY, 1809
OF THE CONTINUANCE OF HIS VALUABLE SERVICES,
BY THEIR UNANIMOUS VOTE
HAVE CAUSED THIS STATUE TO BE ERECTED.

The statue, unveiled in 1813, was placed at south of the dock office, close to the entrance gate. Over the years the statue became an obstacle, blocking the traffic and other activities that took place in the site, which led to its removal in 1875. The statue was then placed at the top of the central pier at the West India Dock Road entrance, but in 1943 when the pier was demolished the statue was removed again. In February 1997, after negotiations between the London Docklands Development Corporation and the Museum of London, the ancient Milligan's statue was reestablished in its original place and original granite base. Because the original plaque depicting Britannia receiving Mercury was destroyed, in 1998 Vincent Butler created a new bronze relief based on the plaque's original design. Despite this addition, the original plaque, without any mention of Milligan's slave-trade activities, remained intact. By this action, in a

period when international projects such as the UNESCO's Slave Route project were already in progress, London public authorities decided to simply conceal the fact that one of the city's prominent men, honored in the public space, was a slave merchant.

This situation started changing in 2007, with the commemoration of the bicentennial of the British abolition of the slave trade and the opening of the gallery *London, Sugar and Slavery*. During the BBC Radio 4 program "You and Yours" in 2008, the museum director David Spence called upon the community to reinterpret the statue of Robert Milligan. In the appeal, which was posted on the museum's website, it was stated that the "wealth Milligan and his colleagues enjoyed was directly related to the suffering of many thousands of enslaved Africans who were forcibly removed from their homes in West Africa to work and die on the plantations." By acknowledging that Milligan was remembered only for his wealth and for the accomplishment of the West India Docks, a project titled "Public Arts Project in Response to the Statue of Robert Milligan in May 2008" to reinterpret Milligan's statue was scheduled. However, the project was accomplished only three years later. In March 2011, the initiative titled "In the Picture," consisting of a display containing twelve pictures of artworks produced by Londoners from eleven boroughs, was finally unveiled. The artworks attempted to answer the proposed question: "A statue of Robert Milligan stands outside the Museum of London Docklands. Robert Milligan was an 18th century sugar trader. His business was inextricably linked to the trans-Atlantic slave trade. Is this statue appropriate? If not, who, or what else could stand in his place?" [42]

Through an innovative approach aiming to reinterpret Milligan's statue, for the first time Londoners had the opportunity to create virtual slavery countermonuments, spaces which, as James E. Young defined them, are "conceived to challenge the very premise of monument."[43] Despite this initiative, no plaque explaining Milligan's involvement in the Atlantic slave trade was added to his statue.

CONCLUSION

The wealth of Francisco Félix de Souza, Joaquim Pereira Marinho, and Robert Milligan resulted from their deep involvement in the Atlantic slave trade, and mainly when this activity was declared illegal. Despite the international official projects developed by UNESCO and other institutions and the numerous initiatives commemorating the bicentennial of the abolition of the British slave trade, in Benin, Brazil, and England, the public memory of these slave merchants remains alive and in some places almost intact, as they are still depicted as great businessmen and benefactors.

In various societies where the legacies of slavery are still visible, several organized groups pressured governments and official agencies to

commemorate the memory of the victims of the Atlantic slave trade. However, acknowledging the Atlantic slave past in the public space has also had unexpected consequences. On the one hand, in countries such as Benin, Brazil, and England, the stigma of being a descendant of slaves, as well as the social and racial inequalities associated with it, still persist. On the other hand, political and economic elites do not wish to publicly blame the descendants of perpetrators and prefer to not reconsider their public image of benefactors because they largely financed an important number of institutions, including hospitals, universities, banks, and companies, which still exist. Moreover, most of the descendants of these perpetrators continue to occupy prominent positions in these societies. Arraigning the perpetrators could provoke division and instability and lead the descendants of the victims to demand financial reparations. By building monuments and organizing exhibitions honoring the victims of the Atlantic slave trade former slave societies are certainly starting a process of recognizing the crucial contribution of the populations of African descent to their economic, political, cultural, and artistic prosperity, sometimes helping to foster self-esteem among the populations of African descent. At the same time, by circumscribing the public memory of slavery to a few specific places, governments and institutions also attempt to control the rise of this memory and the social groups who convey it. Because the memory of the victims and the memory of perpetrators are in competition, it is impossible to harmoniously reconcile them. In some former slave societies like Benin the memories of slavers and the slave returnees are closely intertwined, because among the latter group several individuals became slave merchants, even though the descendants of slaves kept locally are still stigmatized. In other countries, such as England, the process of identifying some perpetrators in the public space was a fruitful way to foment the discussion about the Atlantic slave past. However, in a former slave society such as Brazil the process of acknowledging the country's slave past is just beginning.

NOTES

1. See Robin Law, *Ouidah: The Social History of a West African Slaving "Port" 1727–1892* (Athens, OH: Ohio University Press, 2004).
2. Robin Law, "The Evolution of the Brazilian Community in Ouidah," *Slavery and Abolition* 22, no. 1 (2001): 3–21. Recent studies have focused on the individual trajectories of these former slave returnees; see Lisa Earl Castillo, "Between Memory, Myth and History: Transatlantic Voyagers of the Casa Branca Temple (Bahia, Brazil, 1800s)," in *Paths of the Atlantic Slave Trade: Interactions, Identities, and Images*, ed. Ana Lucia Araujo (Amherst, NY: Cambria Press, 2011), 203–238.
3. See Nassirou Bako-Arifari, "La Mémoire de la traite négrière dans le débat politique au Bénin dans les années 1990," *Journal des Africanistes* 70, nos. 1–2 (2000): 221–231. In my book *Public Memory of Slavery: Victims and Perpetrators in the South Atlantic* (Amherst, NY: Cambria Press, 2010), I

discussed the plural memories of slavery among the Aguda community; see especially Chapters 3, 4, 6, and 7.
4. About the Slaves' Route, see Ana Lucia Araujo, "Caminhos atlânticos: memória e representações da escravidão nos monumentos e memoriais da Rota dos escravos," *Varia História* 25, no..41 (2009): 129–148; "De victime à résistant: mémoires et représentations de l'esclavage dans les monuments publics de la Route des esclaves," *Les Cahiers des Anneaux de la Mémoire* 12 (2009): 84–102; and *Public Memory of Slavery*, Chapter 4. Other works include Gaetano Ciarcia, "Restaurer le Futur: Sur la Route de l'Esclave à Ouidah (Bénin)," *Cahiers d'études africaines* 192, no. 4 (2008): 687–706; and Dana Rush, "Contemporary Vodun of Ouidah, Benin," *African Arts* 34, no. 4 (2001): 32–47.
5. Among the numerous works about the merchant, see Robin Law, "Francisco Félix de Souza in West Africa: 1820–1849," in *Enslaving Connections: Western Africa and Brazil during the Era of Slavery*, ed. José C. Curto and Paul E. Lovejoy (Amherst, NY: Prometheus/Humanity Books, 2003), 189–213; Robin Law, "A carreira de Francisco Félix de Souza na África Ocidental (1800–1849)," *Topoi*, 2001: 9–39; and Alberto da Costa e Silva, *Francisco Félix de Souza, mercador de escravos* (Rio de Janeiro: Nova Fronteira, 2004).
6. Chacha was de Souza's nickname, which later became a sort of noble title conferred to the head of the family.
7. Christian de Souza, during the visit of Francisco Félix de Souza's memorial, Singbomey (Ouidah), June 19, 2005. See also Ana Lucia Araujo, "Renouer avec le passé brésilien: la reconstruction du patrimoine post-traumatique chez la famille De Souza au Bénin," in *Traumatisme collectif pour patrimoine*, ed. Bogumil Jewsiewicki and Vincent Auzas (Québec: Presses de l'Université Laval, 2008), 305–330; "Enjeux politiques de la mémoire de l'esclavage dans l'Atlantique Sud: la reconstruction de la biographie de Francisco Félix de Souza," *Lusotopie* 16, no. 2 (2009): 107–131; and *Public Memory of Slavery*, Chapter 6.
8. "Discours de bienvenue du porte-parole de son Excellence Mito Honoré Feliciano Julião de Souza, Chacha 8 à la délégation de l'Université de Rutgers (État du New Jersey)," Ouidah, July 24, 2005.
9. Interview with Emile Olougoudou, Ouidah, July 24, 2005.
10. Frederick E. Forbes, *Dahomey and the Dahomans: Being the Journals of Two Missions to the King of Dahomey and Residence at His Capital in the Years 1849 and 1850*, vol. 1 (London: Frank Cass, 1966 [1851]), 106–108.
11. John Duncan, *Travels in Western Africa in 1845 & 1846: Comprising a Journey from Whydah, through the Kingdom of Dahomey, to Adofoodia in the Interior*, vol. 1 (London: Frank Cass, 1968 [1847]), 114.
12. Robin Law, "The Atlantic Slave Trade in Local History Writing in Ouidah," in *Africa and Trans-Atlantic Memories: Literary and Aesthetic Manifestations of Diaspora and History*, ed. Naana Opoku-Agyemang, Paul E. Lovejoy, and David V. Trotman (Trenton, NJ: Africa World Press, 2008), 274n20.
13. David de Souza, during the interview with Honoré Félicien Julião de Souza (Chacha VIII) and David de Souza, Singbomey, Ouidah, June 19, 2005.
14. See Bruce Chatwin, *The Vice-Roy of Ouidah* (London: Jonathan Cape, 1980), and Werner Herzog, *Cobra Verde* (1987).
15. See Joel Noret, "Memories of Slavery in Southern Benin: Between Public Commemorations and Lineage Intimacy" (paper presented at the workshop "Politics of Memory: Making Slavery Visible in the Public Space," 125th Annual Meeting of the American Historical Association, Boston, January 6–9, 2011).

16. On the issue of slave trade and cultural tourism in the region, see Ana Lucia Araujo, "Welcome the Diaspora: Slave Trade Heritage Tourism and the Public Memory of Slavery," *Ethnologies* 33, no. 1 (2011): 145–178, and Jung Ran Forte, "'Marketing Vodun': Cultural Tourism and Dreams of Success in Contemporary Benin," *Cahiers d'études africaines* 193–194, nos. 1–2 (2009): 429–452.
17. About African diaspora tourism in Bahia, see Patricia de Santana Pinho, *Mama Africa: Reinventing Blackness in Bahia* (Durham, NC: Duke University Press, 2010), especially Chapter 1.
18. The dam was listed as a Brazilian national heritage site by the National Historical and Artistic Heritage Institute (IPHAN) in 1959.
19. This information is taken from his obituary, quoted by Cristiana Ferreira Lyrio Ximenes, "Joaquim Pereira Marinho: Perfil de um contrabandista de escravos na Bahia (1828–1887)," (MA diss., Universidade Federal da Bahia, 1998), 32. See also Arquivo Público do Estado da Bahia (hereafter APEB), Testamento do Conde Pereira Marinho, Estante 3, Caixa 1019, Maço 1488, Documento 5, 5v, fol. 6. I am indebted to Cristiana Ferreira Lyrio Ximenes, who generously shared with me her MA dissertation on Pereira Marinho, and who patiently answered my numerous questions about the slave merchant.
20. See Ximenes, "Joaquim Pereira Marinho," 32.
21. Through archival research Tânia P. Monteiro showed how Portuguese traders who arrived in Bahia in the second half of the nineteenth century shared similar personal profiles. They quickly prospered and obtained important advantages in their trade activities in Bahia. See Tânia P. Monteiro, "Portugueses na Bahia na Segunda Metade do Século XIX—Imigração e Comércio" (MA diss., Universidade Federal da Bahia, Salvador, 1982). See also Ximenes, "Joaquim Pereira Marinho," 33.
22. Ximenes, "Joaquim Pereira Marinho," 58.
23. See Ximenes, "Joaquim Pereira Marinho," 68. However, we were not able to confirm the connections between Marinho and the slave merchant Ana Joquina dos Santos Silva. For more information on Ana Joaquina dos Santos Silva, see Carlos Alberto Lopes Cardoso, "Dona Ana Joaquina dos Santos Silva Industrial Angolana da Segunda Metade do Século XIX," *Boletim Cultural da Câmara Municipal de Luanda* 37 (1972): 4–14; Douglas Lanphier Wheeler, "Angolan Woman of Means: D. Ana Joaquina dos Santos e Silva, Mid-Nineteenth Century Luso-African Merchant-Capitalist of Luanda," *Santa Barbara Portuguese Studies Review* 3 (1996): 284–297; Júlio de Castro Lopo, "Uma Rica Dona de Luanda," *Portucale* 3 (1948): 129–138; Mariana P. Candido, *Fronteras de Esclavización: Esclavitud, Comercio e Identidade en Benguela, 1780–1850* (México: El Colégio de Mexico, 2011), 59. I am indebted to Mariana P. Candido for providing me numerous references and documents on Ana Joaquina dos Santos Silva.
24. IHGB, Periódicos, *Diario de Notícias*, n° 92, 26/04/1887 qtd. in Ximenes, "Joaquim Pereira Marinho," 59. About Domingos José Martins see David A. Ross, "The Career of Domingo Martinez in the Bight of Benin 1833–1864," *Journal of African History* VI, no. 1 (1965): 79–90. Robin Law, "The Evolution of the Brazilian Community in Ouidah," *Slavery and Abolition* 22, no. 1 (2001): 22–41.
25. See David Eltis et al., *The Trans-Atlantic Slave Trade Database: Voyages*, http://www.slavevoyages.org. However, Verger found in Bahian archives thirty-six voyages of Marinho's vessels, of which only four were captured by the British Navy.
26. See Voyage 3585 in David Eltis et al., *The Trans-Atlantic Slave Trade Database: Voyages*, http://www.slavevoyages.org.

27. Andorinha (1849), Voyage 3829, see Eltis et al., *The Trans-Atlantic Slave Trade Database: Voyages*, http://www.slavevoyages.org.
28. Pierre Verger, *Fluxo e refluxo do tráfico de escravos entre o Golfo do Benin e a Bahia de Todos os Santos dos séculos XVII a XIX* (Salvador: Corrupio, 2002), 461.
29. Ximenes collected a series of 1860s newspaper articles denouncing Marinho's activities. Titled "*O Sr. Marinho—Sempre o Senhor Marinho!*" these articles were published in the Bahian newspaper *Interesse Público*, whereas the responses defending Marinho were published in the newspapers *Pharol* and *Diário da Bahia*, under the title of "*Sempre Calumnia!*"
30. Ximenes, "Joaquim Pereira Marinho," 109.
31. About the Santa Casa de Misericórdia da Bahia, see A.J.R. Russell-Wood, *Fidalgos and Philanthropists: The Santa Casa da Misericórdia of Bahia (1550–1755)* (Berkeley: University of California Press, 1968).
32. Other slave merchants members were also members of the institution, including João da Costa Junior and Francisco José Godinho.
33. Ximenes, "Joaquim Pereira Marinho," 113.
34. APEB, Testamento do Conde Pereira Marinho, Estante 3, Caixa 1019, Maço 1488, Documento 5, 14v, fol. 15.
35. Author's translation from Portuguese.
36. See Christine Chivallon, "Bristol and the Eruption of Memory: Making the Slave-trading Past Visible," *Social & Cultural Geography* 2, no. 3 (2001): 347–363, and Elizabeth Kowaleski Wallace, *The British Slave Trade & Public Memory* (New York: Columbia University Press 2006), Chapter 1.
37. For a brief comment on these exhibitions see Elizabeth Kowaleski Wallace, "Uncomfortable Commemorations," *History Workshop Journal* 68, no. 1 (2008): 223–233. See also in this volume: Richard Benjamin, "Museums and Sensitive Histories: The International Slavery Museum ," and Geoffrey Cubitt, "Museums and Slavery in Britain: The Bicentenary of 1807."
38. Georgie Wemyss, *The Invisible Empire: White Discourse, Tolerance and Belonging* (Farham and Burlington: Ashgate, 2009), 42.
39. For a detailed analysis of the numerous statues of slave merchants in London, see Madge Dresser, "Set in Stone? Statues and Slavery in London," *History Workshop Journal* 64 (2007): 162–199.
40. See Museum in Docklands, *London, Sugar and Slavery: Revealing Our City's Untold History*, a short walk that shows some of the city of London's connections to transatlantic enslavement," http://www.museumindocklands.org.uk/NR/rdonlyres/64C929D2-717B-4100-AD09-AE81ACCB7611/0/LSSETrail.pdf.
41. For the official information regarding Milligan's statue, see Public Monument and Sculpture Association National Recording Project, http://pmsa.cch.kcl.ac.uk/UEL/TH108.htm.
42. See Museum of London Docklands, "In the Picture," http://www.museumoflondon.org.uk/Get-involved/Collaborative-projects/InThePicture.htm.
43. James E. Young, *At Memory's Edge: After-Images of the Holocaust in Contemporary Art and Architecture* (New Haven, CT, and London: Yale University Press, 2000), 96.

2 Reasons for Silence
Tracing the Legacy of Internal Slavery and Slave Trade in Contemporary Gambia

Alice Bellagamba

When discussing African memories of slavery and the slave trade, it should be borne in mind that these themes are linked not only to the heyday of the Atlantic slave trade but also to the history of local communities before and after the development of Atlantic commercial networks. Along the River Gambia, which is one of the major waterways of the West African coast, slavery and the slave trade predated the arrival of the Portuguese in the second half of the fifteenth century, and continued after the British banning of the Atlantic slave trade in 1807. Internal enslavement ended with colonization in the late-nineteenth century, when the British administration promulgated two antislavery ordinances. The first was issued in 1894, immediately after the creation of the British Protectorate of the Gambia, and the second in 1906 with the annexation of the Eastern part of the country. Slavery finally legally ended only in 1930 when all local slaves were declared free.[1]

Today, even as government initiatives commemorate the cultural, social, and economic connections created between the river and the larger world by the Atlantic slave trade, Gambian society is losing sight of its own slave-dealing and slave-holding past. Sequestered from public discussion at state and grassroots levels, the legacy of internal enslavement is fading away along with the emancipation struggles of former slaves and slave descendants.

In 1996, the government launched the Roots Homecoming Festival, a biennial event aimed at attracting the African diaspora. Contextually, it inaugurated the Albreda Slavery Museum, where visitors can familiarize themselves with the history of the Atlantic slave trade and its abolition. But neither the festival cultural activities nor the layout of the museum exhibition provide visitors with an insight into the role of slavery and the slave trade in the political and economic history of the River Gambia up to the end of the nineteenth century.[2] It would be hard for tourists to imagine that there are Gambians who still today respect the hierarchies created by a past enslavement by addressing each other as slave and master descendants, and that there are parts of the country (such as Baddibu, on the north bank of the river) where until recently descendants of slaves

were discriminated against, receiving burial in a segregated section of the cemetery on their decease.

Reasons for silence and stratifications of silences are at the core of the following pages, which draw on long-term fieldwork in The Gambia as well as on archival and historical research. It is not only a matter of the state being unable or unwilling to undertake official initiatives addressing the knowledge from below of internal enslavement, but also of genres and narrative styles which have systematically prevented its public emergence. Both master and slave descendants share the conviction that silence breeds mutuality and social harmony; however, there is a second type of silence which restrains the public display of memories associated with internal enslavement.[3] As I will illustrate, some men and women are not in a position to voice their thoughts and feelings, although they would like to. This silence is key to the experience of many former slaves and slave descendants after the legal ending of slavery in 1930 and explains why their perspective on internal slave-dealing and slave-holding has been so difficult to access.[4]

I conclude this essay by comparing what elderly men and women have taught me about internal enslavement and emancipation in the course of the past twenty years with the representations of slavery and the slave trade current among the younger generations. In doing so, I am following the recommendation of David Berliner to "investigate the concrete social and cultural contexts through which memories are passed down."[5] With regard to the legacy of internal slavery and slave trade, the overlapping of different types of silence has almost completely interrupted the chains of intergenerational transmission.

THE AFTERMATH OF SLAVERY

Until the late nineteenth century, British control over the River Gambia was limited to the enclaves of Bathurst—established in 1816 as a base for British commercial interests in this part of West Africa—the adjacent mainland and MacCarthy Island, which had been acquired in 1823 to become an outpost of the Bathurst trading networks in the interior. Bathurst itself served as military base to intercept the slave vessels that entered the river mouth after the 1807 British Parliament Slave Trade Act banning the Atlantic slave trade. French traders continued to deal in slaves until the 1810s, when France outlawed the slave trade as well.[6] Portuguese merchants and their Luso-African descendants stopped even later. In the 1820s and 1830s, while the administration of Bathurst was signing treaties with native chiefs to curb slave traffic, slave caravans from the upper river were diverted to the Casamance region and present-day Guinea Bissau, where "the slaves were embarked and often escaped the vigilance of British cruisers in the Atlantic."[7]

The decline of the Atlantic slave trade did not end internal slave-dealing and slave-holding. As a consequence of political instability, internal warfare, and economic changes linked to the rapid development of groundnut production for export, the number of slaves actually increased in the course of the nineteenth century.[8] During the religious wars that from the 1860s until the end of the 1890s saw Muslim reformers challenging the supremacy of the pagan river ruling elite, both Bathurst and MacCarthy Island provided sanctuary to fugitive slaves and refugees from the adjacent mainland. Provisions against trading in, or holding, slaves on British soil—like the 1831 Act for the Sierra Leone settlement, which was officially extended to Gambia possessions in 1851[9]—were often skirted by British and native merchants, who dealt in slaves immediately outside the British sphere of influence. British officials had neither the interest nor the means to interfere with the traders' activities or to protect the women and children they were bringing back from their expeditions upriver to incorporate into their domestic entourages.[10]

Effective measures against the slave trade were only taken after the 1888 proclamation of the Colony of the Gambia and the establishment of a Protectorate in the course of the 1890s. The 1894 and 1906 ordinances banned the slave trade and established that adult slave men and women could buy their own freedom and that of their relatives. They also declared free children born after the promulgation and all slaves at their masters' death.

Although slow, the impact of both regulations was significant. Some of the slaves jumped at the chance to claim a better life as soon as they learned about annexation to the Protectorate.[11] Slave women asked the help of British officials to leave abusing masters and save their children from being sold. Young men left their masters either to return home or to join the circuits of migrant labor associated with groundnut cultivation. Many slaves, however, remained where they were, a preferable choice, especially for those men and women who had been born into slavery and could not remember their ancestral places. Moreover, under British rule, they could no longer be sold nor could masters dispose of their offspring as they did prior to the outlawing of the slave trade by selling, exchanging, and pledging slave boys and girls.[12] This was a step toward the renegotiation of labor obligations and terms of inclusion into the masters' communities. Extremely precarious living conditions—as slaves often lacked strong social networks to support them in times of need—kept alive old status distinctions. Masters continued to expect deference and undisputed loyalty in exchange for their economic and social assistance.[13] Their attachment to the vestiges of their social supremacy also shaped the way rural communities incorporated the thousands of seasonal laborers that migrated to the River Gambia from Mali, Senegal, French, and Portuguese Guinea in colonial times to join in the commercial cultivation of groundnuts. Foreigners were welcomed, but if they decided to settle they would be integrated at the lowest level of

the social hierarchy.[14] Many of the oral accounts I have collected report how selectively elders negotiated their children's marriages. Women of high birth were destined to marry chiefs, big traders, and renowned Islamic scholars. A foreigner without substantial social and economic capital could at best aspire to marry the daughter of slaves. Of course he was entitled to free his wife by compensating her masters.[15] But sufficient resources were seldom available, and given that slave ancestry is inherited matrilineally, the children of these marriages would unequivocally be classified as slave descendants despite colonial regulations banning any form of slave-dealing or slave-holding.

Scholars who venture into the study of internal slavery and its aftermath in this part of West Africa should therefore note that the significance of the Mandinka term *jong*,[16] which in the late nineteenth century identified war captives and chattel slaves (or in other terms the first generation enslaved men and women), has shifted since the end of the internal slave trade during the colonial era.[17] Before colonization, slave descendants, pawns, and individuals who voluntarily chose submission in exchange for protection were considered more family dependents than slaves. But after the legal end of slavery in 1930, and the disappearance of first-generation slaves in the first half of the twentieth century, they started to be seen as *jong* and to be set apart as a "pseudo-caste"[18] to which the rest of society attached the stereotype of beggars and dependents, and who traditionally qualified as slaves in the masters' ideology. The core meaning of slavery—*jong* is an individual captured or bought—collapsed because it was no longer possible to acquire new slaves. Contextually, people began to forget that slaves and slave descendants had covered a variety of functions and occupied important positions in the precolonial social order, such as military slaves and the slaves of the king (*mansajong*), positions certainly more powerful than those occupied by any ordinary freeborn. Today, the category of *jong* may refer both to the descendants of men and women in bondage on the eve of colonization and to people whose ancestors came to the River Gambia in search of labor and social redemption after the establishment of British rule. In the early twentieth century, some of them were probably slaves and slave descendants trying to escape their social position. Others, unfortunately, were unable to assert their freeborn status convincingly. Awareness of these complicated circumstances makes Gambians prudent when they discuss social pedigrees.

First, real slave descendants might rudely react to the attempts of others to qualify them as *jong* without their consent. Second, the contemporary category of *jong* may include people classified as such by society but who according to the old criteria would not have been *jong* at all, as is the case of immigrants to the Gambia River Basin.

Last but not least, displaying *jong* identity markers—such as performing manual tasks during ceremonies (which in the old days were a prerogative of slaves)—should never be taken as an immediate sign that the person's

forebears were necessarily slaves. Actually, cross-cousins[19] do this kind of service when no slave descendant is available, as do impoverished men and women seeking the small economic advantages attached to slave ancestry, such as the possibility of begging assistance from so-called "masters." The fuzzy boundary between freedom and bondage becomes more evident when we look at proverbs: "do not beg, otherwise people will classify you low." Another popular saying recalls that "the belly is slavery", referring both to the matrilineal bequeathing of slave status and to the loss of dignity and humiliation caused, in the past as in the present, by social and economic deprivation.[20]

Raids and trading together with hunger and poverty produced the slave before colonization. Although between the 1890s and the 1910s colonial ordinances halted the first two causes of enslavement, hunger and poverty have continued to condition people's lives and curb their dreams of emancipation and social ascent:

> It is difficult for somebody who is hungry to behave as though they were freeborn. If you are hungry and you do not eat today and you do not eat tomorrow, the day after tomorrow when they call the dog for food—"kurì, kurì"—not only the dog will come: You would join in too, no matter what. Human beings need to eat. If you hear that somebody is freeborn, he has something to eat. But if he has nothing, he becomes a slave. If they ask you to dance, you do it; if they ask you to wear the *kankurang* mask, you do it.[21]

By using the present tense in this commentary, Kebba Fanta Koma, a former high-ranking civil servant during the First Republic of The Gambia and descendant of a chiefly family, voices a form of widespread sensibility. Adverse life circumstances can push people onto the social margins, occupied in the past by certain categories of slave. Social and economic destitution today are the lot of illiterate rural people who make ends meet through agriculture and of poor urban dwellers, both men and women, who live from hand–to-mouth and rely on the generosity of relatives and neighbors to survive. Of course, nobody would label these social conditions as slavery—a form of exploitation of labor and complete control over other people's lives which no longer exists in The Gambia. Nonetheless, the suffering, once linked to the condition of slaves, still characterizes contemporary experiences of deprivation and prompts people like Kebba Fanta to say: "they say slavery is finished, but is not true. It is still here with us."[22]

NOT ALL SHOULD BE SAID

Scholars engaged in the reconstruction of Africa's past know that oral sources are more a "social product"[23] than a linear form of evidence.

Narrative genres mold social and personal memories. Culturally grounded conceptions of speech and conventions on how words should be used shape historical recollections. In order to understand silences about internal slavery and slave trade, it is therefore necessary to look at the past and present social dimensions of silence itself from a broader angle.[24]

Bansang, a commercial settlement upriver, was my first research site in the early 1990s. Bansang head chief, Al Haji Bo Kora, was an elderly man particularly conscious of the social relevance of words. "Not all should be said"—he kept repeating when our conversations touched on the most delicate points of his family and personal history.[25] This kind of formulaic statement recurs in most of the historical narratives—not all of them relating to slavery—that I have collected from elderly men and women over the years. As a cliché, it allows the narrators to situate (himself or herself) vis-à-vis their audience by flagging that the account, in itself, is a combination of revelation and silences, silences being as eloquent as words.[26] The "not all should be said" principle also arouses the interest of the listeners by drawing attention to what is implicit in the story. While clearly signaling the narrator's intention to keep his/her narrative under careful control.

When the expression is used in answer to a direct question, the only means of continuing the conversation is to change topic because the narrator might perceive any effort to overcome the barrier of silence as a distasteful and impolite intrusion. For example, one of the areas the head chief of Bansang preferred not to dwell on was a period in his life when, after being appointed head chief for the first time during Second World War, he was removed from office by the colonial government. Behind these events, there was a history of competition and conflict with the district chief, who was his maternal uncle and whose daughter he had married. For the sake of these relationships, Al Haji Bo never wished to discuss the topic at length. The art of living together entails compromise, silence, and patience.[27] All members of the community are expected to cultivate these three virtues, particularly elders such as the Bansang head chief who bear the responsibility of fostering cooperation within large family entourages. In 2008, I asked three elderly friends of mine to comment on this particular aspect of Gambian social life. Their reply bore out what fieldwork and long association with people and contexts had already taught me:

> "Silence avoids evil"—one of them explained—"because if certain things are spoken out even the way you talk about them becomes a problem, it might wreak havoc. If you keep silent, they will not know what is in you, even if your chest is teeming with stories. Silence is the medicine. The moment you open your mouth to say: Ah . . . , somebody is passing in front of you, somebody else is passing by your side, somebody else at your back, somebody here, there, you can never know where they will carry your words. Nor can you ever tell how they are

going to interpret them. It can lead to the destruction of your family or to giving your family a bad reputation."[28]

Balancing revelation with concealment is a widely shared strategy of self-control and conflict management that Gambians apply to daily interactions as well as historical narratives. On another occasion, when one of these three elderly friends of mine was specifically discussing slavery, he clearly remarked that "though it is good to know all, it is not good to say all. If you do it, you may hurt others."[29] Apart from offending people, the stirring up of past memories, if carried on imprudently, might lead to the reopening of conflicts originally resolved precisely because the parties involved agreed to remain silent. There are many things, which if said, could create problems for both the person who speaks and the surrounding social entourage, and slavery is one these. If openly discussed, it might prompt people to express thoughts that they would otherwise not have shared and, probably, did not wish to explore in depth. There are unspoken issues such as the endurance of master ideology, which in the past categorized slaves as inferior human beings, the indignation of slave descendants at the humiliation of their ancestors as well as the possibility that they are unaware of their slave ancestry. Any of these undercurrents can ignite discussion between descendants of slaves and descendants of masters, and create a situation in which people have difficulty controlling their emotions of sorrow and rage with unpredictable consequences for both individuals and society.

In contexts such as Baddibu, where subordinate relationships between slave and master descendants have been preserved, actions, more than words, carry the past into the present. Sitting in a lower position than master descendants is one such practice which I have had the opportunity to observe on several occasions; I have also encountered master descendants who refused this kind of deference, which they considered wholly obsolete, asking the person offering it to take a chair like the others. On ceremonial occasions those who qualify as "slaves" are always properly compensated for their labor contributions to the success of the event.[30] If they wish, they can entertain the audience with dances that people claiming freeborn status would never perform because of their sexual implications. They can also use songs to reveal unpleasant details about the lives of some of the organizers or guests attending the ceremony. In the latter case, the person involved can stop the flow of revelation only by rapidly paying off the performers.

Although these practices ensure continuity to the legacy of internal slavery, it is difficult to decode them in the absence of a proper exegesis. When all or part of the audience share clues about what is going on, they are also aware of the contemporary ambiguous usages of the term *jong* and therefore avoid explicit commentaries. Members of the audience lacking the key to the message are left with a superficial and even folkloric perception of the linkages between past and present.

Michael Taussig has used the expression "public secret" to identify "that which is generally known, but cannot be articulated."[31] Undoubtedly, this accurately represents the strategies Gambians have used to minimize the disruptive social effects of their own slave-dealing and slave-holding past since the abolition of slavery in colonial times. For most of the twentieth century, and even today, the "not all should be said" principle has allowed the descendants of slaves and masters to promote coexistence, mutuality, and reciprocal tolerance as a counter to divisiveness and conflict.[32] From a different perspective, however, censorship could be viewed as the result of enduring subordination and even of new forms of discrimination, which have helped prevent the public display of memories of internal enslavement and slave trade from the side of former slaves and their descendants.

BEING SILENT, BEING SILENCED

Looking at silence as a strategy for social coexistence helps to understand why Gambian society has disregarded its internal association with slavery and the slave trade. Still, it does not account for the fact that slaves and slave descendants have not attempted to articulate memories of their condition nor preserved them across the generations.[33] I attempt to address this controversial point by distinguishing the condition of "being silent"—which amounts to the constructive usage of silence I have described—from that of "being silenced."[34]

For Elizabeth Tonkin, being inarticulate is a social condition linked to a lack of socially valued models and contexts in which to express the particular type of experience the person is going through.[35] "Who am I to have a story?" Bambi Jobarteh asked me when I was striving to collect her life history during my 1992 fieldwork in Bansang. Bambi was a childless elderly widow living in the compound of distant relatives who barely tolerated her presence. With great competence and narrative ability, Bambi provided me with detailed accounts of Bansang and the surrounding district history. But like many of the other elders I met during my first period of fieldwork, most of whom were illiterate, Bambi's eloquence vanished when she had to talk about herself. For her, as for other representatives of her generation, the individual was expected to be modest and silent about what he/she had done, especially if she was a woman or a representative of a subordinate social category, such as former slaves, newcomers, and artisans.[36] Local conceptions of history, which these elders fully shared, reserved the prerogative to gain social reputation and be remembered by future generations to a few extraordinary individuals, generally successful men with renowned ancestors whose deeds would be praised by epic and communal traditions. Women had to disappear from historical narratives because of their subordinate position in relation to men, whereas dependents and slaves were considered an appendix of their patrons' and masters' lives. Male slaves

and slave descendants could gain social recognition only if they had been successful in shading their origins. In any other case, their social and economic achievements would be remembered in the name of the master.[37] Because slave women were twice subordinate, as women and slaves, their experiences were even more historically hidden than those of male slaves.

It is this absence of narrative genres to capture and preserve the memories of slaves and their descendants that explains why today it has proved so difficult to retrieve the world "slaves made."[38] As for personal life-history—which Martin Klein has viewed as a way to overcome the silences surrounding slaves' pasts—it has only recently become a popular historical genre due to the fact that many contemporary Gambian elders are now literate; for the earlier generations, those of Bambi and the Bansang head chief, narrating the self was simply not done.[39] Biographies could be reconstructed of course, as I did, by carefully seeking out the most appropriate contexts—mostly in the confidential and intimate context of personal conversations—in which people felt free to say something about themselves.[40] However, the research of the 1950s, 1960s, and 1970s—that which could have tapped relatively recent stories of emancipation—favored the collection of formal oral traditions above the more unassuming method of following a restricted number people over a long time so as to create the setting and trust required to discuss what society was trying to forget.

In addition, other social and cultural factors have restrained people of slave ancestry from proudly recollecting their origins and their struggles to guarantee a better future for themselves and their offspring. First, social emancipation has meant embracing and practicing the virtues that masters had long reserved to themselves. Restraint and silence have played a crucial role in this regard, insofar as the "not all should be said" principle also functions as a sign of social rank. The Bansang head chief, for instance, was proud of being seen as a man whose words were respected for their social sensitivity. Even the way he spoke, slowly and concisely, added to this reputation. Second, even today the construction of Gambian selves is ruled by a leitmotiv which states that individuals who are patient (*sabari*) will be rewarded, whereas those who can keep quiet will be respected.

After abolition, former slaves and descendants of slaves had to win social respect by adapting to this dominant and inclusive behavioral model. According to masters' ideology, ruthlessness and shamelessness were inevitable attributes of slaves' subordinate condition. Freemen, moreover, have continued to stigmatize people of slave ancestry for their freedom of speech:[41] "they could interrupt any public discussion with shocking comments"—I have often heard freemen repeating—or as the proverb goes "they will tell your secret and your horse's secret." Feelings of personal dignity and shame (although in terms of the masters' ideology, slaves had no shame) have prevented people in this social category from voicing their own past and also, consequently, from cultivating a sense of social self in which

the erstwhile enslavement of their ancestors, as well as their emancipation, are positively represented.

From the second half of the twentieth century onward, the spread of Western literacy has added an extra layer of discrimination to this scenario, as literate younger generations have begun to look down upon elders, and on the knowledge that elders, whether of slave or freeborn origins, can hand down. Bambi is a clear example of this. She was a freeborn woman. Yet because of her illiteracy, the Bansang youth never saw her as a source of interesting information, in the same way that they were generally skeptical of what other illiterate elders could teach me. In addition, her historical competence was denied recognition on the basis of her gender, as I learned when her narratives were discarded by a group of elderly men who simply stated: "women have no memory."[42]

Forms of marginality and discrimination have the capacity to overlap and reinforce one another. If, incidentally, Bambi had been of slave origin, similarly to other women in the town, the lack of opportunity to articulate her own version of history would have been further exacerbated. My three elderly friends, whom I asked in 2008 to comment on silence, also drew a sharp distinction between *sabari* ("patience") and *muunyo* ("self-repression"). The first magnifies the moral and social status of the person. It is a sign of submission to God's will, which nonetheless does not erase individual agency.[43] The second is a painful condition, which amounts to a lack of concrete alternatives:

> In that case, you may want to do something about it but you may not have the strength and there may be nobody to help you, and therefore you have to exercise patience against your will [. . .]. Up to death, the person will have some of those things burning inside, because of inability to do something about it [. . .]. And usually when such a person gives birth to a child, God is great![44]

It is relatively easy to understand how *muunyo* must have restrained the lives of those former slaves who remained with their masters after the legal abolition of slavery. Freed women, in particular, often had children in the masters' families—sometimes fathered by the masters themselves—whom they did not want to leave behind. If they wished to go, they had either to ask the assistance of colonial officials—who used to send freedwomen to the capital of the Colony where they could be employed as domestic servants—or hope to marry one of the immigrants to the River Gambia, perhaps a progressive and hard-working man eager to establish his own household. As these opportunities were not always available, many freed women accepted a state of lasting subordination. It is common belief that *muunyo* produces a sort of intergenerational gift. People say that the children of those who silently endured their condition will be particularly blessed by life, and stories of success always refer to the great suffering of the mother.[45]

Less evident is how *muunyo* could affect those former slaves and slave descendants who decided to cut the ties with their former masters by migrating elsewhere, unless we take into account the endurance of the masters' ideology of supremacy. To masters, former slaves and their descendants were not supposed, and indeed were not even deemed capable enough, to progress through the life cycle as the freeborn did. Before the end of slavery, slaves were precluded from certain crucial life stages such as becoming the fathers and mothers of a great and extended family. Only freeborn men and women could proudly mention their forebears and aspire to become ancestors in turn. Slaves and slave descendants could circumstantially grab power, opportunities, and wealth, especially in the turbulent political situation of the second half of the nineteenth century, which witnessed the outstanding social careers of military leaders of slave ancestry, such as Alpha Moloh Baldeh, the founder of Fuladu, one of the major precolonial centralized polities of southern Senegambia.[46] But the next step, much more difficult to achieve, was that of consolidating a line of descendants able to progress and expand across the generations like the big trees of this savanna area. This is the meaning evoked by the Mandinka verb *yiriwaa*, which is translated by the English as "development."[47] The roots spread through the ground, seeds germinate at a distance and produce other big trees; likewise famous forefathers provide men and women of good origins with a model to emulate in the course of their lives.

Former slaves' and slave descendants' struggles to better their social position have taken place against this long-lasting and solid cultural background and in a difficult socioeconomic context. In the course of the twentieth century, a consistently unpredictable alternation of favorable and difficult periods substituted for the insecurity of the era of enslavement and slave-dealing. In the 1920s for instance, groundnut cultivation made farmers rich one year and desperately poor the next.[48] The jargon of modernity and social change typical of the late 1950s and 1960s bred general optimism, but already in the 1970s, the oil crisis and recurrent droughts brought this short interlude of progress to an end. Since the legal abolition of slavery in 1930, nothing has lasted long enough to be considered permanent, nor have all emancipating efforts translated into success. The early twentieth century migrants, who were attracted to The Gambia by the expansion of the groundnut farming industry, are a case in point. Whether freeborn or slaves, instead of the social and economic improvement they sought on leaving their homeland they ended up with their children being categorized as slave descendants. Many other emancipation stories have produced similar forms of resubordination thereby refueling the old masters' prejudice stating that slaves' achievements, even though they may be great, never last.

"Even in triumph—Antonio Gramsci wrote[49]—subordinate groups remain vigilantly defensive," and this attitude would disappear only

when the cycle of oppression is completely over. In contemporary Gambia, slave ancestry continues to be a stain on the family pedigree which very few slave descendants are eager to display publicly. If it is true that the "memory of events coexists with the relentless ongoing necessity of living in the present with its own exigencies and competing ideologies"—as Jane Guyer has underlined[50]—then the right question to ask about the social disappearance of memories of life in slavery and exit from slavery, particularly from the viewpoint of slave descendants, is whether, if rekindled, these recollections really would have helped them to overcome the discrimination associated with their ancestry.

CONCLUSION

Despite the silences, over the past twenty years I have learned a lot about internal slavery and its aftermath, particularly from Gambians themselves. This confirms the enduring significance of this kind of historical memories even if they have not yet, and probably never will, become a tourist attraction. It also shows that ethnographic and historical fieldwork, if carried out as a form of patient engagement with people and situations[51]—as I have long attempted to do—can move beyond forms of cultural censorship directed at "trying not to remember."[52]

In this essay, I have used this rich research experience to pursue three objectives. First, I have shown that alongside and beyond government initiatives focused on the Atlantic slave trade, there is the silent and silenced legacy of internal slavery, which both slaves' and masters' descendants prefer not to discuss in public. Second, I have distinguished between silences that cut across social hierarchies and those that reinforce old forms of subordination linked to slave ancestry with the effect of repressing above all the ex-slaves' and slave descendants' own memories of their past. In this concluding section I address the third objective: that is to identify the kind of silences predominant today, notably those which depend more on lack of knowledge than on efforts to forget.

In early colonial Gambia, former masters and slaves shared the goal of minimizing the emotions of rage and sorrow that past stories of enslavement could elicit. It was not wise to create conflicts which would draw the attention of colonial officials. Moreover, as explained above, former slaves and their offspring lacked genres and contexts within which to articulate their historical consciousness, and if they wished to shake off their identities they had to follow the behavioral models originally at the core of the masters' social superiority.

Then, the progressive climate of late colonialism and the anticolonial struggles of the late 1950s and early 1960s turned slavery into a reminiscence of the past. At independence, those who had had the opportunity to access education in colonial times joined the ranks of the national

elite. Some were of slave origins as were some of the political figures who played a key role in mobilizing political consensus in the rural areas. In the framework of electoral democracy, the support of subordinate groups—youth, women, and foreigners who had settled in The Gambia, and men and women of slave stock—became crucial to win elections. This further leveled old status distinctions together with the spread of education, urbanization, and international migrations in the second half of the twentieth century.

Probably the 1950s and 1960s marked significant changes in the post-abolition course of Gambian society. The fact that in the following decades slave descendants have successfully climbed the social ladder to occupy high positions in the public and private sectors, whereas some master descendants have become impoverished, has added a further, and strategic, reason for silence by making the legacy of internal slavery even more sensitive. The fallen masters, in fact, would not dare to talk about the humble ancestry of a high-ranking civil servant or politician, especially if they are in need of his favors.

Such stratification of silences has blocked knowledge transmission about internal slavery from the older to the younger generations. In the early 1990s, I had the opportunity to meet rural elders whose remembrances of enslavement by war, trade, and pawnship were still vivid. Like the head chief of Bansang, they had grown up in a social environment hosting first-generation slaves and slaves who still worked for their masters. Pa Baldeh of the village of Sare Madi Ghente in the Fuladu West district recalled how poor Fula families handed their children over to wealthy people who needed labor to tend their cattle.[53] This was a practice which did not end with colonization. Pa Baldeh's emotions while talking (and the fact that he was sitting in a lower position than the elderly man who had called him to join our conservation) indicated that he was one of those kids. Bambi Jobarteh of Bansang described the powerful people of the past sitting draped in beautiful gowns while others worked for them all day long.[54] Nyima, another elderly woman, talked about the violence of enslavement.[55] Samba Kandeh of Sare Bojo narrated how, after the establishment of the British Protectorate, people went in search of their enslaved relatives to negotiate their return home.[56]

Currently, a number of elderly men and women are still able to discuss slavery in depth, if an appropriately confidential setting is created. As a rule however, and especially in the urban areas where the majority of the population is concentrated today, the topic rarely surfaces in discursive forms apart from occasional slanders. Even young people who come from those villages considered to be the most conservative with regard to the legacy of slavery cannot easily connect contemporary relationships between slave and master descendants to local history. Their representation of slavery builds more on what they have learned from history textbooks and from global sources of information than from

exposure to local historical narratives and those fragments of conversations, proverbs, songs, short stories, and dances which made up the legacy of internal slavery for their grandparents and parents. Human cargoes across the Atlantic are part of their imagination, but the consensus tactics through which local masters won the trust of their slaves are not. They talk about the Atlantic slave trade but not about nineteenth-century native enslavers, and quickly dismiss the deference of some slave descendants toward their 'masters' by stating that they have been brainwashed and live in the past.[57]

Change is a characteristic of oral sources and even more when society does not wish to commemorate certain elements of its past. By following Chikunga oral accounts for over thirty years, and comparing them longitudinally, Allen and Barbara Isaacman have been able to provide an account of how they have become more and more shallow.[58] Similarly, I have witnessed the withering away of the historical contexts which for most of the twentieth century fleshed out conceptions of internal slavery and the daily interaction between slave and master descendants. Old meanings of slavery have been pushed onto the margins whereas new ones have started to emerge. Over the past twenty years for instance, the notion of mental slavery, drawn from Bob Marley's repertoire, has become extremely popular.[59] Governments have been using it to spread pan-African feelings against Western cultural and political hegemony, and the diasporic media have turned it into a tool to contest the country's lack of civic and political liberties since the military coup of 1994.

Ethnographic and historical research counters these processes of transformation by creating a public space in which the silent and silenced reminiscences discussed in this essay can acquire a new significance. Most of the people who transcribed the historical narratives that I collected from elderly men and women were young and literate. More than once, the fact of having listened to elders' recollections while transcribing brought them to reflect on events and practices they had witnessed without knowing their real significance. Another aspect is that by the time the researcher wins the trust required to embark on the discussion of certain topics, those who were holding the silenced knowledge about the past may no longer be alive. Moreover, the researcher has to ethically manage the contradiction of being called to break silences in the interest of documenting history and to respect them as part of the lives he/she has intruded on. Even the dissemination of research results ends up being partially curbed by silence. Changing the names of people and localities—which is a common practice to guarantee anonymity, and necessary in places where slave ancestry is still perceived as a stigma—has the side effect of erasing concrete historical individuals, with their personal experiences and suffering, from the records of history. Undeniably, the shifting of meanings that has surrounded the notion of slavery since legal abolition in colonial times is fascinating. But the dynamics of

silence, that I have tried to describe, keep pushing the vicissitudes of a part of Gambian society, that of former slaves and slave descendants, into the shadows of the past.

NOTES

1. Alice Bellagamba, "Slavery and Emancipation in the Colonial Archives: British Officials, Slave Owners, and Slaves in the Protectorate of the Gambia (1890–1936)," *Canadian Journal of African Studies* 39, no. 1 (2005): 5–41.
2. Alice Bellagamba, "Back to the Land of Roots: African American Tourism and the Cultural Heritage of the River Gambia," *Cahiers d'études africaines* 49 (1–2), nos. 193–194 (2009): 460.
3. In this regard, I seek to follow Michel-Rolph Trouillot's suggestion to distinguish between different types of silence. See Trouillot, *Silencing the Past: Power and the Production of History* (Boston, MA: Beacon Press, 1995), 26–29.
4. Martin Klein, *Slavery and Colonial Rule in French West Africa* (Cambridge: Cambridge University Press: 1998), 246.
5. David Berliner, "An 'Impossible' Transmission: Youth Religious Memories in Guinea-Conakry," *American Ethnologist* 32 (2005): 577.
6. France only joined the British antislavery crusade in 1835. Along the River Gambia, the French controlled the commercial outpost of Albreda, which they had established in 1681. In 1857, Albreda was eventually ceded to the British. Today, it hosts a Slavery Museum and, together with Juffureh and James Island, is included in tourist itineraries exploring the Atlantic slave trade.
7. John Gray, *A History of The Gambia* (London: Frank Cass & Co, Ltd, 1966), 295–303.
8. Klein, *Slavery and Colonial Rule in French West Africa*, 68–69; Kenneth Swindell and Alieu Jeng, *Migrants, Credit and Climate: The Gambian Groundnut Trade, 1834–1934* (Leiden: Brill, 2006), 61–64.
9. British National Archives (hereafter BNA), London, Kew Garden, CO 88/1, 31/12/1831, An Act to Explain and Render More Clear and Act of the British Parliament Passed in the Fifth Year of the Reign of His Late Majesty King George The Fourth, entitled "An Act to Amend and Consolidate the Laws Relating to the Abolition of the Slave Trade"; BNA, CO 88/1, 10/7/1851, Enforcement in Gambia of Sierra Leone regulation.
10. Interviews with Cham Diouf, locality of Bakau, The Gambia, January 20, 2010, January 21, 2010; Charlotte Quinn, *Mandinko Kingdoms of the Senegambia: Traditionalism, Islam and European Expansion* (Evanston, IL: Northwestern University Press, 1972), 139.
11. Gambian National Archives (hereafter GNA), Banjul, The Gambia, ARP 28/1, *Travelling Commissioner Reports, South Bank, 1893–1899*; GNA, ARP 32/1, *Travelling Commissioner Reports, North Bank, 1893–1899*. For the Upper River, which was annexed in 1901, see BNA, CO 87/169, 17/08/1903, *Report on the Upper River for 1902 and 1903*.
12. Both colonial and oral sources report that clandestine traffic in slaves continued up until First World War. See, for instance, GNA, CSO2/107, *Commissioner's diaries for 1907, Upper River Province*, 11/07/1907; CSO 2/170, *Commissioner's diaries for 1912–1917, Upper River Province*, 26/04/1913.The practice of sending children and girls to serve as

apprentices in the houses of notables, traders, local chiefs, and big cattle owners lasted even longer under the unseeing eyes of colonial officials.

13. Margaret Haswell, *Economics of Agriculture in a Savannah Village* (London: Her Majesty's Stationary Office, 1953), and David Gamble, *Economic Conditions in Two Mandinka Villages: Kerewan and Keneba (Gambia)* (London: Her Majesty's Stationary Office, 1953).
14. For details on the geographical origins of immigrants to The Gambia see Philippe David, *Les navétanes: histoire des migrants saisonniers de l'arachide en Sénégambie des origines à nos jours* (Dakar: Nouvelles Editions Africaines, 1980), and Swindell and Jeng, *Migrants, Credit and Climate*. The resubordination that foreigners experienced in Gambian communities is a recurrent theme in historical narratives from the Eastern part of the country. See, for instance, Eduard Van Hoven, *L'oncle maternel est roi: La formation d'alliances hiérarchiques chex les Mandingues du Wuli (Sénégal)* (Leiden: Research School CNWS, 1997), and Paolo Gaibazzi, "Two Soninke 'slave' descendants and their family biographies," in *African Voices on Slavery and the Slave Trade*, ed. Alice Bellagamba, Sandra Greene, and Martin Klein (New York: Cambridge University Press, forthcoming).
15. Local customs completely overlooked the fact that the 1930 abolition ordinance had repealed the 1894 and 1906 colonial provisions, which had established a fee for slave redemption, and so slave descendants continued to have to pay for their freedom and undergo a ceremony of purification. See Alice Bellagamba, "'The Little Things that Would Please Your Heart . . .': Enslavement and Slavery in the Narrative of Al Haji Bakoyo Suso (The Gambia)," in *African Voices on Slavery and the Slave Trade*, ed. Alice Bellagamba et al.
16. Singular: *jong*; plural: *jongolu*. Mandinka is one of the most widely spoken languages in The Gambia (where according to official figures Mandinka speakers amount to 42 percent of the population), Middle Casamance, and part of Eastern Senegal.
17. Frederick Cooper, "Introduction," in *Beyond Slavery: Explorations of Race, Labor, and Citizenship in Postemancipation Societies*, ed. Frederick Cooper, Thomas C. Holt, and Rebecca J. Scott (Chapel Hill, NC, and London: University of North Carolina Press, 2000), 7–11; Martin Klein, "Slave Descent and Social Status in Sahara and the Sudan," in *Reconfiguring Slavery: West African Trajectories*, ed. Benedetta Rossi (Liverpool: Liverpool University Press, 2009), 45–84.
18. James Searing, *"God Alone is King!": Islam and Emancipation in Senegal; The Wolof Kingdoms of Kajoor and Bawol, 1859–1914* (Oxford: James Currey), 150.
19. Interview with Bakoyo Suso, locality of Dippakunda, April 23, 2003.
20. Interview with Kebba Suso, locality of Talinding, November 27, 2007.
21. Interview with Lamin and Kebba Koma, locality of Manna, Niani, January 22, 2008. The *kankurang* is a Mandinka mask. "Kurì, kurì" is a Mandinka cry commonly used to call dogs.
22. Interview with Lamin and Kebba Koma, locality of Manna, Niani, January 22, 2008.
23. Jean Bazin, "La production d'un récit historique," *Cahiers d'études africaines* 19 (1–4), nos. 73–76 (1979): 436.
24. Sandra Greene, "Whispers and Silences: Explorations in African Oral History," *Africa Today* 50, no. 2 (2003): 46.
25. Interviews with Al Haji Boubacar Kora, locality of Bansang, December 8 and 9, 1992; December 21, 1992; October 7, 1994; December 23, 1994.

26. Mamadou Diawara, *L'empire du verbe et l'éloquence du silence* (Cologne: Rüdiger Köppe Verlag, 2003), 288.
27. Compromise is *masalaa* in Mandinka, silence is *dewo*, and patience is either *sabari* or *munyoo*. I explain the difference between the both concepts later on in this chapter.
28. Interview with Junkung Sumbundu, Bakary Sidibeh, and Kebba Suso, locality of Talinding, The Gambia, November 28, 2008.
29. Interview with Kebba Suso, locality of Talinding, December 13, 2007.
30. For instance, when an animal is slaughtered during marriage and naming ceremonies, slave descendants (and other dependents) receive the *komasingo*, the back leg, which is the richest in meat, although it represents subordination.
31. Michael Taussig, *Defacement: Public Secrecy and the Labor of the Negative* (Stanford, CA: Stanford University Press, 1999), 5.
32. For a comparative perspective, see Bayo Holsey, *Routes of Remembrance: Refashioning the Slave Trade in Ghana* (Chicago, IL: University of Chicago Press, 2008), 69–70.
33. Pier Larson, "Horrid Journeying: Narrative of Enslavement and the Global African Diaspora", *Journal of World History* 19, no. 4 (2008): 434–436.
34. Anne C. Bailey, *African Voices of the Atlantic Slave Trade: Beyond the Silence and the Shame* (Boston, MA: Beacon Press, 2005), 221.
35. Elisabeth Tonkin, *Narrating Our Past: The Social Construction of Oral History* (Cambridge: Cambridge University Press, 1992), 132; Tonkin, in turn, has drawn inspiration from Edwin Ardener's discussion of female muteness as a sociostructural condition. See Malcom Chapman, ed. *Edwin Ardener: The Voice of Prophecy and Other Essays* (Oxford: Basil Blackwell 1989), 127–133.
36. I call artisans what actually were endogamous professional groups, namely bards (also known as griots), blacksmiths, and cobblers. According to local conceptions of power, representatives of these social categories—as much as women, newcomers, and slaves—could not aspire to political and social leaderships.
37. I am not, of course, stating that former slaves and slave descendants have no history at all. They do have an acknowledged history, as laborers, civil servants, politicians, successful farmers, traders, religious scholars, or any other social role filled by themselves and their offspring since abolition. But this history is only occasionally linked to the former enslavement of their ancestors. No proud narrative of exit from slavery has been elaborated to date, not even by those slave descendants who have successfully parted with their ancestry.
38. Martin Klein, "Studying the History of Those Who Would Rather Forget: Oral History and The Experience of Slavery," *History in Africa* 16 (1989): 213.
39. Personal life-stories and biographies have become significant historical sources from the late twentieth century onward, when the first generation of educated Gambians, such as former president, Dawda Jawara, began to record their memories in writing. See Dawda Jawara, *Kairaba* (Burgess Hill, West Sussex: Domtom Publishing Ltd, 2009).
40. Christine Hardung, "Everyday Life of Slaves in Northern Dahomey: The Process of Remembering," *Journal of African Cultural Studies* 15, no. 1 (2002): 35–44; for a critical perspective on life-histories, similar to the one I have adopted in this essay, Corinne A. Kratz, "Conversations and Lives," in *African Words, African Voices: Critical Practices in Oral History*, ed.

Luise White, Stephan Miescher, and David William Cohen (Bloomington, IN: Indiana University Press, 2001), 127–161.
41. Momadou Diawara, *L'Empire du verbe et l'éloquence du silence*, 284.
42. Interview with Bakoyo Suso, locality of Bakau, August 10, 1996.
43. For an interesting interpretation of the Muslim *sabr* (which in Mandinka is *sabari*) as a form of agency, see Sherine F. Hamdy, "Islam, Fatalism, and Medical Intervention: Lessons from Egypt on the Cultivation of Forbearance *(Sabr)* and Reliance on God *(Tawakkul),*" *Anthropological Quarterly* 82, no. 1 (2009): 173–196.
44. Interview with Junkung Sumbundu, Bakary Sidibeh, and Kebba Suso, locality of Talinding, The Gambia, November 28, 2008.
45. The model is the Sunjata epic, which is at the core of Mande oral traditions. Sunjata's mother was a blemished woman, who endured a lot of suffering. The son became the hero of the Mande world. For a Gambian version of the epic, see Gordon Innes, *Sunjata: Three Mandinka Versions* (London: School of Oriental and African Studies, 1974).
46. For an overview of Fuladu history, and hints on Alpha Molo's slave ancestry, see Charlotte Quinn, "A Nineteenth Century Fulbe State," *Journal of African History* 12, no. 3 (1971): 427–440; Christian Rôche, *Histoire de la Casamance: Conquête et résistances: 1850–1920* (Paris: Karthala, 1985); Boubacar Barry, *Senegambia and the Atlantic Slave Trade* (Cambridge: Cambridge University Press, 1998).
47. Tree is *yiroo*; the nuance of meaning produced by the association between trees and development is not explicitly formulated; but life in general and fertility are linked to water, freshness, and vegetation.
48. Swindell and Jeng, *Migrants, Credit and Climate*, 150.
49. Antonio Gramsci, *Quaderni dal Carcere*, vol. 3 (Quaderni 12–29; 1923–1935), Edizione critica dell'Istituto Gramsci, ed. Valentino Gerratana (Torino: Einaudi, 2007), 2283.
50. Jane Guyer, "Postscript: From Memory to Conviction and Action," *Africa* 75, no. 1 (2005): 121.
51. Michael Carrithers, "Anthropology as a Moral Science of Possibilities," *Current Anthropology* 46, no. 3 (2005): 437.
52. Robin E. Sheriff, "The Muzzled Saint: Racism, Cultural Censorship, and Religion in Urban Brazil," in *Silence: The Currency of Power*, ed. Maria-Luisa Achino-Loeb (New York: Berghahn Books 2006), 118.
53. Interviews with Jakatu Baldeh and Pa Baldeh, locality of Sare Madi Ghente, Fuladu West, and January 16 and 17, 1993.
54. Interviews with Bambi Jobarteh, locality of Bansang, December 22 and 29, 1992, January 10, 1993.
55. Interviews with Nyima Jobarteh, locality of Bansang, October 9 and 22, 1994, November 5 and 30, 1994.
56. Archives of the Research and Documentation Division, National Council for Arts and Culture, Banjul, The Gambia, tapes 4731–4740, Samba Kandeh, locality of Sare Bojo, History of Fulas.
57. Alice Bellagamba, "After Abolition: Metaphors of Slavery in the Political History of the Gambia," in *Reconfiguring Slavery: West African Trajectories*, ed. Benedetta Rossi (Liverpool: Liverpool University Press, 2009).
58. Allen Isaacman and Barbara Isaacman, *Slavery and Beyond: The Making of Men and Chikunda Ethnic Identities in the Unstable World of South-Central Africa, 1750–1920* (Portsmouth, NH: Heinemann, 2004), 28–30.
59. See, for some recent examples, "Jammeh Calls for Disregard of Political Differences, As Gambia Celebrates 15th Anniversary of July 22nd

Revolution," July 23, 2009, The Point, http://thepoint.gm/africa/gambia/article/jammeh-calls-for-disregard-of-political-differences-as-gambia-celebrates-15th-anniversary-of-july-22; "Statement by H. E. Sheikh Professor Alhaji Dr. Yahya A.J.J. Jammeh, President of the Republic of The Gambia on the Occasion of the Re-Naming of James Island as Kunta Kinteh Island and the Roots Pilgrimage in Juffureh, February 6, 2011," http://www.statehouse.gm/Speeches/10th-Edition-Roots-International%20Festival-renaming-James-Island_06022011.htm; "Commentary: Africans Have to Start Emphasizing on Mental Liberation," *The Gambia Echo*, November 22, 2010, http://www.thegambiaecho.com/Homepage/tabid/36/articleType/ArticleView/articleId/2117/Default.aspx.

3 With or Without Roots
Conflicting Memories of Slavery and Indentured Labor in the Mauritian Public Space

Mathieu Claveyrolas

This chapter deals with the Mauritian contemporary context of competing communal memories.[1] Mauritius is the perfect illustration of a Creole society: the island has no native population, its origins are largely linked with slave trade and the sugar industry, and it comprises an important mixture of cultures coming from various parts of the world. However, the majority of the Mauritian population comes from India and practices Hinduism. At least since its independence in 1968, the Indo-Mauritian communities have developed a huge concern for Indian cultural roots in an attempt to differentiate themselves from descendants of enslaved Africans.

This chapter argues that official Mauritian initiatives to promote the memory of slavery and indentured labor must be understood in the context of the ongoing construction of a young nation hesitating between Indianness and Creoleness, here seen as a dynamic interpenetration of various cultures resulting from contexts of forced migration and slavery. Denying or accepting the past—and its original uprooting—is the main mechanism behind competing memories of slavery and indentured labor. The first part of the chapter explores the links between the public memories of enslaved Africans and indentured servants as well as their relations with communal founding narratives that reconstruct the past of each community. The second part discusses the various projects of appropriation of the Mauritian public space through recently built monuments and sites.

HISTORICAL CONTEXT

Mauritius is an island in the Indian Ocean some 500 miles east of Madagascar. The island is densely populated, with 1.2 million inhabitants distributed in an area of only 787 square miles. The island was uninhabited until the seventeenth century. From 1658 to 1710, the Dutch colonized the territory but were forced to leave after failing attempts to develop the island. Then, between 1715 and 1810, the French occupied the territory.

They imported slaves from mainland Africa and Madagascar before developing an estate society based on the sugarcane industry. Under French rule, including the Revolutionary period, Mauritius lived "in splendid isolation from the Metropole."[2]

When the British eventually took over the island—from 1810 to its independence in 1968—they were not able to implement the ban of the transatlantic slave trade they had established in all British colonies in 1807. Indeed, the need for an inexpensive workforce became increasingly urgent since the end of the eighteenth century and the rapid development of the Mauritian sugar industry by the French oligarchy. Actually, many of the leading French planters who benefited from the massive illegal slave trade in the first two decades of the nineteenth century vigorously fought abolition of slavery.[3]

Following the definitive abolition of slavery in Mauritius on February 1, 1835, slave owners were generously compensated. Though a six-year term of apprenticeship was implemented for liberated slaves, the growing demand for cheap labor was met through the development of indentured labor. The massive imports of indentured laborers were justified on the one hand by the refusal of former slaves to work in the sugarcane fields and on the other hand by planters wishing to artificially create an overabundant workforce.[4] This context heavily challenged the balance of the Creole estate society. Indentured workers were recruited as "volunteers" in British India and were brought to Mauritius to replace the former slaves. According to available estimates, from 1835 to 1907, 500,000 Indians were brought to Mauritius through this indenture system.[5] Although five-year contracts guaranteeing wage and free passage back to India were signed, at least in the 1837–1853 period, the working and living conditions of Indian indentured laborers were very close to slavery.

As early as 1861, Indians accounted for two-thirds of the population of the colony, and before the end of the nineteenth century Mauritius-born Indians outnumbered those who were born in India.[6] Thus, the importance of indentured labor in an island without a native population is mainly demographic. The socioideological system of the Creole estate society, built on the relations between white masters and black slaves, was shaken by the arrival of Indian communities that brought different languages and religions—and a very different representation of the past.

Around 1880, economic difficulties led planters to sell their lands. Indian laborers started acquiring sugarcane plots. They became small planters and soon important economic agents. In 1940 they possessed half of the cultivated area of Mauritius.[7] Since the 1880s, they had settled in villages outside the estate camps, which supposedly allowed them to re-create the Indian social context.[8]

Nowadays Mauritius is inhabited by Creole descendants of enslaved Africans, who represent between 20 and 25 percent of the overall population. However, a huge majority of Mauritians (approximately 70 percent)

are descendants of Indian indentured laborers, most of whom are Hindus. Thanks to a new constitution and to a voting system established in 1948, Indians finally became a political majority. Since then, the only "fight" for independence was an internal one, opposing pro-independence Indo-Mauritians to anti-independence Creoles and Franco-Mauritians, who feared that a democratic Mauritius would become fully Indianized.

In the 1970s, interethnic rivalries calmed down thanks to the consensual personality of Seewoosagur Ramgoolam, the first prime minister of independent Mauritius, and because of the general social improvement brought by the welfare state policy, which emphasized class rather than ethnic identities.[9] However, at the end of the 1980s, with the death of class struggle and the implementation of ultraliberal policies by the International Monetary Fund, the competition for social advantages hardened. The credo became that Mauritius was a "rainbow nation" where pluriethnic multiculturalism prevailed, with different cultures living together without merging.

From colonial rule to independent rule, democratization led to an implicit ethnic sharing of powers: the private sector—including banking, sugar industry, and tourism—remained in the hands of the white oligarchy of French origin, whereas the state stayed in the hands of the Indo-Mauritian bourgeoisie, in a context of ethnic-based vote-catching. However, many subgroups emerged on the basis of geographical origin, language, or religion; these claimed both recognition of sociocultural identities and participation in state wealth and advantages.[10] In this context emerged the *malaise créole* when slave descendants, set apart from the sharing of powers, tried to fight their economic, political, and cultural marginalization. In 1999, following the suspicious death in prison of the Rasta singer Kaya, icon of the Creole community, ethnic riots challenged the success story of a harmonious society.[11]

Examining the rhetoric used to describe Mauritius is a good way to present identities as they are locally lived and conceived. Mauritius society sometimes likes to be praised as a cultural, religious, and ethnic melting pot. From this perspective, the island presents itself as representative of a harmonious Creoleness, whose rich identity reconfigurations prefigure all future nations of the globalized world. Whatever the actual difficulties of "melting" the various communities in a single "pot" are, this vision usefully highlights the Creole heritage shared by the whole society. However, the word "Creole" in Mauritius does not refer to all Mauritians, as it does in the Creole Caribbean islands or in the neighboring French Creole Réunion Island, but to the individual identified as black, descendant of African or Malagasy slaves, and Catholic. The "Creole" of African descent is opposed to the individual identified as a descendant of Indian indentured laborers, designated as "Indo-Mauritian" in politically correct speech, and as "Indian" (*endyen*, in Mauritian Creole language) or even Hindu in popular speech.

In the Mauritian context, the processes of identity construction are particularly fascinating. These processes are based on Creole dynamics—forced migration, uprooting, *métissage*—and on Indian and Hindu identity claims, often presented as anti-Creole. Actually, Hinduism, at least for its orthodox defenders, is thought to be based on the fear of mixing with others, and on its consubstantiality with the Indian Territory. When studying memory in Mauritius, the link with India cannot be forgotten, but its overestimation may mistakenly lead one to forget that the Mauritians' India is mostly "imagined" and manipulated for Mauritian purposes.[12] If such a thing as an "Indo-Mauritian" culture exists, it is first based on shared conditions and constraints imposed by the estate society.

MEMORIES AND MYTHOLOGIES: FROM SLAVES TO CONQUERORS

It has been said that "Mauritian traditions do not have a founding myth."[13] True enough: the very fact that Mauritius has never had a native population makes it problematic to claim a legitimate possession of the territory. However, it appears that various communities have been imagining several founding myths. The Creole community, for instance, is said to refer to the maroon slave of the Dutch colonization period (1658–1710) to claim a historical primacy over the Mauritian territory.[14] Indeed, in the second half of the seventeenth century, during the unsuccessful Dutch colonization, slave escapes were particularly common.[15] Since the end of the Dutch occupation, these imagined maroon communities were perceived as the very first Mauritian settlers. The Indo-Mauritian elites, above all, have tried to reinterpret the introduction of indentured labor as a colonization process in order to establish the glorious narrative of their conquest of the island. Indentured laborers are then presented as a combination of conquerors and unremitting workers who saved the Mauritian land from the neglected state in which former slaves had left it. Nevertheless, in spite of these temptations related to communal political projects, the Mauritian territory cannot be easily assimilated to a unique population. The relatively recent history of violent displacement and the rupture with the motherland have led more frequently toward an identity process based on the quest for roots coming from elsewhere. India particularly stands for such external roots for indentured laborers. But some groups of the Creole community, most of them Rastafarian relying on an Afrocentric spirituality, also refer to Africa as an external rooting of their identity.[16]

One of the main public debates in Mauritius turns around the comparison between slavery and indenture systems. The scientific debate was opened by the historian Hugh Tinker who published in 1973 the book *A New System of Slavery: The Export of Indian Labour Overseas*. Since then, there has been a confrontation between those who see indentured

labor only as another slavery system aiming at bypassing abolition, and those who underline the totally different nature of each system.

Actually, well before indentured labor was introduced in the island, Mauritius was very familiar with an ambiguous category of labor performed by slaves being "hired out as agricultural laborers."[17] Then, the racial and socioeconomic logic of the sugar estate were undoubtedly preserved in the transition from slavery to indentured labor. An often-cited example in this debate is the "double-cut" system, consisting in depriving the laborer of two days' pay for each day off work, whatever the reason justifying the absence. This double-cut system symbolized the fundamental difference between a slave and an indentured laborer who received a salary. At the same time, this system put in evidence the complexities of indentured labor. Indeed, in a context of epidemics and working hazards, this double-cut system meant that many laborers did not get any salary at the end of the month.

Despite the relevance of comparing the indenture system and slavery, it is obvious that the national construction processes, both historical and contemporary, radically diverge depending on the point of view adopted. Is it possible to compare the two systems and the fate of the individuals and communities involved? Is it possible to radically differentiate them, drawing a dividing line in Mauritian historiography between slavery times and indentured labor periods?

Risking the Comparison

There are several Indo-Mauritian identity-founding myths. One of these myths is based on the association of indentured labor with slavery. There are many tangible hints of this vision of the past in Mauritian politics, making it uneasy to evoke the slave past without automatically including the indentured labor perspective. When the time came for debating financial compensation for slave descendants, the main Mauritian political alliance—gathering the political parties MMM, "Mouvement Militant Mauricien" (Mauritian Militant Movement), and the MSM, "Mouvement Socialiste Mauricien" (Mauritian Socialist Movement)—wrote in its 2000 program: "given the specificity of Mauritius, we are thinking about broadening such a process [the financial compensation to slavery] to descendants of indentured laborers."[18] Of course, financial compensation was not the only way to promote memories. Heritage projects were also developed, and the idea of a "Route of the Indian Indentured Laborer" on the exact model of the UNESCO's Slave Route project was discussed as well.[19]

An example of the perspective associating slavery and indentured labor is given in the novel *Les Rochers de Poudre d'Or* ("The Golden Powder Rocks") by the Mauritian writer Nathacha Appanah.[20] Its title alluded to the well-known legend of indentured laborers believing they would find gold under each and every Mauritian rock. The novel is built as a

chronological narrative of migration. Starting from the various situations of different characters in India, the narrative follows them through their passage to the island, and then to their arrival, life, and work in Mauritius as indentured laborers.

The focus of the novel relies on the conditions of slavery before the indentured period. The author uses the word "slave" many times to describe the characters' living and working conditions in India.[21] They are described as slaves of the British, but they are also slaves of the Indian socioreligious caste system. One character in the novel is a widow who was supposed to throw herself on her husband's funeral pyre. Furthermore, prior to their experience as indentured laborers, individuals are described as slaves of the socioeconomic system. They are peasants working for local landlords, suffering from hereditary debts, and nearly starving. According to this contemporary Mauritian look at indentured labor, the period before the emigration was not only one of economic or social misery, it was also characterized by a double kind of slavery. The submission to the British in India was synonymous with territorial deprivation, which anticipated the forced exile far from the Indian territory. The submission to the socioreligious Indian ideology of castes foreshadowed the slavery system of the Mauritian estate society. In the novel, leaving India is certainly not unilaterally negative.

Appanah then describes the definitive trauma of the passage from India to Mauritius. The sea journey is represented as ideological identity loss, because crossing the "black water" (*kala pani* in Hindi) is forbidden to Hindus on pain of losing their caste and identity, a risk clearly evoked by the novel's characters.[22] There is also a dehumanization process comparable to the experience lived by enslaved Africans during the Middle Passage. Promiscuity, epidemic diseases, suicides, rats, rape, and dead bodies thrown into the sea without cremation are all described, making the reader understand that the loss of identity is the consequence of breaking the taboo of leaving India and is the result of the voyage's concrete circumstances. Nevertheless, the author also evokes the hope of a Promised Land at the end of the trip. Whether it is utopian fantasy or a necessity for survival, indentured laborers on the boat still dreamed of a better future, which is the biggest difference between them and enslaved Africans. This difference also creates many future ambiguities related to the assimilation of the Indian descendants with "conquerors" more than with "indentured migrants."

Once in Mauritius, indentured laborers faced similar challenges to those faced by slaves. Living and working conditions were analogous: the racial ideology was omnipresent, and laborers were given an immigrant number as if to validate dehumanization. To prevent intercommunication between different "camps" and avoid the organization of potential revolts, indentured laborers were not free to choose their masters or to move outside the estate.

By reading this narrative from the nation-building perspective, one could hope that national unity or, at least, mutual understanding and solidarity could be reached through shared historical fate between ex-slaves and ex-indentured laborers. Undoubtedly, the "Indian culture" in Mauritius has been deeply creolized. The Indian languages, for example, have been creolized (Bhojpuri), or even lost in favor of Creole (Tamil). In the same way, Indian religious practices have undergone radical changes and a kind of Christianization is easily perceived: the temple is called a parish, and seats are provided for the devotees in an organization of space unknown in Indian Hinduism. Other socioreligious characteristics, such as the caste organization and the link with a precise, village-centered territory, gave place to new social and spatial representations inherited from the estate society. The vision opposing the narrative comparing slavery with indentured labor reminds us that migration both in India and abroad is a tradition among many Indians. This idea contradicts the narrative relying on the idea of rupture. Also, in Mauritius, the role of "pull factors"—those that incited Indians to come to Mauritius—weakens the image of all migrants being deceived into the indentured labor.[23] Whether or not these objections fundamentally ruin the comparison with slavery, they are rarely put forward in local debates.

Eventually, the epilogue of the novel describes an Indian laborer fleeing his estate, as if inscribing the indentured Indian in the heritage of the maroon slave history. Alas, the "indentured maroon" finds refuge in a village of recently freedmen. However, the village inhabitants betray the "maroon" and sell him to the white master. This pessimistic epilogue leaves little hope in the context of a Creolist project of class and historical solidarity based on common memories above ethnic differences.

Denying the Comparison

The recent revival of Indianness in Mauritius is visible through the purification of local Hinduism and through the development of many political, cultural, and religious links with India. Such revival means bringing Indian temple builders and religious specialists to correct and purify Indo-Mauritian practices and representations that were supposedly lost after the departure from India, and then contaminated by the Creole culture. This is in fact a double process: it means purifying Mauritian Hinduism not only from the Creole culture, but also from the Indian popular culture first brought to the island by indentured laborers.

Another founding narrative of the Indo-Mauritian identity is grounded on the fierce rejection of any possible comparison between indentured labor and slavery. According to this perspective, the first focus is the fundamental rereading of Indo-Mauritian history. Abhimanyu Unnuth, in his novel *Sueurs de sang*,[24] tells the story of indentured laborers, narrating their daily life in the nineteenth century and underlining their courage and

rebelliousness. The novel was written in 1977 in Hindi, and it is generally considered one of the most important founding narratives of the Indo-Mauritian identity. The first lines of the novel bring the reader back to "the first millennium before J-C," describing Indian monks gone on a boat to discover new lands and finally meeting their death in the Mauritian seas. In the first two pages of the novel, the readers are told that the first sailors to reach Mauritius were Southern Indians. Then, the author underlines that many Indians belonged to the British Army, which took possession of the island over the French in 1810. The British are said to have promised the island to these Indian soldiers as a reward. According to the narrative, the Indians are eternally linked to Mauritius: they discovered the island, they fought for it, and they are its legitimate owners. Indians are depicted as conquerors, and never as descendants of indentured laborers, which might be problematic considering the anteriority of the presence of enslaved Africans and whites on the island. But then again, this chronological problem could well be overcome as enslaved Africans are today presented as having fled the estate and abandoned the land. Actually, one of the slogans of the 2009 indenture system anniversary focused on the courage and determination of Indian laborers: "Tribute to our ancestors. They resisted but they never ran away."

Thus, rejecting any possible comparison between the indenture system and slavery, the second focus is the over-promotion of the ancient Indian civilization, wisdom, and strength, evoking past and present episodes of successful migration movements. Indeed, both anthropologists and historians have compared indentured labor with success-story migrations such as the colonization episodes from India to East Asia in Medieval times, and the high-class diaspora of students, doctors, or computer specialists in North America in the twentieth century.[25] The current domination of Indo-Mauritians in the economic, political, and cultural spheres in Mauritius contributes to the denial of the objective conditions of their indentured migration.

Mauritian historian Kissoonsingh Hazareesingh, who was deeply involved in postindependence politics, illustrated this argument through his writings. In one of the first syntheses of the Indo-Mauritian history, Hazareesingh first denies the historical weight of indentured labor: "I refuse to believe that poverty itself can push a people to migrate massively, to flee its motherland."[26] Then the indentured laborer turns into an immigrant and a conqueror:

> the concept of a greater Indian then came to the minds of many, and at the summit of the revolutionary turmoil [in India], this migratory movement [to Mauritius] reminds us of the colonizing genius of the Vedic times, when the sons of India brought the wonders of national culture to far-away lands . . . There is no doubt that the Indians who then came to Mauritius were animated by the same spirit as those who,

many centuries ago, brought to far away countries the Indian message and the light of its culture.[27]

Coherent with such a rather grotesque vision is the contemporary leitmotiv of indentured laborers coming to Mauritius with a copy of the Mahabharata or Ramayana epics, which were supposed to carry the whole Indian genius, even though these texts were probably unknown in this form by nineteenth-century Indian laborers.

This mythology is linked to a "revisionist" history presenting indentured labor as a choice freely made by Indian individual migrants who were maximizing their opportunities.[28] It allows a dissociation of Indo-Mauritians from the history of slavery. Mauritius becomes the successful creation of an Indian quasi-colonization project. This revisionist history is typical of the importance of intellectual elites in the invention of a nation and of its prestigious past. Despite its real impact on Mauritians of Indian origin, this acclaimed link with Indian roots, coming from a community leading the fate of the new nation, is badly perceived by other communities, mainly descendants of African slaves. First, because Creoles are less prone to rely on their "original" pre-Mauritian identity, because they do not share the same connections with their homeland that Indians do.[29] Second, because such loyalty to one's ancestors is a huge obstacle to Creoleness. The constantly reinvented root-identity bears the temptations of closure, purity, mainly based on the past, thus acting against the Creole's effort to conceptualize a new nation based on shared memories of traumatic uprooting, relations, and *métissage*, and turned toward the future.[30]

THE APPROPRIATION OF PUBLIC SPACE: MONUMENTS AND SITES

For a long period, Indo-Mauritian communities were the only groups in Mauritius to be engaged in a memorialization process. Most of the time, the various Mauritian memories have been manipulated by political elites on a communalist basis. Rare and recent pedagogical projects promoting national shared memories are hardly backed by public authorities.

Steles and Obelisks

An obelisk was one of the first heritage monuments to be erected in Mauritius, at the center of the capital city, Port Louis. The context of the construction of this monument is enlightening. In 1935 Indo-Mauritians celebrated the centenary of the beginning of indenture system. Celebrations were jointly organized by local Indo-Mauritian elites and by Indian nationalist institutions. The main commemorating events took place on the "Champ

de Mars," the very place where the humiliating games known as "Malbar (a pejorative noun for Indians) races" were organized, and where Indo-Mauritian laborers were exposed to the mockery of spectators. The most symbolic and lasting trace of the 1935 celebrations is an obelisk erected on this occasion. The inscription on the obelisk praises "the centenary of Indian colonization," leaving no doubt about the organizers' aim of defending an "Indian identity" and of promoting a new vision of history. The Indo-Mauritian elites were already sufficiently organized to transform the history of indentured labor—a mainly suffering process—into a conquering narrative.[31]

Nevertheless, the obelisk was also ambiguous for Indo-Mauritians. The year 1835 is indeed the date of arrival of the first North-Indians as indentured laborers. The celebration thus neglects the fact that the arrival of South Indian Tamils as free workers occurred one century before the indenture system began. When, in 1984, the Mauritian government erected a stele celebrating the 150th anniversary of the "landing of the first Indians," Tamils renewed their criticism of this abusive terminology confusing once again "first Indians" with "first indentured Indians." Two years later, Tamils finally corrected what was perceived as disrespectful toward their community memory through the erection of their own stele in order to commemorate the "truly first" Indians' arrival in Mauritius.[32]

THE *AAPRAVASI GHAT* SITE OR THE UNEASY FIGHT AGAINST COMMUNALISM

During the year 2000, the place of disembarkment of indentured Indians on the Port Louis harbor was renovated, transformed into a place of memory, and renamed *Aapravasi Ghat*. For the first time, the political project used museum mediation in order to counter communalist temptations.

Physically, the site is located between the frenzy of the contemporary harbor activity and downtown Port Louis, from which it is separated by the main island's highway. The site is organized around a series of renovated and empty stone buildings representing the different rooms, such as kitchen, hospital, registration office, which were supposedly frequented by the freshly disembarked indentured laborers. If one believes the guided tour, the main focus of interest of this project is the renovated stone steps representing the first place where the indentured laborers set foot after their long sea journey.

In 2002, the University of Mauritius historian Vijaya Teelock was named president of the *Aapravasi Ghat* Trust Fund (AGTF). The Mauritian government gave her the mission to put the site on the UNESCO's World Heritage List. According to Vijaya Teelock, her ambition was to work jointly on conservation and research, in order to "bring history, in a tangible manner, to Mauritians, who generally do not read."

She continues explaining the objective perspective that bears an educative mission, "a wholly new concept: that of applied history [...] not only about figures and facts, but most of all about using research in the preservation of a site."[33] The project consisted of renovating the ruins of the original buildings, bringing them to life through a guided tour, and also through collecting oral testimonies. Indeed, only this latter element can explain that the inscription on the World Heritage List was finally accepted under criterion number 6, by focusing on "intangible heritage."

In the context of Mauritius, a nation where identities are being constructed along the dividing line between slavery and indentured labor, it is interesting to note that Vijaya Teelock is indeed a specialist of slavery. Putting a specialist of slavery in charge of an indenture heritage site symbolizes a will to reunify Mauritian history, and gives further credibility to the AGTF anticommunalist perspective.

In July 2006, the *Aapravasi Ghat* was officially registered on the UNESCO's World Heritage List, and by 2008 the site was ready to receive visitors. However, it seems that this was only the beginning of the fight for anticommunalist memories. The AGTF wanted to sweep aside all ambiguities: "we will never insist too much on the fact that the *Aapravasi Ghat* belongs to all Mauritians." Unfortunately, as Vijaya Teelock explained: "This is a constant fight. A many-folded fight: against the media who, sometimes, encourage communalism, against school textbooks and their rather narrow presentation of history."[34] Indeed, communalist references are very sensitive in Mauritius, and the *Aapravasi Ghat* site has not been able to completely stay away from the conflicting issues. Despite the precautions of its promoters, it became a place of memory only for the descendants of North Indian indentured laborers.

True enough, the terminology used by its initiators was ambiguous. The old name "coolie ghat" (from *ghat*—a pan-Indian term for "steps" and coolie—the worker under contract) has been renamed *Aapravasi Ghat* ("immigrants' dock"). One can discuss the legitimacy of the word "immigrant" to define the indentured laborers, but the ambiguity mostly lies in the use of *aapravasi*, a Sanskrit term referring to the culture of Mauritians who: a) are only of Indian origin; b) embrace Hindu religion, and c) come from North India, thus excluding the indentured Chinese, North Indian Muslims, and Tamil South Indians. Because the Mauritian context is particularly sensitive to language policies, this ambiguous terminology is even more pitiful.[35]

One can also question the strategy of supporting the unitary vocation of the site with far-fetched facts and figures, which are not so convincing. The AGTF insists on highlighting the fact that Chinese and Africans also counted among indentured laborers. This is the main point behind "coolitude," an ideology invented by Mauritian poet Khal Torabully, himself engaged in promoting the *Aapravasi Ghat* project. For Torabully,

"coolitude" is an anticommunalist Creole identity able to recognize the weight of Indian origins in Mauritian culture. According to him, "coolitude is to indianity what creoleness is to negritude."[36] Torabully professed in a newspaper article that the *Aapravasi Ghat* should be and manages to be the "matricial site" of the (anticommunalist) Mauritian nation. This vision is indeed congruent with the AGTF ambition: "The indentured comes from a mosaic [of cultures] . . . Hindus, Chinese, Muslims, Tamils, Marathis, etc . . . were *jahaji bhais* (brothers and sisters of [sic] the ships)."[37] Indentured labor is not ethnical in its core meaning, but judicial (labor with a five-year contract). Ethiopians, Japanese, Chinese, Malagasy, Europeans were also indentured laborers."[38] However, the statistics he provided, which pretended to "cancel all exclusive or communalist vision of indentured labor,"[39] were not convincing, and rather underlined the very ambiguity they are supposed to fight, because only 5 percent of the indentured workers were non-Indians. It is then hard to share the optimistic reasoning of those who, with Torabully, want to see in the *Aapravasi Ghat* a site able to unify the Mauritian memory, disregarding geographic and ethnic origins.

As a matter of fact, indentured labor remains undoubtedly associated with the Indian community in Mauritius. In 2008 the Indian prime minister was the authority invited to inaugurate the site. In 2009 it was the turn of the Indian Minister of Foreign Affairs to be invited to the anniversary of the indenture system, opened by a series of Hindu sacrificial prayers (*yaj*), at the *Aapravasi Ghat*. All newspapers celebrating this occasion illustrated the association between indentured labor and India. The newspaper *L'Express*, for example, presented *Aapravasi Ghat* as "a site deeply associated with the memory of more than half a million indentured laborers coming from India to Mauritius."[40]

From the "Malaise Créole" to the Memorial Site of Le Morne Brabant

The promoters of the *Aapravasi Ghat* were not the only actors to insufficiently admit the communalist stakes behind such a memorial site, and its consequent conflicting and centrifugal potential. UNESCO also helped boost an escalation of identity claims. During the same period when the *Aapravasi Ghat* project was a candidate to be included in UNESCO's Heritage List, another symmetrical and rival project was developed. The second Mauritian project also presented for the Heritage List proposed to memorialize Le Morne Brabant, a mountain where—it is believed—maroon slaves found refuge after fleeing the estates.[41] The original choice by UNESCO of the *Aapravasi Ghat* was source of much debate and bitterness. In 2008, Le Morne was eventually added to the World Heritage List. Such a delay in recognizing it as part of World Heritage probably helped fossilize the dual opposition between the two sites in a position far from the idealized heritage representation of a national memory.

From an aesthetic and symbolic point of view, the *Aapravasi Ghat* was very different from Le Morne project.[42] The *Aapravasi Ghat* refers to stone and building renovation to symbolize the original contact between individuals and the Mauritian land. Such is the meaning of the sculpture conceived by an Indian artist representing the footprints of an indentured laborer disembarking in Port Louis. Unlike the *Aapravasi Ghat*, Le Morne evokes through wild and hardly accessible scenery the myth of the maroon slave who most generally found in that site precarious freedom, and death. The mountainous Le Morne is often compared to a slave's profile looking toward Africa, before committing suicide by jumping into the sea, a somehow involuntary symbol of the impossible rooting of the slave in the Mauritian land. One might say that the *Aapravasi Ghat* is about the celebration of an appropriation of the land, whereas Le Morne is more about the celebration of martyrdom.

Several scholars and intellectuals tried to promote a possible coexistence of the two projects in an all-inclusive vision of Mauritian memories. But temptations of communalist reappropriation of Le Morne seem, once again, certain. A site to commemorate the memory of slavery versus a site to celebrate the memory of indentured labor, Creoles versus Indians, Catholics versus Hindus: in Mauritius, such dual oppositions seem difficult to transcend. A common official celebration day for indentured labor and slavery could not be agreed on. As a consequence, the celebration of indentured labor centered on the *Aapravasi Ghat* site each November 2 has become "Hindu celebration" in popular speech, whereas the celebration of the abolition of slavery, each February 1, centered on Le Morne, has become "Creole" or "Christian" celebration. What is remembered is the beginning date of indenture system, symbolically celebrating indentured labor as a great and successful adventure, whereas the commemoration of the abolition of slavery symbolizes the insurmountable slavery past. Then, when the Catholic priest Alain Romaine, promoter of the Creole cause, explains that "time has come for Le Morne to become a sacred mountain,"[43] he is once again emphasizing the communalist appropriation of memories. The association of slavery, African descendants, Catholics, and Le Morne is very far from a unitary national memory. Indeed, it is a tradition to invite Indian political personalities to celebrate indentured labor at the *Aapravasi Ghat*, just as the official personality invited for the 175th of slavery abolition at Le Morne was Joachim Chissano, the former president of Mozambique, one of the main slave ports from where slaves were sent to Mauritius.

In the Mauritian communal context where the Creole community appears marginalized, the imbalance between the promotion of memories of indentured labor and slavery is patent. For instance, the "Place d'Armes," in downtown Port Louis, is organized around various life-size statues. In the square, one can admire the statues of Bertrand-François Mahé de Labourdonnais (1699–1753), the first great organizer of the colony, and of Sir Seewoosagur Ramgoolam (1900–1985), the first leader of independent

Mauritius; each one, according to the pervasive communalist logic, representing the European and Indian communities. However, there is no statue celebrating a Creole leader. Indeed, in November 2009, a life-size statue representing Sir Gaëtan Duval (1930–1996), one of the rare Creoles to have had access to a major political role since independence, was erected. At the occasion, all commentators said that the new statue represented a fair compensation, after many years of exclusion. The newspaper *Le Mauricien,* for example, wrote that "the government corrects an omission, [sic] he was one of the rare builders of Mauritius not to have a life-size statue."[44] But the symbol somehow turned to relegation when the statue was finally erected in Rose-Hill, a town in the suburbs of Port Louis, far from the center of the political and economic power, and unknown to touristic circuits. The anecdote raises the clumsiness or ambiguities guiding the official handling of memory affairs, and the constant risk for communalist appropriation.

CONCLUSION

In less than 150 years, the Indo-Mauritians developed from a quasi-enslaved minority into a majority group leading the battle for independence and controlling the political power. Nowadays, Mauritius is sometimes called "Little India." Although Hinduism is the religion of half of the population, Mauritius is clearly an independent nation combining creolization and Indianization processes.

Despite the overall estate system Mauritius shared with Caribbean societies, the nation has been built on alternative dynamics. The Indo-Mauritian majority claims both its legitimacy to represent and lead the nation and its specificity compared with other Mauritian communities. As a result, the Indian heritage, which was supposedly brought and preserved by indentured laborers, is thought of as founding the nation, and in this reconstruction, references to slavery and the original uprooting are simply omitted.

Memorial reconstructions in Mauritius must be understood in a global context of struggle for the appropriation of the public space. They must be linked with language policies, including the status of Creole and Indian languages in the public sphere, education, and the media. These issues must also be discussed under the light of Mauritian physical landscape within which numerous sacred Hindu sites are being built and enlarged.[45] As in other contexts, Mauritian commemorative monuments and events tell us more about the contemporary context of the communal memories struggle than about the nineteenth-century context they are supposed to commemorate.

In Mauritius the very comparison between memories, and the desire for communal specificity, creates and exaggerates the conflicting nature between memories. I argued elsewhere that when Mauritians of Indian origin focus on their Indian roots, this is to be understood above all in

the context of Mauritian local stakes, such as the creation of a specific Mauritian nation, and the legitimization of the Indo-Mauritians' political leadership.[46] In quite the same way, one can wonder whether, in the Mauritian case, the phenomenon of commemoration of slavery is only a tool for identity positioning and resistance in the local Mauritian political game. The Indo-Mauritian community concern for Indian roots and their disengagement from Creoleness is certainly not dissociated from the Mauritian Creole community concern for commemoration of slavery.

NOTES

1. "Communalism" is the term systematically used in Mauritius to describe the affiliation and loyalty of Mauritian individuals to their supposed "community" first, and before considering the Mauritian nation. Although particularly manipulated during elections, observers, politicians and everyday people present this identity automatic reaction as the scourge of contemporary Mauritius.
2. Megan Vaughan, *Creating the Creole Island: Slavery in Eighteenth-Century Mauritius* (Durham, NC: Duke University Press, 2005), 255.
3. Richard Allen, "Licentious and Unbridled Proceedings: The Illegal Slave Trade to Mauritius and the Seychelles During the Early Nineteenth Century," *Journal of African History* 42 (2001): 91–117.
4. Marina Carter, *Servants, Sirdars and Settlers: Indians in Mauritius, 1834–1874* (Delhi: Oxford University Press, 1995), 19.
5. Carter, *Servants, Sirdars and Settlers*, 7.
6. See Carter, *Servants, Sirdars and Settlers*, 271, and Burton Benedict, *Indians in a Plural Society: A Report on Mauritius* (London: HM's Stationery Office, 1961), 27, 271.
7. See Richard Allen, *Slaves, Freedmen and Indentured Laborers in Colonial Mauritius* (Cambridge: Cambridge University Press, 1999), and Kissoonsingh Hazareesingh, *Histoire des Indiens à l'Île Maurice* (Paris: Adrien Maisonneuve, 1973), 198.
8. Jean Benoist, "De l'Inde à Maurice et de Maurice à l'Inde, ou la réincarnation d'une société," *Carbet* 9 (1989).
9. Jocelyn Chan Low, "Une perspective historique du processus de construction identitaire à l'île Maurice," in *Interethnicité et Interculturalité à l'île Maurice*, ed. Yu-Sion Live and Jean-François Hamon (Île de la Réunion: Kabaro, 2008), 13–26.
10. Catherine Boudet and Julie Peghini, "Les enjeux politiques de la mémoire du passé colonial à l'île Maurice," *Transcontinentales* 6 (2008): 13–36.
11. Kaya was found dead in Port Louis prison after having been arrested for smoking marijuana during a concert. The persistent rumor that he had been murdered, and the general context assimilating Mauritian police forces with the Indo-Mauritian community, rapidly led to the worst ethnic riots since independence.
12. Mathieu Claveyrolas, "L'ancrage de l'hindouisme dans le paysage mauricien: transfert et appropriation," *Autrepart* 4, no. 56 (2010): 17–37.
13. Suzanne Chazan and Isabelle Widmer, "Circulation migratoire et délocalisations industrielles à l'île Maurice," *Sociétés contemporaines*, no. 43 (2001): 85.
14. Boudet and Peghini, *Les enjeux politiques*, 28.
15. Vaughan, *Creating the Creole Island*, 11.

16. Rosabelle Boswell, *Le Malaise Créole: Ethnic Identity in Mauritius* (New York: Berghahn Books, 2006), 150.
17. Vaughan, *Creating the Creole Island*, 263.
18. Jocelyn Chan Low, "Les enjeux actuels des débats sur la mémoire et la réparation pour l'esclavage à l'île Maurice," *Cahiers d'études africaines* 44, no. 173–174 (2004): 401.
19. In 2008, during the commemoration ceremonies of the 174th anniversary of indenture system in Mauritius, the then prime minister, Anerood Jugnauth, announced the launching of this "Route of the Indian Indentured Laborer."
20. Nathacha Appanah, *Les Rochers de Poudre d'Or* (Paris: Folio, 2003).
21. Appanah, *Les Rochers de Poudre d'Or*, 30sq, 91, 222.
22. Appanah, *Les Rochers de Poudre d'Or*, 15, 81. However, leaving India was a socioritual taboo only for orthodox upper castes. Actually very few indentured laborers belonged to orthodox high castes.
23. See Catherine Servan-Schreiber, *Histoire d'une musique métisse à l'île Maurice: Chutney indien et séga Bollywood* (Paris: Riveneuve Éditions, 2010), and Carter, *Servants, Sirdars and Settlers*.
24. Abhimanyu Unnuth, *Sueurs de sang* (Paris: Stock, 1977).
25. See Benoist, *De l'Inde à Maurice*, and Hazareesingh, *Histoire des Indiens à l'île Maurice*.
26. Author's translation. Hazareesingh, *Histoire des Indiens à l'île Maurice*, 16.
27. Hazareesingh, *Histoire des Indiens à l'île Maurice*, 19sq.
28. Carter, *Servants, Sirdars and Settlers*, 6.
29. Boswell, *Le Malaise Créole*, 170.
30. As defined by Édouard Glissant in *Le discours antillais* (Paris: Seuil, 1981).
31. Anouck Carsignol, "La diaspora, instrument de la politique de puissance et de rayonnement de l'Inde à l'île Maurice et dans le monde," [online journal] no. 10 (2009): http://echogeo.revues.org/11329.
32. Suzanne Chazan and Pavitranand Ramhota, *L'hindouisme mauricien dans la mondialisation* (Paris: Karthala, 2009), 64.
33. Author's translation. *La Vie catholique*, December 29, 2006, http://www.laviecatholique.com.
34. Author's translation. *La Vie catholique*, December 29, 2006.
35. Creole is the main daily language spoken by Mauritians. Bhojpuri, though sharing numerous dimensions with the Creole, is mainly spoken by North-Indians. However, Creole is not recognized as a national official language or as an education medium, whereas "oriental languages" (Hindi, Telugu, Urdu, and Mandarin) claim more and more space as identity vehicles in educational and ritual contexts. See Patrick Eisenlohr, *Little India: Diaspora, Time, and Ethnolinguistic Belonging in Hindu Mauritius* (Berkeley, CA: University of California Press, 2006).
36. Marina Carter and Khal Torabully, *Coolitude: An Anthology of the Indian Labour Diaspora* (London: Anthem Press, 2002), 152. Negritude is a literary and ideological movement, mainly developed by the French Martiniquan writer Aimé Césaire, which pretends to link the Caribbean islands back to their African roots, whereas Creoleness considers the actual rupture with Africa a precondition for the invention of a new identity construction, which is based neither on Africa, nor on Europe.
37. "*Jahaji bhais*" is used to evoke the links first established by indentured laborers during the sea voyage, relations partly perpetuated after the settlement in Mauritius, through the intermarriage of children, for instance.
38. Author translation. *L'Express*, November 16, 2009, 1.
39. Author translation. *L'Express*, November 16, 2009, 1.

40. Author translation. *L'Express*, November 2, 2009, 13.
41. See Sandra Carmignani, "Une montagne en jeu: figures identitaires créoles et patrimoine à Maurice," *Journal des Anthropologues* 104 (2006): 265–286.
42. Chazan and Ramhota, *L'hindouisme mauricien*, 75sq.
43. *Le Mauricien*, February 2, 2010, 12.
44. *Le Mauricien*, November 9, 2009, 1.
45. Claveyrolas, *L'ancrage de l'hindouisme*.
46. Claveyrolas, *L'ancrage de l'hindouisme*.

4 Smoldering Memories and Burning Questions
The Politics of Remembering Sally Bassett and Slavery in Bermuda

Quito Swan

In 1730, Sally Bassett, a sixty-eight-year-old black woman enslaved in Bermuda, was burned to death for allegedly poisoning the masters of her enslaved granddaughter. In 2009, in commemoration of Bermuda's four-hundred-year anniversary, Bermuda's first black local Government—the Progressive Labor Party (PLP)—erected a ten-foot-tall sculpture of Bassett in front of the Government's Cabinet Office to memorialize the struggle of blacks against slavery. The monument Spirit of Freedom (Figure 4.1), depicts Bassett as levitating above flames with her hands chained behind her back and "pregnant with freedom."[1]

A racially charged public debate about issues surrounding the monument emerged through print and electronic media (such as newspapers, blogs, radio talk shows, and websites). Some whites decried the statue as "inappropriate" for a number of reasons, such as that Bassett was a convicted "criminal."[2] Several blacks rightly argued that she was a freedom fighter and needed to be recognized as a national hero. In addition, the British governor of Bermuda, Richard Gozney, compared the sculpture to monuments commemorating Confederate General Robert E. Lee and the 1838 Boer Blood River war against the Zulus. Black Bermudians denounced these comparisons between Bassett, who fought against slavery, and slaveholders, defenders of slavery, and colonizers of Africa.[3]

In analyzing this controversy, this chapter demonstrates that the process of publicly memorializing slavery in Bermuda is politically charged, particularly in a colonial society that has historically criminalized black protest but now features a black government committed to the promotion of Bermuda's "national" heritage. Representations of slavery are contested spaces of intellectual and cultural warfare, often reflecting contemporary issues of power, race, racism, and colonialism. This is critical in an era of cultural tourism—the Spirit of Freedom was the most popular site for Bermuda's 2010 Sixth Annual African Diaspora Heritage Trial (ADHT) Conference.[4]

Bassett's experience challenges a white mainstream master narrative that suggests that slavery in Bermuda was benign and devoid of black protest.

72 Quito Swan

Figure 4.1 Spirit of Freedom. Hamilton, Bermuda. Photograph by Quito Swan, 2009.

Thus, this chapter probes the intersections of race, memory, and slavery and asks: how have whites and blacks remembered (forgotten?) Bassett? It also provides a synopsis of black resistance to slavery in Bermuda. Finally, it suggests that Bassett's story has value for understanding transatlantic resistance, gender, and slavery across the diaspora.

BLACK WOMAN AND GRANDCHILD

On June 5, 1730, Sarah (Sally) Bassett was convicted of attempting to kill by poison Thomas and Sarah Foster and their enslaved domestic woman, Nancy. It was claimed that Bassett gave her granddaughter Beck—who was also enslaved by the Fosters—two rags with poison comprised of ratsbane, manchineel root and white toade, along with specific instructions on how to apply them—one as a powdered inhalant, the other to be placed in food. The court found that Bassett did not have "the fear of God before her eyes" but was "moved and seduced by the instigation of the Devil."[5] The chief justice declared:

> It is the Judgment and Sentence of this Court that you Sarah Bassett be return'd to the prison from whence you came and from thence you are to be convey'd to the place of Execution where a pile of wood is to be made & provided, and you are thereto be fasten'd to a sufficient Stake and there to be burnt with fire until Your body be Dead. And the Lord have mercy on your soul.[6]

Bassett, who informed the court "she never deserved it," was "valued" at one pound, four shillings and six pence.[7] According to black oral tradition, Bassett was executed at the foot of Crow Lane, a highly visible intersection at the entrance of Bermuda's capitol, Hamilton City.

Clarence Maxwell contextualizes Bassett's burning within poisoning plots that occurred in Bermuda around 1727–1730. To Packwood, these successful acts of resistance represented the destruction or serious injury of many whites. Maxwell argues that these plots were based on West African/Saint-Domingue medical techniques and that Bassett was perhaps an *okomfo*—a traditional spiritual worker of Akan descent. In 1712, she had been charged for her involvement in the destruction of a white proprietor's cattle, and received "three lashes well laid on her naked back at the end of every thirty paces" as she was driven through Southampton parish. A close associate of Bassett, Indian Tom, was considered to be a notorious thief who took up arms with French privateers and was also charged. Maxwell questions if Tom had connections to Saint-Domingue, and if he was the source of Bassett's poisonous "white toade," which was found in Africa, northern South America, and Saint-Domingue (among Vodou practitioners), but did not appear in Bermuda until the nineteenth century.[8]

Led by Maxwell's implications of Bassett's connections to a transatlantic network of underground resistance, James Pope wonders if knowledge of Bassett's poisoning techniques (and execution) spread across the diaspora through black sailors. He raises the possibility that the white toade was brought to Bermuda by "a mariner who believed he was arming a spiritual practitioner against her enemies."[9]

If one was to believe Bermuda's master narrative of benign slavery devoid of black protest, Bassett's burning should never have occurred. Her

experience—just as Mary Prince's experience—is the proverbial "elephant in the room"; it simultaneously demonstrates the terror of slavery and black resistance to it. The telling, imagining, and memorializing of Bassett's story helps to dismantle the myth of benignness that assuages white guilt about slavery, legitimizes white power, delegitimizes black protest, and warps Bermuda's mainstream understanding of slavery.

It is quite significant that the most visible symbol of black resistance to slavery in Bermuda is a black woman. Her story sets fire to the host of negative stereotypes about enslaved diasporic black women. Far from being Jezebel, Mammy, Sapphire, or the "tragic mulatto," Bassett is Bermuda's Nanny, Harriet Tubman, and symbolic maroon, which explains her invisibility and criminalization by the state.

CHAINED ON THE ROCK

Bermuda is Britain's oldest existing colony. This relatively flat archipelago, lying 570 miles east of the US Carolinas, spans merely twenty-one-and-a-half square miles. The island takes its name from a Spanish slave trader, Juan de Bermudez, a voyage mate of Christopher Columbus. In 1505, Bermudez spotted the island during a transatlantic expedition in which he carried sixteen enslaved Africans from the Guinea coast to Hispaniola.[10]

Bermuda's socioeconomic foundation was based heavily upon African enslavement. Bermuda's white British elite carved its niche in the Atlantic slave trade as privateers, merchant slave traders, and shipbuilders. The island became a significant node for the smuggling and transshipment of enslaved Africans across the Atlantic.

The first known black person on the island was Venturilla, a *ladino* who came with the Spanish in 1603. In 1609, the English arrived when a Virginia Company party shipwrecked off of its shores.[11] Bermuda's enslaved population increased significantly by privateering. In 1616, a British ship called the *Edwin* brought black and Indian pearl divers from the coast of Venezuela. In 1617, Captain John Powell brought a "good store of Negroes" to Bermuda, likely captured from a Portuguese ship.[12] In 1619, the notorious privateer/slave trader Captain Daniel Elfrith captured a Portuguese ship, the *São João Bautista*, which contained about two hundred enslaved West Central Africans. At least twenty-nine of them were carried to Bermuda on his ship, the *Treasurer*. Elfrith gave fourteen of them to Bermuda's Governor as gifts for being hospitable to his acts of privateering. Ships also arrived directly from Africa; in 1748, the *Elizabeth* entered the island with ninety enslaved Africans. In 1672 a ship from Bermuda went directly to Calabar (Bight of Biafra); upon its return half of its one hundred twenty-five captured Africans were sold in Bermuda and the rest in North Carolina and Virginia.[13]

Enslaved blacks cultivated primarily tobacco and toiled in activities such as domestic labor, agriculture, shipbuilding, deep-sea fishing,

privateering, smuggling, piracy, salt raking, stonecutting, masonry, and carpentry. By 1700 Bermuda's economy was structured around maritime industries. Through Bermuda's abundance of cedar wood, the island developed the dubious reputation of producing the enslaving vessel *par excellence*—the Bermuda sloop. This ship was known for its ability to speedily navigate the Atlantic and was a premiere choice for slave traders, privateers, and pirates alike.[14]

Bermuda possessed a white majority population until the late eighteenth century. In 1727, out of a total of 8,947 persons, there were 5,070 whites and 3,877 blacks recorded.[15] Michael Jarvis calculates that between 1670–1774 at least 86 percent of white households owned slaves. Amidst concerns that an increasing black population posed a security threat, whites took careful measures to control Bermuda's black population; in 1675 Governor John Hayden banned the importation of new enslaved Africans to Bermuda.[16] A 1730 *Act for Extirpating all Free Negroes, Indians, Mulattoes* required free blacks to leave Bermuda within six months of being freed or be sold into slavery.[17]

Bermuda still maintains a large white minority population; out of approximately 67,837 persons, the island hosts about 37,174 blacks (54.8 percent), 23,064 whites (34.1 percent), 4,341 mixed persons (6.4 percent), and 2,916 (4.3 percent) persons of other races. Race was defined along similar patterns as in the United States, where the "one-drop rule" led to a sharp distinction between those defined as black and those defined as white.[18]

Maxwell argues that by 1669, slavery in Bermuda had been fully codified. He highlights the 1623 *Act to Restrayne the Insolences of Negroes*, which severely restricted the freedoms of blacks. Laws forbid interracial marriage and specified punishments for white women and black males who had children together (39 lashes on the naked back).[19]

SNAKE GWAAN EAT WHATEVA IN THE BELLY OF THE FROG

Blacks in Bermuda resisted slavery in a myriad of overt and covert ways, including revolts, absconding, harboring runaways, infanticide, cultural retentions (Gombeys), appropriation or smuggling of goods, insolence, poisoning, sabotage, and maroonage. This is evidenced through several laws. For example, any black who was "insulting in speech" or "insolent" could be lashed. In 1755 the penalty for the striking of a white person by an enslaved black was increased from a whipping to having one's ears cut off; blacks apparently did not fear the whippings as whites were being struck at an increased frequency. A 1674 proclamation gave whites the legal recall to apprehend and whip any black found without a ticket from their master. Second-time offenders were to be whipped and have a piece of his or her ear cut off; third time offenders were to be branded with an

76 *Quito Swan*

"R" (rogue) on their foreheads. Blacks, free or enslaved, were also not to engage in any trade or form of commerce. Furthermore, if more than three blacks were found talking and meeting they were to be apprehended and whipped severely.[20]

In 1656, over a dozen blacks devised a plan of "cutting off and destroieng the English in the night"[21] and taking over the island. The plot was discovered, and two of the leaders, Black Tom and Cabilecto, were hung and executed by gibbet on Gallows Island, in St. George's harbor in the east, and Cobbler's Island, centrally located off of Spanish Point (see map on Figure 4.2). Another leader, a free black named William Force, was to be executed in Heron Bay (Warwick/Southampton, located in the east) but was deported to Eleutheria with other free blacks.

In 1661 a group of enslaved blacks and Irish indentured servants sought to "cut the throats of all Englishmen."[22] In 1673 over fifteen blacks planned to kill their masters. They intended to assemble at the foot of Crow Lane, and ride on horseback across the island calling for others to revolt. After

Figure 4.2 Map of Bermuda, Library of Congress General Map Collection. Text by Quito Swan.

the plot was discovered, the letter "R" was burned into the foreheads of the leaders, their noses were slit, and they were whipped before being executed at Crow Lane. Other conspirators were whipped and branded with the "R" but left alive.[23]

In 1682, a man named Tom (from Jamaica) and four companions planned to kill their masters and "shoot their way to Spanish Point," [24] where they had hidden a boat to escape the island. Once again, the men were to first meet at Crow Lane. In 1795, it was also feared that a slave revolt was being instigated by Haitian mulattoes who had been brought to Bermuda in the aftermath of the Haitian Revolution.[25]

In 1761, six enslaved persons—Natt, Juan, Peter, Ben, Mingo, and Nancy—were executed for their suspected involvement in a conspiracy supposedly involving over half of Bermuda's enslaved population. The alleged plan was for all blacks to kill their white owners—including women and children—while they slept. Whites and black sympathetic to whites were to also be poisoned, and blacks would take over the entire island.[26]

One of the most consistent overt acts of resistance was absconding. In 1640, one male, his wife, and another enslaved person, Gubungo, were captured trying to escape by boat.[27] In 1641, three enslaved boys escaped by boat to Long Island, New York. Jarvis notes how Josiah Saunders, during the Seven Years' War, escaped back to Bermuda from St. Eustatius to be with his lover. He then found that her masters had migrated to South Carolina and took her with them. Saunders continued to South Carolina, traced the family's whereabouts to Georgia, and found her. They then both escaped.[28]

The newspaper *Bermuda Gazette and Weekly Advertiser* is replete with advertisements and rewards for the capture of runaways. Readers were typically warned (including masters of vessels) not to harbor runaways or to assist them in escaping the island. For example, on March 3, 1810, a "handsome reward" was offered for a twenty-year-old "yellow" enslaved man named Joe who was trying to escape the island. Advertisements repeatedly asserted that the runaways were probably being harbored in St. David's, Spanish Point, Flatt's, and Crow Lane. For example, both Zackse, a mulatto from Crow Lane, and Jenny, a "short Black fellow," had escaped in the spring of 1784 and were last seen in St. David's parish.[29]

Bermuda's small size made it difficult for runaways to remain hidden, but some were able to do so. A reward of one guinea was offered for the capture of one Caesar, who had been on the run for over three weeks, and was believed to be hiding in Flatt's village, where he kept a wife. In 1810, Stephen Bean, of "yellowish complexion" was wanted for four dollars, and Ben Jones, tall, thin and "well known" was wanted for thirty dollars.[30]

Enslaved women also absconded. A January 17, 1784, advertisement called for the capture of a "Negro Wench," Hagar, who was "slender, mildly tall" and "yellowish" in complexion, possessing a "lantern jaw," and missing most of her front teeth. On January 24, 1784, a forty-shilling

reward was posted for a twenty-two-year-old black woman, Patience, who was described as being "very Black and Lustly." Believed to have been hiding in Spanish Point, she apparently had a "remarkable" "old seal" on her left arm and a very artful look and was an expert thief.[31] On July 23, 1784, a mulatto woman named Dinah had absconded. On October 16, 1784, a three-dollar reward was offered for Jane, a "Negro" woman of "yellowish complexion" who had been escaped for over one month. And Joan from Heron Bay absconded in early 1785. On May 5, 1810, a four-dollar reward was offered for a "very black" thirty-year-old "Negro wench" named Hannah from Somerset.[32]

Children also fled, such as Ned, from St. George's (two-dollar reward). On March 31, 1810, a six-dollar reward was offered for the capture of an Anthony and a five-dollar reward for a Joe Pearman (described as a handsome black with a small black eye), who called himself Sam, and claimed that he was free.[33]

Packwood highlights a case from July 1834 (on the cusp of abolition) in which a runaway, Jeffrey, was discovered after having hidden in a cave (now known as Jeffrey's Cave) for over a month. Along with an enslaved female, Syke—who had been bringing him food—he was sentenced to three days hard labor on the treadmill and seven days of solitary confinement.[34]

As such, Bassett's strike emerged out of a very normalized tradition of black resistance against slavery. Black maritime and small-scale land marronage poses several interesting questions. Was Crow Lane an exit hub for those blacks who sought to flee the "rock?" Frequented by black runaways, a number of planned revolts were to begin there. Apparently a high-traffic area and site for smuggling,[35] was this also an area where blacks congregated, and is this why blacks—such as Bassett—were often executed there?

In addition, Bermuda's multitude of underground and coastal cave complexes provided temporary refuge for blacks until they could flee the island. But where did these maroons escape to and on whose vessels? The likelihood that they were assisted by black sailors operating within a transatlantic network of maritime trade, smuggling, and privateering, warrants further investigation.

DISPELLING THE MYTH OF A BENIGN INSTITUTION

White elitist mainstream productions of Bermuda history have historically legitimized colonialism and white power, downplayed racism, trivialized slavery, and rendered invisible or criminalized black protest. Such perspectives have historically dominated the discourse on slavery. Take for example an excerpt from the account of British traveler Suzette Lloyd's 1828 visit to Bermuda:

> [...] in these islands slavery wears the mildest aspect of which that pitiful condition is susceptible. The character of the Bermudians is

kind and humane ... To the enslaved Negro all the wants of nature are amply supplied. He is, under every contingency, clothed, feed, and attended in sickness, at his master's cost. The ancient laws of slavery ... are never enforced against him, and instances of domestic or private cruelty are ... almost unknown. Indeed in many houses the young Negro grows up with his master's children, and is considered one of the family.[36]

The fallaciousness of Lloyd's account is trounced by the numerous accounts of legal and physical brutality enacted against blacks enslaved in Bermuda. Despite its falsehood, her memoir appears to have been a cornerstone conceptual foundation in which the literary architects of Bermuda's master narrative of benign slavery could uncritically expound upon.

Such a perspective would allow Walter Hayward, a prominent historian of Bermuda, in 1911, to comfortably claim that slavery in Bermuda "was unattended by the same variety of demoralizing evils which cropped out in large slave-owning communities" and that seafaring gave "colored" more freedom as opposed to if they had been held to land. He erroneously suggested that, despite segregation, this was even evidenced by a contemporary absence of a "race problem."[37]

Similarly, James Smith, a lay writer, expressed the opinion that Bermuda's enslaved "were treated more humanely" than blacks enslaved in other British colonies. Slavery in Bermuda "encouraged a degree of intimacy and personal contact between master and slave." Furthermore, Bermuda was a "closely knit society" in which the "moderating influence" of "women and children ... facilitated ... a milder form of slavery."[38]

Unfortunately, the idea of benign slavery in Bermuda remains alive in some quarters. In 1994 a United Bermuda Party (UBP) government-sponsored tourist brochure boasted that Bermuda had a "relatively benign system of slavery." Many blacks, including journalist Ira Philip, challenged this: "Some of the most brutal measures were undertaken by the slave masters ... slavery [in Bermuda] was as cruel and as degrading as anywhere in the world."[39] Former black activist Florence Maxwell stated, "Slavery nowhere was benign. Here it was equally as brutal and as cruel."[40] White respondents felt the opposite. Historian William Zuill dubiously commented that in Bermuda blacks were "treated as people" and not as "chattels." He felt that Lloyd correctly stated that slavery in the island "wore its mildest face." Artist Andrew Trimingham, a member of one of Bermuda's white elite slave-holding families, claimed that local blacks enslaved as domestics and agriculturalists "must have been quite remarkably well treated because they were crews for our ships" and were very fortunate compared to other enslaved Caribbean blacks. He further claimed that "nasty slavery was associated with plantations," which Bermuda did not have.[41]

The brochure was withdrawn due to black protest, but such problematic views have persisted in recent historiography of slavery in Bermuda.

Scholars Virginia Bernhard and Michael Jarvis questionably assert that close physical proximity between whites and blacks created an unprecedented intimacy that led masters to treat enslaved persons like family members.[42] Such scholars have taken real or imagined examples of perceived white benevolence to blacks (or black deference to slavery) and projected these exceptions as the norm, totally neglecting the power dynamics and violence that defined slavery as a "pathologically wrong socio-economic system."[43] Whites were clearly in positions of power, and enslaved blacks could not simply leave such dysfunctional "families." Moreover, masters could sell and resell enslaved persons to pay off debts, on conditions stipulated by wills, or even on a whim. For example, on June 12, 1784, Beck, a thirty-six-year-old "stout wench," who was excellent at a number of tasks was being sold for no other reason than she was "at times impudent to her owners."[44]

White scholars have typically circumvented Mary Prince's iconic account, *The History of Mary Prince: A West Indian Slave* (1831). Prince was born into slavery in Bermuda. In 1828 (the same year of Lloyd's visit to Bermuda) while in London with her owners, she escaped and detailed her story to abolitionists. Prince's account was widely publicized and reproduced as an antislavery narrative—white writers must have noticed it; in all likelihood, they ignored (erased?) it because of its unsettling content.

Prince's painful life of violence, physical, and sexual abuse dispels the assertion that whites treated enslaved blacks as family members. Prince was constantly beaten for the smallest of offenses. Her "savage mistress" caused her "to know the difference between the smart of the rope, the cart-whip, and the cow-skin, when applied to [her] naked body" and face.[45]

Prince details a beating of over one hundred lashes that she received from her master. While his son counted blows, his wife brought him drinks. She also spoke of the brutal beating of Hetty, a pregnant enslaved woman, who accidently allowed a cow to escape. After having her stripped naked and tied to a tree, her master "flogged her as hard as he could lick, both with the whip and cow-skin, till she was all over streaming with blood. He rested, and then beat her again and again. Her shrieks were horrible." The beating caused Hetty, who died, to give birth to a stillborn child.[46]

What about enslaved women? As enslaved sailors were primarily males, their supposed "freedom" cannot be simply applied to land-based enslaved women, possibly the wives and daughters of those at sea. A gendered account of slavery would recognize the psychological and physical dangers of torture and sexual abuse that awaited black female domestics forced to be in close proximity to white males and the jealous rages of their mistresses. And how do writers account for generations of sexual abuse? Bassett herself was a mulatto—had her mother been raped by a white male? And what must it have been like to have to watch her enslaved granddaughter go through adolescence amidst the dangers of sexual abuse?

Sandra Campbell asserts that "mid-twentieth-century writers [read, white writers] tried to sidestep the horror of Sally Bassett's story by suppressing it to make the history of the colony seem rosier." For example, Tucker's reprinted *Bermuda's Story* makes no mention of Bassett's murder.[47] She is noticeably absent in Jarvis's 684-page *Eye of All Trade*.

By the same token, black writers and scholars have been historically marginalized by mainstream academia and often functioned as "intellectual maroons." In the 1970s, two critical black-authored works about slavery were published: *Chained on the Rock* by Cyril Packwood and *Mind the Onion Seed: Black "Roots" Bermuda* by Nellie Musson. Whereas *Mind the Onion Seed* focused specifically on black women, Packwood's statement "a benevolent slave system would never have resulted in the numerous slave escapes and conspiracies, which occurred," marked his perspective.[48] Both books are indispensible for understanding how blacks in Bermuda experienced, resisted, and remembered slavery.

BURNING MEMORIES OF BASSETT

Sojourns across the site of Bassett's burning and visits to the monument and other sites of terror across the island leave us no doubt: whereas enslaved Africans may have experienced harshness in various degrees, they collectively were tortured, faced terror, lived lives of instability, and experienced inconceivable physical and psychological trauma. How else can historians describe an elderly black woman burned while alive until dead? How tall and wide was the fire? How many yards by how many yards? How many blocks of wood were applied? How long does it take for a body to burn? Can we somehow reconstruct her screams (or was she silent?) or the smell of her burning flesh? Can we envision the smoke spiraling into Bermuda's clear blue skies? If the day was as hot as it has been told, then what did that feel like? How were those who stood in attendance dressed? What were the looks on their faces? If this was a lynching—what would photographs tell us? Were the whites in attendance wearing their "Sunday best?" Did anyone cry? Did anyone shout? Was there silence? Were there children present? Were they black, white, enslaved, or all of the above? What was the reason given to black children when they asked "why did they burn old Sally Bassett?" Finally, one of the most burning questions remains: What did they do with her ashes?

Whites have remembered the burning of Sally Bassett through a brass "Sally Bassett" dinner bell, essentially consisting of an old black woman whose skirt formed the body of the bell, which became a popular twentieth-century souvenir among white tourists. The Little Green Door tearoom, frequented by the likes of Mark Twain, used the tabletop bell to "call guests to dine or summon the maid"—who would have likely been black. According to Campbell, this attempt to turn Bassett into a "quaint

object" aimed to deny her "enslavement, hatred and revenge."[49] There is something eerily disturbing about this phenomenon: how does a black woman, defined as a witch and burned alive for poisoning whites, end up as a dinner bell souvenir?

For blacks who have remembered, Bassett is seen as a freedom fighter. Oral tradition asserts that she told the crowds that the "fun would not start until she arrived" at the scene of the burning, and that Bermuda's national flower, the purple *Bermudiana*, emerged out of her ashes. The day is remembered as being exceptionally hot, so much so that older black generations continue to refer to a tremendously hot day as a "Sally Bassett day."[50]

In an effort to quell black resistance, slave societies gave "oppressive meaning" to physical spaces and use these constructed representations as mechanisms of social control to cause blacks to "associate specific sites with particularly violent or oppressive experiences."[51] Such spaces included auction blocks, sites of punishments, and whipping posts.

White Bermudians wholeheartedly embraced these tactics. For example, in August 22, 1664, one "Black Peter" was hung on Cobbler's Island, for stealing a boat. The governor ordered that his head be "fixed upon a spicke upon the top of the island to the terror of all slaves that shall hereafter attempt the like act and offense." On the same day, "Black Matthew" was also executed, essentially for breaking into a home and frightening a white woman. His head was placed on a pole at a Stock's Point, far to the east of Cobbler's Island. In another case, John, an enslaved Indian, attempted to kill his masters by setting their house on fire and shooting into the home. He was executed, his head cut off and quartered and "put upon poles at such remarkable places that the sheriff" thought fit.[52] Whites chose these execution sites—Cobbler's Island (Spanish Point), Stock's Point (St. George's/St. David's), Gibbets Island (Flatt's Village), and Gallows Island (St. George's)—because they were visible places frequented by vessels and other passers by (see map, Figure 4.2).

Many of these spaces of terror in Bermuda have—at best—been relabeled as opposed to transformed (the blood still stains the crime scenes) as sites for tourism and—at worst—been completely forgotten in popular imagination. As such, auction blocks (as in Salt Kettle and Flatt's Village) adjacent to docks can now become parking lots—even for aquariums. The water leading to Gibbets Island is shallow enough to be walked across, short enough for one to forget that the heads of Africans once hung there on poles, as was Quashie, for killing his owner in 1753.[53] A statue of George Somers stands on the memories of those executed on Ordnance (once Gallows) Island. Next to whipping posts in St. George's square, black and white tourists, schoolchildren, well-meaning yet historically oblivious teachers and summer day camp guides place their heads and arms through stockades and smile for photographs. Black town criers in black face presenting fiction as history can reenact docking stool scenes (Figure 4.3). But

Figure 4.3 Children in stockades. St. George's Square, Bermuda. Photograph by Quito Swan, 2009.

who would have the gall to play Sally Bassett? Perhaps no one, because this would mean to not be afraid of being burned to death for unabashedly resisting white supremacy. That would mean playing the role that could not be played, for who wants to be burned?

This question brings us back to the foot of Crow Lane, the remembered site of Bassett's execution.[54] This relabeled site of terror and resistance has been repackaged and commodified for tourist consumption. Crow Lane is now best known to be the site of Johnny Barnes, an elderly black man who has, for decades at the crack of dawn, greeted travelers entering Hamilton with smiles, kisses, and waves, exclaiming, "I love you!" A massive statue of Barnes, The Spirit of Bermuda, stands here.[55]

Speaking of which, Bassett's statue titled Spirit of Freedom seems to be Bermuda's first public monument to honor an enslaved person. This is unsurprising, because black protest was absolutely criminalized under the white elite UBP government, until they were unseated by the PLP for the first time in 1998. Formed in 1963, the PLP aimed to represent Bermuda's majority black working class; its tenure through two more elections has been highly racially charged.

The Bassett monument was constructed as part of the PLP's attempts to nationalize Bermuda's history through programs such as the African Diaspora Heritage Trail and National Heroes Day. The party initially attempted to place it on the grounds of Hamilton's City Hall. Sutherland

Madeiros, mayor of the Corporation of Hamilton, denied this request, claiming that the Hall's gardens were full. Historically speaking, the corporation has been a bastion of Bermuda's white oligarchy. According to the *Bermuda Sun*, the issue became a "race row," as several PLP members believed that the mayor snubbed the government and did not want a "prominent reminder of slavery greeting visitors to City Hall." According to former PLP member of Parliament Walton Brown, Bassett was symbolically important, and he found it "surprising and sad" that Madeiros chose not to have her statue at City Hall.[56]

In an online response to the *Bermuda Sun* article, community activist Nana Peggy Burns suggested that City Hall make space for the monument of her "sister and heroine" by removing other statues—such as those of playing white children—that did not reflect Bermuda's black majority population. Burns suggested that a fountain pool sculpture of a white child playing with a bucket could be placed beneath Bassett's statue to give the impression that he was attempting to "out de fiya." This "would be a symbolic show of remorse (taking upon himself the sins of his ancestors) for the unspeakable act of violence inflicted by them on an innocent Black African enslaved woman." Burns also felt that the Spirit of Freedom could be a "teaching aid to combat historical illiteracy" in those who had "amnesia" of Bermuda's "herstory."[57]

In a blog post titled "Bassett or Barnes," the *Bermy Onion Patch*, a black satirical political Bermudian blog, stated the following:

> [...] they are also talking about putting up a monument to Bassett. Good idea—and since she was burned alive round down Crow Lane, why not put it right where the one for Johnny Barnes is. Ya, right there. Put the one for Barnes up Government House, or on one of Bermuda's golf courses, right on top of the Anglican Church, maybe Botanical Gardens, or on top of a hotel. Cause it ain't for us (us meaning Black Bermudians) is it? Or maybe it is—the *image* of Barnes is what Blacks in Bermuda are socialized to be—happy-go-lucky, a-huh a-huh, massa massa, everything's all right massa, we sick boss, I love the queen, let me shine your shoes Mr. Charlie, ain't nobody in here but us chickens kind of negroes.[58]

The Patch appears to be saying that Barnes, a blatant representation of a colonized native who happily welcomes tourists to Bermuda, is the antithesis to Bassett. According to Dale Butler, then Minister of Culture and Social Rehabilitation, Crow Lane was considered as a site for the statue, but "there was no room," and "there would have been uproar if the [...] Barnes monument was removed."[59]

The PLP's eventual decision to place the monument on the grounds of the Cabinet House was also met with controversy. Khalid Wasi (a member of the former All Bermuda Congress) argued that as Bassett was "from"

Southampton, the statue should have been placed there. He then staged a one-man protest at the Cabinet Office. He placed a rope around Bassett's statue and symbolically tugged it with an oar in the direction of Southampton where he believed it should be taken by boat. Wasi felt that the boat trip would be a ceremony of togetherness, one of atonement for whites and celebration for blacks, stating: "I want everyone to hold the rope and never let go. I want to take Sally Bassett out of conflict and into a place where we can all celebrate." Whereas the monument's placement "had become politically divisive," he believed that it should have been a symbol of the races coming together.[60]

The monument's placement stimulated further debate over where Bassett's execution occurred. Other suggestions included Hamilton's Albouy's Point (a major dock), Gallows Island, and Cobbler's Island.[61] Premier Ewart Brown defended the central location of the monument as necessary for the nation's healing process (in terms of dealing with slavery's legacy). He felt that it might be "easier to understand Sally Bassett if you understand why the Jewish people won't stop talking about the Holocaust . . . If you go all across America and Europe you will find monuments dedicated to the Holocaust."[62] Brown believed that the monument would help Bermuda to confront its own history.

At a "soft unveiling" of the sculpture, Brown further stated that the monument was breathtaking, and he expected it to be "a superb teaching vehicle for school children" and for any "visitors to the Cabinet Office grounds."[63] Bermuda's Minister of Education, Dame Jennifer Smith MP (who led the PLP to its 1998 victory) offered the following: "Sally Bassett is important in giving a full and unbiased view of Bermuda's history for all generations to know and understand . . . It has often been said that slavery in Bermuda was 'benign.' The Sally Bassett story puts aside this myth; slavery by its nature cannot be benign."[64] For Dame Smith, the Spirit of Freedom helped to dismantle Bermuda's biased master narrative.

ONE POUND, FOUR SHILLINGS, AND SIX PENCE FOR YOUR THOUGHTS

When Bermudian black artist Carlos Dowling was commissioned to construct the monument, he "rested, meditated and researched" Bassett's story. He then isolated himself for twenty-eight weeks to complete the project, which he aimed to be "inspiring and acceptable to everyone." He sought to show Bassett as "freeing herself from the experience between life and death" and as being "pregnant with freedom."[65]

Responses to the Spirit of Freedom via electronic media were polarized along racial lines. Tim Vesey, a white columnist for the *Bermuda Sun*, stated that the monument was "as depressing and abject as it is possible to imagine: A pregnant slave, tied to a stake, bound at the feet and burned alive."

He was left "with a feeling of abject depression," as Bassett's "pregnancy" amplified the horror of her burning. Slavery was both tragic and triumphant; "Enslaved people overcame adversity," and he had imagined that the monument would have been proud, uplifting, "exciting and inspiring."[66]

This piece perhaps reflects the crux of the matter. Mainstream discussions about racism have been historically centered on comforting white guilt about slavery and racism. Whites have been socialized to have a "master complex," which often equates to a false sense of entitlement even among matters primarily pertaining to black people. Thus, it is unsurprising that Vesey could speak as if the statue was created with his comfort in mind and to have the audacity to publicly decry it when it did not meet his expectations.

Colwyn Burchall, author of *Freedom's Flames: Slavery in Bermuda and the True Story of Sally Bassett*,[67] responded to Vesey:

> The statue was not created with the easing of your guilt in mind. Just as the tours of [Auschwitz]—the ... killing ground where countless European Jews ... met a horrific end—were not initiated to ease the psychological distress of those whose ancestors participated in the genocide. [...] this monument represents the indomitability of spirit that brought millions of Afrikans ... to the so-called 'new world' ... far from being 'depressing and abject', Bassett's example stands as a glorious testament to the simple truth that we ... will one day claim victory in this savage world, and if that causes you discomfort, well ... [68]

Burchall poignantly asserted that the monument was not constructed to ease white guilt. For him, it was a tribute to enslaved Africans throughout the wider diaspora. Indeed, for many blacks the monument symbolized redemption for the historic denial of black history; hence, many blacks were not concerned at all by how whites felt.

One commentator to what appears to be a local white Internet forum titled *Bermuda Sucks: An Expatriate Worker's View of Life*, reacted to the monument by expressing the following:

> The Sally Bassett statue must be about the most blatant form of white demonization in the nation ... Showing a black person breaking free of their chains would have got the point across just as well ... But the part that bothers me most is that Ms. Bassett was portrayed as being pregnant with the birth of hope. And white people killed her and her baby. Good lord ... how do you explain that to your kids? White people must surely have been demons to have burnt a pregnant woman at the stake ... It's not fact ... And so when we have to explain that to our kids they will now wonder if black people are just making up tales. Being dishonest. Lying in fact ... I sincerely hope the plaque next to the ... statue "explains" the facts and the "folk-lore" so that visitors

understand the magnitude of slavery but are not left feeling they are the sons and daughters of demons.[69]

This commenter seems more concerned about preventing whites from feeling guilty or being demonized about slavery than the "truth" about Bassett and the monument's denouncement of slavery. In fact, Bassett is insignificant, as any arbitrary "black person breaking chains" would have sufficed.

Charles Zuill, a white artist, had been told that Dowling was embellishing history by depicting Bassett as being pregnant and in flames. In a curious article, he stated that her abdomen was "slightly protruded," but that this could have just been "the effect of aging stomach muscles." He also added that the monument lacked "normal anatomical proportions" and that Bassett's legs seemed "too long for her upper body" and her feet and hands "too small and dainty for someone who had spent a lifetime laboring, doing who knows what."[70] Zuill's reaction well illustrates how white elites historically denied their responsibility in the evils of slavery. By focusing on the monument's anatomical "proportions" the artist refused to admit that the monument was not about classic beauty, but an artwork embodying resistance to slavery.

One commentator named "Pamela" felt that the monument was an "ugly and disgusting ... eye-sore on front-street" and should have been placed where people would not be "forced to look at it." She even believed that it would "discourage tourism" and asked that it be removed and used as a mooring weight.[71] Pamela's comments are revealing. Blacks have historically been told by white society to put aside their interests or grievances so as to not upset the white tourist industry. Ironically, the monument was a popular African Diaspora Heritage Trail site for black visitors to the island. Was it the monument's reminder of slavery in and of itself that Pamela found to be "ugly?" For it is exactly this kind of perspective—that representations of slavery should remain hidden in the recesses of Bermuda's collective memory in places where they can not remind society of the ugliness of slavery—which deemed necessary the central visibility of the monument.

During the official unveiling, British governor Richard Gozney compared the Spirit of Freedom to monuments of Confederate General Robert E. Lee, South Africa's Blood River Monument, and one of Oliver Cromwell. For Gozney, Lee became a US hero "because of his strengths of character," and "the battle of Blood River was "an iconic event for the Boers of the apartheid regime in South Africa."[72] This was a very disconcerting statement, as the governor is the most visible icon of British colonialism in Bermuda.

Rolfe Commissiong, PLP advisor on race relations, found the comparisons to be "insensitive and racially invidious:"

> To equate the military career of Robert E. Lee, the confederate general whose aim was to ensure that the then confederacy of the southern US states could maintain the institution of slavery within that region, and

the life of Sally Bassett who was a slave and the victim of racial repression was bizarre. The same would apply to the invocation of the Boer War monument that he referenced.[73]

Tim Vesey, the afore-referenced contributor to the *Bermuda Sun*, also felt that the governor needed to apologize, as to equate "a statue honoring those who suffered under white domination" with "statues honoring those who fought for white rule over blacks" was "bound to be offensive to a lot of people."[74]

CONCLUSION: MAKING SENSE OF RESIDUES OF POISON

The controversy surrounding the Spirit of Freedom tells us just as much about contemporary race relations in Bermuda as it does about Bassett's story. Although this analysis would be certainly strengthened by interviews (perhaps with tourists and Bermudian youth), most responses for the monument were very polarized along racial lines. Whites remembered Bassett as a criminal who deserved to be burned. Blacks remembered her as a martyred freedom fighter and inspiration for black political struggle. Blacks were generally in agreement as to the significance of the monument but may have differed in their opinions as to where it should have been placed. Whites, on the other hand, were generally negative about the monument, perhaps because by deconstructing the master narrative it also delegitimizes contemporary white power. Dowling's depiction of Bassett as pregnant with freedom seemed to bother whites just as much as it inspired blacks.

It is often asserted that societies need to move away from slavery. However, Bassett's experience is a reminder that Bermuda needs to move toward it, because the society at large still envisions slavery from the master narrative perspective. As former premier Brown explains: "The story of Sally Bassett will live for at least as long as this monument stands. All of us must forge ahead in our effort to make history, to shatter glass ceilings, to confront historic wrongs."[75] The debate surrounding the Spirit of Freedom should encourage further investigations that question the myth of Bermuda's benign slavery from the perspectives of enslaved Africans who suffered from and resisted the institution.

The Bassett monument will continue to remind us of her burning memory as long as the legacies of slavery, oppression, and colonialism remain. In doing so, it will continue to generate unavoidable and uncomfortable discussions about an unforgettable history, an absolute freedom fighter, and her legacy of uncompromising resistance.

NOTES

1. *Bermuda Sun*, July 13, 2007; Carlos W. Dowling, "Statement," http://CarlosDowling.com/Sculpture/Statement.asp.

Smoldering Memories and Burning Questions 89

2. Including news columnists, bloggers ,and anonymous respondents to mainstream media.
3. *The Royal Gazette*, February 11, 2009.
4. Kitty Pope, "The Sally Bassett Statue: The Controversial Legacy Continues," African Diaspora Tourism, http://www.africandiasporatourism.com/index.php?option=com_content&view=article&id=425:the-sally-bassett-statue-the-controversial-legacy-continues&catid=72:features.
5. Bermuda, Bermuda Archives, *Book of Assizes,* AZ 102-6, 1730, 221-222.
6. Bermuda, Bermuda Archives, *Book of Assizes,* AZ 102-6, 1730, 221-222; Clarence Maxwell, "'The Horrid Villainy': Sarah Bassett and the Poisoning Conspiracies in Bermuda, 1727-1730," *Bermuda Journal of Archaeology and Maritime History* 12 (2001): 55.
7. *Book of Assizes,* AZ 102-6, 1730, 221-224.
8. Maxwell, "'The Horrid Villainy,'" 60; Cyril Packwood, *Chained on the Rock: Slavery in Bermuda* (Hamilton: Island Press Ltd, 1975), 146.
9. James Pope, "A Dangerous Spirit of Liberty: The Spread of Slave Resistance in the Atlantic, 1729-1745" (paper presented at University of West Indies at Cave Hill, Barbados, October 15, 2010).
10. Roberto Barreiro-Meiro, *Las Islas Bermudas y Juan Bermudez* (Madrid: Instituto Historico de Marina, 1970), 9.
11. Packwood, *Chained on the Rock*, 1-2.
12. Linda Heywood and John K. Thornton, *Central Africans, Atlantic Creoles, and the Foundation of the Americas, 1585-1660* (New York: Cambridge University Press, 2007), 27-28.
13. Clifford Smith and Clarence Maxwell, "A Bermuda Smuggling-Slave Trade: The Manila Wreck' Opens Pandora's Box," *Bermuda Journal of Archaeology and Maritime History* 13 (2002): 82; Heywood and Thornton, *Central Africans,* 7, 28-29, 258; Packwood, *Chained on the Rock,* 5; Michael Jarvis, *In the Eye of All Trade: Bermuda, Bermudians and the Maritime Atlantic World, 1680-1783* (Chapel Hill, NC: University of North Carolina Press, 2010), 102.
14. See Jarvis, *In the Eye of All Trade.*
15. Packwood, *Chained on the Rock*, 76. Also see Jarvis, *In the Eye of All Trade,* 101, and Virginia Bernhard, *Slaves and Slaveholders in Bermuda, 1616-1782* (Columbia, MO: University of Misssouri Press, 1999).
16. Jarvis, *In the Eye of All Trade*, 268, 103.
17. Packwood, *Chained on the Rock*, 77-78.
18. Except for the Portuguese, who were not officially identified as "white" until the 1930s.
19. Clarence Maxwell, "Race and Servitude: The Birth of a Social and Political Order in Bermuda, 1619-1669," *Bermuda Journal of Archaeology and Maritime History* 11 (1999): 39-65.
20. Packwood, *Chained on the Rock*, 133, 145.
21. Packwood, *Chained on the Rock*, 142.
22. Packwood, *Chained on the Rock*, 143.
23. Packwood, *Chained on the Rock*, 145.
24. Packwood, *Chained on the Rock*, 149.
25. Packwood, *Chained on the Rock*, 157.
26. Packwood, *Chained on the Rock*, 156.
27. Packwood, *Chained on the Rock*, 160-161.
28. Jarvis, *In the Eye of All Trade*, 369.
29. *Bermuda Gazette and Weekly Advertiser*, February 7, 1784; May 8, 1784; March 3, 1810; Packwood, *Chained on the Rock*, 158-159.
30. *Gazette*, August 7, October 16, 1784; April 21-May 12, 1810; June 12-July 21, 1810.

31. *Gazette*, January 17, 24, 1784.
32. *Gazette*, July 23, January 21, 1785; May 5, 1810.
33. *Gazette*, March 13, 1784; March 31, 1810.
34. Packwood, *Chained on the Rock*, 158–159.
35. Jarvis, *In the Eye of All Trade*, 174.
36. Suzette Lloyd, *Sketches of Bermuda* (London: James Cochran, 1835), 93–94.
37. Walter Hayward, *Bermuda Past and Present* (New York: Dodd, Mead & Company, 1911), 68.
38. James Smith, *Slavery in Bermuda* (New York: Vantage Press, 1976), 38–39.
39. *Royal Gazette*, January 20, 1994.
40. *Royal Gazette*, January 20, 1994.
41. *Royal Gazette*, January 20, 1994.
42. Jarvis dubiously asserts, "Most slaves' work was done alongside that of planters' wives and children within the larger rubric of uncompensated family labor done for the collective good of the household" (*In the Eye of All Trade*, 107). Bernhard erroneously states that masters "realized that they, like their slaves were not free," and argues that "Whites and Blacks, mulattos and Indians, masters, slaves, and servants shared the same economic pursuits, obeyed the same laws, worshipped in the same churches, lived together in the same houses" (*Slaves and Slaveholders in Bermuda*, 99, 116).
43. Alvin Thompson, *Flight to Freedom: African Runaways and Maroons in the Americas* (Kingston, Jamaica: University of the West Indies Press, 2006), 14.
44. *Gazette*, June 12, 1784.
45. Mary Prince, *The History of Mary Prince: A West Indian Slave*, ed. Moira Ferguson (Ann Arbor, MI: Michigan University Press, 1997), 66.
46. Prince, *The History of Mary Prince*, 67.
47. Sandra Campbell, "Searing Memories," *Bermudian Magazine Online* Spring, http://www.thebermudian.com/past-issues/32; Terry Tucker, *Bermuda's Story* (Hamilton: Island Press Ltd, 1980).
48. Packwood, *Chained on the Rock*, xi.
49. Campbell, "Searing Memories."
50. Nellie Musson, *Mind the Onion Seed: Black "Roots" Bermuda* (Nashville, TN: Parthenon Press, 1979), 38–39.
51. David Walker, *No More, No More: Slavery and Cultural Resistance in Havana and New Orleans* (Minneapolis, MN: University of Minnesota Press, 2004), vii, xi.
52. Packwood, *Chained on the Rock*, 140–141.
53. Packwood, *Chained on the Rock*, 135.
54. Packwood, *Chained on the Rock*, 148.
55. See Quito Swan, *Black Power in Bermuda: The Struggle for Decolonization* (New York: Palgrave Macmillan, 2009), 192, n100, 224.
56. Tim Hall, "Race Row Swirls Around Statue: *Why Did City Hall Turn Down Sally Bassett?*" *Bermuda Sun*, November 14, 2008.
57. Peggy Burns, November 16, 2008, comment on "Race Row Swirls Around Statue: *Why Did City Hall Turn Down Sally Bassett?*" *Bermuda Sun* online, November 14, 2008, http://bermudasun.bm/main.asp?Search=1&ArticleID=39546&SectionID=24&SubSectionID=270&S=1.
58. Bermy Onion Patch, "Bassett or Barnes," July 30, 2008, http://bermyonionpatch.blogspot.com/2008/07/bassett-or-barnes.html.
59. Matthew Taylor, "Bassett Statue Should Be in Southampton—Davis," *The Royal Gazette* online, December 2, 2008, http://www.royalgazette.com/article/20081202/NEWS/312029981.
60. Taylor, "Bassett Statue Should Be in Southampton—Davis."

61. Maxwell, "Horrid Villainy," 65, n70.
62. Amanda Dale, "Central Position of Sally Bassett Statue is Necessary Says Brown," *The Royal Gazette* online, February 13, 2009, http://www.royalgazette.com/article/20090213/NEWS/302139958.
63. Progressive Labour Party, "Sally Bassett Sculpture Unveiled at Cabinet Office," November 7, 2008, http://www.plp.bm/node/1331.
64. Progressive Labour Party, "Sally Bassett Sculpture Unveiled at Cabinet Office."
65. *Bermuda Sun* online, July 13, 2007; Carlos W. Dowling, "Statement," http://CarlosDowling.com/Sculpture/Statement.asp.
66. Tim Vesey, "A Magnificent Statue, in Just the Right Place," *Bermuda Sun*, November 21, 2008, http://bermudasun.bm/main.asp?Search=1&ArticleID=39637&SectionID=4&SubSectionID=135&S=1.
67. Colwyn Burchall, *Freedom's Flames: Slavery in Bermuda and the True Story of Sally Bassett* (Hamilton: Mazi Publications, 2010).
68. Junior Burchall, November 26, 2008, comment on Tom Vesey, "A Magnificent Statue, in Just the Right Place," *Bermuda Sun* online, November 21, 2008, http://bermudasun.bm/main.asp?Search=1&ArticleID=39637&SectionID=4&SubSectionID=135&S=1.
69. Smoking Gun, March 1, 2009, comment on "I'm Not a Crook," *Bermuda Sucks: An Expatriate Worker's View of Life in Bermuda*, http://www.bermudasucks.com/forum/index.php?topic=4491.15;imode.
70. Charles Zuill, "The Sally Bassett Statue—An Appraisal," *Gazette*, November 27, 2010.
71. Pamela, Nov 16, 2008, comment on "Race Row Swirls Around Statue: *Why Did City Hall Turn Down Sally Bassett?*" *Bermuda Sun* online, http://bermudasun.bm/main.asp?Search=1&ArticleID=39546&SectionID=24&SubSectionID=270&S=1.
72. Tauria Raynor, "Governor's Remarks Were 'Insensitive'—Commissiong," *The Royal Gazette* online, February 11, 2009, http://www.royalgazette.com/article/20090211/NEWS/302119944.
73. Raynor, "Governor's Remarks Were 'Insensitive'—Commissiong."
74. Tom Vesey, "Governor, Please Explain What You Meant about Those Statues," *Bermuda Sun* online, February 19, 2009, http://bermudasun.bm/main.asp?SectionID=4&subsectionID=16&articleID=40480.
75. Kitty Pope, "The Sally Bassett Statue: The Controversial Legacy Continues," African Diaspora Tourism, http://www.africandiasporatourism.com/index.php?option=com_content&view=article&id=425:the-sally-bassett-statue-the-controversial-legacy-continues&catid=72:features.

5 Making Slavery Visible (Again)
The Nineteenth-Century Roots of a Revisionist Recovery in New England[1]

Margot Minardi

In a second-floor chamber at the Massachusetts Historical Society stands a table said to belong to Phillis Wheatley, the Boston slave girl-turned-poet who became an international celebrity on the eve of the American Revolution. According to family lore, a relative of Revolutionary War General Israel Putnam purchased the table in an auction of Wheatley's possessions following her death, and a descendant donated it to the Society in 1992.[2]

Nearby in the city of Cambridge, in the Longfellow House—one-time home of poet Henry Wadsworth Longfellow and headquarters of General George Washington—rests a doll wearing a tricorn hat and an elegant waistcoat. He is said to have been fashioned some time in the nineteenth century to resemble Tony Vassall, slave to the Loyalist occupants of the house who fled at the outbreak of the Revolutionary War.[3]

In the collections of Historic New England (formerly the Society for the Preservation of New England Antiquities) sits a squat pewter teapot. The preservation society received the teapot from descendants of William Brown, owner of Crispus Attucks, the fugitive slave who was the first casualty of the Boston Massacre. In the 1850s, Brown's grandson presented two other relics associated with Attucks—a goblet and a powderhorn—at a public commemoration of the Massacre.[4]

The presence of these objects and others like them in New England house museums and historical collections both confirms and complicates the dominant narrative of New England slavery as found in recent historical scholarship and public history venues. Studies of race and memory that focus on the northern United States—and particularly in New England—tend to emphasize erasure. In her pathbreaking book on gradual emancipation in New England, Joanne Pope Melish describes a two-sided process of social and cultural "disowning." She argues that during emancipation and its aftermath, roughly from the 1780s through the 1830s, white New Englanders not only gave up their ownership of individual people, but they also sought to remove people of color from social institutions and cultural memory. The memory of slavery, and the continuing presence of people who were reminders of that past, simply

didn't suit a region that, due to its influential role in the American Revolution, was touting itself as the "Birthplace of American Liberty."[5]

Yet if enslaved and formerly enslaved New Englanders were simply to be forgotten, why did anyone bother to keep Wheatley's purported table, or the Tony Vassall doll, or the teapot said to have belonged to Attucks? Why, in the face of all the reasons *not* to remember slavery, were New Englanders remembering local people who had lived in bondage? And what should historians, curators, and educators make of these objects and the stories associated with them?

This chapter addresses these questions with reference to the period in which memories of New England slaves and former slaves first appeared in noticeable numbers. Objects and stories associated with individual slaves surfaced as the last generation of New Englanders born into slavery was dying out, in the 1830s, '40s, and '50s. This period was coincident with the rise of American abolitionism, and there is little question that the interest in New England's former slaves was connected in part to the expansion of antislavery sentiment and the concomitant urge to ensure that people of color had a place in the region's and the nation's history. But these recoveries emerged from another desire as well: nostalgia for the racial order that prevailed in the generation right after gradual emancipation, when close relationships still existed between freedpeople and their former masters or other elite whites. This racialized nostalgia explains why white New Englanders, including slave owners and their relatives, continued to read meaning into objects like Phillis Wheatley's table, even after the patron-client relations of the immediate postemancipation period were severed by death, personal choice, or shifting patterns of social relations. Placing that nostalgia in time can help to move surviving stories and objects associated with New England slaves from the realm of memory to the realm of history.

SLAVERY AND FREEDOM IN NEW ENGLAND'S HISTORY AND MEMORY

At first glance, slavery seems to have been a marginal institution in early New England. Apart from Narragansett County, Rhode Island, the climate and soil of the region was not amenable to the large-scale agricultural production that fueled the demand for slaves elsewhere. The total number of enslaved persons across the whole region was small, amounting to no more than 3 percent of the population on the eve of the American Revolution. Still, slaves of African and Native American ancestry were to be found scattered across rural New England—usually no more than one or two in a household, amounting to no more than a handful of people of color in any given town. In seaport cities, where there was easy access to the African slave trade and ample demand for enslaved people in wealthy households and in the maritime trades, slaves constituted as much as 10 percent

of the population.[6] The small number of slaves per household meant that enslaved people and their masters often lived and worked in close proximity to each other, a situation that historian William Piersen describes as "family slavery": "family slavery often fostered close and relatively humane relationships that sometimes approached a fictional kinship between masters and slaves." Recent scholarship, while acceding to the salience of the kinship discourse, has cautioned against romanticizing "family slavery." These scholars stress the family's hierarchical (that is, patriarchal) nature in colonial New England. In this context, identifying slaves as part of the family provided a way to assimilate outsiders into New England's social structure while also fixing them to an inferior social status.[7]

The Revolution dislodged slavery from households across New England. The exact means and timeline varied from state to state, but in general, the process was a gradual one. Rhode Island and Connecticut both passed emancipation statutes in 1784 that decreed that children born to enslaved mothers would become free upon reaching a certain age. Since only those born after the enactment of these laws were freed by them, people continued to live in slavery in New England well into the nineteenth century—as late as 1848 in Connecticut. After Connecticut, Massachusetts had the largest number of slaves in the New England colonies (nearly 5,000 in 1770). But the Bay State never legislated an end to slavery. Instead, the first article of the new state constitution, ratified in 1780, proclaimed that "all men are born free and equal." Although many later commentators suggested that this provision was intended to abolish slavery, the contemporary evidence is ambiguous. In 1783, however, in a legal case brought by an enslaved man against his master, a judge charged that slavery was, in fact, unconstitutional in Massachusetts. It is unclear how influential this case was as legal precedent, but by 1790, the takers of the first national census counted no slaves in the state. An even more obscure process, involving conflicting opinions on the part of legal authorities, led to slavery's gradual demise in New Hampshire in the decades after the Revolution. The last of the original New England states, Vermont, was home to only twenty-five enslaved people in 1770. The Green Mountain State outlawed adult slavery with its 1777 constitution declaring that no person "born in this country, or brought from over sea, ought to be holden by law, to serve any person, as a servant, slave or apprentice" upon reaching the age of 21 for a man and 18 for a woman.[8]

Like emancipation elsewhere, the ending of slavery in New England was at least as much a social process as a legal one. In fact, the social realities of emancipation account for some of the difficulties in piecing together a clear legal narrative of when and how slavery ended. It was often difficult to tell how many people were actually enslaved in post-Revolutionary New England, which meant that it was hard to determine how necessary a legislated emancipation was. As public opinion turned against chattel slavery in the Revolutionary period, slave owners had less reason to be

forthcoming about how many human beings they counted among their personal property. Moreover, emancipation was often a process initiated by enslaved people themselves rather than by masters, judges, or legislators. Amid the upheavals of the Revolutionary War and its aftermath, some enslaved people simply left their masters, often to join the army. For others the prudent choice was to continue to live with and work for their masters—though with greater freedom to negotiate the terms of those relationships. Other men and women of color recognized the value of ties to well-to-do and well-connected whites, but instead of staying in the families in which they had been slaves, they sought connections with whites who had shown some kind of antislavery sympathy. A good example is the western Massachusetts slave woman known as "Mum Bett," who sued her master for freedom. Once her master decided not to contest the matter, Bett assumed the name of an emancipated woman, "Elizabeth Freeman," and became a long-serving domestic in the family of her lawyer, Theodore Sedgwick.[9]

In 1795, when a correspondent in Virginia wrote to Boston minister Jeremy Belknap to ask about how Massachusetts had ended slavery, Belknap in turn consulted forty other local men to try to figure out whether and how slavery had been abolished—all this to remember events that had occurred within the previous twenty years. If, from the beginning, it was difficult to figure out how slavery had ended, as time passed it became easier and easier to imagine that it had never existed at all. Thus the very means by which emancipation took place facilitated the process of forgetting—though, as Melish argues, white New Englanders already had ample incentive to remove slavery from their historical consciousness:

> By the 1850s ... New England had become a region whose history had been re-visioned by whites as a triumphant narrative of free, white labor, a region within which free people of color could be represented as permanent strangers whose presence was unaccountable and whose claims to citizenship were absurd. The narrative of a historically free, white New England also advanced antebellum New England nationalism by supporting the region's claims to a superior moral identity that could be contrasted effectively with the "Jacobinism" of a slaveholding, "negroized" South.

For white New Englanders, national, regional, and racial identities coalesced around the exclusion of people of color from the region's historical memory.[10]

However, this process of exclusion did not go uncontested. Efforts to recover the histories of men and women of color who had contributed to the development of a free New England emerged with the rise of abolitionism in the mid-nineteenth century. Of particular interest to those engaged in this recovery were black participants in the Revolutionary War, foremost among them the first person to die in the Boston Massacre, a runaway slave

named Crispus Attucks. In 1851, black abolitionist leader William Cooper Nell petitioned the state legislature to build a monument in Attucks's honor. The legislators refused, setting Nell off on a mission to research how men and women of color, including both slaves and free people, had contributed to the fight for American freedom, especially in New England. Nell's work resulted in numerous publications, notably the book *The Colored Patriots of the American Revolution* in 1855. Although the book documented instances of black virtue and heroism of various stripes, Nell focused especially on exemplary individuals who had fought in the military or engaged in other acts of forceful resistance as part of the American Revolutionary cause. *Colored Patriots* was not simply a work of history; it was also a call for what Nell called the "citizenship and manhood" of people of color. In the 1850s, when the civic status of even *free* people of color was called into doubt first with the Fugitive Slave Act of 1850 and later with the Dred Scott decision, Nell's approach was powerful because it rooted the call for equality in fundamental American values.[11]

In short, one set of roots for the memory of slavery in New England comes from the mid-nineteenth-century effort to recover the patriotism and civic contributions of people of color. In stressing the individual initiative and civic commitment of these people, these memories did not necessarily make it easier to see larger structures of slavery and disfranchisement. Freedpeople and their descendants could be ambivalent about remembering slavery—albeit with very different motivations from white New Englanders seeking an idealized historical identity for their region. For many people, memories of individual heroes better served the political priorities of the mid-nineteenth century, when black leaders were seeking to assert themselves as capable citizens, than did narratives stressing victimization and the "dark past" of slavery.[12]

The effects of this recovery of patriotic men and women of color on the mythical narrative of a "free" New England are ambiguous. Organized into chapters by state, Nell's 300-page account of Revolutionary African Americans devoted 130 pages to New Englanders—including a 100-page chapter on Massachusetts alone. On the one hand, by positioning one black patriot after another on New England's soil, Nell buttressed the narrative that the region was a place of distinctive opportunity and equality, where a man or woman of humblest origin could get ahead on merit alone. The corruptions of slavery made such advancement impossible in the South. Despite having a black population close to 200,000 in 1770—nearly forty times that of Massachusetts—Virginia furnished only 16 pages' worth of "colored patriots" for Nell's book. On the other hand, the research of William Cooper Nell and other early African American historians disrupted the prevailing narrative of a "free" New England simply by putting enslaved and formerly enslaved people onto the landscape of memory. A local history populated by Crispus Attucks, Elizabeth Freeman, and others like them may not have unveiled the region's history of slavery in quite the same way that modern

historiography has done, but it did ensure that this history could not be simply "forgotten" but instead was hidden in plain sight.

DOMESTICATING MEMORY: RACE RELATIONS AT THE TEA TABLE

Historical research into black Revolutionary heroes wasn't the only recovery going on in the mid-nineteenth century. A different set of roots for the public memory of enslaved and formerly enslaved New Englanders lies, perhaps, beneath Phillis Wheatley's table and the other objects said to be associated with local former slaves. For the most part it was white New Englanders who preserved these artifacts and donated them to museums. Clearly these white people were remembering something about New England slaves and freedpeople when they held onto these things, but what was it?

We can begin to answer this question for Wheatley's case, at least, by looking to the most influential account of her life yet published. Margaretta Matilda Odell's *Memoir of Phillis Wheatley* first appeared in print in 1834 and has since shaped many subsequent biographical accounts by scholars and popular historians alike. Odell was a relative, probably the great-grandniece, of Phillis's mistress, Susanna Wheatley. The memoir indicates that Odell's informants were Susanna's female descendents, including her granddaughter and grandnieces. So, in effect, the memoir is the product of oral traditions among the Wheatley women about the family's former slave. The development of a vocal and strident—but by no means widely popular—abolitionist movement in Boston during the early 1830s no doubt contributed to the decision to put Wheatley's life story in print. The *Liberator*, William Lloyd Garrison's antislavery newspaper, reviewed, advertised, and published excerpts of the book. But the main text of the biography itself does not assume a strong antislavery stance. Though Odell was critical of southern slavery, she reinforced the benign discourse of "family slavery" by presenting Phillis Wheatley as more of a daughter to John and Susanna Wheatley than their slave: "the chains which bound her to her master and mistress were the golden links of love, and the silken bands of gratitude." Concerned that readers might wonder why Phillis, who was well known for her elegies, did not write a poem commemorating her mistress's death, Odell explained that the pious and humble Susanna had requested Phillis not to write in her honor. Through her explanation of Phillis's poetic silence, then, Odell celebrated her own ancestor, Susanna Wheatley, at least as much as the putative subject of the *Memoir*.[13]

For Odell, Phillis Wheatley deserved commendation for her devotion to the Wheatley family. In the context of the memoir, Wheatley's respectability as a woman of color also stemmed from her deference to the racial etiquette of the early American republic. Odell approvingly noted that "whenever [Wheatley] was invited to the houses of individuals of wealth and distinction, (which frequently happened,) she always declined the seat offered her

at their board, and, requesting that a side-table might be laid for her, dined modestly apart from the rest of the company." A reviewer of Odell's memoir for a New York magazine singled out this passage, echoing Odell's assertion that Wheatley's behavior at these tea parties was "both dignified and judicious" and noting that such conduct, if practiced more widely, "would unquestionably add to the harmony of society at large."[14]

This anecdote shows how a humble household object like a table could become the site for vivid memories of racial propriety. The motif of a black man or woman ceding table space to whites recurs in other memories of blacks deemed respectable by whites. An obituary of a free man of color published in 1838 honored David Mapps, "a highly intelligent and respectable man," because "his unassuming modesty and humility was such, and he so respected the feelings of others, that he would not sit at his own table, to eat with his white visitors, unless at their pressing solicitations."[15] Tea-table stories like these are explicitly not about the erasure of people of color. They memorialize and honor specific individuals, but they also use the space of the tea table to model the carefully regulated ways in which people of color might be incorporated into social life. According to this obituary writer, Mapps, like Wheatley, was to be commended for his deference to the racial etiquette that allowed whites to set the terms of interracial sociability. Moreover, by idealizing freed slaves who exemplified virtues associated with women—namely, deference and humility—this trope of the tea table gendered black respectability as feminine. This contrasted with the stress on masculine traits of military heroism and virtuous resistance in the commemorations of Crispus Attucks and black Revolutionary veterans whom mid-nineteenth-century African American activists were more likely to embrace.

Another striking example of this feminized "trope of the tea table" comes from a different memoir of a freedwoman in early national Boston. Published in 1832—two years before the *Memoir of Phillis Wheatley*—the *Memoir of Mrs. Chloe Spear* concerned a woman whose ordinariness contrasted starkly with Wheatley's rags-to-riches-to-rags-again life story. But Chloe Spear proved that a woman of color did not have to achieve international fame in order to be remembered locally. Authored by the white evangelical reformer Mary Webb, the *Memoir of Mrs. Chloe Spear* celebrated its subject's industry, piety, and selflessness. Born around the same time as Wheatley, Spear had also been kidnapped in Africa and taken to Boston in the early 1760s. Freed near the end of the Revolution, Spear worked as a laundress, making enough money to buy a house. Spear proved adept in navigating the racialized social landscape of postemancipation Boston as well as its precarious economy: "occasionally, pious ladies, of the first respectability, were pleased to make [Spear] an afternoon visit; when, with her accustomed modesty, she would wait on them, and then take her own tea by herself." For Webb, Spear's respectability was in her modesty, whereas the white women—probably fellow members of Boston's

Second Baptist Church—demonstrated their benevolence by condescending to call on a black sister in Christ. Webb went on to explain how these "ladies" further showed their magnanimity by convincing Spear to have tea along with them. For Webb, there was nothing inherently wrong with blacks and whites sharing a table, but blacks had a place there only on white people's terms—even when the table in question belonged to a black woman herself.[16]

The comparison between Webb's memoir of Spear and Odell's memoir of Wheatley highlights the gendering and domesticating of black respectability in these narratives. Both biographers represented their subjects' husbands negatively. The *Memoir of Mrs. Chloe Spear* portrays Cesar Spear as a good-for-nothing who left most of the breadwinning to his wife. Indeed, Webb configured Cesar's death as liberation for his wife, akin to her earlier emancipations from slavery and heathenism. In her memoir of Wheatley, Odell presented Phillis's husband, John Peters, as similarly dissolute: "utterly unworthy of the distinguished woman who honored him by her alliance," Odell wrote, "he is said to have been both too proud and too indolent to apply himself to any occupation below his fancied dignity."[17] The wives in these narratives fare better than their husbands because the traits that the memoirs cast in an approving light—humility, piety, modesty, deference—were gendered feminine. In a context in which the primary activities of civic agency (voting and military service) were the province of men, a feminized black respectability did not openly challenge white supremacy in public life.

The trope of the tea table even appeared in reminiscences of people of color generally known for challenging the racial norms of the new republic. A case in point is the distinguished sea captain Paul Cuffee of Nantucket and New Bedford, Massachusetts, who by the early nineteenth century was one of the wealthiest men of color in the nation, as well as a vocal abolitionist. Daniel Ricketson, town historian of New Bedford, related how Cuffee invited William Rotch, a distinguished local Quaker, to dine at his home. Upon arriving, Rotch noticed that

> Paul and his wife had no chairs set for themselves, and were modestly preparing to retire or remain until their guests had dined. At this Friend Rotch rose, and, in a firm but kind manner, addressing his host and hostess, said that he could not consent to such an arrangement, and that he should not take his seat at the table unless Paul and his wife presided. With all his gentleness and humanity, no man was more unflinching where a matter of conscience was concerned than Friend Rotch, and Paul was too well acquainted with this trait in his friend's character to demur.[18]

Here, in what is ostensibly a biographical sketch of Paul Cuffee, Ricketson diverts attention from Cuffee himself and instead makes the white Quaker

the hero. In one sense this story makes a stronger point against prejudice than the Wheatley or Mapps anecdotes, in that it celebrates the possibility of a multiracial gathering around the table. But it does so without seriously challenging the norm that it is the white man who decides who takes a seat—even in the black man's home.

An abolitionist writer revised the trope yet again to highlight why it was worthwhile for whites to include people of color at their tea tables. In 1836, an anonymous anecdote in the *Anti-Slavery Record* described a visit young Phillis Wheatley made to the family of slave trader "Colonel Fitch." The Fitch daughters were quite startled to learn from their mother that their guest would be taking tea with the family. Unable to countenance "the idea of sitting down at table with a colored person," the girls "pouted a little, but submitted to their mother's directions." And they were glad they did, for it turned out that Wheatley had marvelous stories to tell of her recent trip to England: the daughters "became more and more inquisitive to learn what she had seen, and found that with all their wealth and advantages, she knew more than they did. As she went on with her stories, they forgot she had been a slave; they felt no prejudice against her because she was black, and they felt ashamed they had ever made any objections to her having a seat at the tea-table."[19]

This tea-table story expressed the utopian vision of a certain strain of abolitionism. In this most unlikely of places, the parlor of a slave trader's home, people of dramatically different backgrounds came together to learn that "wealth and advantages" did not necessarily confer knowledge or moral worth. In order to accept Wheatley at their table, the daughters "forgot she had been a slave." In other words, Wheatley's stories (about royal visitors, English cathedrals, kindly countesses) supplanted Wheatley's story (about her own enslavement and emancipation). The success of this scene hinged not on Wheatley's own autonomous agency but upon her proper performance of the script that Mrs. Fitch had established, a kind of "guess who's coming to tea" for the eighteenth century. This anecdote is notable for its acknowledgment of white prejudice as a real obstacle to social equality and its optimism about interracial social interaction as a means for deconstructing such prejudice. But what unifies this scene with more common versions of the trope of the tea table is that even as these texts ostensibly honored people of color, they also celebrated the whites (Mrs. Fitch and William Rotch) whose benevolence elevated men and women of color to respectability.

These tea-table anecdotes provide a narrative context for surviving objects associated with particular men and women of color. Often these objects are also associated with femininity or domesticity: a table, a teapot, a plate, a goblet, a doll. The artifacts and stories engaged the nostalgia of mid-nineteenth-century whites for what historian James Brewer Stewart calls the "deference politics" of a previous generation. When large numbers of enslaved New Englanders were freed after the Revolution, this postwar

generation of newly emancipated people forged social and economic connections to well-placed whites. These whites were often the freedpeople's employers, their erstwhile masters, or their masters' relatives, and free blacks maintained harmonious relationships with them by observing established codes of social deference. The alliance between newly emancipated blacks and elite, relatively conservative whites functioned for a time because it served the interests of both groups: it created a patronage system that gave freedpeople access to jobs and social protection, at the same time as it confirmed the Federalist elite's sense of organic social order. But as the nineteenth century progressed, that order broke down.[20] Consequently, when a respected black man from Cambridge died in 1861 at the age of 92, the writer of his obituary observed that "he was probably the oldest colored man in Massachusetts, and in his death has been severed the last link which associated many of his race with the wealth and dominant class in Boston." This man, Darby Vassall, like a number of other former slaves of his generation (including Chloe Spear), was buried in the tomb of his former master's family.[21]

Darby Vassall's grave and other artifacts, spaces, and stories associated with New England freedpeople show us, first, that people of color weren't entirely excluded from cultural memory in nineteenth-century New England and, second, that the process of including people in historical memory is often as fraught as the process of excluding them. Those whites who developed the trope of the tea table were too subtle to say "back then black people knew their place," but in showing how emancipation and inequality were compatible with each other, these stories did exhibit fond memories for a time when blacks' place at the table was by invitation only. But that's not quite the whole story. The obituary of Darby Vassall was written not by a white patron of the Cambridge freedman but by William Cooper Nell—the staunch integrationist and man of color who also wrote *The Colored Patriots of the American Revolution*. His observation that Vassall's death severed a link between freedpeople and influential whites shows that black New Englanders also perceived that the social politics of race had changed in the second quarter of the nineteenth century. Of course, Nell's memories of the era of deference politics should hardly be described as nostalgic. Deference precluded the active political engagement of someone like Nell, who ran for public office and fought tirelessly for the rights of people of color to share militia service, schools, and railroad cars with whites—let alone to sit with them at the tea table. But Nell's comment about Vassall does highlight the new challenges, and even the sense of loss, faced by the first generation born after emancipation.

It is tempting for historians to be dismissive of nostalgia. Svetlana Boym cautions against this impulse and instead highlights the complexity behind longing for the past: "Nostalgia is paradoxical in the sense that longing can make us more empathetic toward fellow humans, yet the moment we try to repair longing with belonging, the apprehension of loss with a rediscovery

of identity, we often part ways and put an end to mutual understanding."[22] If Boym's nostalgia—that of the émigré—isn't exactly the same as the longing of nineteenth-century Americans for an earlier moment in their history, both forms of nostalgia nevertheless share a craving for home: the native land left behind in the former case, the domestic space of the private household in the latter. As the politics of slavery and race heated up in the 1830s, '40s, and '50s, it is little wonder that some Americans looked back longingly to a moment in which racial differences could be worked out beyond the public square, in the contained and peaceful spaces of ordinary people's parlors. Of course, the limitation of this nostalgic vision was, in Boym's terms, that it repaired longing with a kind of belonging that stopped well short of genuine reciprocity and understanding: a racially regulated system for seating people around the table.

OBJECTS OF HISTORY

As a complex institution deeply embedded in the fabric of the region—but often masked through celebrations of freedom—slavery in New England has been hard to remember. But memories of individual people, of the places and objects associated with them, are more difficult to erase. Ironically, the tangibility of these personalized memories can also make them difficult to integrate into history. David Blight points out how, unlike history, memory often functions as a family heirloom, an exclusive possession that must be carefully preserved from one generation to the next: "Memory is often owned; history is interpreted. Memory is passed down through generations; history is revised. Memory often coalesces in objects, sites, and monuments; history seeks to understand contexts in all their complexity."[23] The nostalgia that inheres in the objects and stories associated with formerly enslaved New Englanders shows how, when memories manifested themselves in tangible terms and forms, they became detached from the context and complexity of history.

In sketching out the trope of the tea table, I am seeking to situate these objects in a history—specifically, to connect the material objects that survive in museum collections as mementoes of people of color with scholarship on racial ideology and social relations in the nineteenth century. Often the presence of these objects in exhibits, books, and lectures seems primarily metonymic: having Wheatley's table in front of us gives us an occasion to talk about Wheatley herself. The material object thus becomes a device to remind us about the individual person or events associated with it. This approach is certainly valuable, but what it leaves out is the particular materiality and meaning of the object—the tableness of the table, so to speak. It also tends to emphasize the exceptional characteristics of the individual person associated with the object, as opposed to using the object to embed that person in a set of historical structures or relationships.

In arguing for that more contextual approach to material culture, Laurel Thatcher Ulrich has contended that "there must be room for a social history of objects that focuses on the small politics of everyday life."[24] Ultimately, I would argue that the objects and stories that I am grouping under the trope of the tea table evoke nostalgia not only for particular individuals, but also for a "politics of everyday life." Within the logic of this particular politics, Phillis Wheatley was refined enough to own a beautiful table, and Paul Cuffee was respectable enough to be able to invite a distinguished Quaker to dinner, yet Wheatley and Cuffee were also refined and respectable enough to know that they, as people of color, should not sit at table with whites without invitation. If we see these objects and stories as artifacts of nostalgia for this particular racial politics, then we can see how these memories of people of color could buttress the same racial ideology as does their erasure. Our task as scholars, curators, and educators presenting these objects and stories to our various publics, then, is to make this complexity visible to our audiences in an effort to undermine that ideology.

NOTES

1. Portions of this chapter were originally published in Margot Minardi, *Making Slavery History: Abolitionism and the Politics of Memory in Massachusetts* (New York: Oxford University Press, 2010). Used by permission.
2. I am grateful to Anne Bentley, curator of art at the Massachusetts Historical Society, for showing me the table and sharing with me records relating to its acquisition. A digital image and description of the table is accessible on the society's website, http://www.masshist.org/objects/2005april.cfm.
3. *Longfellow House Bulletin* 7, no. 1 (June 2003): 8. I am grateful to Anita Israel of the Longfellow House for showing me the doll and additional information about the Vassalls.
4. Nancy Carlisle, *Cherished Possessions: A New England Legacy* (Boston, MA: Society for the Preservation of New England Antiquities, 2003), 24–25; Minardi, *Minardi, Making Slavery History*, 31.
5. Joanne Pope Melish, *Disowning Slavery: Gradual Emancipation and "Race" in New England, 1780–1860* (Ithaca, NY: Cornell University Press, 1998).
6. Robert K. Fitts, *Inventing New England's Slave Paradise: Master/Slave Relations in Eighteenth-Century Narragansett, Rhode Island* (New York: Garland, 1998), Chapter 3; William D. Piersen, *Black Yankees: The Development of an Afro-American Subculture in Eighteenth-Century New England* (Amherst, MA: University of Massachusetts Press, 1988), 14–18, 168; Ira Berlin, *Many Thousands Gone: The First Two Centuries of Slavery in North America* (Cambridge, MA: Belknap Press of Harvard University Press, 1998), 54–59, 177–186; Lorenzo Johnston Greene, *The Negro in Colonial New England* (1942; rpt. New York: Atheneum, 1969), 84–88, 98–99.
7. Piersen, *Black Yankees*, 35; Melish, *Disowning Slavery*, 27–29; Fitts, *Inventing New England's Slave Paradise*, 62–64.
8. Arthur Zilversmit, *The First Emancipation: The Abolition of Slavery in the North* (Chicago: University of Chicago Press, 1967), 116–124; David

Menschel, "Abolition Without Deliverance: The Law of Connecticut Slavery, 1784–1848," *Yale Law Journal* 111, no. 1 (2001): 183–222; Berlin, *Many Thousands Gone*, 369; Minardi, *Making Slavery History*, Chapter 1; Melish, *Disowning Slavery*, 64–66; Constitution of Vermont (1777), Avalon Project, http://avalon.law.yale.edu/18th_century/vt01.asp.

9. Minardi, *Making Slavery History*, 18, 125–126. For a critique of the "heroic legal narrative" of emancipation, see T. H. Breen, "Making History: The Force of Public Opinion and the Last Years of Slavery in Revolutionary Massachusetts," in *Through a Glass Darkly: Reflections on Personal Identity in Early America*, ed. Ronald Hoffman, Mechal Sobel, and Fredrika J. Teute (Chapel Hill, NC: University of North Carolina Press, 1997), 67–95.

10. "Queries Respecting the Slavery and Emancipation of Negroes in Massachusetts, Proposed by the Hon. Judge Tucker of Virginia, and Answered by the Rev. Dr. Belknap," *Collections of the Massachusetts Historical Society*, 1st ser., 4 (1795): 192; Melish, *Disowning Slavery*, 3.

11. William Cooper Nell, *The Colored Patriots of the American Revolution* (Boston, 1855), 11. For Nell's recovery of Attucks, see Mitch Kachun, "From Forgotten Founder to Indispensable Icon: Crispus Attucks, Black Citizenship, and Collective Memory, 1770–1865," *Journal of the Early Republic* 29, no. 2 (2009): 249–286; Stephen Kantrowitz, "A Place for 'Colored Patriots': Crispus Attucks among the Abolitionists, 1842–1863," *Massachusetts Historical Review* 11 (2009): 96–117; Minardi, *Making Slavery History*, Chapter 5.

12. Mitch Kachun discusses the tension between the desire for amnesia and the imperative of remembering slavery within African Americans' postemancipation commemorative culture in *Festivals of Freedom: Memory and Meaning in African American Emancipation Celebrations, 1808–1915* (Amherst, MA: University of Massachusetts Press, 2003), especially Chapter 4.

13. Margaretta Matilda Odell, *Memoir and Poems of Phillis Wheatley, a Native African and a Slave* (Boston, 1834), 12, 19, 25.

14. Odell, *Phillis Wheatley*, 22; "African Anecdotes," *The Knickerbocker, or New York Monthly Magazine* 4 (August 1834): 88.

15. *Liberator*, 23 March 1838, 47.

16. "A Lady of Boston" [Mary Webb], *Memoir of Mrs. Chloe Spear* (Boston, 1832), 72.

17. Webb, *Chloe Spear*, 68–70; Odell, *Phillis Wheatley*, 20.

18. Daniel Ricketson, *History of New Bedford* (New Bedford, MA, 1858), 254–255.

19. "Phillis Wheatley," *Anti-Slavery Record* 2 (1836): 7–8. If the sole initial "F." that stands as the anecdote's signature stands for "Fitch," then this story could be another example of slaveholders' descendants appropriating the memory of their families' former slaves. On Timothy Fitch, see "The Medford Slave Trade Letters, 1759–1765," Medford Historical Society, http://www.medfordhistorical.org/slavetradeletters.php.

20. On "deference politics," see James Brewer Stewart, "The Emergence of Racial Modernity and the Rise of the White North, 1790–1840," *Journal of the Early Republic* 18 (1998): 186–191. On black Federalism, see John Saillant, *Black Puritan, Black Republican: The Life and Thought of Lemuel Haynes, 1753–1833* (New York: Oxford University Press, 2003), 118–129; Linda Prince, "White Community, Black Compromise: Blacks and the Experience of Interraciality in Boston from Slavery to Freedom, 1693–1815" (PhD diss., Harvard University, 2002), 205–208.

21. *Liberator*, November 22, 1861; Webb, *Chloe Spear*, 90–91.

22. Svetlana Boym, *The Future of Nostalgia* (New York: Basic Books, 2001), xv.

23. David W. Blight, "If You Don't Tell It Like It Was, It Can Never Be as It Ought to Be," in *Slavery and Public History: The Tough Stuff of American Memory*, ed. James Oliver Horton and Lois E. Horton (New York: New Press, 2006), 24.
24. Laurel Thatcher Ulrich, "Hannah Barnard's Cupboard: Female Property and Identity in Eighteenth-Century New England," in *Through a Glass Darkly: Reflections on Personal Identity in Early America*, ed. Ronald Hoffman et al. (Chapel Hill, NC: University of North Carolina Press, 1997), 269.

6 Teaching and Commemorating Slavery and Abolition in France
From Organized Forgetfulness to Historical Debates

Nelly Schmidt

The study of the history of the French colonies in the Caribbean since the suppression of slavery would be ill designed if it did not adequately take into account the mythmaking that occurred after the second abolition of slavery in 1848. These historical myths had a profound influence on the way history was written, transmitted, and subsequently commemorated. In the twentieth century several commemorations supported the past mythmaking, the distortions of history. The celebration of the tercentenary of French colonies in the Caribbean in 1935 and the commemoration of the centenary of the abolition of slavery in 1948 were high moments of this mythmaking enterprise. In 1998, on the 150th anniversary of the 1848 abolition, began a sense of awareness of the wide gaps in the knowledge of the history of the slave trade, slavery, and the abolitions on the part of a nonspecialist public and the teaching profession. Historians, who since the 1960s have been exploiting new sources and raising new questions, have not yet bridged the gap that separates the results of their research from the various means of disseminating knowledge. This has heralded a long period of transition and debate, often ambiguous and contradictory.

This chapter recalls the events of 1848 in the French Caribbean colonies, the actual end to slavery, and the policy of forgetfulness of the past, which was then implemented. The chapter also examines the functions attributed to the various myths that emerged from the historical commemorations that have been celebrated since the middle of the nineteenth century in France and its colonies, and looks at some of the questions raised by the teaching that thereby established them.

UNDERSTANDING 1848—ABOLITION OF SLAVERY AND FRENCH COLONIAL POLICY

The decrees that accompanied the abolition of slavery, signed in Paris by the Provisional Government in 1848, instituted the right to and freedom of

assembly, expression, publication in the press, universal male suffrage for appointing representatives to the National Assembly, freedom of employment, access to education for all, and the protection of the weakest members of society. Nevertheless, the decrees also made possible the denial of these freedoms. It should be recalled here that the second abolition intervened, for the French colonies, after the first suppression of slavery in 1793 in Saint-Domingue, confirmed by the vote of the Convention in Paris on February 4, 1794. In 1802, Napoléon Bonaparte reestablished slavery after a ferocious attack against the rebels in Guadeloupe. The failure of the military expedition sent by Bonaparte to Saint-Domingue resulted in the proclamation of independence of the colony on January 1, 1804, under the name of Haiti.[1]

Actually, the decrees passed by the French republican Provisional Government in 1848 contained all the necessary legal means for controlling, regulating, and ultimately destroying access by the "new freedmen" to these new rights.[2] Victor Schœlcher, as chairman of the Abolition Commission and representative to the Provisional Government, drew inspiration from the work of the French Revolution in the colonial field as well as the British abolition decree of 1833 and the proceedings of the various French colonial commissions in the years 1838 to 1843. He informed the government that the commission had undertaken "a major act of reparation for an injury to humanity." He wrote that the decrees "should apply in as beneficial a manner to all those who had been victims" and warned against "any harmful influence which might compromise the outcome,"[3] that is to say, that might threaten public order, employment, and production.

From June 1848 onward, scarcely a month after the suppression of slavery, which the governors were compelled to proclaim even before the decree arrived from Paris—on May 23 in Martinique and on May 27 in Guadeloupe—a series of measures were taken that were aimed at restricting the promised freedoms and reestablishing tight social control. In May 1848, the serious incidents that had occurred in Le Prêcheur and Saint-Pierre in Martinique, together with the gatherings of slaves and threats of rebellion in Guadeloupe, followed a long period of social tension and hastened the proclamation of freedom.

In *La liberté assassinée* (*The Assassinated Freedom*), Oruno D. Lara gathers documents illustrating the progress of this emancipation policy through strict economic, social, and political supervision of the populations of the colonies.[4] Between 1848 and 1857, former slaves known as "new freedmen" had become potential wage earners, ready to hold jobs in the early factories and subsequently in the "sugar central factories." They were required to enroll their children in the schools that were to be opened in each village but would have to pay increased taxes if they wished to keep their children in school beyond the age of ten. The measures of social protection that should have covered abandoned children, the sick, and the elderly remained an illusion. The planters were compensated for their

"lost" slaves. The slaves received neither financial compensation, nor land, contrary to the plea expressed by Victor Schœlcher as chairman of the Abolition Commission, a plea that had been rejected by the government.[5]

In the weeks that followed their going into effect in the colonies, the proclaimed rights and freedoms were therefore gradually reduced. The agitation caused by the freedoms of assembly, expression, and the press shortly before the first legislative election in August 1848, combined with an increasing number of political clubs run by the Masonic Lodges and the press, led the commissioners of the republic to issue orders aimed at restricting and even abolishing such freedoms. Between 1848 and 1855 to 1857, a policy of low-wage labor was introduced. Two orders were issued in Martinique and Guadeloupe with regard to "labor policy," leading to the suppression of freedom of assembly, while press freedom was neutralized through exorbitant guarantee deposits, and the crops cultivated by the new freedmen were regularly checked and taxed if they were not sugarcane or coffee. Movement of the "new freedmen" from one village to another was subjected to holding an "internal passport" approved by the mayor of the village of origin. The obligation to carry a "work permit" indicating a worker's commitment to a specific employer was instituted under threat of arrest for vagrancy. Two types of response were put forward regarding the problem of labor, which the planters considered insufficient and too expensive in the wake of abolition: the recourse to bringing in indentured workers and the departure of certain categories of colonial populations considered to be "dangerous" to public order and "useless" in the process of reorganizing employment.[6] A series of coercive measures were introduced that Schœlcher described a few decades later as "infringements on individual freedom."[7]

FORGETFULNESS OF THE PAST

After the abolition of slavery, colonial authorities implemented a policy of social control aimed at supporting public order in an attempt to prevent possible acts of revenge and to ensure continued economic activity. Neglect of the past seemed then to be one of the preconditions of this postabolition colonial policy. The elaboration of myths participated closely in this manipulation of history.

Myths and Their Purposes

The 1848 abolition was associated with the myth of a new era of prosperity and access to civil rights. This abolitionist myth as the sole key to emancipation was associated with the image of an assimilating republic, that of public education and the right to vote. The myth of prosperity through the cultivation of sugarcane alone was also associated with an indefectible

but also vital and salvatory attachment to the colonial power (which was the exclusive marketer of sugarcane production), the survival of the holdings, and the well-being of the sugarcane workers. The existing vocabulary of slavery and its abolition in the former slave colonies reveals the power of words and the part they played in deepening social fears in the public discourse on emancipation. "Work," "order," "social reconciliation," "forgetfulness of the past," "respect for property," "economic ruin" and "peril," "risks of sedition," "risks of separatist tendencies," "communism," "the sharing of land and colonial socialism," "colonies/departments" are all words and expressions most frequently found in official documents between 1848 and 1857.

In parallel with the development of mythical interpretations of history specific to the French Caribbean colonies, an extraordinary policy of forgetfulness of the past and a stricter focus of memory was implemented. The process, which began in 1802–1804 with the reestablishment of slavery, expanded considerably after 1848. The colonial war in Saint-Domingue, fierce repression in Guadeloupe in 1802–1803, and the reestablishment of slavery in the latter and in French Guiana were deliberately kept concealed. Saint-Domingue/Haiti became an international example of mistakes to be avoided in matters of colonial government—as France had lost that particular colony. Haiti was considered to be a dangerous breeding ground for disruptive agents, a place that spread a discourse of rebellion and independence throughout all the Americas over several decades.

The Western Abolitionists Fashion and Pass on their History

Western abolitionists contributed—at least as much as the planters did—to the dissemination of their own works—interventions and parliamentary speeches—by devising, as it were, their own history. Their silence with regard to the incessant calls for resistance made by the slaves was analyzed in lesser detail. Some issues were not raised, such as getting an accurate assessment of the phenomena of slave resistance, and developing relationships that could have been established between slaves and a few Western abolitionists who visited the colonies.

The arguments developed by the abolitionists were often of a moral and even religious nature. They were hardly incisive, wary as they were of harming the economic interests at stake, in particular the interests of the planters and of the merchant navy. Some abolitionists, however, took the initiative of providing their contemporaries with a more accurate description of servitude and showing them some of the realities of slavery. Cyrille Bissette, "a colored man" from Martinique, published articles in the *Revue des Colonies* from 1834 to 1843 on life on the plantations, the punishment inflicted on the slaves, and the life of the maroons in Guadeloupe and Martinique. Each article contained small etchings illustrating the scenes described. At the end of 1847, he published a brochure entitled *Martyrologe colonial: Tableau*

de l'esclavage aux colonies françaises, about which he said: "Today, only illustrated books are read, provided they are not too cumbersome." He had therefore chosen to "reproduce through pictures a picture of slavery" in the colonies in the hope of helping readers "to read and understand" the cause of the abolitionists.[8] In fact, he adopted a strategy identical to that of Auguste de Staël who had, in 1825, bought and displayed, for the *Comité pour l'abolition de la traite négrière* of the *Société de la Morale Chrétienne*, various types of slaves' irons and shackles that the merchants on the quayside of the port of Nantes had offered him.[9] As for Schœlcher, he returned from a second trip to the Caribbean in 1840–1841 with a quantity of artifacts connected with slavery and daily life obtained in Guadeloupe, Martinique, Antigua, Puerto Rico, and Haiti. The works he published upon returning from each mission to study slavery in Africa and the Caribbean continue to be irreplaceable, well-documented testimonies of inestimable value.[10]

May Slaves Forget Their Past

In the wake of emancipation in 1848, the public authorities and all candidates for parliamentary representation explicitly advocated "forgetting the past," in the name of "social reconciliation," which they hoped could be achieved between former slaves and their former masters. Accordingly, *Schœlcherist* republicans—supporting the candidacy of Victor Schœlcher—and *Bissettists*, the supporters of Cyrille Bissette having concluded an electoral alliance with the planters, often opposed each other violently, when in fact both leaders defended reconciliation and other very similar causes. Bissette, the political martyr of the 1824–1827 years, a victim of repeated trials for having called for civil rights for "colored freedmen" in the French colonies, and banished from his island, also recommended reconciliation and a forgetting of the past. He stated in his electoral campaign in 1849 that the colonies no longer comprised "blacks" or "mulattos" or "whites" but were populated only by "citizens."

In his first speech before the National Constituent Assembly, Louisy Mathieu, a former slave who was elected representative of Guadeloupe in 1848 among the Schœlcher ranks, thanked France for the freedom granted to his brothers. In his brief address, he emphasized that former slaves had "extended a hand and expressed these very noble words: may the past be forgotten!"[11] François-Auguste Perrinon, a "freed colored man" from Martinique who had had a military career and had become general commissioner of the Republic on the island in the wake of abolition, launched an appeal for calm "to his brothers in the colonies" as early as on February 27, 1848. He advocated "reconciliation with the former masters" and "a complete denial of the past."[12]

It was through an efficient policy of intimidation among the population and a forgetting of the past that the colonial authorities were able for more than a century to eradicate from the collective memory the most

controversial political trial that had ever occurred in the Caribbean in the nineteenth century—that of the separatist Marie-Léonard Sénécal in Guadeloupe and his partisans. Sénécal was accused of having wanted to repeat the events of Saint-Domingue in Guadeloupe in the aftermath of abolition in 1848. The two trials resulting in his being sentenced to hard labor in 1851 were the subject of a publication at the government's expense of verbatim accounts of the proceedings and the sentences that were deemed exemplary were aimed at eradicating any separatist ideas.[13] One month after taking up his duties as governor of Guadeloupe in February 1854, Captain Bonfils stated what his line of conduct would be: "[W]hat matters today is to get a hold over public opinion and guide it."[14] Touchard, his successor, expressed satisfaction at how effectively the press had been brought under control. The editors of local newspapers had "completely adopted" his views and assured him of their "unmitigated support."[15] After several interviews, the press had accepted, according to the governor, his "system of silence" with regard to all the troubles that might occur in the colony.[16]

The slave trade, slavery, and the resistance they prompted were reduced in written publications to their simplest and briefest terms. Accounts of the days of slavery were passed on orally within some families, but these testimonies remained very furtive. This forgetfulness of the past in colonies where knowledge of history might be a source of revenge, or at least might perpetuate deep social rifts, was combined with comparable silence in France. News from the colonies was confined to feats of glory, to tributes rendered to courageous and pioneering settlers, to abolition presented as having solved all problems, and to encouragement aimed at would-be investors in the colonial economies.

One question remains, however, with regard to an imbalance in the sources at a historian's disposal. Genuine testimonies from slaves are available for the anglophone colonial world and for Spanish-speaking colonies. Examples include the autobiography of Olaudah Equiano, published in 1789, and the account by Frederick Douglass of his life as a slave and his escape to the North in the United States. Many similar accounts were drafted, no doubt very laudably, by the abolitionist committees as items of propaganda. Authentic—truly French—accounts are nonexistent. There are no such accounts by authors who lived in the French colonies. The system of silence to which the governors were so attached—as a means of stifling information on incidents that had occurred in a colony so that they might not contaminate any other colony— was a long-standing practice in colonial government. On the plantations, another system of silence prevailed: fear and intimidation. When magistrates were called upon to investigate working conditions on the plantations in Guadeloupe and Martinique in the 1840s, the records of the visits they submitted to the governors after having questioned masters and slaves illustrated the silence observed by the slaves.

At the same time, a central feature of the slaves' social survival faded and disappeared: the memory of "societies" or "convoys" of slaves, networks

of mutual help existing between slaves since the eighteenth century that were genuine safety valves controlled from afar by the authorities who at all times feared rebellions or possible threats.[17] These facts encourage historians to be cautious, because of the doubt cast on the reliability of the sources. Historians work with materials available, but nothing can replace the voice of the slaves themselves before, during, and after their liberation.

COMMEMORATION AND THE CONSTRUCTION OF AN APPROPRIATE HISTORICAL ACCOUNT

Among the questions raised by any analysis of a commemoration is the one relating to its meaning, its purpose, and the memory that it is supposed to pass on. Indeed, there is a deep connection between commemoration and political power. Any commemoration is chosen, decided on, organized, and brought to the notice of the public through a multitude of means. A study of the purposes assigned to it, whether explicit or not, is particularly revealing of the manner in which the commemorating authority seeks to guide, or even focus, public memory of the commemorated event. The questions raised in this way are therefore directly linked to the relationship existing between history and power.

In the specific framework of commemorations linked to the history of the French colonies in the Caribbean, a historian cannot only take note of the particular purposes assigned to any commemoration but must also examine the astonishing distortions of history. Four commemorative periods are referred to here: the celebration of the first anniversary of the abolition of slavery in Guadeloupe in 1849, the commemoration of the tercentenary of the French West Indies and French Guiana in 1935, the centenary of the abolition of slavery in 1948, and the 150th anniversary of the abolition of slavery in 1998.

1849

In 1849, in spite of the very clear instructions sent to the colonial governors by the Ministry of the Navy and Colonies with regard to how the event should be conducted, the first so-called "freedom" anniversary gave rise in Guadeloupe to incidents that brought into conflict the contending political movements for the legislative elections in June. A tree of liberty was to be planted by the governor in the presence of the "apostolic prefect." The leaders of the primary separatist current on the island, which had emerged in 1848 and was led by Marie-Léonard Sénécal, undertook to steal the tree that had been prepared for the event and to put it to their own use. They organized a parallel commemoration, widely announced throughout the countryside.[18] At a time when more than two-thirds of the population of the colony achieved the status of freedom, there were an increasing number

of official proclamations and ceremonies to encourage work, respect for private property, law and order, and the establishment of a system of social control that would be likely to replace the framework of slavery.

At the end of the nineteenth century, while commemorations of abolition in Paris took the form of banquets in honor of Schœlcher, they became distinctly more political after his death in 1893. The memorial associations increased in number in Paris and the colonies. It was in tribute to Schœlcher that the first soldiers from Guadeloupe and Martinique engaged in the first world conflict set off for Europe. At the same time, in 1914 Emile Merwart, governor of Guadeloupe, declared July 21, Saint Victor's Day, to be a public holiday.

1935

In response to the alarm raised by the ills that the colonies had endured for decades, the strikes by the sugarcane workers in the 1930s, and the difficulties linked to the reconstruction of Guadeloupe after the devastating cyclone of September 1928, the government organized a major celebration commemorating the tercentenary of the linking of the French West Indies and French Guiana to France.[19] Echoing the success of Paris International Colonial Exhibition in 1931, a program to commemorate the origins of French colonization was devised at a time when movements bringing into question the "benefits" of the colonial process were beginning to emerge in the Caribbean, Africa, and Asia. The government took control of this unorthodox venture in order to distort history. In Paris, a great variety of events, including lectures, films, opera performances, and commemorative dinners, were planned. A luxurious cruise took more than three hundred leading figures to the Caribbean on the *Colombie* liner. Streets, roads, bridges, and monuments in Guadeloupe, Martinique, and French Guiana were hastily restored for the occasion. The press was called upon to provide a unanimous chorus of praise and promises of indefectible unity of these colonies with the "mother country."

The most fanciful historical accounts referred to the dangers that early settlers had to face when coping with the native populations, described as fearsome "savages."[20] Emphasis was placed on the competence of the early administrators, the "salvatory" nature of the slave trade, and the "generous" treatment given to slaves. One of the main objectives of such accounts was to attract capital and tradesmen to the colonies, which were having difficulty in recovering from chronic social unrest. Although the International Colonial Exhibition of 1931 was to surprise visitors by the prospect of a "greater France," the events marking the tercentenary of the West Indies and French Guiana did not have the same objective. What mattered, in effect, was to convince the colonial populations themselves of the "benefits" of their dependency and to convince the French population of the fact that these distant territories were exotic extensions of France, which for some three centuries had given proof of their attachment to the mother

114 *Nelly Schmidt*

country. On this basis, skillful propaganda was to persuade investors and entrepreneurs of the real prospect of prosperity that transatlantic investment had to offer.

1948

In the aftermath of the Second World War, after the passing of the law on the departmentalization of Guadeloupe, French Guiana, Martinique, and La Réunion, the centenary of the French abolition of slavery was commemorated. The Schœlcher myth—that an abolitionist brought liberty and that abolition itself resolved all problems—was created in 1848 and was further developed over the years. It had provided justification for many political decisions and symbolized the republican myth in the colonial territories. During the Second World War, the name of Victor Schœlcher had been invoked by the Vichy authorities as well as among the ranks of the Resistance. "Attachment to the mother country" was celebrated in all quarters by public celebration of Saint Victor's day.[21]

In 1946, Aimé Césaire referred on several occasions to Schœlcher as the heir of the Principles of 1789 and the first Republic in the speeches he made as a deputy in the Assembly on the draft bill on departmentalization of the "former colonies." In 1947, Emile Merwart and Gaston Monnerville chaired the Federal Committee of Overseas Territory Populations for the purpose of organizing the centenary of the abolition of slavery and for the transfer of the ashes of Victor Schœlcher and Félix Eboué to the Panthéon. The departmental committees created in the colonies organized local festivals and the "planting of a tree of liberty."[22] Schœlcher and the date of April 27, 1848, the day on which the abolition decrees were signed by a majority of the members of the Provisional Government in Paris, were two references commemorated and chosen by the Ministry of National Education. The ministry advised its rectors to organize a commemoration of the abolition by accompanying its instruction circular with a "memorandum on Victor Schœlcher."[23] Gaston Monnerville, Léopold Sédar Senghor, and Aimé Césaire were invited to the Sorbonne to give lectures on April 27, 1948.[24]

The event benefitted from adequate press coverage together with lectures and radio broadcasts organized by the *Grand Orient de France* and ministerial circulars in the field of education that unswervingly conveyed the planned leitmotif. However, in spite of the many publications produced in Paris[25] and in the colonies[26]—compilations of texts by Schœlcher and the letters of various contemporaries—no research initiative or any historical movement emerged from all these events.[27]

1998

Some one hundred fifty years after the abolition of slavery, the French mass media continue to be surprised when historians account for the long-

standing success of the policy of forgetfulness of the past that was implemented in 1848. The iconography abundantly disseminated used imagery that was specifically commissioned in 1848 and 1849. The cliché of the slave with broken chains looking gratefully toward the abolitionist and the liberating republic was still the order of the day. Paintings commissioned by the government of the Second Republic, such as those by François-Auguste Biard, *L'abolition de l'esclavage dans les colonies françaises en 1848* (1849),[28] or by Alphonse Garreau, *Proclamation de l'abolition de l'esclavage à La Réunion* (ca. 1849),[29] glorified freedom brought to the slaves by the general commissioners of the Republic who had replaced the governors of the monarchical era. But various important components of these large-scale works were also propaganda instruments, with sketches of sugar refineries, sugarcane fields, and in the distance, merchant vessels waiting for their cargos of barrels of sugar and other colonial commodities. The message was that there was no freedom without work, law and order, respect for private property, and submission to the new "labor policy." The same remark can also be made with regard to the famous painting, *Blacks Celebrating the Emancipation of Slaves in British Dominions August 1834* (1834), by Samuel Raven, which features in the most widely used representations of the period of emancipation in the British West Indies.[30] The lithograph *Proclamation de l'abolition de l'esclavage à la Guadeloupe: Plantation d'un arbre de la liberté à Basse-Terre* (1849) representing the emancipation of May 1848 in Guadeloupe states just as clearly what the mediators of republican policy would be in regard to colonial matters.[31] Against a background of a crowd, carrying pikes, bayonets, and evocative Phrygian caps and crucifixes, the scene illustrates a plantation and a stem of sugarcane in the guise of a tree of freedom, all in the presence of the governor and his private advisors and the "apostolic prefect" of the colony.

When in 1969, Aimé Césaire said in an interview about the political evolution of the French Caribbean colonies that they were still profoundly influenced by the 1848 events—"*Nous sommes restés profondément des quarante-huitards*" ("We still are profoundly 'forty-eighters'")—it was a sort of warning about the revolutionary spirit and capacity of the Caribbean populations.[32]

The thrust of what was said to mark the 150th anniversary was particularly ambiguous. The slogan of the main organizers of the events at the national level, the Ministry of Culture and the Secretariat of State for Overseas Territories, was "All born in 1848." The net result of this slogan was denying the past centuries of slave resistance and giving 1848 a particularly positive character, representing it as a solution to all the problems raised at that time in the form of national reconciliation. The centuries of slavery, the phenomena of resistance by slaves, and the process of abolition on which so much historical research has still to be undertaken were dissolved into another discourse entirely. That discourse celebrated "the creative expression of identity" of the continents involved in the transatlantic slave trade in a joyful and positive

"interbreeding" that erased all past antagonisms.[33] The undeniable impact that the concerts, television programs, conferences, and other events organized in 1998 had on both public opinion and the media—and in the longer term on research and education—should be recognized, but the whole process remained essentially centered on France. An international comparative dimension, which would have enabled the commemorative events to be positioned in a broader context, remained absent. This was the case even though in 1994 UNESCO had launched The Slave Route project, and there were some academic seminars and conferences in the latter part of the century.[34]

TEACHING

The French school curriculum provides a direct reflection of the poor knowledge about the colonial system being based on slavery and human trafficking between the sixteenth and nineteenth centuries. In fact, the schools provide, as it were, a sort of magnified vision of colonial history. They only tackle this theme through economic exchange, "discoveries," or via major figures who left their mark on that history, such as Toussaint Louverture or the abolitionists Abbé Grégoire and Victor Schœlcher.[35] Furthermore, most school textbooks do little more than mention one or more of these facts: the transatlantic slave trade, the conditions of a slave in Surinam through Voltaire's *Candide*, and the initial abolition of slavery in 1794 and in 1848. No chapter in the curriculum's textbooks is devoted in any specific, global manner to the subject of the first colonial social structure in the Caribbean, the phenomena of human trafficking, or the slavery system—and none deal in any depth with the abolition of slavery. The subject referred to as "civic education" refers at best to the 1848 abolition under the chapter of "Individual and Collective Freedoms." Admittedly, Guadeloupe, Martinique, French Guiana, and La Réunion have since 2000 had a curriculum "adapted" to "local" contexts and supported by a bibliography of specific textbooks.[36] The national teaching of history nevertheless remains quite separated from this trend. The texts and iconography reproduced for the benefit of schoolchildren consecrate the myth of freedom granted by a triumphant republic.[37]

Even more revealing than the history textbooks is the issuing of instructions or "orders" by the Ministry of National Education as support for the curriculum. In February 1998, a ministerial circular requested the rectors of academies to organize training for teachers in the history of the slave trade, slavery, and their abolition. In January 2004, three years after the May 10, 2001 vote by the French parliament of the law recognizing the slave trade and slavery as crimes against humanity, the Committee for the Memory of Slavery was created. The committee was responsible for historical research, teaching, museums, media, and commemorations. The task was great, as was the resistance to it. Since then, teaching programs have been modified very little. Another circular from the Ministry of National

Education, in November 2005, after a demand from the Committee for the Memory of Slavery, recommended that the rectors encourage teachers to refer to the subject every year on the occasion of the commemoration of the "National Day of commemoration of the slave trade, slavery and their abolition," set for May 10—the day the law was passed.[38]

In fact, for many years, history has been relegated to the status of an "early-learning subject" in the French primary education system. This approach was thought to leave teachers free to tackle any historical theme of their choice, provided that primary schools instilled a "national consciousness" in their pupils—I refer here to ministerial instructions regarding curricula. But what about colonial expansionism? These criteria were seen as a means of ensuring "national cohesion" through a judicious choice of events to be highlighted, to be learned, at the expense of other, frequently less glorious, events.

Since the social explosion in the suburbs—the *"banlieues"*—of Paris and some other towns in France in October and November 2005, it had been shown—among other things—how difficult it was at that time for politicians, journalists, and for the "world" of culture and of teaching to understand and to accept the weight of the French colonial past in its social dimensions. Understanding that the French model of "assimilation" and/or "integration" had collapsed seemed difficult. The same was true with regard to recognizing the truth of racial discrimination.[39] At the end of 2005, the Ministry of National Education felt the need to organize a special European seminar about the "difficulties in teaching" some subjects, such as the Shoah, or the history of the slave trade and of slavery. Workshops were organized with teachers from the *"banlieues,"* where riots had existed two months earlier.[40]

Although it has always been a compulsory subject, ministerial measures in 2009 and 2010 tended to reduce the time allocated to history in the upper secondary grades. It would seem appropriate, in this instance, to refer to the "guidelines" or instructions with which the teaching of history must comply in France today. These instructions apply in fact to memorization of events. What matters is not to understand, but to recall a number of facts whereby one can acquire, as advocated by Michelet and Lavisse more than a century ago, the much-vaunted "national consciousness." It involves passing on a selection of facts that symbolize a nation, its development, its unity, and its power, in the name of values considered to be "universal."

ISSUES AND DEBATES: A NARROW-FOCUS MEMORY

When subjects relating to the history of colonization and slavery are examined, the colonial prism is particularly revealing of the "unspoken" and the gaps that continue to exist. Preconceived ideas still abound, not only in teaching but also in the media and even in certain research circles. Recent

generalizations—from the beginning of the twenty-first century—with regard to the so-called "memorial laws" have revealed major gaps that continue to separate research from its means of dissemination for the benefit of a wider public.

One of the effects of the framing of the past that was established after the abolition of slavery in 1848 is still to be found in reactions of astonishment and sometimes denial when a part of history hitherto abridged, often watered down, and sometimes falsified, is given the status of national commemoration. This was the case after the law of May 2001 was passed, which recognized the slave trade and slavery as crimes against humanity and which led to the designation of May 10 as a national day of commemoration. But the transnational emergence of the memory of slavery in the last twenty years is still often ignored in France. The most positive result of the law was the beginning of public recognition of the French slave past, the multiple websites on that subject, and the publication by the National Archives of a guide to sources about the slave trade, slavery, and abolition,[41] even though today there is no slavery museum in France.

The debates engendered by Article 4 of the law of February 23, 2005, relating to the teaching of the "benefits" of French colonization—which was subsequently repealed—reveal how difficult it is for France and certain European countries to face their colonial past, the reality of human trafficking, and the reduction to servitude of millions of individuals.[42] It still seems very hard to unveil the issues involved in the French colonial past with regard to slavery because certain themes have reemerged that glorify colonization. These themes were raised both in the French parliament and in certain European university circles, and the media have only just come out of a long period of auto-censorship in this regard. How should one understand that while certain historians rightly believed that major periods of human history needed to be studied, criticized, and disseminated, others, in contrast, considered that qualifying the slave trade and slavery as crimes against humanity was anachronistic and even out of place? How can one accept that some believe that the assertion of the trauma caused by slavery, the slave trade, the colonial system, and still experienced today by the descendants of slaves is unjustified?

FOR A CRITICAL LOOK

The historical colonial context, regardless of the angle from which it is viewed, generates specific phenomena regarding its framework and the narrow focus on history and the way it is passed on. Perhaps it should be recalled that when a historian enters into this world of misery and incoherence—which was the reality of the Atlantic slave trade and slavery in the Caribbean and Americas from the sixteenth to the nineteenth century—it soon becomes clear that no norm or any customary criterion of evaluation

and formation of history is operative, and none is adapted to what was hitherto an unknown historical process. No comparison with any other systems of imprisonment and exploitation of forced labor can be applied in this instance. It has been told that every generation rewrites its own history. Each generation rereads the texts, discovers new ones, multiplies and compares the types of written, oral, archaeological, literary, and artistic sources. Much has yet to be done in the field of slavery, its abolition, and the aftermath. Many questions remain unanswered regarding the way that history was conveyed and regarding the safeguarding of the traces and legacies it left behind.

Giving memory a narrow focus required specific modes of transmission through carefully constructed myths that were likely to stand up both to reality as well as to time. In fact, many of the myths constructed in the immediate aftermath of the abolition of 1848 still survive today. They are conveyed by the various commemoration activities and teaching curricula. In France, citizens and scholars continue to question the revolutions of 1848 and to attempt to decipher the symbols and ambiguities revealed and brought about by the abolition process. Once again, the task of history is to cast a critical look at what has been taken for granted, together with the myths that it has managed to nurture. New problems that require a renewed diversification of sources have come to the fore.

Not all of the many questions raised by the consequences of the Atlantic slave trade, the slave system, and the forms of social organization that followed its suppression were given adequate answers. The troubles that occurred in Guadeloupe, Martinique, French Guiana, and La Réunion in early 2009—strikes, street demonstrations against economic structures— have proved how the problems raised in 1848 were still alive, to the surprise and perplexity of observers and politicians. The strong dependency of the economies of the Caribbean colonies was deeply connected to the long-standing paradox and subsequent failure of the single sugar crop economy. At the same time, the absence of production structures that resulted from this model and the social ruin that accompanied the policies of introducing low-wage labor throughout the second half of the nineteenth century emerge from a past that is in fact quite recent. Today, this heritage is still a part of the deep-rooted features of the societies in question.[43] Should one say that the policy of forgetfulness of the past implemented in 1848 and the narrow focus of human memory had achieved their aims to that extent?

NOTES

1. See Laurent Dubois, *A Colony of Citizens: Revolution and Slave Emancipation in the French Caribbean, 1787–1804* (Chapel Hill, NC: University of North Carolina Press, 2004); Laurent Dubois, *Les esclaves de la République: l'histoire oubliée de la première émancipation (1789–1794)* (Paris: Éditions Calmann-Lévy, 1998); Carolyn E. Fick, *The Making of Haiti: The*

Saint Domingue Revolution from Below (Knoxville, TN: University of Tennessee Press, 1990); David Geggus, ed. The Impact of the Haitian Revolution in the Atlantic World (Columbia, SC: University of South Carolina Press, 2001); Oruno D. Lara, Caraïbes entre Liberté et indépendance: Réflexions critiques autour d'un bicentenaire, 1802–2002 (Paris: Harmattan, 2002); Marcel Dorigny and Yves Bénot, eds. Rétablissement de l'esclavage dans les colonies françaises: 1802, aux origines d'Haïti (Paris: Maisonneuve et Larose, 2003); Frédéric Régent, Esclavage, Métissage, Liberté: La Révolution française en Guadeloupe, 1789–1802 (Paris: Grasset, 2004).
2. See Oruno D. Lara, La liberté assassinée: Guadeloupe, Guyane, Martinique et La Réunion, 1848–1856 (Paris: Harmattan, 2005).
3. Victor Schœlcher, chairman, and Henri Wallon, secretary of the commission, "Premier rapport fait au ministre de la Marine et des Colonies par la commission d'émancipation," Moniteur universel, 3 Mai 1848, and "Premier rapport fait au ministre de la Marine et des Colonies par la commission d'émancipation," L'Abolitioniste Français: Bulletin mensuel de la Société instituée en 1834 pour l'abolition de l'esclavage (1849): 25–40.
4. Lara, La liberté assassinée. For a comparative study of the colonial policies in the Caribbean see also Oruno D. Lara, Breve Historia del Caribe (Caracas: Academia Nacional de la Historia, 2001), and Oruno D. Lara, Space and History in the Caribbean (Princeton, NJ: Markus Wiener Publications, 2006).
5. See Oruno D. Lara and Inez Lara, Guadeloupe, Propriétaires d'esclaves en 1848, vol. 1, (Paris: Harmattan, 2010), and Oruno D. Lara and Inez Fisher-Blanchet, Propriétaires d'esclaves en 1848: Martinique, Guyane, Saint-Barthélemy, Sénégal, vol. 2 (Paris: Harmattan, 2011).
6. See the anonymous report entitled "Quelques considérations sur l'état actuel de nos colonies et leur avenir," Revue Coloniale (Ministère de la Marine et des Colonies, 1850).
7. In Victor Schœlcher, L'arrêté Gueydon à la Martinique, l'arrêté Husson à la Guadeloupe, (Paris: Le Chevalier, 1872), published on his return from exile. See also Émile Thomas, Rapport à M. le Ministre de la Marine et des Colonies sur l'organisation du travail libre aux Antilles françaises et sur les améliorations à apporter aux institutions coloniales, 15 avril 1849 (Paris: Imprimerie nationale, 1849). About the policies conducted in the colonies in the decades following abolition, see Nelly Schmidt, La France a-t-elle aboli l'esclavage? Guadeloupe, Martinique, Guyane, 1830–1935 (Paris: Perrin, 2009).
8. Letter from Cyrille Bissette to Guillaume de Felice on December 31, 1847, in Nelly Schmidt, Abolitionnistes de l'esclavage et réformateurs des colonies: Analyse et documents, 1820–1851 (Paris: Karthala, 2000), 781–784.
9. See Schmidt, Abolitionnistes de l'esclavage et réformateurs des colonies, 76–78.
10. See the analysis and the bibliography of the works of Schœlcher in Nelly Schmidt, Victor Schœlcher (Paris: Fayard, 1994); on the collections of artifacts which Schœlcher brought back from Africa and the Caribbean in the first half of the nineteenth century and which he donated to several museums, see Schmidt, Victor Schœlcher and Nelly Schmidt, Combats pour une abolition: sur les pas de Victor Schoelcher (Versailles: Conseil général des Yvelines, 2010).
11. Émile Thomas, Rapport à M. le Ministre de la Marine et des Colonies sur l'organisation du travail libre aux Antilles françaises et sur les améliorations à apporter aux institutions coloniales, 15 avril, 1849, Bibliothèque nationale de France, Département des Imprimés.
12. Letter from Perrinon addressed "to his brothers in the colonies," February 27, 1848, published by Lara in La liberté assassinée, 744–745.

13. See Inez Fisher-Blanchet, "L'affaire Sénécal en Guadeloupe, 1848–1851," *Cimarrons I* (Paris and Guadeloupe: Institut Caraïbe de Recherches Historiques and Éditions Jean-Michel Place, 1981), 93–111.
14. Archives nationales d'outre-mer (ANOM), Série géographique Guadeloupe 4–48.
15. Lara, *La liberté assassinée*.
16. Lara, *La liberté assassinée*.
17. See Schmidt, *La France a-t-elle aboli l'esclavage?*, 321–323.
18. See Fisher-Blanchet, "L'affaire Sénécal en Guadeloupe, 1848–1851."
19. The law on the tercentenary of the uniting of the French West Indies and Guiana to France, the thrust of which was presented on February 25, 1935, and passed by the National Assembly on April 25, 1935.
20. See for example Alcide Delmont, "Trois siècles de colonisation française," *Le Courrier colonial illustré* (Paris, December 13, 1935), or *L'Illustration*, special issue for the "Tricentenaire" (Paris, November 23, 1935).
21. See Oruno D. Lara, *De l'Oubli à l'Histoire: Espace et identité caraïbes* (Paris: Maisonneuve et Larose, 1998); Richard D. E. Burton, "Vichyisme et vichyistes à la Martinique," *Cahiers du Cerag*, no. 34 (1978): 1–107. See also the *Bulletin d'information et de documentation du Comité français de la Libération Nationale* (Algiers, May 30–July 3, 1943) and Aimé Césaire, "Hommage à Victor Schœlcher (I)," *Tropiques* (1945): 229–235.
22. For a report of these events in Guadeloupe see Raoul Bogat, "Commémoration du Centenaire de l'abolition de l'esclavage" (lecture given on April 27, 1948, Basse-Terre, in Guadeloupe) (Basse-Terre: Imprimerie officielle, 1949).
23. Circular dated April 16, 1948, signed by the private secretary of the Minister of National Education, H. Viguier. The document entitled "Schœlcher et l'abolition de l'esclavage" drafted by the historian Charles-André Julien was taken from "Notice biographique sur Victor Schœlcher," *Larousse Mensuel Illustré: Revue encyclopédique Larousse*, no. 405, May 1948.
24. The speeches given at the Sorbonne were published by the Presses Universitaires de France in 1948.
25. For example, the compilation of extracts from the works of Schœlcher in Emile Tersen, *Esclavage et colonisation* (Paris: Presses Universitaires de France, 1948); the special issue "Le Centenaire de la liberté," of the *Revue d'histoire des colonies*, 1948; Louis Joubert, "Les conséquences géographiques de l'émancipation des Noirs aux Antilles, 1848," *Cahiers d'outre-mer* (April–June, 1948), 105–118; and Gaston Martin, *L'abolition de l'esclavage: 27 avril 1848* (Paris: Presses Universitaires de France, 1948).
26. See Pierre Baude, *Centenaire de l'abolition de l'esclavage dans les colonies françaises et la Seconde République française, 1848–1948: L'affranchissement des esclaves aux Antilles françaises, principalement à la Martinique* (Fort-de-France: Imprimerie Officielle, 1948).
27. See Nelly Schmidt, "Victor Schœlcher, mythe et réalité," *Revue d'histoire du XIXe siècle: Société d'histoire de la Révolution de 1848 et des révolutions du XIXe siècle* 4 (1988): 51–73, and Nelly Schmidt, "La commémoration du centenaire de l'abolition de l'esclavage dans les colonies françaises, 1848–1948," *Revue d'histoire du XIXe siècle: Société d'histoire de la Révolution de 1848 et des révolutions du XIXe siècle* 5, special issue "Histoire des centenaires, ou le devenir des révolutions, 1848: Révolutions et mutations au XIXe siècle" (1989): 31–54.
28. Currently conserved in the National Museum of the Château de Versailles.
29. Currently conserved in the Quai Branly Museum in Paris.
30. The painting is housed at the National Library of Jamaica and reproduced in Linda Colley, *Britons: Forging the Nation, 1707–1837* (New Haven, CT: Yale University Press, 2005), 357.

31. Lithograph, Bibliothèque nationale de France.
32. See Auguste Charmet, "Césaire et le Parti progressiste martiniquais: le nationalisme progressiste," *Nouvelle Optique, Recherches haïtiennes et caraïbéennes* 1, no. 2 (1971): 69.
33. See the vocabulary employed in the official list of the 1998 cultural events and initiatives commemorating the 150th anniversary of the abolition of slavery: "Préambule," *Liste officielle des événements culturels et des initiatives de commémoration du 150e anniversaire de l'abolition de l'esclavage pour l'année 1998* (Paris: Ministère de la Culture, Secrétariat d'État à l'Outre-Mer, 1998).
34. See, for example, Assemblée Nationale (France), Société d'Histoire de la Révolution de 1848 et des Révolutions du XIXe Siècle (Paris), *Cent cinquantenaire de la révolution de 1848: Colloque international organisé par la Société d'histoire de la révolution de 1848 et des révolutions du XIXe siècle* (Paris: Assemblée Nationale, 1998); Marcel Dorigny, ed. *Esclavage, résistance et abolitions: Actes du 123e congrès des sociétés historiques et scientifiques, Fort de France, avril 1998* (Paris: Editions du CTHS, 1999); Marcel Dorigny, ed. *Les abolitions de l'esclavage: de L. F. Sonthonax à V. Schoelcher: 1793, 1794, 1848* (Saint-Denis: Presses Universitaires de Vincennes and UNESCO, 1995); *Esclavage: Le devoir de mémoire, l'impératif de vigilance* (Paris: Sénat, 1998); and some exhibition catalogs, such as: Musée national des arts et traditions populaires (France), *Tropiques métis: mémoires et cultures de Guadeloupe, Guyane, Martinique, Réunion: Musée national des arts et traditions populaires, 5 novembre 1998–12 avril 1999* (Paris: Réunion des musées nationaux, 1998); Ghislaine Bouchet, Archives Départementales et al., *1848: une aube de liberté: l'abolition de l'esclavage à la Guadeloupe: Archives départementales, Bisdary—Gourbeyre, 27 avril–28 juin 1998: catalogue de l'exposition* (Basse-Terre: Direction des Archives départementales de la Guadeloupe, 1998); Frédérique Decoudun-Gallimard, ed. *Île de La Réunion, regards croisés sur l'esclavage: 1794–1848, Musee Léon-Dierx à Saint-Denis de La Réunion du 13 novembre 1998 au 25 avril 1999* (Paris: Somogy, 1998). See also Catherine A. Reinhardt, *Claims to Memory: Beyond Slavery and Emancipation in the French Caribbean* (New York, Oxford: Berghahn Books, 2006).
35. An analysis of the primary and secondary education curricula, which was the subject of research and proposals discussed by the Research and Teaching Sub-Commission of the Committee for the Memory of Slavery between 2004 and 2008, was published in Comité pour la mémoire de l'esclavage, *Mémoires de la traite négrière, de l'esclavage et de leurs abolitions* (Paris: La Découverte, 2005).
36. See Ministère de l'Éducation Nationale, de la Jeunesse et de la Vie Associative, "Spécificités des DOM dans les programmes d'histoire et de géographie," *Bulletin Officiel*, no. 8, February 24, 2000, http://www.education.gouv.fr/bo/2000/8/default.htm.
37. Nevertheless, supplementary pedagogical material does exist. See also the UNESCO DVD, *The Slave Routes: A Global Vision,* and Nelly Schmidt, "Asservir: Fiches Bilans de Connaissance: Dossier d'accompagnement du film" (Paris: UNESCO, 2010). See also, *Quel enseignement de la traite négrière, de l'esclavage et des abolitions: Séminaire du Réseau national des écoles associées à l'UNESCO, 4, 5 et 6 novembre 2004* (Champigny: SCEREN-CRDP de l'Académie de Créteil, 2008), and *La traite négrière, l'esclavage et leurs abolitions: mémoire et histoire: séminaire national organisé le 10 mai 2006, Carré des sciences, Paris* (SCEREN, CRDP Académie de Versailles, 2007).

38. See the Ministère de l'Éducation Nationale, de l'Enseignement Supérieur et de la Recherche, "Devoir de mémoire: Mémoire de la traite négrière, de l'esclavage et de leurs abolitions," *Bulletin Officiel*, no. 41 (November 10, 2005), http://www.education.gouv.fr/bo/2005/41/MENE0502383C.htm.
39. For the debates about those questions in Europe, see *Black Europe and the African Diaspora*, ed. D. Clark Hine, Trica Danielle Keaton, and Stephen Small (Urbana and Chicago, IL: University of Illinois Press, 2009).
40. See Laurent Wirth, Benoît Falaize, Nelly Dejean, Jean-March Bassaget, Nelly Schmidt, and Jacques Desquenes, "Quelles solutions pour enseigner les questions sensibles aujourd'hui et demain?" in *Quelles pratiques pour enseigner des questions sensibles dans une société en évolution? Actes du séminaire européen, Paris, les 14 et 15 décembre 2005* (Paris: Ministère de l'Éducation Nationale, de l'Enseignement Supérieur et de la Recherche, EduSCOL, Formation continue), 51–55 and 59–60.
41. *Guide des sources de la traite négrière, de l'esclavage et de leurs abolitions* (Paris: Archives nationales, La Documentation française, 2007).
42. I am referring in particular to discussions nurtured by Article 4 of the law of February 2005 passed by the French National Assembly, which states that "university research curricula grant to the history of French presence overseas, particularly in North Africa, the importance it deserves" and that "school curricula recognize in particular the positive role of the French presence overseas, particularly in North Africa, and grant to the history and sacrifices of the combatants of the French army originating from those territories the eminent role which they deserve." See also, with regard to British historiography, the article by Seumas Milne, "Réhabilitation du colonialisme," *Le Monde Diplomatique*, Paris (May 2005): 4–5.
43. See Oruno D. Lara, *Guadeloupe: faire face à l'Histoire* (Paris: Harmattan, 2009).

7 Commemorating a Guilty Past
The Politics of Memory in the French Former Slave Trade Cities

Renaud Hourcade

When the Taubira Law was unanimously passed by the French parliament in May 2001, it was noted well beyond France's borders. The world's first law to declare the slave trade and slavery "crimes against humanity," it also included an official commitment to enhance the importance of the history of slavery in French schools and in academic research. Moreover, the Law created a committee responsible for choosing a date for the nation to commemorate slavery each year. This official commemoration was later set to May 10, in reference to the day when the Taubira Law was passed. Passage of the law was viewed as a decision that eloquently highlighted France's evolving collective understanding of slavery. However, the text of the Taubira Law presents a flattering view of France's regime of memory, and thus there is a risk that the winding and ambiguous processes that led to this important step will be obscured, or simply forgotten.

When close attention is paid to the history of memory in France, it appears that, as in many countries, the undermining of slavery in the national historical narratives, and the correlative absence of national commemorations, were virtually unquestioned for nearly a century and a half. Slavery was—and to some extent still is—a difficult part of the past in France. Particularly uncomfortable has been the position of the country's former slave trade ports.

Among a handful of French cities involved in the Atlantic slave trade,[1] Nantes was by far the more active port, with 1,754 expeditions recorded between 1688 and 1830.[2] Although Bordeaux's prosperity was largely due to Europeans' taste for its wines and the colonial goods it traded, depending on the period, this southwestern port ranked second or third in the French slave trade. Indeed, between 1672 and 1826 about 508 expeditions left Bordeaux.[3] Notwithstanding their difficult position, the politics of memory that took place in Nantes and Bordeaux are an important part of the progressive national paradigm shift that occurred during the last twenty years. As such, the role of these two cities in the construction of a national consciousness about slavery must not be underestimated.

This chapter examines the emergence and institutionalization of the public memory of the transatlantic slave trade and slavery in Nantes and

Bordeaux through a diverse range of symbolic devices, including commemoration activities, museums, and memorials. Discussing the processes that led both cities to put an end to decades of amnesia and to acknowledge their role in the transatlantic slave trade, the chapter attempts to map the local "memory entrepreneurs" and to assess their effectiveness.[4] It also aims to shed light on the impact of the local, national, and international contexts of the policy decisions in Bordeaux and Nantes. Finally, the chapter examines the specific political stakes that both cities have had to face when setting up a policy of memory related to a guilty past.

SOUNDS OF SILENCE

Although hardly noticeable, material traces of the transatlantic slave trade are quite numerous in Nantes and Bordeaux. They range from black slaves heads sculpted on some old pediments as symbols of the owner's economic activities to streets bearing the names of families who drew their wealth and consequent influence from slave trading. But to what extent was this past a living memory in those cities? Enslaved Africans, unlike sugar or cotton, were very rarely shipped to France, although in some cases they accompanied their colonial masters on their way back to their homeland.[5] The transatlantic slave trade was thus less visible in France but certainly not unknown or dissimulated, except between 1815 and 1848, the years of the illegal slave trade. However, the memory of the transatlantic slave trade seemed to vanish soon after the last expedition to the African coast (1830), and that lapse in memory lasted well into the final decades of the twentieth century, when memory activists began to noticeably increase their calls for action.

This disappearance refers neither to a loss of historic knowledge, nor to a hole in the local consciousness; instead, it refers to the complete absence of any reference to this period in the public space. The slave trade and slavery were not highlighted in any public landmarks, exhibitions, or commemorations. Remarkably, before the last decades of the twentieth century, social claims to overcome this "amnesia" and to make this past more visible were also very rare. Indeed, the absence of slavery in the public memory was grounded not only in a feeling of distaste among the descendants of "perpetrators" but also in a feeling of shame on the part of the victims' descendants.[6] Black people from the French West Indies (comprising the Guadeloupe and Martinique islands), French Guiana, and La Réunion have been widely present in metropolitan France since their migration was organized through official institutions between 1963 and 1982.[7] In 1848, following the second abolition of slavery, they had been declared French citizens, and since 1946 the four territories have the status of overseas departments (DOM), which entitles their population to the same rights as every other French person.

However, very little public memory activism came from this population. This is not surprising, because many studies have demonstrated the difficulties surrounding the memory of slavery in the French Caribbean, French Guiana, and La Réunion. Although there is no doubt that this memory is still alive and transmitted,[8] it has always been associated with a sense of shame and a fear of stigmatization that prevented its public expression. The French historian Myriam Cottias has added a provocative perspective to this interpretation of the memory of slavery in the French Caribbean. She argues that as soon as the emancipation of slaves in the French colonies was decreed in 1848, the Republican ideology associated the promise of a full belonging to the nation with the forgetting of former identities, and in particular, the forgetting of the former slave status.[9] By disapproving any reference to slavery in the public space, this ideology disqualified the descendants of slaves from grounding any claim in such an identity. This taboo continued to prevail in mainland France among the French citizens who migrated from the DOM. Understandably, they were not interested in identifying themselves as "descendants of slaves," a label that they feared would have perpetuated the social stigmas associated with their origin and race.

Those conceptions, however, were increasingly challenged during the second half of the twentieth century. Starting in the 1940s, Aimé Césaire and his fellow *Négritude* writers endeavored to reverse the stigma of being black in colonial France, elaborating in their poems and novels new conceptions of the slavery legacy as a phenomenon that, beyond the traumatism, was creative of identities. A sense of singularity and richness was slowly built upon this literary movement at a time when decolonization wars were shaking the assumption of white universal superiority and especially the white construction of the black, powerfully denounced by Frantz Fanon.[10] Thinkers from the Caribbean world drew on these new racial ideas but highlighted the specificity of the societies born from the slavery "encounter."

Thus, partly breaking with Césaire's Afrocentric conception of Antillean roots, Édouard Glissant has insisted on how the slave trade deterritorialized Africa and created new creolized societies, resulting in a specific rhizome-identity.[11] Continued by influential contemporary writers such as Patrick Chamoiseau, this positive understanding of the slave trade and slavery has progressively spread among the French DOM elites, providing them with a new understanding of their identity—one of particular ethnicity, pride, and richness. Since the 1970s, autonomist movements gave even more resonance to these conceptions. Making memory a powerful vehicle to put forward their political claims, they argued that breaking with the enduring consequences of slavery implied breaking with France's political domination. All this evolution, however, only slowly transformed the traditional relation to slavery as a taboo past. Apart from the Creole intellectual elites, in many families slavery tends

to remain an unvoiced part of their identity, a "crossed-out collective memory."[12]

Consequently, when the first slavery memory entrepreneurs appeared in metropolitan France, they were not from the Creole migrant communities. In Nantes, starting in the 1980s, advocacy for a visible public memory of slavery initially came from a different side: professional historians. In 1985, the 300th anniversary of the *Code Noir* (code of colonial slavery regulation issued by Louis XIV) led Nantes scholars of the transatlantic slave trade to propose an ambitious event: mixing academic meetings and cultural activities around the memory and legacies of slavery. Whereas the city at first supported these initiatives, a newly elected right-wing city council unexpectedly decided not to back the event. Consequently, only the academic part of the program was maintained.[13] For many commentators among the opposition and in the press, this attitude clearly confirmed an enduring reluctance in important sectors of the population and elites of Nantes to acknowledge the city's slaving past.[14]

Bordeaux's relationship to the memory of the transatlantic slave trade was even more uncomfortable. A stronghold for conservative parties since the end of World War II, Bordeaux's elites stood in a long tradition of political moderation, which made them reluctant to turn their sights toward the city's slavery past. When memory entrepreneurs from the black community became active in the 1990s, political leaders used to refuse their claims by arguing that Bordeaux's merchants, unlike the merchants from Nantes, sent relatively few expeditions to Africa compared to the volume of direct trade with the Caribbean islands, and that Bordeaux therefore drew a much smaller part of its eighteenth-century growth from the slave trade than Nantes. As shown by several exhibitions in the city museum and through political discourses, Bordeaux strove instead to preserve its image as a dynamic colonial port "whose merchants were audacious and succeeded."[15] Late exhibitions in the 1990s were more concerned with integrating slavery in the city's historical narrative, but they still ambiguously referred to the city as a kind of open door towards exoticism, dealing in rare and luxurious tropical goods, as explained by Christine Chivallon.[16] Thus, commercial entrepreneurship and tropical romanticism long remained at the core of Bordeaux's public commemoration of its colonial role.

THE MEMORY RESURGENCE

The context started to change much sooner in Nantes than in Bordeaux. In Nantes, the failed commemoration of 1985 appears as a turning point, perhaps because those events left no doubt about the intensity of the taboo surrounding the city's slaving past. The next year, in 1986, a Caribbean association started to publicly challenge the reluctant memory of the city at a time when the memory of slavery was gaining a new legitimacy within

the Creole community. Once a year, on a fixed day, that community commemorated the transatlantic slave trade on the banks of the Loire, right on the dock where slave ships were once moored. Their goal was to honor the "victims without a grave" by throwing flowers in the Loire, turning the river and the nearby ocean into symbolic witnesses of the tragic events of the slaving past. Willing to "maintain alive two centuries of history, after two centuries of silence,"[17] they advocated the erection of a museum or a memorial as a permanent symbol of the city's acknowledgment of its role in the slave trade.

The relatively moderate positions of these black memory agents allowed them to develop connections with left-wing political challengers to the conservative Nantes city council. These politicians were motivated both by potential electoral gain and by evolving public opinion on the need to change the municipal memory regime. As a result, when a new socialist mayor was elected in 1989, he rapidly gave the official stamp of approval to the association's yearly Loire commemoration, making Nantes the first former slave trade port in Europe to officially commemorate slavery. The new mayor also set up a committee, the "Commission Nantes-Afrique-Amériques," which was charged with the organization of an ambitious slavery and slave trade exhibition; some leaders of the African and Caribbean communities were involved in the project. Notwithstanding the probable sincerity of the mayor's team, this decision of the new mayor was clearly designed to satisfy the black community's claims while at the same time permitting the new city officials to bring public attention to their "bravery" and open-mindedness, especially when compared to the attitudes of the former city leaders. Another strong motivation was to make the efforts of Nantes with regard to its uncomfortable memory a basis on which to rebuild local identity, including tourism marketing.[18]

The exhibition *The Shackles of Memory* (*Les Anneaux de la Mémoire*) became a popular success, with 300,000 visitors in two years. It opened in 1992, the year Europe commemorated the "discovery" of America, and closed in 1994, two hundred years after the first (and temporary) abolition of slavery during the French Revolution. For the first time in Europe, a former slave trade port not only acknowledged its role in transatlantic slavery but also showed what the city gained from the trade, the vile conditions under which slaves were transported across the ocean, and the reality of slavery and life on the plantations in the Americas and the Caribbean. Not all of the black community, however, praised the exhibition. Some spoke of the display as "tenacious Nantes historical revisionism" consisting in "making the voice of the perpetrators equal to the victims' one." Moreover, they denied the exhibition's honesty on the grounds that it neglected to take into account African opinions and sensibilities, resulting in a "clean" vision of slavery.[19] But those critical accusations remained confined to a small part of the community. Memory agents, both locally and nationally, still remember the 1992

Nantes exhibition as an important benchmark in France's way toward recognition of slavery.

During the following decade, the city decided to add two mnemonic devices to upgrade the local policy of memory. A first decision was to dedicate a section to slavery and the slave trade ("Le négoce et l'or noir au XVIIIe siècle") in the new Musée d'Histoire de Nantes ("Nantes History Museum"), the local museum, after it underwent a complete renovation between 2004 and 2007. Only a few items related to this subject had been presented in the former version of the museum. The narrative of slavery developed in these new rooms is centered on the city and gives priority to the link between the slave trade and the development of Nantes. In addition, the museum provides a clearer and franker account of the transatlantic trade processes as well as information about the plantation system and the lives of slaves and masters in the French colonies in the Americas. Remarkably, the museum also recalls the successive stages that led Nantes from silence to recognition of slavery. Thus, the scope of the museum encompasses both a historical narrative of slavery and a reflexive and flattering account of the progression of Nantes with respect to its relationship to its memory. The second memory device is an ambitious memorial currently being built on the *Quai de la Fosse*, one of the eighteenth-century slave ships' docks. Designed by the artist Krzysztof Wodiczko and the architect Julian Bonder, the memorial is conceived as a "meditation path." Following the river, the 1,300-foot esplanade is planted with trees, and 2,000 commemorative plaques recall all slave-trading voyages that departed from Nantes as well as the main merchant outposts in Africa and the Americas. At the end of the path, a staircase leads underground, inside the dock, where the confined space is made to recall the slaves' captivity. A wall of windows looking out onto the river is engraved with citations linked to the worldwide fight for abolition. The path ends with a small room displaying historical information about the slave trade and slavery. This memorial, which is expected to open in 2012, is the result of a complicated process. The mayor's decision goes back to 1998. At the time, a statue of a freedman, erected by an Antillean association to commemorate the 1848 abolition, had been destroyed the night after it was unveiled. To respond to the emotion caused by this event, the mayor promised to erect a public memorial. However, the high cost of the selected project, political opposition denouncing an excess of memory activism, and technical obstacles delayed its completion.

Bordeaux's era of silence regarding its role in the slave trade lasted even longer than that of Nantes. It was not until 2005 that the city questioned its collective memory and asked a consultative committee for a set of proposals for commemorating the city's involvement in the slave trade and slavery. In contrast to Nantes, Bordeaux took a long time to respond to the local memory entrepreneurs, whose mobilization began in the 1990s. Concerns about the memory of slavery in Bordeaux first emerged in the city's university campus. Students from Africa and the West Indies have been relatively numerous in

Bordeaux since the 1960s because of the historical relationships of the city with overseas territories. For the duration of their studies in France, some of these students joined various associations concerned with politics in their home countries, with the development of Africa, or with cultural activities. But from the 1980s, some of them started to turn their attention toward the city's slaving past. This was at a time when references to this part of the city's history were still completely absent from the local public sphere. Led by a Guadeloupean student from Bordeaux University, a group called Africapac decided to commemorate the slaves' resistance to slavery on a day of celebration (the "Journée au Morne") they organized each year. They also began to advocate that a street be named after Toussaint Louverture, the hero of the Haitian Revolution. Indeed, in Bordeaux, only a cul-de-sac had been named after him hitherto, and memory militants interpreted this fact very negatively. Meanwhile, historians also played a remarkable role in denouncing Bordeaux's amnesia, albeit in a different way than they did in Nantes. The coup came from an individual initiative by a historian who was not from Bordeaux but from Nantes, Eric Saugera. In 1995 he published a groundbreaking book, *Bordeaux, port négrier (Bordeaux, Slaving Port)* with the aim of clearly asserting Bordeaux's slaving past.[20]

This well-documented book has had an immediate and lasting influence. By sharpening the contrast between the reality of Bordeaux's engagement in the transatlantic slave trade and the total absence of public acknowledgment of it, the book favored the emergence, and to some extent the radicalization, of local memory entrepreneurs. Among them, the association Diverscités became central in Bordeaux's memory movement during the period 1998–2010. This association can be credited with a long, tireless, and inventive course of activism on the issue of Bordeaux's memory of slavery. Diverscités is composed of individuals of various origins; its leader, a former public law student at Bordeaux University (and former member of Africapac), is from Senegal, but many militants come from white Bordeaux families. Diverscités carried out a long campaign to have a memorial built in Bordeaux. Although they managed to raise private funds and had well-known sponsors (including the writer Patrick Chamoiseau), they never convinced the city. For more than ten years, the group also used to gather regularly to commemorate slavery and organized slave trade heritage marches in the city. In 2010, they launched a campaign to rename the city's streets, many of which bore the names of families that were slave traders. Some of them were well-known historical figures of the local bourgeois community, so the proposed action was not without impact on the local community. None of these initiatives triggered any significant change in the city's attitude toward its slave trade past. They might, however, have helped to increase the public's awareness of this traumatic history because of the heavy coverage of their activities in the local press. In fact, Bordeaux's evolution on the memory of slavery issue can be best understood as the result of local, national, and international factors. Indeed, it seems fair

to assume that Bordeaux's official silence over its past as a slave trade city did not resist the rapid rise of the memory of slavery that France has known over the ten past years.

Since the 1990s, a series of official public initiatives had made clear that a new regime of memory was emerging in the national public sphere. The 1998 initiative by Lionel Jospin's left-wing government to commemorate the second abolition of slavery (1848) appears as a starting point in this process, after various missed opportunities. Actually, before 1998, neither the bicentenary of the French Revolution in 1989 nor the 1992 celebration of the discovery of America had fomented a national discussion on the public memory of the transatlantic slave trade. But regardless of Jospin's willingness to get ahead with this issue, the framing of the commemoration raised deep protests within France's black community, because many people felt outraged at the emphasis put on the positive role of France as an abolitionist state. Most activists considered this commemoration was biased since it kept silent on the role of France as an oppressor and failed to recognize the role played by the slaves themselves in the struggle for freedom. Equally disrespectful in their view was the official motto, "all born in 1848," designed to make Republican universalism prevail on concurrent race-oriented narratives of the past, which was perceived by the authorities as potentially divisive. Such a frame imposed on the first national commemoration of the abolition may have had the paradoxical effect of "updating the resentment" of France's black population, as Jean-Luc Bonniol explains.[21] In May 1998, an unprecedented protest demonstration in Paris gathered 40,000 people, mainly from the DOM. Considering that one of the claims voiced during the debate was that the transatlantic slave trade and slavery be recognized as crimes against humanity, this episode may have opened the way for the Taubira Law. Jospin, indeed, strongly backed the law, which was proposed a few months later by Christiane Taubira, deputy of French Guiana. The context of this national debate resonated with Bordeaux's own disputes about increasing the local memory of the slave trade. The frequent comparison with Nantes, which in the meantime was clearly making visible the city's public memory of the slave trade, added pressure. In addition to this changing national memory regime, The Slave Route project (1994) of UNESCO also exerted influence in the local context. Moreover, the ambitious local policies of memory launched by Bristol (a former slave trade port and Bordeaux's twin city[22]) and Liverpool made it hard for Bordeaux to maintain its reluctance to act. What was becoming increasingly stigmatizing was no longer mentioning Bordeaux's slaving history but refusing to refer to it and continuing to deny its importance.

As a consequence, the city cautiously started to respond differently. In 2005, amid sharp disputes with local memory activists, the city appointed a committee of historians, memory entrepreneurs, and religious leaders. Its task was to try to lower the tension and study whether some public initiatives should be developed. Eventually, the committee recommended

building a new *lieu de mémoire*, but it did not offer any clear ideas about the shape it should take. However, the mayor, who considered it pointless to build a new monument or memorial, vetoed the proposal. He favored the renovation of the eighteenth-century rooms of the Museum of Aquitaine, the city's museum, instead. In the meantime, there were signs of a cautiously changing understanding of the past, as the taboo was shaken by a series of sporadic initiatives. A public park was named after Toussaint Louverture in 2003, and a bust of him was unveiled in 2005. In 2006, a small and almost unnoticeable bronze plaque was set on a Garonne River dock, close to the heart of Bordeaux's merchant's district. It reads:

> At the end of the seventeenth century, the first ship equipped in Bordeaux for the slave trade departed from this place. Hundreds of expeditions followed, until the nineteenth century. The city of Bordeaux honors the memory of the African slaves who were inhumanely deported to the Americas.[23]

In 2008, the city actively participated in the official commemorations of slavery on May 10. During a visit of Canada's Governor General, Michaëlle Jean, a Haitian native who claims to be a slave descendant, Mayor Alain Juppé declared that Bordeaux was willing to confront its slaving past and honor the victims of the Atlantic slave trade. However, his proposals might not have been convincing enough to the local memory activists. Actually, both the unveiling of the plaque and the commemoration with Michaëlle Jean brought criticism and outright opposition from the memory activists. Diverscités and other associations maintained pressure on the city, denouncing the "ridiculous and disrespectful" size of the commemorative plaque, the insincerity and unwillingness of the city to associate Diverscités with the commemoration, and calling the mayor's public memory initiatives "political marketing."[24] This led the city and the local memory activists to commemorate slavery on the same day but separately, making each year's commemoration a scene of controversy and confrontation with the mayor and his team.

But a major public memory operation came soon after these events and contributed to dramatically reducing the tension. On May 10, 2009, the Museum of Aquitaine, Bordeaux's museum, opened the permanent exhibition, *Bordeaux, the Atlantic Trade and Slavery* (*Bordeaux, le commerce atlantique et l'esclavage*). Composed of three new rooms, the exhibition proposes a more accurate narrative of the role of the slave trade and colonial trade in Bordeaux's development, and also underscores the legacies of slavery in the present. This, at last, may have appeared as a sufficient policy of memory able to convince memory activists that Bordeaux's leaders had changed their minds. The initiative was indeed largely praised in the city and beyond as an appropriate and respectful way of dealing with such a traumatic history. In October 2010 the decision of Diverscités to break up

and stop its activities seems to confirm the point that perhaps Bordeaux may have entered into a normalized regime of memory.

MEMORY AS COMPETING INTERPRETATIONS OF HISTORY

Robin Wagner-Pacifici and Barry Schwartz wrote in a seminal article that "to understand memorial making is to understand it as a construction process wherein competing 'moral entrepreneurs' seek public arenas and support for their interpretations of the past."[25] One can see Bordeaux and Nantes as clear examples of such processes. In both cities memorialization of slavery is the result of a confrontation between various types of memory entrepreneurs, public authorities, and changing ideological contexts at local, national, and international levels.

In this perspective, memory must be seen as a relatively malleable resource to be shaped and used in the present according to the visions and interests of competing groups on the public scene. When they act as memory entrepreneurs, historians often tend to be concerned with the historical accuracy of the narrative of the past delivered through public memory devices. Their claims are mainly grounded in the feeling that public understanding of the past (or absence of understanding) becomes a problem when it doesn't match the real historical relevance of the event remembered. On the other hand, black memory entrepreneurs often forward specific—and sometimes competing—concerns. In Nantes, for instance, memory activists from Africa used to ground their claims in a pan-African perspective, insisting on the enduring consequences of the slave trade for African economical and social development. This leads them to pay relatively more attention to the issue of reparations. Caribbean memory entrepreneurs often highlight the ethnic dimension of the memory of slavery. In that perspective, the slave trade and slavery are perceived as the core elements of their Creole culture. As the influential *Créolité* writers have argued, the slave trade opened the way to multiple racial mixtures that have defined new cultural identities, languages, and religious practices.[26] This leads memory entrepreneurs from the DOM to emphasize slavery and the slave trade as founding moments of Black Atlantic identities, which must be remembered and commemorated as such. However, identities overlap, and beyond these ethnic particularities lies the more general issue of racial identities.

Indeed, in contemporary French cities, the various memory advocacy initiatives, controversies, and symbolic struggles have always embedded the political question of race relations in a predominantly White country. The background of the late 1980s, when various memory organizations emerged, was deeply influenced by the appearance of anti-racist movements in France. At the time, numerous associations strongly opposed race discrimination and promoted the integration of immigrants, in opposition to the first successes by the far-right Front National Party in local and

national elections. From the beginning, the slave trading and slavery past has been interpreted as a potentially useful resource in the racial struggle. Significantly, in their accounts of their commitment in this cause, memory entrepreneurs very often underline the role of racism and discrimination suffered in France. For instance, as its very name makes clear, Diverscités' struggle on memory is bound to a more global present-day fight for equal opportunities. In their view, acknowledging the past, speaking frankly of the slave trade, and assessing the importance of slavery are pedagogical actions supporting the vision of racial difference as nothing natural, but a socially constructed vision of human difference able to provide a moral basis for the exploitation of human beings.

Their approach, in Nantes as well as in Bordeaux, aims essentially at updating the memory of slavery in order to point out the legacies of slavery, incarnated in persistent racial discrimination. From this viewpoint, history and memory made the support for racial claims to which they want the local community to listen and respond. To some extent, this is what grounds the contentious dimension of that memory. As Vered Vinitzky-Seroussi explains, "[T]he past threatens to penetrate the contemporary social and political scene, to change the hegemonic narrative, to encourage voices to demand justice and recognition."[27] However, what is at stake here is not only the past, but also a past bound to guilt and responsibility. This is a second, related, contentious dimension of the memory debate. To what extent can a guilty event of the past be remembered collectively, both by those who present themselves as "descendants of victims" and those designated as "descendants of perpetrators"? How does one deal with these identifications in a political context that tends to dismiss community affiliations and particular belongings? Actually, the involvement of public authorities in the local commemorations of slavery resulted in a process of negotiating, selecting, and framing the meanings that had to be highlighted through the remembering process. This is made evident though an analysis of the memory devices elaborated by Nantes and Bordeaux to express their official visions of the past and the present, especially in the museums.

Public authorities in these two cities showed permanent concern with the risk of stigmatization of their elites as "perpetrators" responsible for the past misdeeds. In virtually every commemorative speech, both mayors strive to impose a narrative of the memory of slavery that dismisses such a conception, firmly rejecting "repentance" as a perverse and divisive way of interpreting the past. According to them, one has not to be judged for his history through contemporary moral lenses.[28] When Diverscités launched a controversial campaign calling for elimination of the street names that honored merchants involved in the slave trade, the mayor wrote on his blog: "When will all this repentance come to an end?" He justified his opposition to changing the names by claiming that it would unfairly indict some families. To him, acknowledgment of responsibility becomes unfair when it points at present-day citizens. Moreover, public

authorities consider it a dangerous approach of memory, bearing the risk of feeding division among the population by setting forever victimhood and suffering as the ontology of black people and guilt as the everlasting burden of whites. Most of the memory entrepreneurs tend to agree with this precaution, and consider "repentance" as an inadequate approach as well. Historians, on the one hand, refuse moral anachronism and stress the importance of contextualization. Black memory entrepreneurs, on the other hand, are not comfortable with this qualification as "victims," fearing that it could reinforce the stigma of weakness and passivity usually associated with blackness. Victimization, as McCarthy explains, can be "culturally and politically debilitating."[29]

Black militants strive to counter this idea of a "genealogy of victimhood" by putting forward, in their commemoration practices, the agency and initiatives of enslaved men and women. Remarkably, in Nantes, the memory associations chose "resistance" as the topic of their 2010 commemorative events in a bid to highlight the active role of enslaved individuals in the antislavery struggles. This absolute refusal of the "victim–perpetrator" interpretation of the slavery past has noteworthy repercussions. Whereas reparations—whether under the form of financial compensation or symbolic gestures—has been a backdrop for many memory debates about slavery, such an approach is largely absent from the collective remembrance practices developed in French former slave trade cities. Whereas the United Nations Conference in Durban in 2001 had put reparations for Africa on its agenda, and whereas black memory entrepreneurs in the United States and England have made claims for financial compensation for slavery, such considerations are virtually unconceivable in the French context.

At a more local level, the 1999 decision of the city council of Liverpool to express a formal apology for the city's role in the slave trade could not now be imitated in Bordeaux or in Nantes because it identifies a community of perpetrators and an opposite community to which the perpetrators express sorrow.[30] By all evidence, another important factor has to be taken into account to understand the rejection of symbolic compensation processes. French social and political conceptions traditionally consider the expression of racial identities in the public space as illegitimate. Thus, there is no institutionalized community, in the French context, to whom an apology could be addressed *a priori*. Expressing regret to a community would thus have the unacceptable effect, in the French traditional view, to encourage the racial division of the society. It is worth noticing that the same conceptions and processes have framed the building of slavery memory at the national level. In 1998, when France celebrated the 150th anniversary of the 1848 abolition of slavery, Lionel Jospin, then prime minister, asked the French people to "remember the truth, but not to develop a debate between the descendants of victims and the descendants of perpetrators that would create misunderstandings in France and in the

Antilles." Far from feeding the so-called "competition" between ethnic or racial memories, public policies of memory in Nantes and Bordeaux are likewise meant to enhance political unity and belonging to the same shared community.

This orientation of the public narrative on slavery is manifest in the recently opened exhibits in the city museums. Emphasis is put neither on race relations nor on the suffering of the slaves but on historical accuracy and objectivity. The main character of the story is not the slave; it is the city, the local community. The Nantes History Museum's exhibition proposes an historically incontestable account of transatlantic slavery. Figures and facts are accurate and objective, and all is done to make historical transparency prevail over other considerations. The slave trade in Africa, the Middle Passage, life on the plantations, and rebellions are, of course, mentioned and largely illustrated with maps, engravings, and objects. However, the slave perspective is rarely at the center of this narrative and is not supported by sensible instruments, such as video or slave narratives, resulting in a static and emotionless representation of a dead past. Emphasis is put neither on the crime nor on the legacies of slavery. Moreover, nothing is told about the racial continuity between the past and the present, whether in Nantes or beyond the city. Instead, the master-narrative focuses predominantly on the prosperity that was brought to the city by the transatlantic trade. Quite ambiguously, a strong emphasis is put on the goods brought from the French Caribbean colonies, as well as on development in Nantes and its commercial domination. Furthermore, the exhibit deals extensively with the luxurious way of life among elites in Nantes, represented by dozens of pieces of bourgeois furniture, artworks, or precious objects of everyday life. Despite the historic accuracy of the narrative, the general tone has far more to do with glory than with contrition, while objectivity prevails over sensibility.

In Bordeaux's Museum of Aquitaine, the will to favor a more sensitive approach of black identities is unquestionable. The museum has imported some of its conceptions from Liverpool's International Slavery Museum, which opened in 2007, as mentioned by Alain Juppé, the mayor of Bordeaux, in his inauguration discourse.[31] But whereas Liverpool's museum is mainly a museum about black history, Bordeaux's museum is mainly a museum about Bordeaux. The first room, which deals with Bordeaux's bourgeois culture and architecture, is titled "the Pride of a Stone City," which can sound inappropriate in an exhibit dedicated to the transatlantic slave trade and slavery. Further, another room is named *An Eldorado for Aquitans*. All these elements suggest a kind of duplicity similar to the one pointed out in Nantes. In Bordeaux's case, however, the museum strategy clearly tries to conciliate historical accuracy with a more sensitive approach to memory. Following Liverpool's example, a large part of the exhibit is devoted to the legacies of slavery. Although it deals much more with the abolition and the French Revolution than

with black history in a broader sense, this room underscores the contemporary issues of racism, cultural diversity, and the lives of black people in Bordeaux. This can be considered an effort to address race relations concerns that are embedded in most public memory claims, including the local ones. To some extent, Bordeaux's museum expresses a negotiated memory of slavery: whereas its historical narrative focuses on the city's identity, it nevertheless integrates a racial minority perspective.

CONCLUSION

In a French ideological context where racial identifications remain illegitimate, black memory entrepreneurs have used the memory of slavery and the slave trade to support claims for more diversity consciousness. Whereas the public memory response of Nantes is confined to an emotionless version of historical accuracy and disregards racial issues, Bordeaux's answer to slavery memory claims demonstrates more sensibility to race relations concerns. One could argue that acknowledgment of the past, as opposed to silence or amnesia, is already a step toward justice, following James Booth who states that "the great fear for memory–justice is that the crime will be allowed to slip into oblivion, into the forgotten; that the passage of time will, like a natural solvent, free the perpetrators and weaken the already weak hold of justice in the world."[32] But shouldn't one expect more from memory as a tool for justice? While it is indubitable that both cities' policies of memory (including museums, public commemorations, and memorials) now prevent the past from slipping back into oblivion, they have nevertheless deprived the slave-trading memory from its most contentious dimensions. Its racial significance in particular has been largely maintained invisible. Instead, the policies of memory of both cities have forged a comparable narrative about the past, one that is congruent with the French traditional perspective about identities. Such a perspective considers that a shared "recognition" of the past (conceived as an equivalent to historical transparency) is able to maintain political unity, whereas victimhood, guilt, and redress are race-oriented divisive concepts. This position expresses a political conception of identity concerned with the slave-trading past not as part of a racial history or struggle, but as part of a unifying political project. In other words, Nantes and Bordeaux have adhered to a "republican" vision of collective memory, which enhances the capacity of a political community to remember collectively its history. Correlatively, another important dimension of the memory regime elaborated by the two former slave trade ports is the focus on local identity. As cities once at the forefront of the slavery economy, the great fear of their leaders was the public stigmatization for the guilty past. Acknowledgment of their role in the slave trade, in fact, allowed them not only to resist

this process but to reverse it. By appearing as brave communities willing to confront history through museums and memorials, these two former slave trade ports have engaged in a re-creation of their identities in which they have involved their elites, their population, and the local memory entrepreneurs. While they officially acknowledge the past, both cities have developed a new and positive worldwide image. This confident self-identification demonstrates to the world that these two cities are no longer shame-filled bourgeois communities inherited from slave traders but modern, realistic cities proud to build on a troubled past. Contrasting with a past of narrow-mindedness, recognizable keywords of modernity such as "transparency" and "cultural diversity" have thus been put at the center of their new identity narratives. In other words, Nantes and Bordeaux expect that their identity will not be determined by the past, but by the way they remember it.

NOTES

1. La Rochelle (482), Le Havre (452) and Saint Malo (218) follow Bordeaux and Nantes in terms of number of expeditions. See David Eltis et al., *The Trans-Atlantic Slave Trade Database: Voyages*, http://www.slavevoyages.org.
2. Olivier Pétré-Grenouilleau, *Nantes et la traite négrière* (Nantes: RMN-Château des Ducs de Bretagne, 2007), 4.
3. Eric Saugera, *Bordeaux port négrier* (Paris: Karthala, 1995), 202.
4. The notion of "memory entrepreneurs" stems from Howard Becker's analyses of the particular role of groups of militants in the construction, diffusion, and preservation of moral values. See Howard Becker, *Outsiders* (Paris: Métailié, 1985), 171. The parallel between this designation and the comparable dynamics of memory entrepreneurship is made by Michael Pollak in *L'Expérience concentrationnaire. Essai sur le maintien de l'identité sociale* (Paris: Métailié, 1990), 246–247.
5. Researchers have identified only 54 voyages from African shores to Europe between 1514 and 1866. The main destination of most of these voyages was Portugal; France appears as the main landing port in only four voyages whose identification numbers are: 30339, 33731, 33732, and 33784. See Eltis et al., *The Trans-Atlantic Slave Trade Database: Voyages*, http://www.slavevoyages.org.
6. Before decolonization, pride tended to dominate. The early twentieth-century public discourses in the two port cities usually referred to the centuries of transatlantic trade as a lost golden age. For instance, at the opening of a colonial fair in Bordeaux in 1919, a representative called for more commercial initiatives in order to revive the "magnificent effort that gave Bordeaux its splendor under Louis XVI" and to "go back to the Atlantic roads (and) discover new Saint Domingues." See Christelle Lozère, *Bordeaux colonial. 1850–1940* (Bordeaux: Sud Ouest, 2007), 210.
7. Fred Constant, "La politique française de l'immigration antillaise de 1946 à 1987," *Revue européenne des migrations internationales* 3, no. 3 (1987): 9–30.
8. Christine Chivallon, "Mémoires de l'esclavage à la Martinique," *Cahiers d'études africaines* L (1), no. 197 (2010): 235–261.

9. Myriam Cottias, "L'oubli du passé contre la citoyenneté: troc et ressentiment à la Martinique" in *1946–1996. Cinquante ans de départementalisation outre-mer*, ed. Fred Constant and Justin Daniel (Paris: L'Harmattan, 1997).
10. Frantz Fanon, *Peau noire, masques blancs* (Paris: Le Seuil, 1952).
11. Édouard Glissant, *Poétique de la relation* (Paris: Gallimard, 1990).
12. Édouard Glissant, *Le discours antillais* (Paris: Le Seuil, 1981).
13. On the 1985 events, see Marc Lastrucci, "L'évocation publique à Nantes de la traite négrière et de l'esclavage de 'Nantes 85' aux 'Anneaux de la Mémoire' 1983–1994" (MA diss., Université de Nantes, 1996).
14. Lastrucci, *L'évocation publique*, 44–52.
15. Jacques Chaban-Delmas, "Préface," *Bordeaux, le rhum et les Antilles* (Bordeaux: Musée d'Aquitaine, 1991), 5.
16. Christine Chivallon, "L'émergence récente de la mémoire de l'esclavage dans l'espace public : enjeux et significations," *Revue d'histoire moderne et contemporaine* 52, no. 4 (2005): 54–81.
17. "Commémoration de l'abolition de l'esclavage, déclaration au port de Nantes, 23 mai 1992" *DOM TOM COM: périodique pour la communication de la Communauté d'Outre-Mer et de ses sympathisants*, 1, 1992.
18. Lastrucci, "L'évocation publique, " 132.
19. Lastrucci, "L'évocation publique, " 99.
20. Saugera, *Bordeaux port négrier*.
21. Jean-Luc Bonniol, "Echos politiques de l'esclavage colonial, des départements d'outre-mer au cœur de l'État," in Claire Andrieu, Marie-Claire Lavabre, and Danielle Tartakowsky, ed. *Politiques du passé. Usages du passé dans la France contemporaine* (Aix-en-Provence: Publications de l'Université de Provence, 2006), 64.
22. Christine Chivallon, "Construction d'une mémoire relative à l'esclavage et instrumentalisation politique: le cas des anciens ports négriers de Bordeaux et Bristol," *Cahier des Anneaux de la Mémoire* 4 (2002): 177–203.
23. The original text reads: "À la fin du XVIIe siècle, de ce lieu est parti le premier navire armé dans le port de Bordeaux pour la traite des Noirs. Plusieurs centaines d'expéditions s'en suivirent jusqu'au XIXe siècle. La Ville de Bordeaux honore la mémoire des esclaves africains déportés aux Amériques au mépris de toute humanité."
24. "À Bordeaux chacun commémore de son côté," *Sud Ouest*, May 10, 2007.
25. Robin Wagner-Pacifici and Barry Schwartz, "The Vietnam Veterans Memorial: Commemorating a Difficult Past," *American Journal of Sociology* 97 (1991): 376–420.
26. Jean Bernabé, Patrick Chamoiseau, Raphaël Confiant, *Éloge de la créolité* (Paris: Gallimard, 1989).
27. Vered Vinitzky-Seroussi, "Commemorating a Difficult Past: Yitzhak Rabin's Memorials," *American Sociological Review* 67 (2002): 31.
28. "We 21st century citizens of Bordeaux are obviously not responsible nor guilty for what has been done during the seventeenth, eighteenth, and nineteenth centuries in a profoundly different historical context." Alain Juppé, Mayor of Bordeaux, Speech for the inauguration of "Bordeaux, le commerce Atlantique et l'esclavage," Museum of Aquitaine, May 10, 2009.
29. Thomas McCarthy, "Coming to Terms with Our Past, Part II: On the Morality and Politics of Reparations for Slavery," *Political Theory* 32 (2004): 768.
30. There are a few examples of such apologies or expression of regrets related to slavery and the slave trade. In 1991, taking the opportunity of a visit to Gorée Island (Senegal), Pope John Paul II expressed regrets for "Christian Europe's sins against Africa." This induced some of the participants at the

Abuja (1993) and Durban (2001) conferences to call for official apologies on the part of the former slave trade nations, a claim that was unsuccessful. Bill Clinton also expressed regret for the slave trade on behalf of the United States during a 1998 trip to Africa. In 1997, US Representative Tony Hall had unsuccessfully introduced a resolution into the US House of Representatives calling for an official apology for slavery. On the debate about reparations for slavery, see Rhoda Howard-Hassman, "Reparations to Africa and the Group of Eminent Persons," *Cahiers d'études africaines* 173–174 (2004): 81–97.
31. Alain Juppé, Discourse for the inauguration of "Bordeaux, le commerce atlantique et l'esclavage," Museum of Aquitaine, May 10, 2009.
32. James Booth, "The Unforgotten: Memories of Justice," *American Political Science Review* 95–4 (2001): 779.

8 The Challenge of Memorializing Slavery in North Carolina

The Unsung Founders Memorial and the North Carolina Freedom Monument Project

Renée Ater

Commemoration of the Atlantic slave trade, slavery, and subsequent emancipation of African Americans has presented a formidable challenge for artists working in three-dimensional form in the United States. Nineteenth-century sculptors such as John Quincy Adams Ward, Edmonia Lewis, and Thomas Ball wrestled with the questions of how best to memorialize slavery and freedom, and how to depict the black body in bronze and marble.[1] In the early twentieth century, amateur art historian Freeman Henry Morris Murray, in his volume, *Emancipation and The Freed in American Sculpture* (1916), recognized that the location of sculpture in civic and public spaces spoke to communities about who they were and how they remembered the past. He wrote:

> The fact is, nearly all sculptural groups and a considerable number of individual statues, are based on some purpose beyond mere portraiture or illustration. Moreover, these commemorative and "speaking" groups generally stand in the open, at the intersections of the highways and in the most conspicuous places. We cannot be too concerned as to what they say or suggest, or what they leave unsaid.[2]

Murray succinctly articulated the problem and politics of representation, meaning, and remembrance of the slave past in public space. He was concerned, foremost, with how sculpture shaped the public's understanding of slavery and of African Americans in the post-Civil War era. Murray feared that citizens and local governments would use monuments dedicated to the Civil War to erase slavery from public memory, and that they would only celebrate the white heroes and common soldiers of this seismic event. One might argue that Murray was right about erasure—a one-hundred-year gap exists between the late-nineteenth- and early-twentieth-century monuments Murray discussed in his book and the current wave of monument building in communities in the South, Midwest, and Northeast. In the early twenty-first century, it seems there is a scramble to commemorate the slave past.

Slavery remains an unreconciled and painful aspect of the American past. It is not that the United States lacks nuanced histories on slavery; historians from Eugene Genovese to Ira Berlin have written on slavery, concentrating on the dynamics of African American lived experience in the antebellum South.[3] Even with the dozens of histories on slavery, it is difficult as a nation to place slavery into a national narrative of freedom. Historians James Oliver Horton and Johanna Kardux argue, "For Americans, a people who see their history as a freedom story and themselves as defenders of freedom, the integration of slavery into their national narrative is embarrassing and can be guilt-producing and disillusioning. It can also provoke defensiveness, anger and confrontation."[4] The anguish of this past makes North Americans uncomfortable and often unwilling to engage in dialogue about its meaning because the slave past is linked inextricably to issues of race and race relations in the present moment.[5]

In the twenty-first century, how then are slavery and its memory to be represented in public monuments in the United States? How are artists to render this sensitive subject, which has the potential to produce feelings of shame and antipathy? In the words of the art historian James Young who writes on Holocaust memorials, "How does a nation memorialize a past it might rather forget?"[6] In the last two decades, artists and communities have come together to remember and to memorialize slavery through public monuments made of steel, bronze, stone, glass, and other organic materials. They use diverse forms: abstraction, figural representation, and the built and natural environment. Some reference the Middle Passage and slavery, others resistance to slavery, and still others the emancipated men and women. These monuments are about recovering the slave past and creating a public memory of slavery. The building of these monuments and memorials are often divisive, and foster difficult conversations about slavery, the black body, site, and artistic vision.

This chapter examines two memorials/monuments in North Carolina where conflict over and discussion of the meaning of slavery, the events of the Civil War, and the Confederate past are ongoing. In the past decade, the University of North Carolina at Chapel Hill and at Greensboro as well as the North Carolina State Archives have initiated digital library projects on slavery in the state. And the UNC School of Education in collaboration with the *Documenting the American South* initiative offers online lessons plans on slavery and the black experience across North Carolina to middle and high school teachers. In the past two decades, public conversations have erupted periodically regarding the numerous monuments to the Confederacy in North Carolina, particularly those monuments located on the grounds of the capital building. The monuments I examine here are the Unsung Founders Memorial situated on the campus of the University of North Carolina at Chapel Hill, and the North Carolina Freedom Monument Project planned for downtown Raleigh (Figures 8.1 and 8.2). I assess the visual forms of the memorials and consider how the diverse constituencies,

The Challenge of Memorializing Slavery in North Carolina 143

the university community at Chapel Hill, and the monument planning committee and citizens of North Carolina, have sought to remember slavery in the public spaces of the campus and city. The two monuments take different forms: one, using figuration, text, and site, recalls the untold number of African Americans, free and slave, who helped to build the university, the other to be located in the state's capital utilizes abstraction, space, time, and movement to consider broadly the idea of freedom.

I am interested in the Unsung Founders Memorial and the North Carolina Freedom Monument Project as "sites of memory." Such sites are "places where we struggle over tensions between our experience of the past (memory) and our organization of it (history)."[7] The purpose of sites of memory, according to the scholar Pierre Nora, is "to stop time, to block the work of forgetting, to establish a state of things, to immortalize death, to materialize the immaterial."[8] Both the Unsung Founders Memorial and the North Carolina Freedom Monument Project act as sites of memory and typify larger issues in monument building regarding how to memorialize the slave past in visually comprehensible ways for various audiences.

This chapter is part of a larger research project entitled *Unsettling Memory: Public Monuments to Slavery in the United States*. From Peoria, Illinois, to Richmond, Virginia, to Savannah, Georgia, local governments and communities are in conversation about their cities' relationships to the slave

Figure 8.1 Do-So Huh, Unsung Founders Memorial, bronze and granite, McCorkle Place, University of North Carolina at Chapel Hill, 2005. Photograph by Renée Ater, 2010.

144 Renée Ater

Figure 8.2 Schematic drawing of the North Carolina Freedom Monument Project, Raleigh, prepared by Juan Logan, Lyneise Williams, and David Swanson, June 2008. Courtesy of North Carolina Freedom Monument Project.

trade and slavery; some have built monuments to the slave past, and others are still engaged in conversation about what sort of memorials should be built. In *Unsettling Memory*, I examine a wide range of monuments as sites of memory and the way in which various publics interact and understand slavery through the process of monument building. At the core of my research are two questions: What should these monuments do? What should they look like? Issues related to figuration and abstraction, site relationship, materials and the significance of form, and the visitor encounter and the creation of meaning are at the core of the book project.

THE SLAVE PAST AND COLLECTIVE IDENTITY

In October 2001, the senior class at the University of North Carolina at Chapel Hill considered their class gift to the institution. The senior class officers presented three options to their fellow students: a freestanding sculpture, to be titled the Unsung Founders Memorial, "honoring men and women of color who helped raise the first buildings on campus"; a marquee for the campus' Memorial Hall to promote events; and a need-based scholarship for a senior student.[9] Although the gift committee did not publicly indicate why they had chosen a monument to honor slavery, the Confederate soldier statue, Silent Sam, located on the north campus has generated an enormous amount of controversy over the years with repeated calls for its removal. In UNC classrooms, students have considered the significance of Silent Sam and slavery to the university.

In the discussions that ensued in the student paper about the three gift options, *The Daily Tar Heel*, one writer placed the class gift within the context of the September 11, 2001, attack on the Twin Towers in New York City. She wrote:

> My senior year has been tainted with evil and the present reality of war. Things that I might have felt were very important before are not nearly as pressing now. The idea of giving money to a senior class gift . . . seems trite, when many are suffering not only in our own nation but all over the world from this unthinkable act of terrorism.[10]

The writer made a plea that seniors should pursue "an alternative gift idea that better memorializes Carolina's own from Sept. 11."[11] Although students apparently debated the efficacy of the gift, the suggestion of a memorial to September 11 never gained ground with the class of 2002. Of the seniors who voted, approximately 44 percent selected the Unsung Founders Memorial.[12]

By March 2002, the senior class gift committee, which included African American students, had selected Korean-born artist Do-Ho Suh to create the memorial; he was one of fourteen candidates who submitted

designs for the monument, and one of four finalists invited to the campus to present his work to the committee. The senior class president Ben Singer argued, "This monument is not about improving the university aesthetically, but rather embracing our roots and telling a story."[13] The gift committee was determined that the slave past of the university be openly and visibly acknowledged. The students, parents, and alumni quickly raised $54,000, and the university contributed an additional $40,000 for the project. The student committee, the artist, and the university reflected on the form and placement of the monument. From the beginning, Suh relayed he would incorporate his signature miniature figures into the memorial, and in visits to the campus, he hoped to place it in a highly visible and well-traveled location.[14]

On May 11, 2005, the Unsung Founders Memorial was installed on the McCorkle Place lawn in front of the Alumni Building, joining a constellation of monuments that made this green space rich with reminders of the university's history (Figure 8.1). Suh created three hundred small bronze figures, which hold in their upraised arms a round granite table. Suh racialized these figures through physiognomy and dress: all of the figures have distinctive Negroid features. The women are modeled wearing handkerchiefs or short hair and dressed in long skirts. The men are depicted in three ways: dressed in jacket, shirt, and pants (freeman), attired in a simple shirt and pants (laborer), or bare chested and barefoot (slave). Inscribed on the highly polished surface of the table, which resembles a pool of water, are the words: "The Class of 2002 honors the University's unsung founders—the people of color, bond and free, who helped build the Carolina that we cherish today." Surrounding the low-to-the-ground memorial are five seats made from local granite, allowing members of the university community and visitors to sit and contemplate slavery and UNC history, or to use the surface of the monument as a table. Suh sculpted the seats to resemble the rough-hewn stone grave markers of slaves and free persons of color found in the Old Chapel Hill Cemetery, not far from McCorkle Place.

Suh is known for work that challenges his viewers to think about collective action and individual identity, and about the dynamic between public space, architecture, and scale. In his sculptural installation entitled *Floor* (1997–2000), commissioned for the Indianapolis Museum of Art, Suh created a grid of thirty-two individual glass squares. Beneath the glass, hundreds of Atlas-like, interlocking figures with heads upturned and arms raised support the glass platform. Visitors were encouraged to walk on the piece, exploring the tension between personal and communal space.[15] In *Public Figures* (1998–1999), created for an exhibition at MetroTech Center Commons in Brooklyn, Suh undermined the idea of monument building by inverting its form.[16] Instead of a famous individual standing on top of the pedestal, Suh left the top of the stone platform empty. Beneath the plinth, he cast six hundred diminutive men and women who carry the stone mass in their upraised arms. He upends the reverence for the famous individual

The Challenge of Memorializing Slavery in North Carolina 147

in *Public Figures* and emphasizes the collective who sustain those in power. Suh remarked, "I was asked to do some public sculpture in this public place. And I started to think about what it means, public space, and what is the meaning of public art or monument. I tried to rethink this whole notion of monument. Usually it is a bigger than life size, individual, an illustrious figure. What I did was I took it down, and made it smaller, and made it into multiples. I just want to recognize anonymous everyday life, people who pass through that space."[17]

The Unsung Founders Memorial is deeply tied to Suh's previous installations in its subversion of what we think a monument should be. Public monuments often aggrandize our heroes and memories of them. They offer spaces of consolation, redeem traumatic events, or mend memory. They present a fixed point for engaging and understanding the past.[18] In effect, Suh has created a countermonument, "a memorial space conceived to challenge the conventional premises of the monument," in the words of Young.[19] Suh's memorial offers us no aggrandizing of black heroes or historic events and no redemption of the trauma of slavery. Instead, Suh focused on collective endeavor through the gesture of the upraised arms. "If you look at the figures' facial expressions they don't look oppressed, so it has a kind of positive gesture, but what they are doing actually is just bearing weight."[20] It is this bearing weight as a community that Suh brings into presence.

The university dedicated the monument on November 5, 2005, with then chancellor James Moeser and then dean Bernadette Gray-Little delivering remarks. In their speeches, both Moeser and Gray-Little addressed the legacy of slavery and its role at the University of North Carolina. Moeser understood the memorial as encouraging public conversation about slavery, stating:

> What we do today will not rectify what our ancestors did in the past. But this memorial, I believe, attests to our commitment to shed light on the darker corners of our history. Yes, the University's first leaders were slaveholders. It is also true that the contribution of African American servants and slaves were crucial to its success.[21]

Gray-Little spoke to the pain of the past: "One of the troublesome legacies of slavery is the pall that it casts over the family histories of those who were bought and sold. This monument finally recognizes the many unnamed whose toil and talent made the nation's first public university possible."[22] The official interpretation of the memorial stressed willingness to recognize the slave past as integral to the fabric of the university with Moeser and Gray-Little celebrating the figuration of Suh's memorial expression. The university and local communities, however, responded to the memorial with wariness and understood it in competing ways.[23]

The struggle over meaning and interpretation of the Unsung Founders Memorial is related to the tension between the site and the nearby landmarks

and to the issue of race relations in the past and present at the university.[24] As a site of memory, McCorkle Place heralds the persistence and nobility of the university. The Unsung Founders Memorial resides within the context of four monuments that are indelibly linked to the history and iconography of the university: the Old Well, the Davie Poplar, the Joseph Caldwell Monument, and Silent Sam. Most important for the discussion here, the memorial has disturbed the celebratory narrative of McCorkle Place and provoked a rethinking of the university's past and its identity.

The Old Well stands at the southern end of McCorkle Place and is the official logo of the University of North Carolina at Chapel Hill. For years, it was the primary water source for the Old East and Old West dormitories. In 1897, the old wooden structure was replaced with a small neoclassical rotunda with Ionic columns, the design based on the Temple of Love at the Palace of Versailles. The fountain located in the rotunda is said to bring good luck to students who drink from it on the first day of classes. The Davie Poplar is an enormous tulip poplar said to mark the spot where the Revolutionary War general William Richardson Davie picked the site for the university. The story is apocryphal: a six-man committee from the university's governing board selected the location in November 1792; the tree was named for Davie by Cornelia Phillips Spencer almost a century later to commemorate this myth of origin. University lore maintains that as long as the poplar remains standing, the university will flourish.[25]

The marble obelisk of the Joseph Caldwell Monument commemorates the first president of the university, who was also a slave owner, and serves as grave marker for Caldwell and his wife, who are buried at the base of the monument. The memorial on McCorkle Place is the second monument designed for Caldwell. The original obelisk, made of sandstone, was moved to the Old Chapel Hill Cemetery and rededicated to Wilson Caldwell, November Caldwell, David Barham, and Henry Smith, four African American slaves who served the University. The most controversial of the monuments is Silent Sam, located at the northern end of McCorkle Place. The United Daughters of the Confederacy gave the statue to the university in 1909, and it was erected in 1913 to honor the memory of the 321 alumni of the school who fought for the Confederacy during the Civil War. A statue of a confederate soldier holding a rifle, *Silent Sam* wears no cartridge box for ammunition, and thus, cannot fire his gun, which remains silent.[26]

The university community's relationship to and understanding of Silent Sam is complicated and often polarized. For some Silent Sam is a symbol of regional heritage and pride in the Confederacy. Others view the statue as an integral part of the university's history that should not be erased. For others, he represents racial oppression, white supremacy, and continued social conflict.[27] The statue has also been the site of numerous protests and acts of vandalism in the past. After the brutal beating of Rodney King by the Los Angeles police in March 1991, the subsequent April 1992 trial in which a jury acquitted the police, and the ensuing Los Angles riot, students rallied

at the statue to speak out against racism and injustice. In May 2000, April 2003, and most recently in January 2011, former UNC Professor Gerald Horne called for the removal of the statue: "There is no better example of racial separatism than the Confederacy and the statues that honor it."[28] He suggested that the work should be moved to a historical society or museum. University officials responded that the statue would remain at McCorkle Place. Nancy Davis, associate vice chancellor for university relations, argued: "We are a Southern university, and we have to come to terms with that history. This sculpture tells people where we have been."[29]

By selecting McCorkle Place as the site for his memorial, Suh established a visual dialogue between Silent Sam and the Unsung Founders Memorial that has been contentious at times, something that Suh was surely aware would happen at this southern university. And from the time of its dedication, the Unsung Founders Memorial has provoked an equally wide range of responses from the university and local communities. The senior gift committee understood the monument to be "advanced and progressive," and saw their gift as one of remembrance not glorification.[30] Some feel that it stands in the shadow of Silent Sam, the memorial too low to the ground to compete with the monumental size of the Confederate soldier. Others see its use as a functional table as inappropriate for a memorial. Others are surprised that the word slavery is not inscribed on the table. Some view the miniature figures that hold up the table as inadequate and see the men and women as being crushed by the symbolic weight of the university. Still others feel that the anonymity of the figures continues a legacy of denial on the part of the university.[31] Local social activist Yonni Chapman, who died in 2009, said of the Unsung Founders Memorial,

> the black workers holding up the table are nearly invisible to such visitors, who inadvertently kick mud in the faces of the unsung founders. Disrespected, poorly paid and anonymous black workers have always carried the weight of the university on their backs . . . Now they have a monument that supposedly honors them by mocking their sacrifice.[32]

The Unsung Founders Memorial has elicited a charged response similar to that of Silent Sam, albeit for different reasons. This countermonument has interrupted the sacred memory work of McCorkle Place, making it a space where slavery remains an uncomfortable aspect of the university's past.

Coinciding with the dedication of the Unsung Founders Memorial, the University Archives sponsored both a physical and digital exhibition entitled *Slavery and the Making of the University*. The physical exhibit was displayed in the Manuscripts Department of the Wilson Library from October 12, 2005, through February 28, 2006. The purpose of the exhibition was "to introduce materials that recognize and document the contributions of slaves, college servants and free persons of color primarily during the university's antebellum period."[33] Do-Ho Suh's memorial

and the exhibition were meant to work in concert, the memorial visually acknowledging slaves and free persons of color who labored on the campus, and the exhibition adding layers of information, mostly textual—letters, speeches, diaries, historical financial records, ledger and expense books, wills, slave narratives, advertisements, photographs, and a bibliography of sources. A graduate student in public history also created a self-guided walking tour of the campus that highlighted the contributions of enslaved people at the university. Officials at the University of North Carolina saw the unveiling of the Unsung Founders Memorial and "Slavery and the Making of the University" as intertwined, and as opportunities to begin a dialogue about the slave past, a slow, and at times, heart-searing one, and for some, unsatisfactory.

THE SLAVE PAST AND THE MOVEMENT TO FREEDOM

The planned North Carolina Freedom Monument Project in Raleigh (figure 8.2), in contrast, approaches the slave past and the memory of it in fundamentally different ways than the Unsung Founders Memorial. Instead of a singular monument, the project leaders envision a "space for contemplation and inspiration and an extraordinary work of public art" at the heart of North Carolina's capital. It is meant "to pay tribute to those who experienced slavery, Jim Crow and other forms of discrimination and oppression," to highlight the concept of freedom, and to provide a sensory experience of the past.[34] The goals of the project are fourfold: "to create and strengthen bonds between diverse people; to educate and enhance mutual understanding; to honor the African American experience in North Carolina; and to serve as a model of cooperation, respect, and common values."[35] The slave past is one aspect of the project with the concept of freedom providing the longitudinal frame for the open plaza.

The project has its origins in the Paul Green Foundation, an organization established in 1982 to perpetuate the vision of the dramatist and civil rights activist Paul Green (1894–1981). His grandson, Paul Mac Green, traveled to Barbados in 2001 where he saw Karl Broodhagen's *Bussa Emancipation Statue* (1985). The image of a slave breaking free from his manacles inspired Green to persuade the foundation to start a freedom monument project in North Carolina.[36] In June 2002, the foundation convened a meeting of fifty community leaders and educators from across the state to discuss the conceptual and organizational issues related to creating the monument. Following this meeting, project leaders held regional town meetings across the state—in the cities of Durham, Raleigh, Greenville, Hickory, Asheville, and Elizabeth City—to encourage the public to share its opinion on what the monument should look like, and more importantly, to stimulate dialogue on the African American experience in North Carolina. The steering committee used these meetings to discuss the nature

The Challenge of Memorializing Slavery in North Carolina 151

of oppression and freedom; they encouraged participants, both black and white, to conceptualize the legacy of the slave past within the context of their present lives. In June 2003, teachers, scholars, and community leaders reconvened at a meeting in Raleigh to "to identify the areas where this public process has led to consensus—and where it has not."[37]

The advisory board was determined to create a monument that looked and felt different from other monuments to the slave past. They turned to neighboring states to assess how statues and memorials in these capitals visualized slavery and the progress of African Americans, giving special consideration to Columbia, South Carolina's African American History Monument. They did not want to honor a singular historical figure or event, nor did they want to materialize the African American body in the spaces of the North Carolina Freedom Monument. They desire a "living" public space that allows the school children, citizens, government workers, elected officials, and visitors of North Carolina to wrestle with the meaning of the slave past, to understand the historical experience of African Americans in the state, and to consider the nature of freedom—"freedom of thought, freedom of expression, and freedom to respect one another."[38]

An international competition was held to find an artist or design team to conceive and build the project. In 2006, a jury of artists, architects, and community leaders from North Carolina reviewed 108 proposals, selecting the Chapel Hill team of multimedia artist Juan Logan, art historian Lyneise Williams, and landscape architect David Swanson to design the monument. With information from the town meetings contained in a report entitled *Communicating the Project's Vision and Voice*, the Logan team designed a space that uses words and abstract forms; local granite, fieldstone, and slate; flowing water; walkways, walls, and benches; and native trees and plants. The proposed site for the monument is symbolically important: near the state's Office of Archives and History, across from the Legislative Building, and several blocks away from the capital building.[39] Although the project has been delayed due to the downturn in the economy, the Paul Green Foundation made a significant contribution to the project, and Governor Bev Perdue has appropriated state funds toward the construction of the monument. Recently, it received approval from the North Carolina Historical Commission, a major step toward its realization.[40]

The North Carolina Freedom Monument Project will be composed of a series of interactive spaces and "sculptural vignettes." The case statement for the monument outlines its form: "This public art installation has been designed to carry visitors on the circuitous path to freedom as experienced by African Americans. The composition uses landscape elements to powerfully convey fundamental and recurring themes of African American's struggle for freedom: ingenuity and resilience, tension and hope."[41] Visitors will enter the monument from Lane Street, onto a sloped walkway symbolizing African Americans' uphill struggle and through broken entrance arches that represent unachieved freedom. A wide, spiraling walkway will

152 Renée Ater

lead visitors to several significant sculptural elements in the landscape: an auction block and weeping wall with the words "many thousands gone" inscribed on its surface; a circular granite fountain whose abstracted form is meant to suggest that "freedom originates in thoughts"; a serpentine wall whose undulations evoke the eastern coast of North Carolina, the arrival point for some slaves to the state; a wall fissured in two symbolizing Jim Crow; a jagged seating area representing turbulent times—the granite boulders will be placed strategically to interrupt the flow of the open plaza; and a reading bench signifying the connection between literacy and freedom. A large grassy area, "Freedom Ground," and an amphitheater filled with large steel forms are designed to allow the public areas to engage in dialogue about the past and present.[42]

The North Carolina Freedom Monument Project attempts to harness bodily and intellectual experience through landscape and abstract form, and longitudinal movement. The Logan team's design for Freedom Grove will require interaction not passive viewing. In its planned form, the monument appears to skillfully balance the tension between the remembrance of the past and experience in the present. In a 2006 interview, Logan remarked that team hoped to create "moments of transcendence and reflection, such as when walking around the fountain and reading the engraved words *Polaris, exodus, ownership, north*, and others. Some of the words will be partially obscured by water flowing over various parts of the fountain. When people touch and connect with the individual elements of the monument, we hope that each will see themselves differently."[43] The aims of the North Carolina Freedom Monument Project are lofty. This monument is not meant to be static, but rather through the physical and sensory encounter with the space, and the activities and dialogues planned for schoolchildren and visitors, the artists and advisory board envision that the North Carolina public will be constantly challenged to remember the past as an agent for transformation in the present: "Freedom Grove will not only be a work of public art but a point of entry for North Carolinians to contemplate and reflect upon issues of race and humanity, past and present."[44]

The design team and advisory board of the North Carolina Monument Project have created a "working memorial," a term used by architect Julian Bonder, to describe projects that encourage collective engagement and active dialogue.[45] He proposes that the role of the artist and architect in creating memorials is to uncover and anchor histories and memories. "Neither art nor architecture can compensate for public trauma or mass murder. What artistic and architectural practices can do is establish a dialogical relation with those events and help frame the process of understanding," argues Bonder. "Hence, it seems important to conceive of these projects as roadmaps, as spatial topographies, condensing voices, opening spaces for study, re-presentation, and dialogue with a measure of spatial clarity and architectural depth."[46] The North Carolina Monument Project encourages this sort of collective engagement and dialogic experience. It asks North

Carolinians to engage in conversation about the African American experience, and to inhabit the distance between past and the present, between remembrance and present-day struggles for freedom.

CONCLUSION

The Unsung Founders Memorial and the North Carolina Freedom Monument Project offer two differing approaches to memorializing the slave past and its legacy. Do-Ho Suh worked within the memory site of McCorkle Place to commemorate those men and women of color who helped to build the university, but remained unacknowledged. Suh purposefully called into question the nature of the public monument by challenging the monument form and asking the university community to consider the idea of the collective over the individual. For some, his miniaturized black bodies seem to bear the weight of the past with no visible acknowledgment of individuals or the historic role of slavery at the university. Like the other monuments at McCorkle Place, it has the potential to become yet another stone in the landscape. The North Carolina Freedom Monument Project will require visitors to experience its physical space as a somatic and cerebral journey to freedom. The project has the luxury of a large enclosed expanse of land that isolates visitors, to a certain degree, from competing surroundings. Interestingly enough, both monuments skirt picturing slavery by resorting to generic anonymity in the case of the Unsung Founders Memorial, and by using metaphor in the case of the North Carolina Freedom Monument. As sites of memory, they attempt to transcend the specifics of the slave past, particularly its abjection and suffering, in order to express larger truths.

NOTES

1. See for example, Kirk Savage, *Standing Soldiers, Kneeling Slaves: Race, War, and Monument in Nineteenth-Century America* (Princeton, NJ: Princeton University Press, 1997), and Charmaine A. Nelson, *The Color of Stone: Sculpting the Black Female Subject in Nineteenth-Century America* (Minneapolis, MN, and London: University of Minnesota Press, 2007).
2. Freeman Henry Morris Murray, *Emancipation and the Freed in American Sculpture: A Study in Interpretation* (Washington, DC: Murray Brothers, 1916), xx.
3. Eugene D. Genovese, *Roll Jordan Roll: The World the Slaves Made* (New York: Pantheon Books, 1974), and Ira Berlin, *Many Thousands Gone: The First Two Centuries of Slavery in North America* (Cambridge, MA: Belknap Press of Harvard University Press, 1998).
4. James Oliver Horton and Johanna C. Kardux, "Slavery and the Contest for National Heritage in the United States and the Netherlands," *American Studies International* 42, nos. 2 and 3 (June–October, 2004): 52.
5. Ira Berlin, "Coming to Terms with Slavery in the Twenty-First Century," in *Slavery and Public History: The Tough Stuff of American Memory*, ed.

James Oliver Horton and Lois E. Horton (Chapel Hill, NC: University of North Carolina Press, 2008), 3.
6. James E. Young, "Memory/Monument," in *Critical Terms for Art History*, ed. Robert S. Nelson and Richard Shiff (Chicago, IL, and London: University of Chicago Press, 2003), 240.
7. Scott A. Sandage, "A Marble House Divided: The Lincoln Memorial, the Civil Rights Movement, and the Politics of Memory, 1939–1963," *Journal of American History* 80, no. 1 (June 1993): 137.
8. Pierre Nora, "Between Memory and History: *Les Lieux de Mémoire*," *Representations* 26 (Spring 1989): 19.
9. Meredith Nicholson, "Students Respond to Class Gifts," *The Daily Tar Heel*, October 2, 2001, http://www.dailytarheel.com/index.php/article/2001/10/students_respond_to_class_gifts.
10. Kate Hartig, "Choosing the Right Senior Gift," *The Daily Tar Heel*, October 9, 2001, http://www.dailytarheel.com/index.php/article/2001/10/choosing_the_right_senior_class_gift.
11. Hartig, "Choosing the Right Senior Gift."
12. "Class Vice President Urges Seniors to Look At All Options for Gift," *The Daily Tar Heel*, October 10, 2001, http://www.dailytarheel.com/index.php/article/2001/10/class_vice_president_urges_seniors_to_look_at_all_options_for_gift, and Jamie Dougher, "Senior Class Gives Nod to Unsung Founders," *The Daily Tar Heel*, October 12, 2001, http://www.dailytarheel.com/index.php/article/2001/10/senior_class_gives_nod_to_unsung_founders.
13. Elliott Dube, "Suh Chosen as Gift Artist; Design, Funding in Works," *The Daily Tar Heel*, May 23, 2002, http://www.dailytarheel.com/index.php/article/2002/05/suh_chosen_as_gift_artist_design_funding_in_works.
14. Karey Wutkowski, "Group Chooses Senior Class Gift Artist," *The Daily Tar Heel*, March 27, 2002, http://www.dailytarheel.com/index.php/article/2002/03/group_chooses_senior_class_gift_artist; Dube, "Suh Chosen as Gift Artist; Design, Funding in Works"; and Heather Knighton, "Class of 2002 Raises $54K for Unsung Founders Memorial," *The Daily Tar Heel*, November 5, 2002, http://www.dailytarheel.com/index.php/article/2002/11/class_of_2002_raises_54k_for_unsung_founders_memorial.
15. "*Floor*, Gallery Label," Indianapolis Museum of Art, http://www.imamuseum.org/art/collections/artwork/floor-suh-do-ho.
16. "Do Ho Suh, Maquette for *Public Figures*," Public Art Fund, *MetroSpective*, Archived Projects, http://www.publicartfund.org/pafweb/projects/03/metrotech/metrospective_suh_s03.html.
17. "Stories: Art21," online video at PBS, http://www.pbs.org/art21/series/seasontwo/stories.html.
18. Savage, *Standing Soldiers, Kneeling Slaves*, 4.
19. Young, "Memory/Monument," 240.
20. "Stories: Art21."
21. "Celebrating the Unsung Founders: Memorial Dedicated on McCorkle Place," *University Gazette Online*, November 16, 2005, http://gazette.unc.edu/archives/05nov16/file.4.html.
22. "Celebrating the Unsung Founders."
23. See John Bodnar's discussion of official memory and vernacular memory as it relates to monuments and commemorative activities in *Remaking America: Public Memory, Commemoration, and Patriotism in the Twentieth Century* (Princeton, NJ: Princeton University Press, 1992), 21–38.
24. See James Young, *The Texture of Memory: Holocaust Memorials and Meaning* (New Haven, CT, and London: Yale University Press, 1993), 7. Young argues, "For a monument necessarily transforms an otherwise benign site

The Challenge of Memorializing Slavery in North Carolina 155

into part of its content, even as it is absorbed into the site and made part of a larger locale. The tension between site and memorial can be relieved by a seemingly natural extension of site by monument, or it can be aggravated by a perceived incongruity between site and monument."

25. For information on the buildings and memorials on the campus of the University of North Carolina at Chapel Hill, see "Landmarks," Virtual Tour of the University of North Carolina at Chapel Hill, http://www.unc.edu/tour/index.html.
26. "Landmarks," Virtual Tour of the University of North Carolina at Chapel Hill.
27. Mync Staff, "Silent Sam Statue is Point of Controversy," April 9, 2008, NBC17, Raleigh, NC, http://www2.nbc17.com/news/2008/apr/09/silent_sam_statue_is_point_of_controversy-ar-285123/. See also Christopher Jones, "Erasing History: Criticizing Controversial Statues Misunderstands Past," *Carolina Review* 17, no. 5 (February 2009): 10.
28. Nina Willdorf, "Loud Debate Over Silent Symbol," *The Chronicle of Higher Education*, May 19, 2000, http://chronicle.com/article/Loud-Debate-Over-Silent-Symbol/7720/. See also Stephanie Hawco, "Silent Sam Sparks Conversation at UNC," wral.com, April 23, 2003, http://www.wral.com/news/local/story/104969/, and Gerald Horne, "Letter to the Editor," *News & Observer*, January 3, 2011, http://blogs.newsobserver.com/orangechat/is-it-time-to-topple-uncs-silent-sam.
29. Willdorf, "Loud Debate Over Silent Symbol."
30. Bryon Wilson, "Gift Meant to Recall Past," *The Daily Tar Heel*, September 29, 2006, 7.
31. "Public Art at Carolina: Unsung Founders, Bond and Free," The Carolina Story: A Virtual Museum of University History, http://museum.unc.edu/exhibits/public_art/unsung_founders/; Tim McMillan, "UNC Slaves Deserve More," *The Daily Tar Heel*, September 29, 2006; and Mark Schultz, "Honor and Offend? Local Poet Says Memorial Sends Mixed Message," *The Chapel Hill News*, November 22, 2009, http://www.chapelhillnews.com/2009/11/22/53708/ honor-and-offend.html.
32. Cynthia Greenlee-Donnell, "UNC-Chapel Hill Examines Race and History," *Independent Weekly*, October 18, 2006, http://www.indyweek.com/indyweek/unc-chapel-hill-examines-race-and-history/Content?oid=1199381.
33. "Introduction," *Slavery and the Making of the University*, online exhibition, Manuscripts Department, University of North Carolina at Chapel Hill, http://www.lib.unc.edu/mss/exhibits/slavery/index.html.
34. "About Us," The North Carolina Freedom Monument Project, http://www.ncfmp.org/about/, and "Monument to Honor North Carolina African-Americans," Press release, November 1, 2002, http://www.ncat.edu/press_release/oct28_02/monument.html.
35. "About the Freedom Monument: A Statewide Public Process," The North Carolina Freedom Monument Project, http://www.ncfmp.org/curriculum/about.html.
36. "The Story of the Freedom Monument Project," Information sheet, North Carolina Freedom Monument Project, and Terry Watson, "NC Freedom Monument Project," *Mykel Media Company*, November 4, 2010, http://mykelmedia.com/nc-freedom-monument-project/.
37. "Monument to Honor North Carolina African-Americans," Press release, November 1, 2002, and "About the Freedom Monument: An Ongoing Educational Dialogue," The North Carolina Freedom Monument Project, http://www.ncfmp.org/curriculum/about.html.

38. Janet Kagan, "The North Carolina Freedom Monument Project: Freedom Grove for All," *Independent Weekly*, April 19, 2006, http:/www.indyweek.com/gyrobase/the-north-carolina-freedom-monument-project/Content?oid=1197171&mode=print, and Aaron Carpenter, "Interview with Reginald Watson," *The Common Reader: Newsletter of the ECU Department of English* 21, no. 3 (December 2002), http://www.ecu.edu/english/tcr/21-3/Watsonlink.html.
39. "Monument Would Honor Black History," *News & Observer*, May 12, 2008, http://projects.newsobserver.com/under_the_dome/monument_would_honor_black_history, and Thomasi McDonald, "Freedom Monument's Plan Will Get a Hearing," *Charlotte Observer*, January 17, 2010, http://www.charlotteobserver.com/2010/01/17/v-print/1185716/freedom-monuments-plans-will-get.html.
40. North Carolina Department of Cultural Resources, *North Carolina State Capitol Memorial Study Committee Report*, May 2010, www.ncdcr.gov/capitolmemorial.pdf.
41. "Case Statement," The North Carolina Freedom Monument.
42. "Site Plans," The North Carolina Freedom Monument.
43. Kagan, "North Carolina Freedom Project Monument."
44. "Case Statement," The North Carolina Freedom Monument.
45. Julian Bonder, "On Memory, Trauma, Public Space, Monuments, and Memorials," *Places: Forum of Design for the Public Realm* 21, no. 1 (May 2009): 67.
46. Bonder, "On Memory, Trauma, Public Space, Monuments, and Memorials," 65.

Part II
Slavery and Slave Trade in the Museum

9 Museums and Slavery in Britain
The Bicentenary of 1807

Geoffrey Cubitt

The year 2007 saw the bicentenary of the Abolition of the Slave Trade Act which formally ended Britain's participation in the transatlantic slave trade.[1] Gestures to mark the occasion included the predictable issue of commemorative postage stamps, the minting of a special £2 coin, a wave of slavery-related programming on radio and television,[2] and a succession of commemorative events involving senior dignitaries of church and state in the days immediately surrounding the anniversary date (March 25). Special services of "penitence" or of "remembrance and reconciliation" were held in cathedrals in Bristol and Liverpool, and a National Service of Commemoration in Westminster Abbey, presided over by the Archbishop of Canterbury, was attended by the Queen and by Prime Minister Tony Blair. In official rhetoric, the bicentenary was framed as a national event, engaging the pinnacles of state and church in affirmations of public attitude and national purpose.[3] Equally remarkable, however, was the extensive calendar of activities relating to slavery and abolition and their contemporary legacies, which unfolded across the country as a whole. Throughout 2007, local authorities, community organizations, voluntary groups, and cultural and religious institutions competed and collaborated with each other in organizing lectures, conferences, debates, exhibitions, workshops, film-showings, dramatic performances, commemorative ceremonies and other cultural events. Commemorative activities were varied and sometimes ingenious: bell-ringers in Bristol arranged "a mass ding-a-ling," timed to mark the precise instant at which the royal signature had been appended to the Act two hundred years before;[4] and two breweries marked the occasion of the bicentenary with special commemorative ales.[5] The movement to mark the bicentenary bore witness not just to the extensive financial support made available for local initiatives, chiefly through the agency of the Heritage Lottery Fund (HLF), but also to an impressive commitment of time and effort by numerous individuals and organizations.

Museums, and heritage institutions more generally, played a major part in this bicentenary activity.[6] Museums promoted and hosted many of the activities already mentioned, produced catalogues and education packs, and were involved, often in partnership with other institutions, in many

160 Geoffrey Cubitt

other local initiatives. The most obvious products of museum involvement in the bicentenary, however, took the form of new displays and exhibitions.[7] If the museum highlight of 2007 was the opening in August of the new International Slavery Museum (ISM) in Liverpool,[8] the year also saw the reopening of the Wilberforce House Museum in Hull, and the launching of important new galleries with a slavery theme at the National Maritime Museum (*Atlantic Worlds*) and at the Museum of London Docklands (*London, Sugar and Slavery*). A host of other institutions marked the bicentenary year with temporary displays. If media attention focused on activity at major London institutions like the National Portrait Gallery, the Victoria and Albert Museum, and the British Museum, on the major exhibition mounted by the Houses of Parliament in Westminster Hall (*The British Slave Trade: Abolition, Parliament and People*), and on high-profile displays in major provincial centers like Birmingham (*Equiano: An Extraordinary Life* at Birmingham Museum and Art Gallery) and Bristol (*Breaking the Chains: The Fight to End Slavery* at the British Empire and Commonwealth Museum), such a focus scarcely did justice to the proliferation of displays on slavery and abolition put on by regional and local museums, galleries and archive centers, and even by churches, schools, and community centers, up and down the country. These ranged from substantial exhibitions, such as Plymouth City Museum and Art Gallery's *Human Cargo*, and coordinated initiatives involving several museums, such as Greater Manchester's *Revealing Histories* program,[9] to far smaller exhibits—perhaps a single room, or a couple of panels or cases in the corner of a larger gallery, or a trail indicating objects with slavery connections in a local museum's collections. In some areas, travelling exhibitions brought a bicentenary message successively to different localities,[10] and over forty websites offered online exhibitions or educational resources on slavery-related themes.[11]

Exhibitions to mark the bicentenary were of various kinds. Some reflected the particular concerns of specialist institutions. Thus, the Royal Geographical Society (*Bombay Africans*) uncovered the role of formerly enslaved Africans in the exploration of the African continent; the Library and Museum of Freemasonry (*Squaring the Triangle: Freemasonry and Antislavery*) viewed the issues of slavery and abolitionism through the revealing prism of Masonic history; and naval dockyard museums in the Royal Navy's traditional bases at Portsmouth (*Chasing Freedom: The Royal Navy and the Suppression of the Transatlantic Slave Trade*) and Chatham (*Freedom 1807: The Chatham Dockyard Story*) charted naval involvement first in support of transatlantic slavery and then against it. Museums of the decorative arts, such as the Bowes Museum in Barnard Castle (*Revealed: Luxury Goods and the Slave Trade*), or of everyday life, such as York's Castle Museum (*Unfair Trade*), explored the impact of slavery in these fields. Some exhibitions concentrated on particular individuals, such as the eighteenth-century judge Lord Mansfield and his black great-niece Dido Belle, twin foci of an exhibition (*Slavery and Justice*) at their former

residence, Kenwood House. A handful of exhibitions in stately homes such as Harewood House (*Harewood 1807*) or Penrhyn Castle (*Sugar and Slavery: The Penrhyn Connection*) acknowledged these properties' connections to Caribbean slave-based fortunes. Despite these variations, however, the majority of exhibitions covered a certain common territory, typically presenting a general account of transatlantic slavery's history (usually embedded in a broader description of the "triangular trade"), an evocation of the horrors of enslaved experience (and especially the ordeal of the Middle Passage),[12] a narrative of abolitionism (and perhaps of slave resistance), and a reading off of the legacies of all of this for contemporary society.

The present chapter contextualizes and analyzes the museum and heritage sector's response, in the form of exhibitions, to the challenges posed by the task of marking the bicentenary of 1807. The first section will locate museum activity in the broader context of public debate over slavery's meanings and implications in British history. The second will show how museums, in wrestling with the dilemmas of 2007, sought to position themselves in relation to different audiences and communities, and were caught up in uneasy negotiations over their own social role and cultural authority. The third will focus in more detail on the interpretative and presentational issues with which museums were confronted, and on the thematic emphases that exhibitions developed. Taken together, the three sections will seek to show how museums strove to meet a difficult history's demands for recognition, and to articulate its implications for contemporary society.

CONTEXT AND CONTESTATION

In Britain, as in other European countries whose histories are marked by an extensive participation in transatlantic slavery, the significance of this participation has been, to a large extent, ignored or obscured in the prevailing narratives of national history that have shaped public awareness since the time of abolition. This neglect is no doubt encouraged by the relative absence, on British soil, of obvious *lieux de mémoire*—slave-forts, auction sites, plantation buildings—such as might literally give slavery a place in British public awareness. It has been too easy for British citizens to view this as a history that unfolded elsewhere—in Africa, in the mid-Atlantic, in the Caribbean, and in the Americas. Discerning its presence in the splendor of English landed estates, in the warehouses of London's West India Dock, or in the buildings housing charitable institutions founded by slave-trading philanthropists has required a degree of specialist knowledge. Only occasionally has something like the grave of an enslaved African supplied a poignant glimpse of personal histories of enslavement lived out on British soil.[13] In a country that memorialized abolitionists, memorials to enslavement, or to the long-standing black presence in British society, have until recently had no discernible place in the landscape.[14] Geographical distance

and topographical absence have played a part in keeping slavery marginal in British historical awareness.

Equally fundamental, however, has been the persistent submergence of the history of transatlantic slavery beneath the history of abolitionism.[15] Britain's status as the foremost abolitionist power has consistently overshadowed her lengthy previous record as a dominant slaving nation. The story of slavery has been subordinated—in historiography, in commemorative culture, and in popular awareness—to the story of its ending, itself conceived of as a heroic moral drama, featuring a cast of virtuous white (and mainly male and middle-class) abolitionists, in which Britons have been encouraged to take patriotic pride. Among the heroes of this drama, the best known—or at least the most often cited—has been the parliamentary abolitionist leader William Wilberforce: indeed, for many British people at the beginning of the twenty-first century, a sense of the slave trade's relevance to British history was probably reducible to the ability to name Wilberforce as the man who had abolished it—an awareness that was reaffirmed, but scarcely turned in a critical direction, by the eve-of-bicentenary success of Michael Apted's Wilberforce biopic *Amazing Grace* (2006). In 2007 itself, figures like the influential broadcaster Melvyn Bragg and the Conservative politician (and Wilberforce biographer) William Hague publicly reaffirmed this celebratory vision of the abolitionist achievement.

In the abolitionist vision of history, the evils of slavery itself were not denied: on the contrary, they were the essential backdrop against which the virtuous heroics of abolitionism assumed their full splendor. But they were narratively taken for granted, not analyzed or explained in ways that might focus deep attention on the extent and nature of Britain's own involvement. The story of abolitionism, on the other hand, was told and received not just as the tale of how slavery was ended, but as a vital passage in the narrative of Britain's emergence as a liberating and moralizing force in the world arena—a narrative long closely entangled with the justification of her role as an imperialist and colonialist power.

But if the traditional abolitionist vision remained influential, it was also, by the time of the bicentenary, significantly under challenge, both in academic circles and among representatives of African and African-Caribbean communities, whose members had a very different perspective on this history. Critics of the traditional configuration pressed two lines of argument, sometimes separately but often in tandem. The first focused essentially on British history, and amounted to the insistence that the achievements of British abolitionism should not be allowed to function as a kind of redemptive whitewash allowing the nation to overlook its long and shameful history as a slaving power and beneficiary of the slave system. Any inclination to celebrate abolitionist legislation must be balanced by recognition of the longer record of legislation that had previously actively assisted and protected transatlantic slavery's development. "Isn't the UK celebrating the abolition of slavery rather like celebrating that you've stopped beating your wife?" asked one critic provocatively in

2007.[16] Others pushed the issue further: the point was not simply that Britain had a slaving history that it was dishonest to ignore, but that her role as a beneficiary of slavery had not neatly ended when her retrospectively celebrated conversion to antislavery began. Britain "made more money out of slavery and the slave trade after 1807 than before": her links to the slave-based economies of the Caribbean remained crucial to her wealth and development long after the slave trade was formally ended.[17] Any honest appraisal of the meanings of slavery in British history must hinge, this line of argument suggested, on recognition of the deep and multifaceted contribution of transatlantic slavery to the making of modern British society.

The second line of argument led in a slightly different direction. Here the call was for a more far-reaching shift of perspective, away from a history told from the standpoint of white Europeans, and toward one in which Africans themselves would be the central figures. In terms of content, this meant an emphasis on African cultures, African suffering, African resistance and endurance, and the vibrancy of African cultural contributions. But the challenge of the proposal lies in the fact that voice and agency, as well as thematic content, are at stake. The defect of the abolitionist vision, from this perspective, lies in the way it casts enslaved Africans as abject victims, dependent for rescue on the benevolence of white abolitionists, thus sidelining their struggles and achievements, denying them meaningful agency in their own history, and reducing them to a status of passivity in a history in which it is whites—whether as slave owners or as emancipators or as colonial rulers—who supply initiative and leadership. Reinforcing the atrocity of enslavement through the retrospective insult of interpretative infantilization not only demeans the Africans of the past; it also denies their descendants the means of drawing pride and inspiration from ancestral example, casting them in an inherited posture of humiliation, and thus reinforcing the mental structures of subordination in today's society. Critics such as Marcus Wood have extended this argument further by analyzing some of the ways in which perceptions of slavery have continued to be framed by imaginative structures, inherited from abolitionism itself, whose tendency has been to perpetuate precisely those hierarchies and inequalities that antislavery might superficially seem to call in question.[18] Images of black suffering have long served, according to this argument, as pretexts for self-congratulatory white displays of empathetic feeling, rather than as starting points for investigations of responsibility or movements toward equality. Museum curators in 2007, faced with difficult decisions on how to deploy abolitionism's rich but tainted imagery in exhibitions on slavery, would have been anxiously aware of these sensitivities.[19]

The movement to commemorate the bicentenary of 1807 brought these tensions to a point of focus. 1807 was itself a date that prompted controversy. The Act of that year was not, after all, an obvious point of closure in transatlantic slavery's history. Britain's participation in the slave trade had been formally ended, but slavery itself had remained a brutal reality, in British colonies as elsewhere. Those who were already enslaved remained so until the

further legislation of the 1830s. For enthusiastic acclaimers of the abolitionist achievement, 1807 remained, despite this, a monumental year—the moment of a great and irreversible advance in the movement toward slavery's eventual demise, and in the words of one government bicentenary publication, "an important point in this country's development towards the nation it is today—a critical step forward into the modern world, and into a new and more just moral universe".[20] For those who stood outside this vision, however, 1807's status as a moment inviting commemoration was more equivocal. For many, it was a date that begged as many questions as it answered—the most important of a series of moments of guarded concession that would end by seeing much of slavery's injustice reinscribed into postemancipation society, under cover of a celebratory rhetoric whose effect was to forestall any real reckoning with past responsibilities. For Marcus Wood, the Act of 1807 was "a piece of compromised and well-overdue legislation", its commemoration "a device cleverly constructed to police a particularly ghastly part of national memory."[21] Without necessarily going so far in denouncing the intentions behind commemoration, many black members of British society found it hard to accept 2007 as a meaningful commemorative moment. Some emphatically repudiated the bicentenary as a "Wilberfest"—a cozy government-sponsored celebration of white abolitionist heroes, in which the memories and interests of the black population would be ignored or marginalized. The Bristol-based group Truth 2007 stated plainly that "the events of 1807 have no special significance to African people" and dissociated itself from "any events that appear to herald the actions of 'abolitionists' such as William Wilberforce as the primary emancipators of enslaved Africans in 1807."[22] Toyin Agbetu of the pan-Africanist Ligali organization, who captured headlines when he interrupted the National Service of Commemoration in Westminster Abbey, denounced the service as "an act of astonishing arrogance" and "an orgy of hypocritical moral profligacy."[23] Reflecting on the bicentenary a year later, the *African History Month Newsletter* would note "how in 2007 Britain spent over £20 million pounds on revisionist 'white' propaganda in an attempt to obliterate and reduce our history of African resistance, rebellion and revolution into 'black' history."[24] Such rejectionist views may not have commanded majority support within black communities, but the articulation of them was important in challenging the easy dominance of abolitionist perspectives.[25] Other black organizations, although sometimes more willing to view the bicentenary as a creative opportunity, were similarly insistent on the need for a vigorous assault on slavery's social legacies to be coupled with a forthright recognition of African voices and experiences.[26]

MUSEUMS, VOICES, AND COMMUNITIES

Such was the matrix of competing narratives and conflicting sensitivities within which museums and other heritage institutions putting on exhibitions

to mark the bicentenary of 1807 were forced to maneuver. Attracted by the funding and publicity opportunities that the bicentenary offered, museums were nevertheless mindful of the difficulties involved in dealing with a long neglected and still divisive history of suffering and atrocity. Most hoped that their presentation of that history would facilitate an ultimately healing acknowledgment of, and willingness to confront, its painful legacies. In practice, however, museums struggled to reconcile two objectives. On the one hand, they strove to give a still predominantly white and middle-class museum-going public a deepened understanding of the part that transatlantic slavery had played in British history—to show that public, in effect, how the conventional reference points of abolitionist commemoration, which for many were the ostensible starting point for any bicentenary activity, were only part of a much broader and morally less reassuring historical picture. This was an essentially educative task, which most museums were still inclined to realize through the controlled use of a relatively conventional "authoritative" curatorial voice. On the other hand, however, museum professionals labored to persuade black members of British society that museums—long regarded as temples of white supremacy—could now be places for the articulation of their voices, for the honest acknowledgment of their ancestors' histories of suffering and achievement, and for recognition of their own entitlement as full members of British society. This was a task, not of education, but of recognition and acknowledgment. What it required was not a simple shift in presentational emphasis, a redirection of curatorial authority, but commitment to an opening up of the social relations and institutional structures within which views of the past are framed and formulated, so as to ensure that a greater diversity of voices is heard, and that the means of controlling the sense that is publicly made of the past are no longer monopolized by the inheritors of a colonializing Eurocentric vision.

Issues of voice and empowerment, as well as issues of interpretation, were thus central to the dilemmas facing museums in 2007.[27] The bicentenary supplied, indeed, something of a test case for new conceptions of museums as places of engagement, where identities are negotiated and debates initiated, under the guidance of a curatorial voice now liberated from the need to be dispassionate and authoritative. HLF guidelines, which made clear that heritage institutions hoping to benefit from funding must engage in active partnership with community-based organizations, gave further impetus in this direction.

This conjunction of factors made the tasks of 2007 formidable ones for museums and other heritage institutions. Nowhere more than in the heritage sector, indeed, was the "persistent, fundamental, even necessary unease," seen by Cora Kaplan as permeating the bicentenary as a whole, so apparent, and it is clear that the unease arose not just from the "contradictions between national crime and national pride" that were triggered by trying simultaneously to celebrate abolitionism and to acknowledge the depth of Britain's slaving involvement, but from a wider set of tensions.[28] As Ross

Wilson's researches, based on interviews with museum staff gathered by the 1807 Commemorated project, tellingly indicate, many of those working on exhibitions dealing with slavery during the bicentenary year found the experience challenging and stressful, both professionally and personally. Their discomfort reflected the traumatic character of slavery's history, and the inevitable grimness of any immersion in its source materials. It also, however, reflected the insecurity of museum workers forced to engage—in most cases under considerable pressure of time and with scant resources of manpower, material, and prior knowledge—with a painful history in which others had not just a fierce emotional investment, but a claim of ownership.[29] Many museums had little prior experience working with members of black communities on these kinds of issues. Kalliopi Fouseki and Laurajane Smith's analyses of community consultations at seven museums, based on a workshop and interviews with participants conducted as part of the 1807 Commemorated project, show how consultations of this kind, often improvised at short notice, frequently failed to meet the expectations of active empowerment and genuine dialogue that they aroused in those consulted. Tensions were also apparent between the "object-centered" concerns of museum professionals and the more "people-oriented" priorities of community representatives.[30] No doubt, some attempts at community involvement were successful at developing a measure of productive understanding and creative participation, and it is important (as Fouseki and Smith point out) to remember that tension and contestation are normal and potentially creative features of any negotiatory process that takes the task of social recognition seriously.[31] In many cases, however, the experience of consultation in 2007 was one that left museum staff (especially the relatively junior ones to whom the task was often entrusted) feeling invidiously exposed, and community representatives let down and frustrated.

To say this is not to say that the heritage sector's involvement in the bicentenary, if taken as a whole, was lacking in efforts to enlist a diversity of voices or to harness the creative efforts of groups within the community. Exhibitions such as *Bombay Africans* at the Royal Geographical Society and *Voices from Africa* at Glasgow's Saint Mungo Museum of Religious Life wove reflections by members of black community groups commenting on the contemporary significance of what was being displayed into the structure of the exhibition text. Others, like the Birmingham *Equiano* exhibition, or the display at the National Trust's Penrhyn Castle in North Wales, gave extensive space within the overall display to an assortment of community-based projects commissioned for the occasion, in which different groups of participants—women, schoolchildren, elders of the community—used a diversity of creative methods to interpret the history on display or to articulate its relevance to their own experience. Individual projects of this kind were at the center of many smaller displays as well. The London Print Studio, for example, worked with children from a local primary school to produce both a film and an exhibition (*The Print that Turned the World?*) interpreting the Brooks slave ship

diagram.[32] In the West Midlands, the touring exhibition *Interwoven Freedom: Abolitionist Women in Birmingham* was the outcome of a project by a local group, the Sparkbrook Caribbean and African Women's Development Initiative (SCAWDI). Members of SCAWDI produced personalized versions of the textile workbags used by earlier abolitionist women for the distribution of antislavery literature: the memory of white women's participation in abolitionism was thus creatively put to use by women of African-Caribbean heritage positioning themselves within the ethnic and gender and political configurations of today's British society. Some museums and galleries also incorporated artistic installations, by artists of different ethnic heritages, alongside or as part of slavery-themed exhibits.[33] A museum of art such as the Whitworth Gallery in Manchester, used to evoking multiple perspectives, and relatively unshackled by any expectation that its exhibition should supply the public with a basic historical narrative, could encourage guest curators creatively to "dialogize" objects in the museum collection and to express their own views on these objects freely and provocatively.[34] Elsewhere, however, a more cautious spirit tended to prevail: museums strove to recognize different voices and perspectives, but were often reluctant to relinquish overall narrative control: licensed expressions of subjectivity supplemented rather than supplanted more conventional presentations of slavery's history.

THEMES AND INTERPRETATIONS

At the interpretative level, museums responded in different ways to the challenge of combining the triple histories of slavery, of abolitionism, and of slave resistance. In a few exhibitions, a heroic conception of white abolitionism remained indisputably central. Sometimes, it was the local connections of particular abolitionist celebrities that sustained such a focus: this was so with Wilberforce in Yorkshire's East Riding, with Thomas Fowell Buxton in Norwich, and nowhere more than with Thomas Clarkson in his home town of Wisbech in Cambridgeshire. In the local Wisbech and Fenland Museum, the visitor was confronted, at the entrance to the exhibition (aptly entitled *A Giant with One Idea: Thomas Clarkson and the Anti-Slavery Movement*), with a looming model of an enslaved African framed against a backdrop redolent of the Middle Passage—an obvious figuration of transatlantic slavery as an evil awaiting its solution. Swerving to avoid this figure, a visitor's gaze would be drawn on to the figure of Clarkson himself—his bust positioned in a shrine-like space in the middle of the exhibition, with a framing caption from his own writings highlighting the moment of his decision to devote himself to the antislavery cause, and thus—the display seemed clearly to imply—to become the heroically embodied solution to the evil just identified.

Such an emphatic personalization of the abolitionist achievement was now, however, more the exception than the norm in the museum sector.

Images of Wilberforce and Clarkson were common features of exhibitions, but they were usually embedded in a broader account of abolitionism that stressed the movement's social breadth and its status as a pioneering instance of mass political mobilization. Even where the focus was still strongly on the traditional giants, a discernible shift of emphasis from the patrician parliamentarian Wilberforce to the hard-touring, information-gathering, consciousness-raising Clarkson offered hints in this direction. The shift of emphasis was plainly apparent in the exhibition mounted by the Houses of Parliament themselves, which paid tribute to both celebrities and gave a prominent place to Clarkson's famous "chest"[35]—the emblem of his personal prowess as an innovative campaigner—but whose central exhibit was the massive Manchester abolitionist petition, powerfully symbolizing abolitionism's strength as a collective social movement. Also significant was the newfound emphasis placed in some exhibitions on the importance of women as abolitionist campaigners.

Perhaps most significant of all, not necessarily in marking a departure from the cult of individual celebrities, but in broadening the selection of those celebrities and in opening—potentially at least—a bridge between the themes of abolitionism and of African agency, was the attention paid in most bicentenary exhibitions to the role of black abolitionists—Ottobah Cugoano, Ignatius Sancho, but above all Olaudah Equiano, whose ubiquity in the bicentenary year rivaled that of Wilberforce and Clarkson, and whose career and personality were the subject of one of the largest exhibitions, at the Birmingham Museum and Art Gallery. By inducting Equiano (and occasional selected others) into the pantheon of abolitionist heroes, museums did not necessarily avoid the charge of tokenism; but the broadening of descriptions of abolitionism to recognize the agency of such figures was at least a step toward rethinking the racially exclusive emphases of earlier celebrations.

On their own, however, such adjustments of emphasis within the historical presentation of abolitionism had little potential to radically affect the terms of public engagement with slavery's implications for British society. Museums' contributions to such an engagement depended on how they handled three further issues: the role of slave resistance; the effects of the involvement with slavery on British social and economic development; and the legacy—or unfinished business—bequeathed by the histories of slavery and abolition to today's society.

The great majority of exhibitions dealing with slavery and abolition in 2007 referred to the importance of resistance by the enslaved.[36] Most described this resistance as a more or less universal aspect of the life of enslaved people and an endemic feature of slave-based societies; many explicitly cited it as a significant factor contributing to transatlantic slavery's eventual demise. Some went further in shifting the focus from abolitionism to resistance. The British Museum conspicuously advertised its day of events and activities on March 25 as a Day of Resistance and Remembrance. The

Ipswich Museum gave its exhibition the conventionally celebratory title *Abolition! The Thomas Clarkson Story* but balanced this with a powerful opening image of a gunslinging African male, the Jamaican maroon captain Leonard Parkinson. The Museum of London Docklands prominently displayed the table (complete with inlaid commemorative plaque) on which Wilberforce's parliamentary heir Thomas Fowell Buxton and others were said to have drafted abolitionist legislation, but used this abolitionist relic as a surface onto which the dates and places of slave rebellions were hauntingly projected—an effect calculated to unsettle the conventional erasure of resistance from abolitionist memory.

Gestures like these bore witness to museums' intentions of giving resistance a new degree of thematic prominence. Few museums, however, really integrated an extended analysis of resistance into larger narrative structures. Among those that did, the ISM in Liverpool, proclaiming its belief "that Africans, despite their oppression, were the main agents in their own liberation,"[37] was the most assertive. Outside the museum, publicity materials featured images of Africans with captions enjoining the visitor:

> Remember not that we were freed, but that we fought.
> Remember not that we were sold, but that we were strong.
> Remember not that we were bought, but that we were brave.

Inside the museum, a key structural feature of the display was a "Timeline Wall," which visually affirmed the essential unity and continuity of black liberation struggles from the days of slavery to the present. References to abolitionist personalities and successes found space on the wall alongside references to slave insurrection, but their place was now a subordinate one in a presentation dominated and driven by the notion of African resistance. At Hull's Wilberforce House Museum, too, references to slave resistance were scattered throughout the exhibit. Curators here were less forceful than their Liverpool counterparts in reversing traditional abolitionist emphases, but their arrangements of text and image nevertheless repeatedly undermined the conventional thematic distancing of resistance from abolitionist narratives: portraits of Wilberforce and of the Jamaican rebel leader Samuel Sharpe hung side by side, as did images of the white working-class abolitionist Ann Yearsley and the maroon leader Queen Nanny.

In their different ways, both the ISM and Wilberforce House made the theme of resistance an operative element in a larger historical understanding. For many museums, however, doing this remained to a large extent an unfulfilled objective. By comparison with the rich material and visual resources available for presenting the abolitionist movement, curators found few material objects around which to organize treatments of resistance. Partly as a result, such treatments were frequently formulaic, often confined to a single textual panel that did little more than affirm the theme's importance, and illustrated from a standard repertoire of familiar—and generally

decontextualized—emblematic images. The importance of resistance was more often affirmed than creatively and convincingly incorporated.

Where museums did, both individually and collectively, more effectively open up a new and important territory for public understanding of slavery's history was in the ostensibly tamer—but in fact deeply significant—field of local history. A key achievement of the bicentenary, it may be argued, was simply to heighten slavery's local visibility. Various agencies were involved, both nationally (with the BBC's network of regional websites, and the national heritage networks of the National Trust, and the state's English Heritage acting as important disseminators of information) and within specific localities. Building on earlier initiatives in cities such as Bristol, 2007 witnessed a proliferation of slavery trails and walking tours, encouraging visitors and residents to discover the footprints of slavery and abolitionism in different urban neighborhoods, either on foot or electronically. Museums participated in and helped to publicize some of these trail-mapping initiatives and, in some cases, included maps—showing, for example, the residences of local abolitionists or former black residents—in their own locally focused displays. They also participated, along with local libraries, archive centers, academics and volunteers, in a range of locally or regionally focused research initiatives that contributed significantly, across the bicentenary year, to altering the basic contours of public awareness of Britain's involvement with slavery. Prior to 2007, this awareness was heavily focused on the handful of major port cities—principally Liverpool, Bristol, and London—whose involvement in the slave trade had been direct and massive and had remained notorious. The bicentenary's mobilization of local energies focused critical scrutiny on a wider range of localities and a greater diversity of connections. In Leicestershire and Rutland, for example—central English counties well removed from the major maritime centers—the county record office mounted a travelling exhibition (*The Long Road to Freedom: The Story of Slavery and its Abolition as Told through Local Records*), which gave impressive detail not just of the activities of local abolitionists, but of the multiple linkages of family and fortune that had connected local landowning families to plantation interests in the Caribbean. In the North-East of England and in East Anglia, regions again seldom previously thought of in connection with slaving activity, publicly funded archival projects exposed a host of ways in which members of local society had been drawn—through investment, ownership, career, production, and consumption—into transatlantic slavery's network of connections.[38] In a striking combination of the archival and the commemorative, the Archive Centre in Norwich punctuated the wall-length display of its *Norfolk and Transatlantic Slavery* exhibition with panels simply listing the names of enslaved Africans to whom reference had been found in the Norfolk county archives, indicating that they had been owned by Norfolk families, either in Norfolk itself or in the Caribbean. Locally focused exhibitions in the Midlands, in South Wales, and in Southwest Scotland showed, in similar

ways, how the implicating ramifications of Liverpool's and Bristol's slave-based prosperity had shaped lives and careers and local economies over a far wider area.[39]

Closely connected, in many exhibitions, to the investigation of local particularities was a new focus on the importance and diversity of economic connections, not just to the slave trade itself, but to the larger complex of trading relationships that had slavery at its core. The long indebtedness of the Lancashire cotton industry—and hence of an entire regional economy—to the trade in slave-produced cotton was spelled out in exhibitions in Bolton, Rochdale, Bury, and elsewhere across the region.[40] Probably less familiar—but now evoked in exhibitions in places such as Swansea, Walsall, and Wolverhampton[41]—was the other pattern of connections by which the metal-producing and metal-working industries of regions such as South Wales and the West Midlands supplied the slave trade with chains and manacles, and with an array of commodities—guns, manilas, metal bars—exchangeable for human beings on the west coast of Africa. By focusing a new kind of attention on long-established (even if nowadays often defunct) local industrial traditions, exhibitions on slavery not only invited visitors to reflect on the foundations of Britain's much-vaunted economic growth; they also engaged directly with still powerful conceptions of local identity.

Equally notable, although less precisely localized, was the emphasis that many museums placed on slavery's contribution to the development of British consumer habits and lifestyles. Museum tactics owed something here both to the consumer-focused campaigns of abolitionism itself and to the contemporary Fair Trade movement. "Every time a wealthy Victorian gentleman sat down on a fashionable mahogany chair to eat rice, semolina, tapioca or any sugared food, or to drink rum," affirmed a panel in the Ipswich Museum, "he was benefiting from the sweat of enslaved Africans". In the small community-based exhibition (*Our Ancestors, Our Histories, Our Stories*) at Bantock House Museum in Wolverhampton, a display on snuff-taking juxtaposed the elaborate "Twelve-point etiquette of taking snuff" with "Twelve facts about slave labour and tobacco production." In exhibitions up and down the country, displays of teacups, sugar-cutters, cotton dresses and other consumer items reinforced the point. Displays of this kind may have seemed tame to some who felt that any treatment of slavery should confront its brutal realities directly, but consumer objects lay more easily within the reach of most museum collections than chains and shackles did, and their very mundaneness helped to show how the threads of connectedness to transatlantic slavery were woven into British life and culture at every level.

Displays of the kinds that have just been described did much to raise public awareness of transatlantic slavery's profound contribution to Britain's development. Museums faced, however, a final set of challenges in eliciting the meanings of this history for British audiences. How was the story of slavery and abolition to be ended? Or how, if closure was to be

rejected, was its open-endedness to be managed? Few exhibitions, if any, presented 1807 as a moment of ending, and although the tendency of many was to wind down the historical narrative with the events of the 1830s, most incorporated final sections addressing the presumed "legacies" or contemporary relevance of the history just presented. The messages transmitted at this point helped to position museums in a context of contemporary debate. Here again, divergent emphases were apparent.

For many museums, the legacy message—conveyed through ubiquitous use of readily available publicity materials from organizations like Anti-Slavery International and the Fair Trade movement—had to do, first and foremost, with the need to raise awareness of contemporary forms of human trafficking and unfree labor, both in the world at large and in contemporary Britain. Attention was shifted here from transatlantic slavery as a particular historically located system of oppression and exploitation, with particular groups of victims and perpetrators, to slavery in general, a capacious and variegated category of abuse, whose projected eradication required a renewal of humanitarian zeal and reforming effort. In presentations along these lines, the legacy that was evoked was less the traumatic and destructive legacy of transatlantic slavery itself than the inspiring legacy of struggle against it, and of abolitionism in particular: it was the work of Wilberforce and Clarkson that museum visitors were urged to emulate and continue. As a way of turning the bicentenary to the practical benefit of important humanitarian causes, such a way of envisaging the question of legacy had obvious strengths. But as a way of encapsulating the meanings of slavery for British society, in the tension-ridden conditions of debate that were described earlier, it had obvious shortcomings. For some at least, a neo-abolitionist channeling of attention toward assorted forms of contemporary slavery might look like a confusion of priorities—a diversion of energy from the more pressing task of confronting transatlantic slavery's concrete historical legacies of social injustice and frustrated development, and from recognizing how these legacies had been transmitted and refracted through Britain's subsequent history of imperial and colonial engagement, a history largely passed over in most museum displays. Only in a few museums—for example the ISM, whose legacy sections focused explicitly on issues of global inequality and contemporary racism, and which prominently evoked the memory of Anthony Walker, a black Liverpool teenager murdered in a racially motivated attack in 2005—were the latter legacies brought to the fore.

Another way of conceptualizing legacy is apparent at the Museum of London Docklands. Here, the issue of slavery's legacy is entwined with that of local identity. Two themes run persistently through the gallery's displays. The first affirms the centrality of slavery to London's emergence as a financial and commercial center—a theme explicitly connecting the local to the national and the global. The second addresses more directly the nature of the local community, insistently reminding the visitor that part of the legacy

of this involvement with slavery had been the development of London as a vibrantly multiracial and multicultural city. The opening exhibition space articulates these themes together, juxtaposing a wall-high panel listing slaving vessels sent out from the Port of London with images of London and Londoners, black and white, from the eighteenth century to the present. Later in the exhibit, as the vistas of larger national and international histories are opened up, locality and local identity, as things molded by slavery's legacy, remain in view. Visitors are encouraged, even challenged, to participate in the collective identity of Londoners striving for an adequate recollection of what slavery has meant in the making of their community. "How are we as Londoners to come to terms with these legacies?" reads one panel. "In our everyday lives, do we . . . remember that Africa beats in the heart of our city?" reads another. The museum turns London's involvement with slavery inward and outward, opening up its connectedness to the world in general, moving it back in toward the question of what it means today to be a part of this particular local community.

CONCLUSION

The bicentenary of 1807 challenged museums in Britain to negotiate a range of tensions. These had to do with the legacies of Britain's slaving history, with the effects of different ways of remembering and narrating that history, and with evolving conceptions of museums as institutions, and of their role in mediating the social processes by which societies, groups, and individuals develop and test out meaningful relationships to a past that is often difficult and contentious. Museums evolved a range of responses to these challenges, most of which were, in one way or another, compromise solutions, tentatively moving in new directions, gesturing toward alternative visions, without entirely rupturing the frameworks of earlier understandings. Whereas individual museums—usually among the better resourced ones—moved some way toward a provocative engagement with slavery's contemporary legacies or toward a more African centered reading of its history, the sector as a whole proved less successful at reworking overall narrative structures than at deepening—arguably transformatively—public understanding of the local modalities of Britain's involvement with slavery and of the far-reaching contribution of this involvement to the wealth and growth of the nation. It is simply harder now than it was before 2007 for members of British society to behave as if abolitionism were the only point of contact between slavery and the nation's history. This in itself is no guarantee of further movement toward the kind of collective historical reconsideration, presumably required to be grounded in adjusted relationships of power in the production and cultural embedding of historical knowledge, which would help to facilitate Britain's full emergence as a postimperial multicultural society. It still leaves plenty of scope for the mental strategies

of avoidance that Laurajane Smith sees as characteristic of many white British visitor responses to bicentenary exhibitions.[42] However, it does at least help to make slavery visible as part of Britain's historical landscape and as a factor to be reckoned with in the working out of national identity.

NOTES

1. For general reflections on the bicentenary, see Catherine Hall, "Introduction," *History Workshop Journal* 64, no. 1 (2007): 1–5; Catherine Hall, "Afterword: Britain 2007: Problematising History," in *Imagining Transatlantic Slavery*, ed. Cora Kaplan and John Oldfield (Basingstoke: Palgrave Macmillan, 2010), 191–201; Anthony Tibbles, "Facing Slavery's Past: The Bicentenary of the Abolition of the British Slave Trade," *Slavery and Abolition* 29, no. 2 (2008): 293–303; Diana Paton, "Interpreting the Bicentenary in Britain," *Slavery and Abolition* 30, no. 2 (2009): 277–289; James Walvin, "The Slave Trade, Abolition and Public Memory," *Transactions of the Royal Historical Society* 19 (2009): 139–149; Marcus Wood, "The Horrible Gift of Freedom and the 1807/2007 Bicentennial," in *The Horrible Gift of Freedom: Atlantic Slavery and the Representation of Emancipation*, ed. Marcus Wood (Athens, GA, and London: University of Georgia Press, 2010), 296–353; Roshi Naidoo, "High Anxiety: 2007 and Institutional Neuroses," in *Representing Enslavement,* ed. Laurajane Smith et al. (New York and London: Routledge, 2011), 44–60. For a local perspective, see Madge Dresser, "Remembering Slavery and Abolition in Bristol," *Slavery and Abolition* 30, no. 2 (2009): 223–246.
2. For the bicentenary season in the media, see Ross Wilson, "Remembering to Forget? The BBC Abolition Season and Media Memory of Britain's Transatlantic Slave Trade," *Historical Journal of Film, Radio and Television* 28, no. 3 (2008): 391–403; Helen Weinstein, "The Making of the 1807 Bicentenary in the Media: Commissioning, Production, and Content" (paper presented at the conference "Remembering Slave Trade Abolitions: Commemorations of the Abolition of the Slave Trade in International Perspective," Newcastle University, November 2007).
3. For the official government view on the bicentenary, see *Bicentenary of the Abolition of the Slave Trade Act, 1807–2007* (London: Department for Communities and Local Government, 2007). For critical analysis of political and media discourse surrounding the event, see Emma Waterton and Ross Wilson, "Talking the Talk: Policy, Popular and Media Responses to the Bicentenary of the Abolition of the Slave Trade Using the 'Abolition Discourse'," *Discourse and Society* 20, no. 3 (2009): 381–399; Emma Waterton, "Humiliated Silence: Multiculturalism, Blame and the Trope of Moving On," *Museum and Society* 8, no. 3 (2010): 128–157; Emma Waterton, "The Burden of Knowing Versus the Privilege of Unknowing," in *Representing Enslavement*, ed. Smith et al., 23–43.
4. BellsUnbound.com, A World Wide Ring of Freedom, http://www.bells-unbound.com/.
5. Elgoods Brewery's Brookes Ale and Westerham Brewery's Wilberforce Freedom Ale.
6. On museum activity for the bicentenary, see also Katherine Prior, "Commemorating Slavery 2007: A Personal View from Inside the Museums," *History Workshop Journal* 64, no. 1 (2007): 200–211; Celeste-Marie Bernier and Judie Newman, "Public Art, Artefacts and Atlantic Slavery: Introduction," *Slavery and Abolition* 29, no. 2 (2008): 135–150; Geoffrey Cubitt,

Museums and Slavery in Britain 175

"Bringing It Home: Making Local Meaning in 2007 Bicentenary Exhibitions," *Slavery and Abolition* 30, no. 2 (2009): 259–275; Elizabeth Kowaleski Wallace, "Uncomfortable Commemorations," *History Workshop Journal* 68, no. 1 (2009): 223–233; Douglas Hamilton, "Representing Slavery in British Museums: The Challenges of 2007," in *Imagining Transatlantic Slavery*, ed. Kaplan and Oldfield, 127–144; Ross Wilson, "Rethinking 1807: Museums, Knowledge and Expertise," *Museum and Society* 8, no. 3 (2010): 165–179. On specific local cases, see Zoe Norridge, "Finding a Home in Hackney? Reimagining Narratives of Slavery through a Multicultural Community Museum Space," *African and Black Diaspora* 2, no. 2 (2009): 167–179; Alan Rice, "Revealing Histories, Dialogising Collections: Museums and Galleries in North West England Commemorating the Abolition of the Slave Trade," *Slavery and Abolition* 30, no. 2 (2009): 291–309; Andy Green, "Remembering Slavery in Birmingham: Sculpture, Paintings and Installations," *Slavery and Abolition* 29, no. 2 (2008): 189–201.

7. The analysis that follows is based largely on work undertaken as part of the Arts and Humanities Research Council funded "1807 Commemorated" project, based at the University of York between 2007 and 2009. The project investigated museum activity for the bicentenary from a variety of angles: see publications by members of the project team (Laurajane Smith, Geoffrey Cubitt, Ross Wilson, and Kalliopi Fouseki) in a special issue of *Museum and Society* 8, no. 3 (2010) and in *Representing Enslavement*, ed. Smith et al.; also the project website: http://www.history.ac.uk/1807commemorated/. Members of the project team visited over sixty exhibiting institutions between 2007 and 2008.
8. The new museum was lodged on the third floor of the Merseyside Maritime Museum, whose previous Transatlantic Slavery Gallery it replaced.
9. See the project's website: http://www.revealinghistories.org.uk.
10. Examples include *The Longest Journey* (Essex); *Everywhere in Chains?* (South Wales); *The Long Road to Freedom* (Leicestershire and Rutland); *Remembering Slavery 2007* (Tyne and Wear).
11. R. V. Roberto, "A Critical Look at Online Exhibitions and Online Collections: When Creating One Resource is More Effective than the Other," *DESIDOC Journal of Library and Information Technology* 28, no. 4 (2008): 63–71.
12. On the elements of horror and atrocity, see Geoffrey Cubitt, "Atrocity Materials and the Representation of Transatlantic Slavery: Problems, Strategies and Reactions," in *Representing Enslavement*, ed. Smith et al., 229–259.
13. For examples, see Alan Rice, *Radical Narratives of the Black Atlantic* (London and New York: Continuum, 2003), 210–217; James Walvin and Alex Tyrrell, "Whose History Is It? Memorialising Britain's Involvement in Slavery," in *Contested Sites: Commemoration, Memorial and Popular Politics in Nineteenth-Century Britain*, ed. Paul A. Pickering and Alex Tyrrell (Aldershot: Ashgate, 2004), 164–165.
14. Walvin and Tyrrell, "Whose History Is It?" 147–169; Madge Dresser, "Set in Stone? Statues and Slavery in London," *History Workshop Journal* 64, no. 1 (2007): 162–199; and on abolitionist monuments J. R. Oldfield, *"Chords of Freedom": Commemoration, Ritual and British Transatlantic Slavery* (Manchester: Manchester University Press, 2007), 56–87. For recent memorializations of slavery in the North-West of England, see Alan Rice, "Naming the Money and Unveiling the Crime: Contemporary British Artists and the Memorialization of Slavery and Abolition," *Patterns of Prejudice* 41, nos. 3–4 (2007): 321–343.
15. See especially Oldfield, *"Chords of Freedom."* For movements toward a recovery of the public memory of slavery before the bicentenary, see Elizabeth

Kowaleski Wallace, *The British Slave Trade and Public Memory* (New York: Columbia University Press, 2006); Christine Chivallon, "Bristol and the Eruption of Memory: Making the Slave-Trading Past Visible," *Social and Cultural Geography* 2, no. 3 (2001): 347–363.

16. John Beech, "A Step Forwards or a Step Sideways? Some Personal Reflections on How the Presentation of Slavery Has (and Hasn't) Changed in the Last Few Years," http://www.history.ac.uk/1807commemorated/exhibitions/museums/step.html.
17. Marika Sherwood, *After Abolition: Britain and the Slave Trade since 1807* (London and New York: I.B. Tauris, 2007), 175.
18. Marcus Wood's influential critical views have been developed in a succession of works; see notably his *Blind Memory: Visual Representations of Slavery in England and America* (New York: Routledge, 2000); *Slavery, Empathy and Pornography* (Oxford: Oxford University Press, 2002); "Packaging Liberty and Marketing the Gift of Freedom: 1807 and the Legacy of Clarkson's Chest," in *The British Slave Trade: Abolition, Parliament and People,* ed. Stephen Farrell, Melanie Unwin, and James Walvin (Edinburgh: Edinburgh University Press, 2007), 203–223; *The Horrible Gift of Freedom.*
19. See Cubitt, "Atrocity Materials," 237–240.
20. *Reflecting on the Past and Looking to the Future: The 2007 Bicentenary of the Abolition of the Slave Trade in the British Empire* (London: Department for Culture, Media and Sport, 2007), 7.
21. Wood, "Packaging Liberty," 203, 205.
22. Truth 2007 "Position Statement," http://www.ligali.org/truth2007/position.htm.
23. Toyin Agbetu, "How African Truths Abolished British Lies," *Socialist Review*, May 2007, http://www.socialistreview.org.uk/article.php?articlenumber=9943.
24. *African History Month Newletter*, April 2008, http://www.bnvillage.co.uk/community-announcements/98456-african-history-month-news-letter-april-2008-a.html.
25. In relation to the politics of the bicentenary in Bristol, see Dresser, "Remembering Slavery and Abolition in Bristol," 232–235.
26. The organization Rendezvous of Victory, for example, worked closely with museums such as the British Museum and the Natural History Museum, and through the interorganizational Cross-Community Forum, to ensure an African emphasis in bicentenary events.
27. For an earlier statement of these issues, see Stephen Small, "Contextualizing the Black Presence in British Museums: Representations, Resources and Response," in *Museums and Multiculturalism in Britain*, ed. Eilean Hooper-Greenhill (Leicester: Leicester University Press, 1997), 50–66.
28. Cora Kaplan, "Commemorative History without Guarantees," *History Workshop Journal* 64, no. 1 (2007): 390; similarly Naidoo, "High Anxiety," 44.
29. Ross Wilson, "The Curatorial Complex: Marking the Bicentenary of the Abolition of the Slave Trade," in *Representing Enslavement*, ed. Smith et al., 131–146.
30. Kalliopi Fouseki, "'Community Voices, Curatorial Choices': Community Consultation for the 1807 Exhibitions," *Museum and Society* 8, no. 3 (2010): 180–192; Laurajane Smith and Kalliopi Fouseki, "The Role of Museums as 'Places of Social Justice': Community Consultation and the 1807 Bicentenary," in *Representing Enslavement*, ed. Smith et al., 97–115. See also Tracy-Ann Smith, "Science and Slavery, 2007: Public Consultation," in *Representing Enslavement*, ed. Smith et al., 116–130; Bernadette Lynch and Samuel Alberti, "Legacies of Prejudice: Racism, Co-Production and Radical

Trust in the Museum," *Museum Management and Curatorship* 25, no. 1 (2010): 13–35.
31. Smith and Fouseki, "The Role of Museums," 111–112. For positive statements, from the museum angle, on particular museums' experience of interaction with communities, see Smith, "Science and Slavery"; David Spence, "Making the London, Sugar and Slavery Gallery at Museum of London Docklands," in *Representing Enslavement*, ed. Smith et al., 149–163.
32. For discussion of this project, see Wood, "The Horrible Gift of Freedom," 284–294.
33. Consideration of this important artistic aspect of the bicentenary in museums lies outside the scope of this chapter; see however Celeste-Marie Bernier,"'Speculation and the Imagination': History, Story-Telling and the Body in Godfried Donkor's "Financial Times" (2007)," *Slavery and Abolition* 29, no. 2 (2008): 203–217; Bernier and Newman, "Public Art, Artefacts and Atlantic Slavery"; Rice, "Revealing Histories, Dialogising Collections," 291–309; Green, "Remembering Slavery in Birmingham," 196–199; Christopher Spring, "Art, Resistance and Remembrance: a Bicentenary at the British Museum," in *Representing Enslavement*, ed. Smith et al., 193–212.
34. See Rice, "Revealing Histories, Dialogising Collections," 292–301.
35. For critical reflections on the significance of Clarkson's chest in the bicentenary, see Wood, 'Packaging Liberty'.
36. The analysis outlined in the next three paragraphs is developed in greater detail in Cubitt, "Lines of Resistance," 143–164.
37. Text from "We Are One," an additional panel celebrating the first year of the ISM's opening.
38. See http://www.norfolkshiddenheritage.org.uk/ for the Norfolk project, and John Charlton, *Remembering Slavery 2007: A Brief Guide to the Archive Mapping and Research Project* (Newcastle: Literary and Philosophical Society, 2007) for the North-Eastern one; also Charlton's *Hidden Chains: The Slavery Business and North East England, 1600–1865* (Newcastle: Tyne Bridge, 2008).
39. For example: *Trade Links: Walsall and the Slave Trade* (Walsall Museum); *Everywhere in Chains? Wales and Slavery* (National Waterfront Museum, Swansea); *Dumfries and Galloway and the Transatlantic Slave Trade* (traveling exhibition).
40. *Remembering Slavery* (Bolton Museum), *Cotton Threads: Bury's Industrial Links to Slavery* (Bury Museum and Archives); *The Fight to End Slavery: A Local Story* (Touchstones Rochdale).
41. *Everywhere in Chains?* (Swansea); *Trade Links* (Walsall); *Sugar-Coated Tears* (Wolverhampton).
42. Laurajane Smith, "Man's Inhumanity to Man and Other Platitudes of Avoidance and Misrecognition: An Analysis of Visitor Responses to Exhibitions Marking the 1807 Bicentenary," *Museum and Society* 8, no. 3 (2010): 193–214; see also her "Affect and Registers of Engagement: Navigating Emotional Responses to Dissonant Heritages," in *Representing Enslavement*, ed. Smith et al., 260–323.

10 Museums and Sensitive Histories
The International Slavery Museum

Richard Benjamin

The International Slavery Museum (ISM), part of National Museums Liverpool (NML), is located on the third floor of the Merseyside Maritime Museum on the Albert Dock in Liverpool. Due to the transatlantic slave trade being an international phenomenon with global consequences the word "international" rather than "national" was used in its title. ISM is the only British museum that comprehensively deals with this subject. Its scope extends beyond the transatlantic slave trade and encompasses other human rights and contemporary slavery-related issues.

This chapter discusses the breadth of ISM's mission and content, both historical and contemporary, along with the issues involved in developing diverse and often difficult programs and exhibitions. Through the experiences of ISM, this chapter aims to highlight some of the issues and concerns affecting museums that focus on sensitive histories: in particular, the ethical and moral dimensions when developing permanent collections and exhibitions around subjects that have often been regarded as unrepresentable.

The chapter begins by focusing on the events that commemorated the 2007 bicentenary of the Slave Trade Act that abolished the British slave trade, when more than at any other period the nation focused on the subject of transatlantic slavery and its abolition. It examines in detail national and local events and how ISM negotiated various related issues alongside a number of other cities and institutions. The chapter describes the relationship between ISM and its predecessor, the *Transatlantic Slavery Gallery* in Liverpool, a city with a long association with transatlantic slavery, and places it in the broader context of remembering slavery in the City of Liverpool and indeed the United Kingdom. The chapter then charts the steady progress of the ISM since opening in 2007 and discusses the value of ownership within the museum and on the collections. It also emphasizes ISM's innovative and challenging contemporary slavery collection by giving a clear indication of how the institution is approaching the ethical and moral dimensions of museum collecting. The chapter concludes with a clear statement of intent for the ISM and how it sees itself moving forward in what is a difficult time for the cultural sector in the United Kingdom.

PUBLIC MEMORY OF THE ATLANTIC SLAVE TRADE

The display galleries at ISM opened on August 23, 2007. Not only was 2007 the bicentenary of the Slave Trade Act abolishing the British slave trade, it was also a day designated by UNESCO as Slavery Remembrance Day: the anniversary of an uprising of enslaved Africans on the island of Saint-Domingue (modern Haiti) in 1791. These commemorative dates provide a strong reminder that enslaved Africans were the main agents of their own liberation. Each year NML commemorates Slavery Remembrance Day with a series of events culminating in a traditional libation on the world famous Liverpool waterfront. The day pays homage to the many lives lost as a result of the transatlantic slave trade, it remembers Liverpool's role as the main British slaving port, and it also celebrates the survival and development of African and Caribbean cultures.

The main objectives of ISM are to: a) inform and help visitors understand the history of transatlantic slavery and the wider issues of freedom and injustice; b) challenge preconceptions, prejudice, and ignorance; c) encourage visitors to regard transatlantic slavery and its consequences as a shared history with shared responsibility for addressing its legacy in the modern world; and d) interpret, in an open and honest manner, Liverpool's role in the transatlantic slave trade and its impact on the economic and cultural growth of the city.[1]

ISM is a campaigning museum and an active supporter of social change and social justice. Is the museum making a difference? Does the public care what we are doing? If comments left in the Museum Response Zone so far are any measure, the answer is "yes":

> It is our responsibility to speak while we can, before it is too late for us all. Excellent display.

> Born and raised free in Liverpool. Unbelievable that not so long ago this would not have been possible.

> It think it is great and a right thing to do, to recognize and to remember the past (and present) so this won't happen again. I celebrate also the free entrance.

> Moving, disturbing, I really enjoyed learning about the part of Liverpool which is often ignored.

> "We shall overcome!" A long journey to this point and a long way to go. A comprehensive, informative exhibition that everyone should see.

Since 2007 there have been upwards of 1.25 million visits to ISM, which is located on Liverpool's Albert Dock, at the center of a World Heritage Site and only yards away from the dry docks where eighteenth-century

slave-trading ships were repaired and fitted out. By the 1780s Liverpool was considered the European capital of the transatlantic slave trade. Vast profits from the trade helped to physically transform Liverpool into one of Britain's most important and wealthy cities. Other British ports such as London and Bristol were heavily involved in the Atlantic slave trade as well, but in total more than 5,000 slave voyages were made from Liverpool. Overall, Liverpool was responsible for over half the British slave trade. Liverpool was at the epicenter of the transatlantic slave trade, and as such ISM is ideally placed to elevate this subject onto an international stage.[2]

On December 9, 1999, after a proposal by Councillor Myrna Juarez, Liverpool City Council made an unreserved motion of apologies for the involvement of the city in the transatlantic slave trade over a period of three centuries and formally acknowledged responsibility for its involvement in the transatlantic slave trade, which influenced the city's commerce and culture and affected the lives of all its citizens.[3] Some years later in 2006 the British Empire & Commonwealth Museum in Bristol hosted a lively public debate to discuss whether Bristol should formally apologize for its role in the slave trade. The general feeling of attendees was in favor of a civic apology, and although this was not forthcoming, the Bristol Black Churches Council and Churches Together in Greater Bristol issued a framed and signed statement in January 2007. Now in the permanent collections of ISM, this statement noted "the signatories regret wherever and whenever inhumanity is exercised, but in 2007 we especially recognize the evil of the transatlantic slave trade." The British government has not to date issued a formal apology.

In 2007, the other two leading British slaving ports, London and Bristol, also developed permanent transatlantic slavery-related displays and educational material. London acknowledged its links to slavery by opening permanent galleries called *London, Sugar and Slavery* at the Museum in Docklands, based in a historic sugar warehouse on West India Quay. The various interactive displays and educational materials reveal London's relationship with and role in the transatlantic slave trade and, like ISM, cover the legacies of this relationship by highlighting the ongoing cultural links with London, the Caribbean, and Africa. In Bristol a two-year exhibition, *Breaking the Chains* opened at the British Empire & Commonwealth Museum. The exhibition was a multisensory experience, spread over six galleries on the entire third floor of the museum, which focused on Britain's role in the transatlantic slave trade, with particular attention paid to the abolition of the trade rather than the continuing legacies. After closure, the exhibition was available to school and educational groups until the end of March 2009.

Unlike the main slavery-related port cities, Hull, on the east coast of England, was on the wrong side of the country to fully reap the benefits of the trade. Its trading links tended to be focused on the Baltic ports, rather than West Africa and the Americas.[4] Hull's most famous son is the

MP William Wilberforce, and indeed his birthplace, known as Wilberforce House Museum, became one of Britain's first slavery-related attractions. Hull is also the location of the Wilberforce Institute for the Study of Slavery and Emancipation (WISE), an interdisciplinary research institute for academic dialogue with the aim of advancing public understanding of both historic and contemporary slavery, which was set up by Hull University and Hull City Council in 2006. It should also be noted that there were a number of smaller scale, community focused events across the country, many of which were able to get information and support from the Arts Council England.[5]

Due to the relative paucity of slavery-related displays and exhibitions in the United Kingdom there was often a very close working relationship between staff from the ISM, WISE, and the Museum in Docklands. This is highlighted by the current collaboration between ISM and WISE in developing the Modern Slavery Educational Resource Pack, which will provide British teachers of students at Key Stage 2 and upward, pupils aged 7–16 years old, with lesson plans and other relevant information on modern forms of slavery. The resource pack will also be accessible through a website on "Teaching Modern Slavery" and will feature teacher training sessions and other outreach activities conducted by ISM and WISE.

National Museums Liverpool's previous focus on slavery, the *Transatlantic Slavery Gallery*, which opened in 1994 in the basement of the Merseyside Maritime Museum, won worldwide recognition and was central to the development of ISM. Museum curator Anthony Tibbles, who became project leader on the development of the *Transatlantic Slavery Gallery*, noted:

> The Merseyside Maritime Museum had covered the history of the port of Liverpool until 1857 in one of its [the Merseyside Maritime Museums] first galleries opened in 1987. The slave trade was placed in the context of the overall trade of the port and because of this its significance was underplayed. We had also hurried the brief and were unaware of recent research. On reflection our treatment was woefully inadequate and not surprisingly we were criticized for it. By 1989–90 we were looking at ways of improving this gallery and in particular of fully recognizing the importance of Liverpool's role in the slave trade.[6]

In 1996, the Peter Moores Foundation, founded by the British philanthropist Sir Peter Moores, which had an interest in the visual arts and education including transatlantic slavery, approached the Merseyside Maritime Museum. Tibbles goes on to note:

> After several months of discussion on how we could do it, where we could do it, how much it would cost etc, we came to an agreement whereby the Foundation would make available nearly £550,000 for the development of a 400 square meter gallery devoted to the transatlantic

slave trade in the basement of the Merseyside Maritime Museum. The scheme was publicly announced in December 1991 and the development process began.[7]

After more than a decade the gallery needed updating, and David Fleming, director of National Museums Liverpool, decided that the subject of slavery needed greater recognition and a museum in its own right. A location was proposed that was more than three times the size of the previous gallery, and in a more prominent position on the third floor of the Merseyside Maritime Museum. Until its closure in 2007, the *Transatlantic Slavery Gallery* had been a leader in the representation of transatlantic slavery, although its development had often been difficult. One issue was how to get the support of the local Liverpool black community,[8] as many believed that the Merseyside Maritime Museum had a poor record of addressing black issues and black concerns.

According to Uduku and Ben-Tovim a "significant" black community in Liverpool was originally situated around the south dock areas of Liverpool, due to the fact that ships docked there after trading with Africa, as well as Southeast Asia and China.[9] This early black settlement mainly composed of seamen working for the Elder Dempster Line and the Blue Funnel Line,[10] both of which built lodging houses for seamen. Elder Dempster also opened a black seamen's mission in 1878, due to the large number of West African seamen it employed and whose contracts they terminated while in Liverpool. The hostel also offered black seamen some respite from the alienation and racism they often suffered in general seamen's hostels.[11]

In 1988 Liverpool City Council set up a committee named the Gifford Inquiry to look into policies and community relations in Liverpool. It was chaired by Lord Gifford QC, and its members included Wally Brown, a black Liverpudlian who at the time of the inquiry was a community activist and later became principal of Liverpool Community College, and Ruth Bundey, an immigration solicitor. The inquiry aimed to examine: a) the policies and practices of Liverpool City Council; b) tensions between the black community and the police; c) discrimination against black people in the law enforcement process; and d) the conditions in L8 (Toxteth), which led to deprivation and racism.[12] As a result, the committee recommended that Liverpool's museum and public institutions should and give a full and honest account of the involvement of black people in the city: how black people who settled in the city and generations of Liverpool-born blacks have been central to the city's fabric. An archive of black people's history should be established.[13]

Between 1991 and 1994 Tibbles and the project team acknowledged that although it was important to have academic and official support for the gallery, the consultations for this gallery had to be much wider and had to include members of the local Liverpool community. Public meetings between museum staff and members of the local community, in particular

the black community, were often difficult and highlighted concerns and even some hostility. Why was National Museums Liverpool taking these actions? Was it making a profit? What were Peter Moores' motives? Were local black people going to get work from the project? There was also criticism of the composition of the advisory committee under the chairmanship of the late Lord Pitt, former chairman of the Greater London Council, the British Medical Association, and a doyen of the campaign against racial discrimination. The committee included representatives of National Museums Liverpool (known as National Museums and Galleries on Merseyside at the time), the Peter Moores Foundation, and members of the British black community, including Liverpool. The role of the committee was to advise and guide the project team. In general there was suspicion of an institution that was seen to have a poor record of addressing black issues and black concerns suddenly undertaking a project so central to the history of black people.[14]

Judging by comments made by a member of the Liverpool black community at the second ISM—then known as the National Museum and Centre for the Understanding of Transatlantic Slavery—consultation meeting in May 2005, Liverpool's black community had often felt overlooked by "outsiders" in the museum service in the past. As a result the future planned consultation series of focus groups organized by NML was curtailed after just two weeks as only two people attended this second session. However, a new NML consultation process was started in May 2006. At this meeting plans for the new International Slavery Museum were shown for the first time.

NML now has a very successful communities team that works on a plethora of community projects and leads on the consultation process for all NML's venues. The fact that relationships with the Liverpool black community in particular have improved significantly has been a great positive in the development of ISM. Trust is not so much of an issue, and most people would agree that various community organizations and individuals have a voice within the new museum.

THE BICENTENARY

The opening of ISM in 2007 coincided with the bicentenary of the British Slave Trade Act in what was probably the greatest national awareness of the subject of transatlantic slavery and indeed the British role in that historical narrative. The British government, through the Department of Communities and Local Government (DCLG), convened a number of initiatives, such as the formation of the 2007 Bicentenary Advisory Group, in an attempt to coordinate a national response to the bicentenary and, importantly, the August 23 Slavery Remembrance Day.

The 2007 Bicentenary Advisory Group was made up of a number of influential stakeholders who would help encourage action across the cultural,

community, and indeed faith sectors to ensure the bicentenary was made relevant to local communities across the country. As well as NML staff, representatives attended from Bristol City Council's Abolition 200 project, the Wilberforce Institute of Slavery and Emancipation (WISE), the Museums, Libraries and Archives Council (MLA) and several faith and community leaders. The group was chaired by the then deputy prime minister, John Prescott MP.

Discussions centered on the large number of national, regional, and local events taking place throughout 2007, such as the production of Royal Mail commemorative stamps and a Royal Mint £2 coin. Through the Abolition 200 project, Bristol marked the bicentenary with a £2 million program, which resulted in more than 100 community-led events and projects. The day of the bicentenary, March 25, was marked by a service of reconciliation at Bristol Cathedral, organized by a partnership of the Cathedral and the Council of Black Churches. The theme for the Notting Hill Carnival, a prominent showcase of African Caribbean culture in Britain, was "Set All Free," which focused on the bicentenary and the fact that slavery continues to exist in various forms across the world. The then mayor of London, Ken Livingstone, used the city's first Slavery Memorial Day on August 23 to apologize on behalf of the capital, whereas Westminster Hall hosted the exhibition *British Slave Trade: Abolition, Parliament and People.*

There was also a plethora of published critiques of the bicentenary, including several by individuals close to ISM, such as Anthony Tibbles, who worked on the development of the *Transatlantic Slavery Gallery* and ISM, and Alan Rice,[15] a reader in American cultural studies at the University of Central Lancashire who cocurated the *Trade and Empire: Remembering Slavery* exhibition at the Whitworth Art Gallery in Manchester, which opened in June 2007. Tibbles and Rice were at the time board members of the Centre for the Study of International Slavery (CSIS), a partnership between the University of Liverpool and National Museums Liverpool. The CSIS works together with other universities and organizations to develop scholarly and public activities related to slavery in its historical and contemporary manifestations. The head of ISM is also a codirector of CSIS.

The Understanding Slavery Initiative (USI) placed a particular focus on the bicentenary in 2007 and produced a number of related school resources. Launched in 2006 at the National Maritime Museum by then deputy prime minister, John Prescott MP, and Minister for Culture, David Lammy MP, the USI was a free resource designed to give teachers and educators a toolkit for teaching the history of the transatlantic slave trade and its legacies. Partners included both national and regional museums, including the National Maritime Museum, National Museums Liverpool, the British Empire and Commonwealth Museum, Bristol City Museums, Galleries and Archives, and Hull Museums and Art Gallery. Understanding Slavery's main objective was to encourage teachers and students to examine

the history of the subject, including its modern legacies, through museum collections, and history and citizenship within the National Curriculum, the nationwide curriculum for primary and secondary state schools in the United Kingdom.

For a clear, concise, and objective critique of 2007 a critical factor is an understanding of the inner sanctums of both large and small museums. The research carried out by Laurajane Smith and Geoffrey Cubitt as part of the 1807 Commemorated project coordinated within the Institute for the Public Understanding of the Past (IPUP), at the University of York, made an effort in achieving this understanding through regular participant group meetings.[16] The ISM's involvement showed that political and economic factors for institutional and community involvement in national events are closely linked. A museum such as ISM, although a national museum in status, has a greater degree of autonomy than other museums and is relatively well funded. The autonomy of ISM will thus allow greater involvement in events such as the bicentenary.

Although not directing or controlling events, the government's approach to the bicentenary tended to ensure that some local organizations were financially supported. At the eighth (and final) meeting of the 2007 Bicentenary Advisory Group members were rather dismayed to discover that the group was to be wound up without a commitment to a successor. The disbanding of the group was seen by many as a missed opportunity to keep influential organizations and individuals around the table to discuss future events, including the official declaration of August 23 as British Slavery Remembrance Day. As a result there was an informal agreement by some members that a new legacy group should be established to discuss and cooperate on 2007 legacy-related issues and events. Even though relationships between members of the Bicentenary Advisory Group remained, there was no formalized government-supported initiative.

PROGRESS OF THE INTERNATIONAL SLAVERY MUSEUM

In 2008 NML had purchased the Grade 1 listed Dock Traffic Office on the Albert Dock, which is adjacent to the Merseyside Maritime Museum. By 2012–2013 this building will become the new ISM entrance and will accommodate education and research facilities, a resource center, collections center, and community spaces. The resource center gives visitors access to slavery-related digital archives, as well as black British and human rights multimedia and documentaries. It also enables visitors to research family and local history. The collections center aims to exhibit all accessioned ISM collections in a publicly accessible and interactive storage and display area. In essence, the ISM is intended to be a resource, a tool to be used in a multitude of ways by visitors, and which is gently oiled and well maintained by the museum staff. The ISM was designed to be an organism

suited to the environment of the day: to be relevant to society and not afraid to focus on political or social issues

Over the last few years, several national and international institutions recognized the leading role of ISM in promoting the cause of human rights. In November 2009 ISM was one of the only two organizations in the world to receive an Honorable Mention from UNESCO for the Madanjeet Singh Prize for the Promotion of Tolerance and Non-Violence. The director general of UNESCO awarded the Honorable Mention to ISM "in recognition of the efforts of the International Slavery Museum to commemorate the lives and deaths of millions of enslaved Africans, and for its work to fight against the legacies of slavery such as racism, discrimination, inequalities, injustice, exploitation, as well as against contemporary forms of slavery."[17]

ISM has also been working in collaboration with the children's development agency, Plan UK, on an antislavery project titled Make the Link, Break the Chain, linking schools along the transatlantic slave triangle (including Sierra Leone, Senegal, and Haiti). For this groundbreaking project the Museum won the UK Museums and Heritage award 2008.

Since 1999, Slavery Remembrance Day activities have been led by NML with the support of the local black community and, over the last few years, with funding from and in partnership with Liverpool City Council. Each year NML runs a program of events in Liverpool to commemorate the lives and deaths of millions of enslaved Africans and to remember that the legacies of slavery still persist. It is the largest event of its kind in the United Kingdom.

In 2006 National Museums Liverpool formed the Liverpool Slavery Remembrance Initiative (LSRI) to lead on the organization of its annual events.[18] The group was made up of members of the Liverpool black community, Liverpool City Council representatives, and a range of NML staff. The broad objectives of the group were to: a) promote the understanding of the slave trade and its contemporary consequences in collaboration with the ISM and other partners—locally, regionally, nationally, and internationally; b) develop an annual program of events that provides a platform for increasing the awareness of the transatlantic slave trade; and c) campaign for the recognition of a national day for the Remembrance of Slavery.

In 2009 the LSRI Group had been replaced by the RESPECT Group, which had a broader remit than just Slavery Remembrance Day events. This group would also act as a consultative body to advise ISM on a diverse range of issues such as improving access and social inclusion, particularly with hard to reach communities, and supporting the work of the museum in developing and evaluating programming, exhibitions, and events.

In 2010 ISM coordinated two inaugural initiatives. The International Slavery Teachers' Institute took place in July and August and was a working partnership between NML and Liverpool Hope University. The aim of this project was to deliver a national teachers' institute, "Teaching the Transatlantic Slave Trade," bringing together teachers from across the United

Kingdom for an eight-day training program held at ISM. The program explored themes including life in West Africa prior to transatlantic slavery, the Middle Passage and enslavement, life in the Americas, abolition, resistance, and the legacies of transatlantic slavery. It considered how these themes might be addressed across the national curriculum, complemented by a series of interactive workshops and lectures. Participants explored a number of approaches to teaching this subject area, thereby also improving their knowledge base.

The Institute was delivered by ISM staff and featured a number of notable scholars within the field, including Anthony Tibbles (emeritus keeper of Slavery History at ISM and author of *Transatlantic Slavery, Against Human Dignity*), Suzanne Schwarz (Liverpool Hope University), Barbara Bush (Sheffield Hallam University), and Robin Law (University of Stirling).

The second initiative was the establishment of the Federation of International Human Rights Museums (FIHRM). This federation enables museums that deal with sensitive and controversial subjects, such as transatlantic slavery, the Holocaust, and the fight for human rights, to work together and share new thinking and initiatives in a supportive environment. The ethos underpinning this initiative is that all types of museums within the field of human rights share similar challenges. The Federation promotes the exchange of experiences among participant institutions with fewer resources to join together in this international collaboration. FIHRM seeks ways to fight contemporary forms of racism, discrimination, and human rights abuses, issues ISM attempts to confront, collectively rather than individually. September 2010's inaugural conference welcomed delegates from over eighty countries, with the second FIHRM conference planned for Liverpool in October 2011.

OWNERSHIP

Although international in scope, ISM is first and foremost a museum which aims to be embraced by the local community and which through its permanent displays, exhibitions, publications, and educational activities seeks to contribute to a changing public social agenda. The museum aims to enhance the understanding of the past and how its legacies affect people's daily activities, opportunities, and aspirations. One of the ways in which ISM aims to achieve these goals is by being an active supporter and vehicle of social change, as well as a political campaigner, in the field of human rights.

Janet Marstine explains that "[m]useums are not neutral spaces that speak with one institutional, authoritative voice. Museums are about individuals making subjective choices"[19]—a comment echoed by David Fleming at the opening of ISM, when he stated, "This is not a museum that could be described as a 'neutral space' it is a place of commitment, controversy,

honesty and campaigning."[20] Actually ISM relies on the idea that museum professionals and visitors should be conscious that "[h]istory always has been and always will be regularly rewritten, in response to new questions, new information, new methodologies, and new political, social, and cultural imperatives."[21] As guardians of snapshots of history, museums are "imbuing the past with present-day intention."[22] As a result, museums are not neutral and merely convey to the best of their abilities what Foner calls a "reasonable approximation of the past." [23]

Agency and ownership need to be carefully considered when planning collection strategies. For ISM, dismissing the neutrality myth is essential. Only when this happens can truly democratic dialogue and debate be held in the museum. These discussions were central to the development of one of the more disturbing yet constructive juxtapositions displayed in the ISM: the relationship between the Ku Klux Klan outfit, which was donated to ISM in 2007 by an American citizen living in the United Kingdom who wished to remain anonymous, just a few months before the opening of the display galleries, and the Black Achievers Wall, both within the *Legacy Gallery*. As soon as one walks into the *Legacy Gallery* it is difficult not to catch a glimpse of the Black Achievers Wall—it has a central, prominent position. It sits close to the Ku Klux Klan outfit (Figure 10.1) but is not dominated by it—achievement versus oppression. Further investigation of this gallery would also allow the visitor to interact with the Cultural Transformation section, including the Music Desk, a central and popular feature that examines the global influence of African music. This juxtaposition lends itself to the words of Barbara J. Little, who observes that "our experiences with our histories can leave us both heartened and dismayed, sometimes simultaneously."[24]

In various community consultation sessions arranged prior to the museum's opening in August 2007, a recurring theme was that ISM had to carefully balance the horror and the often visceral presentation of transatlantic slavery with a backdrop of resistance and African and black achievement. The Black Achievers Wall shows black achievement across the arts, sciences, and sporting world, constituting one of several attempts at challenging the visitor not to leave ISM only associating African and black history with the transatlantic slave trade and slavery and a solely negative history. The Black Achievers Wall is intended especially for those visitors, of all ages, who know very little about the subject of transatlantic slavery and African history before their visit to the museum.

One example of the way the *Legacy Gallery* is used was a recent collaboration between ISM and the Aim Higher Reaching High Project aimed at supporting young black males from Merseyside to achieve higher level education. This particular project had a number of objectives such as: exploring historic influences of black music and its connections to the contemporary music scene; examining how young people engage with culture and cultural organizations; and, most exciting, developing new musical content for the Music Desk.

Figure 10.1 Ku Klux Klan display, International Slavery Museum, *Legacy Gallery*. Photograph by Lee Garland. Courtesy of International Slavery Museum.

Young people involved with the project visited ISM on several occasions. They engaged with museum staff and produced professionally recorded end products. However, there was some discussion whether the final product had more in common with mainstream British music than we would have liked. The final product did not seem to have the edginess one associates

with urban music, an underground sound of disillusioned youth. However, the ISM team took a step back and realized this was exactly the kind of attitude and broad generalization that should be challenged. The idea that new Liverpool black urban music would not be influenced by other underground British genres, such as Grime, a combination of UK Garage, drum 'n' bass, and hip-hop music developed in London around 2002, was a surprise, yet it should not have been. The very fact that new black urban music was most definitely influenced by recognizable mainstream music is an indicator of the cultural and musical development and identity of black youths in Liverpool. Thankfully, preconceived ideas of urban music did not affect the outcome of this musical journey; the end product was not diluted to suit the tastes of the ISM staff.

To achieve a balanced view, the ISM team works with some of the leading experts in the field in order to allow visitors to understand, among other things, British and European involvement in transatlantic slavery and their role in the enslavement of Africans. At the same time ISM makes Africa and Africans the central agents of the whole museum narrative. This approach is developed by starting with areas of achievement, often born out of resistance. This starting point for the narrative of transatlantic slavery and its legacies is a way for some audiences to begin their journey of dialogue with the subject.

The Ku Klux Klan outfit is central to the Racism and Discrimination section of the *Legacy Gallery*. The gallery also includes objects that depict racist and stereotypical imagery of black people, as well as multimedia presentations depicting subjects such as the rise of the Ku Klux Klan and the killing of the young British black man, Anthony Walker, in 2005. The ISM learning base is named after Anthony Walker. After visiting ISM and seeing the rushes (pre-edit film footage) of the film, Walker's mother and sister approved the use of footage and images relating to a press conference given by the family. Although difficult to measure the understanding and communication of ISM's values to the public, when Walker's sister recently referred to the Anthony Walker Education Centre as "my brother's room" there had been a very thought provoking shift of ownership. It was a significant move for ISM not only to seek out legal permission but also moral permission from relatives of an individual featured within the display galleries. Especially when ISM enthusiastically claims that it is not neutral but is an active museum, engaging with local and national issues is crucial.

CAMPAIGNING COLLECTIONS

ISM is currently developing one of the world's first permanent collections on the subject of contemporary slavery, focusing on objects associated with it, including bonded labor, early and forced marriage, forced labor, slavery by descent, trafficking, and child labor. The focus of this collection

is individuals' experiences of being enslaved. The collection will be used as an interpretive tool to ignite discussion and dialogue about contemporary slavery and to support campaigns and raise awareness. Moreover, the museum also supports exhibition proposals from external organizations that actively campaign against all forms of contemporary racism, discrimination, and slavery.

In 2009 the ISM developed the post of Collections Development Officer. The remit of the post was to develop ISM's future collections policy. Central to the role was the development of an updated contemporary collections policy in line with the aims and objectives of the museum. This policy was intended to emphasize contemporary slavery and the associated sensitivities. Within six months, thanks to new partnerships with human rights organizations such as Stop the Traffik and Anti-Slavery International, a contemporary slavery strand was developed alongside an already well-established transatlantic slavery strand.

This new collection stands alongside several other collections. The Diaspora Collection focuses on social history material relating to the black diaspora, both historical and contemporary, from countries that have a link to the transatlantic slave trade and slavery and, in particular, on the black presence in the United Kingdom. The curatorial team is particularly interested in Liverpool's social history, actively sourcing collections that reflect the experiences and identities of Liverpool's black community, their relationship to the city, and the impact of social, political, and economic change on their lives.

The Legacy Collection covers two main areas. Racist Memorabilia is a collection of manufactured items that depict racist imagery and racist stereotypes of people of African descent. This material is usually American or British in origin and is often referred to as "Americana" or "black memorabilia." The collection Global Inequalities reflects the political, economic, and environmental issues associated with global inequalities and fair trade. The domination of world trade by western markets is considered by many as a form of economic imperialism, a legacy of the colonial era, and a source of present inequalities. The collection seeks to show these inequalities through case studies and objects.

It was a steep learning curve for the museum to create one of the few, if not the only, permanent contemporary slavery collections. The first accessioned object within the contemporary slavery strand was the artwork *Missing* (2007) in 2009 by the artist Rachel Wilberforce. It consists of a series of photographs depicting scenes of a slave trade, which still thrives, and illustrating to what extent slavery is a contemporary issue. Photographed in urban and suburban Britain, the images depict sex trafficking and prostitution: the interiors and exteriors of working or derelict flats, brothels, and so-called massage parlors. The photographs are devoid of people, yet at the same time reveal human activity. *Missing* responds to the psychology of sexual exploitation: the loss of identity, a

192 *Richard Benjamin*

sense of displacement, the violation of human rights, and the clandestine nature of the crimes.[25]

Rachel Wilberforce works with photography, film, video, installation, and live art intervention. She lives and works in London and has exhibited at Leeds City Art Gallery and the Courtauld Institute of Art in 2006, and in 2007 at the Open Eye Gallery in Liverpool, and Tate Modern and Freud Museum in London. Her work has also been seen in the Netherlands, Austria, Serbia, and the United States. Wilberforce's work reflects on the human condition through psychological, cultural, and social ideas, playing on the tension between reality and fiction, the familiar and the uncanny, and the public and the private.

Following this visually evocative work, in 2010 the museum acquired several slavery-related ankle bracelets from the collections of Anti-Slavery International. One of the bracelets (Figure 10.2) was "worn" by a young girl in Niger who was subjected to a form of descent-based slavery. Descent-based slavery occurs in some countries where people are either born into or are descended from a group perceived by other groups as suited for slave labor. A status carried from one generation to the next, people subject to descent-based slavery are not allowed to own land or inherit property and are denied the right to receive education.

The bracelets represent the importance of the museum's work in developing its collections in contemporary slavery and campaigning to fight it. The ISM curatorial team understood that it was important to display the ankle bracelets with personal stories that really challenge the visitor who believes slavery to be an issue of the past rather than the present. Indeed, there was discussion about referring to the objects as "bracelets," which

Figure 10.2 Niger ankle bracelet, International Slavery Museum, *Legacy Gallery*. Photograph by Anti-Slavery International. Courtesy of International Slavery Museum.

tends to conjure up images of physical adornment for personal vanity reasons, rather than a tool of enslavement. Eventually, it was decided to use the title given by Anti-Slavery International but to recognize that this subject may need to be addressed at a later stage. The bracelets are currently being exhibited in a new display case in the *Legacy Gallery*.

The curatorial team discussed in detail where a contemporary slavery collecting policy might lead ISM, and it was agreed it could well be a visually and emotionally distressing place. Should the museum exhibit personal effects of victims of the Morecambe Bay cockling tragedy to highlight the exploitation of workers by gang masters? In 2004 twenty-three Chinese workers were drowned by rising tides off the Lancashire coast. Would the contents of a raided brothel highlight the blight of human trafficking? These are difficult decisions that need to be addressed by the museum.

Alongside the collections one of the most challenging ways in which ISM is looking to be a democratic museum is in the development of a public gallery called *Campaign Zone*, a newly developed exhibition and community space which will highlight current human rights campaigns with accompanying community and education programs. The first exhibition of this kind, *Home Alone: End Domestic Slavery*, highlights a two-year Anti-Slavery International campaign intended to raise awareness about the plight of domestic workers in the United Kingdom and internationally. Historically and still today, domestic work has been a sector that is vulnerable to abuse. Domestic workers lack legal protection, and the campaign is hoping to bring about a change in the law to protect domestic workers in the United Kingdom and abroad. It is an exhibition that makes a clear statement about the Museum's campaigning intentions.

CONCLUSION

The bicentenary events of 2007 highlighted the national interest in the subject of transatlantic slavery and its legacies. As such national and local government supported a plethora of initiatives and projects. One such initiative was the International Slavery Museum, which by opening on August 23 gained maximum publicity that has continued to the present day. Whereas some of the exhibitions and projects were very much focused on 2007, the ISM's permanence allowed it to use the bicentenary as a springboard rather than being an outcome. This has allowed the museum to develop and broaden its remit and become the campaigning museum it is today.

To arrive at this place the ISM looked at ownership in a progressive and decisive manner. Visitors should be involved with the core messages of the museum on display, and as part of this democratic process, community voices, such as the Liverpool black community, should be listened to. Through close consultation with community members the need for visitors to leave with messages of resistance and African and black achievement,

as well as an understanding of the core subject matter concerning transatlantic slavery and its legacies, was heeded, using juxtapositions such as the Black Achievers Wall and the Ku Klux Klan display. At the same time, members of the public, especially core visitors such as families and school groups who are not used to seeing such hard-hitting, up-to-date, and often disturbing displays and exhibitions, are taken out of their comfort zones by requests to get involved. The ISM for one is prepared to accept this approach if the intention is to cater for all members of the public, particularly on behalf of the invisible visitors, those who might not have even the basic human rights knowledge to make a visit to a museum.

The museum's aim is also to develop new collections of international importance which reflect the legacies of the transatlantic slave trade and slavery, and the heritage of the African diaspora in today's world. As the museum's contemporary slavery collection grows, and as its partnerships with human rights organizations develop, museum staff will have to make difficult decisions about how much we expose our visitors to. Human trafficking, bonded labor, and slavery in all its forms are not new phenomena, but internationally there is renewed interest from governments in these areas, such as the United Kingdom government opting-in to the European Union Trafficking Directive at the beginning of 2011. As such the museum must seize the moment to gain maximum publicity, just as the various human rights organizations themselves will. One specific aim of the ISM is to act as a national depository for the collections and archives of NGO's such as Anti-Slavery International or Amnesty International. In this way, well-documented and provenanced material can be regularly accessioned by the museum for display, educational, and research purposes. The benefit to NGOs is that sensitive yet powerful material can be preserved and made accessible to the wider general public, which in turn would be of benefit to their campaigns.

Allison and Gwaltney point out that "most visitors are collecting impressions and experiences that will 'make sense' later in conjunction with other experiences and activities in their lives."[26] The ISM recognizes the fundamental need for social issues to be challenged and addressed, and it can become a place where visitors, and community members, such as the Liverpool black community, not only "make sense" but "get involved" with subjects and campaigns that the ISM champions.

The continued growth in NML visitor figures from 2000[27] to the current age of austerity show that people still value museums; they value the museum's staff expertise; and they value the opportunity to see, feel, and touch the past, albeit a past firmly anchored in the nuances of today. The museum aims to inform and hopefully inspire the public to action. Not only do the plethora of positive and supportive comments left in the museum's Response Zone give a good indication that the aims and objectives of the museum are being met, but events in the new Campaign Zone have been well attended, and a number of human rights organizations are keen

to get involved and host events. In the field of human rights ISM might still not be seen in the same light as Amnesty International or Anti-Slavery International, but the interest generated by the Campaign Zone shows the demand for such a museum space. Last year this space was inaccessible nonpublic storage space, but through the commitment of NML it is now a space which is high profile, has a growing footfall, and demonstrates our willingness to work with national and local community human rights focused organizations.

NOTES

1. David Fleming, "Liverpool: European Capital of the Transatlantic Slave Trade" (paper presented at the annual conference of International Association of City Museums, Amsterdam, November 3, 2005).
2. David Richardson, "Liverpool and the English Slave Trade," in *Transatlantic Slavery: Against Human Dignity,* ed. Anthony Tibbles (Liverpool: Liverpool University Press, 1995), 67–68.
3. Mark Christian, "The Age of Slave Apologies: The Case of Liverpool, England," podcast audio program, November 14, 2007, http://www.liverpoolmuseums.org.uk/podcasts/talks/liverpool_slavery_apology.mp3.
4. John Beech, "The Marketing of Slavery Heritage in the United Kingdom," in *Slavery, Contested Heritage, and Thanatourism,* ed. Graham Dann and A.V. Seaton (New York: Haworth Press, 2001), 99.
5. Wesley Zepherin, *Connecting with the Bicentenary of the Abolition of the Transatlantic Slave Trade: A Toolkit for Developing Projects* (Dewsbury: Arts Council England, Yorkshire, 2007).
6. Anthony Tibbles, "Against Human Dignity: The Development of the Transatlantic Slavery Gallery at Merseyside Maritime Museum," in *Proceedings, IXth International Congress of Maritime Museums,* ed. Adrian Jarvis, Roger Knight, and Michael Stammers (Greenwich and Liverpool: National Maritime Museum, Merseyside Maritime Museum, 1996), 95–96.
7. See Tibbles, "Against Human Dignity," 95.
8. Liverpool-born black historian, Ray Costello describes several reasons, other than the slave trade, why black people arrived in Liverpool. See Ray Costello, *Black Liverpool: The Early History of Britain's Oldest Black Community, 1730–1918* (Liverpool: Picton Press, 2001).
9. Ola Uduku and Gideon Ben-Tovim, *Social Infrastructure in Granby/Toxteth: A Contemporary Socio-Cultural and Historical Study of the Built Environment and Community in L8* (Liverpool: University of Liverpool Press, 1998), 11.
10. Elder Dempster was the main cargo transporter between West Africa and Liverpool, sailing between Freetown in Sierra Leone, Lagos, and Calabar in Nigeria and Takoradi in Ghana in the late nineteenth and early twentieth century. For a detailed account of routes see Peter N. Davies, *The Trade Makers: Elder Dempster in West Africa, 1852–1972* (London: George Allen & Unwin, 1973).
11. Laura Tabili, *"We Ask For Justice": Workers and Racial Difference in Late Imperial Britain* (Ithaca and London: Cornell University Press, 1994), 141.
12. Anthony Gifford, Wally Brown, and Ruth Bundey, *Loosen The Shackles: First Report of the Liverpool 8 Inquiry into Race Relations in Liverpool* (London: Karia Press, 1989), 5.

13. Gifford, Brown, and Bundey, *Loosen The Shackles*, 227.
14. Tibbles, "Against Human Dignity," 96.
15. See Anthony Tibbles, "Facing Slavery's Past: the Bicentenary of the Abolition of the British Slave Trade," *Slavery and Abolition* 29, no. 2 (2008): 293–303, and Alan Rice, "Revealing Histories, Dialogising Collections: Museums and Galleries in North West England Commemorating the Abolition of the Slave Trade," *Slavery and Abolition* 30, no. 2 (2009): 291–309.
16. Laurajane Smith and Geoffrey Cubitt, "1807 Commemorated Project Report: International Slavery Museum" (York: University of York, 2009).
17. UNESCO, *UNESCO-Madanjeet Singh Prize for the Promotion of Tolerance and Non-Violence* (Paris: UNESCO, 2009), 3.
18. National Museums Liverpool, "Liverpool Slavery Remembrance Initiative (LSRI) Business Plan 2006–2008" (Liverpool, 2006).
19. Janet Marstine, *New Museum Theory and Practice* (Oxford: Blackwell Publishing, 2006), 2.
20. David Fleming, "Opening of the International Slavery Museum," http://www.liverpoolmuseums.org.uk/ism/resources/opening_speech.aspx.
21. Eric Foner, *Who Owns History? Rethinking the Past in a Changing World* (New York: Hill and Wang, 2002), xvii.
22. David Lowenthal, *The Past is a Foreign Country* (Cambridge: Cambridge University Press, 2003), 356.
23. Foner, *Who Owns History?* xvii.
24. Barbara J. Little, "Introduction," *CRM: The Journal of Heritage Stewardship* 7, no. 1 (2010), http://crmjournal.cr.nps.gov/print.cfm?type=Introduction.
25. "*Missing* 2007/08," http://www.rachelwilberforce.com/works/missing.
26. David K. Allison and Tom Gwaltney, "How People Use Electronic Interactives: Information Age—People, Information & Technology," in *Hypermedia & Interactivity in Museums: Proceedings of an International Conference*, ed. David Bearman (Pittsburgh: Archives & Museum Informatics, 1991), 69.
27. National Museums Liverpool, *Annual Review 2009* (Liverpool: National Museums Liverpool, 2009), 4–5.

11 The Art of Memory
São Paulo's AfroBrazil Museum

Kimberly Cleveland

On November 20, 2003, national Black Awareness Day in Brazil, the mayor of São Paulo, Marta Suplicy (2001–2004), announced plans to create the Museu AfroBrasil or AfroBrazil Museum. The foundation of this institution constituted one of the numerous steps the government had taken since 1988, the country's centenary of the abolition of slavery, to reexamine[7] and recontextualize the social and cultural contributions that Africans and African descendants had made in Brazilian history. More than just a space for art exhibitions, this museum aimed to "tell an alternative Brazilian history" by "deconstructing an image of the Black population constructed from a historically inferior perspective" and "transforming it into a prestigious image founded on equality and belonging."[1] Although Brazil has the highest number of peoples of African descent outside the African continent, this fact is not reflected in the country's cultural institutions. Therefore, the creation of a museum dedicated to representing the history of Brazil's African and Afro-Brazilian populations was momentous. Even more audacious, however, was that the institution would examine one of the darkest periods in the country's history—the era of slavery.

Through an overview of the AfroBrazil Museum's successes and failures since it opened in October 2004, this chapter considers the museum within the contexts of local, national, and transnational representations of the history of slavery. As the majority of the Brazilian population has traditionally only been open to acknowledging the aesthetically pleasing African-influenced aspects of Brazilian culture, such as the liturgical costumes and instruments affiliated with Afro-Brazilian religions, the museum strategically uses visual materials as its primary tool to teach about black history. In glossing over deeply rooted racial inequality in a seemingly benign manner, the institution appropriates the technique inherent in *racismo cordial* or cordial racism, which whites have historically used to discriminate against Afro-Brazilians.[2] Despite its innovative approach and demonstration of agency, the institution still faces racially based obstacles. I argue, by examining the AfroBrazil Museum's political and financial challenges, that the institution acts as a microcosm of the resonances of slavery, which continue to plague contemporary Brazilian society.

REPRESENTING BLACK HISTORY: A PRIVATE AND PUBLIC COLLABORATION

Although the AfroBrazil Museum was created by the mayor of São Paulo's special decree 44.816 of June 1, 2004, the man behind the institution was not a politician, but rather an artist and curator. Born in the northeastern state of Bahia, Emanoel Araújo served as the director of the Art Museum of Bahia from 1981–1983. In 1988, in conjunction with the centenary of abolition, he organized Brazil's first large-scale exhibition of Afro-Brazilian art—*A Mão Afro-Brasileira* or *The Afro-Brazilian Touch*. Subsequently, he curated several national and international exhibitions on this same theme while continuing to build his own career as an artist. In 1992 he became director of one of São Paulo's major art museums—a position he held for a decade. His was an unparalleled professional rise to the top in the Brazilian art world for an individual of African descent. Furthermore, even before he started to make Afro-Brazilian art more public both domestically and internationally via a series of exhibitions, Araújo had begun to privately purchase artworks and objects by and related to Afro-Brazilians. When the mayor of São Paulo learned from her cultural secretary, Celso Frateschi, that Araújo had amassed approximately 1,100 pieces, she invited him to create the AfroBrazil Museum.[3] As a major cultural institution dedicated to a comprehensive representation of Brazil's African-descendent population, the museum, like its director, was without equal.

Even though Araújo was, and unquestionably still is, the driving force behind the institution, the AfroBrazil Museum only became a reality through municipal and private collaboration. The governor of São Paulo, Geraldo Alckmin (2001–2006), donated the Manoel da Nóbrega Pavilion, designed in 1954 by famed national architect Oscar Niemeyer, to the museum. For his part, Emanoel Araújo made a commodate loan of his collection, which primarily consisted of paintings, sculptures, and prints.[4] He installed his pieces in the exhibition space reserved for the permanent collection, to which additional museum acquisitions have since been added. The museum does not emphasize this public-private collaboration to its visitors, even though it is the foundation of the institution. When the museum opened on October 23, 2004, numerous key figures, including Senator Aloísio Mercadante, Lieutenant Governor Cláudio Lembo, and Deputy Mayor Hélio Bicudo, were there to mark the historic occasion. Brazilian President Luiz Inácio Lula da Silva's attendance, above all the other politicians', was indicative of not only the size and scope of this institution, but above all, its importance to the nation.

The AfroBrazil Museum is both similar to its neighboring cultural institutions and yet also unique in certain aspects. The modern architecture is typical of Niemeyer's style, other examples of which are found just minutes away, including the Modern Art Museum and the Ciccillo Matarazzo Pavilion, the home of the São Paulo Biennial. In addition to the usual exhibition

and administrative areas, the 118 million square-foot building also allows for a theater and a sizeable library, which houses a wide range of approximately 6,800 publications and is open to visitors without appointment.[5] The majority of the materials deal with the Atlantic slave trade and African and Afro-Brazilian art, history, cuisine, and religion.

In spite of the AfroBrazil Museum's nondistinct exterior, the building's contents are exceptional. The exhibition space for the permanent collection is divided into six sections: Africa: Diversity and Persistence; Work and Slavery; Afro-Brazilian Religions; The Sacred and the Profane; History and Memory; and The Visual Arts: The Afro-Brazilian Touch. This collection occupies the entire upper level of the museum. Because there are no closed galleries, floating dividers distinguish different thematic areas and guide visitors through the space. The extensive collection spans approximately the sixteenth to the twenty-first centuries, and ranges from historical examples of material culture to contemporary artworks. Moreover, the number of pieces that not only depict Africans and African descendants in Brazil, but were also made by black artists, makes them inimitable.

In its focus on representing history from the black point of view, and primarily through visual representations, the AfroBrazil Museum distinguishes itself from the handful of other museums in Brazil that highlight the country's black population. Most of the museums that address black Brazilian art and culture are located in the states of Bahia and Rio de Janeiro, and are closely linked with regional ethnic tourism geared toward exploring African social and cultural retentions. In the interests of demonstrating clear African influences, these museums have a somewhat narrow emphasis on the Afro-Brazilian religion of Candomblé.

Brazil has no national museum dedicated to exploring the country's history of slavery.[6] This fact in and of itself is not entirely unusual given that neither does the United States. However, the lack of national institutions that examine black Brazilian history, including the period of slavery, *is* problematic and yet wholly unsurprising for those familiar with the deep-rooted racial inequality in the country.

The Brazilian government has only rather recently been open to reexamining and recognizing the challenges that Africans and African descendants have faced, with the majority of the corrective measures dating from 1988, the country's centenary of the abolition of slavery. In an effort to combat inequity in education and employment, the Brazilian congress incorporated an updated version of the antidiscriminatory Afonso Arinos Law, first written in 1951, into the new 1988 constitution with much stricter penalties for violations.[7] The new constitution also provided for the creation of the Palmares Cultural Foundation, an entity of the Ministry of Culture, which is dedicated to Afro-Brazilian culture. Three years later, Leonel Brizola, the governor of Rio de Janeiro, created the Secretariat for the Defense and Promotion of Afro-Brazilian Peoples (SEAFRO). In order to encourage a greater sense of social inclusion, federal legislation, including Laws 7.668 of August

22, 1988, and 10.639 of January 9, 2003, require the teaching of African and Afro-Brazilian history and the African contribution to the formation of Brazilian society in primary and high school curriculum.[8] In 2002, legislation that called for affirmative action-style programs in public and private universities, civil service exams, and some private businesses was passed.[9]

Still, much of the downplaying and, at times, outright denial of racially based social problems stem from the way Afro-Brazilians have historically been incorporated into the official conceptualization of the nation. This attitude dates back to Brazilian sociologist Gilberto Freyre's seminal book *Casa-grande e senzala* (1933), later published as *The Masters and the Slaves* (1946), in which he asserted that all Brazilians could participate in a common national culture because of the country's historical mixture of European, African, and Amerindian peoples and influences. In essence, the nation was a "racial democracy," in which cultural and racial hybridity formed the foundation for equality.[10] In the second half of the twentieth century, scholars, including Brazilian sociologist Florestan Fernandes, debunked this theory and renamed it the "myth of racial democracy," but many Brazilians still remain wedded to the idea.[11] As a result, much research in Brazil is weighted toward examinations of black culture and religion, with little attention paid to "race relations, racial discrimination and the complex relationship between 'race' and class."[12] These studies on culture and religion promote better understanding of blacks' contributions to Brazilian society. The choice to explore only these often aesthetically pleasing themes, however, ultimately perpetuates the ongoing cycle of denial.

Several scholars have identified Brazil's comparatively late abolition of slavery in 1888 as a possible reason why the country has not devoted more time and effort to exploring certain aspects of its national history. Anthropologist Livio Sansone asserts that this paucity is perhaps due to the "short period Brazil has lived without slavery and [that] the scars left by slavery on Brazilian society are still fresh."[13] The director of the AfroBrazil Museum echoes the idea that the country is still in the process of digesting its past when he states: "Brazil was not only a slave-driven society, but also the last country in the Americas to free its slaves on whose labor wealth was based . . . Today Brazil has still not come to terms with this."[14] Founding the country's first major cultural institution dedicated to exploring the history of Brazil's African and African-descendent peoples in the twenty-first century can therefore only be understood as a milestone.

THE AFROBRAZIL MUSEUM: STRATEGICALLY REMEMBERING THE PAST

Simply creating an institution to present a revisionist history of blacks and their contributions to Brazil was not enough in and of itself to have a social impact given contemporary society's preference not to revisit ugly

details of its slave past; rather, the AfroBrazil Museum had to devise a tactical approach. It is a common assumption that the institution is an art museum and, indeed, it does feature a large number of artworks. Araújo often emphasizes the artistic nature of his institution in interviews and statements, and the museum has published a number of exhibition catalogs filled with artistic images. Yet, it is not solely an art museum. In point of fact, in discussing the museum for a publication, the director referred to it interchangeably as a "historical museum" and an "ethnographic museum," in addition to an "art museum."[15] This multiplicity is related, in part, to the museum's mission statement, which emphasizes the institution as an intersection of art, history, and memory.

Though the polyvalent characterization of the AfroBrazil Museum may be somewhat confusing, and might at first suggest a lack of focus or organization, in reality, the institution's diversity is quite tactical. In its goal to attract Brazilians beyond the normal "museum-going" crowd, it doesn't burden its visitors with lengthy text panels and explanations that require a good deal of reading, characteristically found in history museums or anthropology museums that feature ethnographic collections. Neither, however, is it an environment that primarily focuses on aesthetics, artistic trends, and movements—artistic production done in the vein of what is commonly referred to as "Art for Art's sake." Rather, the AfroBrazil Museum's didactic instrument of choice is visuals, including the frequent juxtaposition of historical objects or material culture with artistic renderings of the same or related subjects. Thus, in contrast to some art museums that employ a work of art's subject matter to teach about history as a secondary concern, this museum brings artistic and historical representations together in such a way that their function in the space is inextricably bound.

In teaching about slavery through its permanent collection, the museum positions historical objects alongside fine art pieces. The references to slavery sometimes appear overtly within the larger exhibition, such as the slave ship replica, which stands in the middle of the museum. Although not a highly realistic or detailed replica, the model speaks to the Middle Passage. Instead of focusing on African retentions in the form of spiritual beliefs that highlight ties with Africa, this ship acts as an instrument to prompt visitors to stop and think how and in what capacity those religions were transported to Brazil. Other times, the references to slavery are more subtly interspersed among the exhibition pieces. There are, however, also historical objects juxtaposed with paintings depicting scenes of slavery, which can be understood as a curatorial technique or tactic. The AfroBrazil Museum recognizes that because many Brazilians still resist addressing race and other sensitive subjects, they are more likely to visit an art museum than a slavery museum. Thus, for a museum that strives to reconstruct national history, thereby revealing both a historical period and point of view that is largely muted, the institution strategically communicates the horrific history of slavery beneath the veil of an aesthetically pleasing atmosphere.

In addition to demonstrating a curatorial tactic, the museum's technique of revealing and concealing functions on another level—as both a subversive act and a demonstration of institutional agency. Because Freyre's alleged "racial democracy" was rooted in the idea of social equality, it allowed whites to discriminate against nonwhites without acknowledging the nature of their actions. In 1995, a widespread study published in the newspaper *A Folha de São Paulo* labeled the resulting form of day-to-day discrimination *racismo cordial* or cordial racism.[16] This term suggests that although racism was never institutionalized in Brazil the way it was in the United States, it was just as deeply rooted socially, though often glossed-over in informal interactions and experiences via a process of "veiling." Thus, in representing national history through a more inclusive, yet still aesthetically pleasing, approach the museum appropriates that act of "veiling" for its own purposes.

The practice of revealing and concealing is also evident in other areas of São Paulo, although it does not have the same dual purpose as it does for the AfroBrazil Museum.[17] Generally speaking, most of the references to the country's history of slavery in the public sphere are nonconfrontational, visual representations. In various parts of the city, seemingly innocuous references to slavery appear in the form of public sculptures. Immediately outside Ibirapuera Park, in which the AfroBrazil Museum is located, for example, stands Victor Brecheret's 1953 Monument to the Bandeiras. The sculpture includes individuals of different races, which seems in keeping with the Brazilian historical blending of different peoples. However, the *bandeirantes* were Portuguese colonial scouts who went on *bandeiras* or expeditions in the interior to look for untapped resources, including Amerindians for enslavement, from the sixteenth to the eighteenth centuries.[18] São Paulo's history of African enslavement is also commemorated in the Monument to the Black Mother or Monumento à Mãe Preta, another public sculpture. In various parts of Brazil, it was a common practice for upper-class whites to use an African slave as a wet nurse, also known as a *mãe preta* or "black mother." Júlio Guerra's 1955 monument is located in Paiçandu Square in front of the Our Lady of the Rosary of Black Men's Church. This romanticized, though somewhat abstract, representation of a seated black woman with a child at her breast recognizes the role that wet nurses played in the local and national history of that era without any acknowledgment of their suffering.

São Paulo's benign remembrance of the slave era elides the region's ties to the practice. In the nineteenth century, it was one of Brazil's three largest coffee-producing states and was dependent upon the labor of enslaved Africans.[19] In the early twentieth century, however, the region's coffee boom resulted in greater European immigration and the marginalization of its former slave population. Despite the area's sizeable historic and current black population, historian Barbara Weinstein asserts that this region has had a "white" identity since the 1930s, due to of the

influx of Europeans.[20] This characterization separates São Paulo from Bahia, and to a lesser extent Rio de Janeiro, states which have maintained their "black" identity and serve as the geographical loci of both scholarly studies of African retentions in Brazil and ethnic tourism.

Because São Paulo is outside this "Afro"-centric scholarly and touristic "loop," the AfroBrazil Museum's location within the city is especially pertinent to its ability to have a public impact. The museum is located in the city's largest public park—Ibirapuera Park. At any hour of the day, the area is full of people—joggers, cyclists, walkers, skateboarders, school groups, people pushing baby strollers, and amorous couples, and the numbers are substantially multiplied on the weekends. Importantly, the park is also a site for art and culture. The city's Museum of Modern Art is approximately a five-minute walk from the AfroBrazil Museum. The park also contains venues for musical concerts, and is the location for São Paulo's International Fashion Week runway shows and the São Paulo Biennial. Framed against a backdrop of trees, the AfroBrazil Museum's building lures visitors with its unassuming environment and its floor-to-ceiling windows, which invite passersby to come in for a closer look.

Although the museum employs numerous creative techniques to attract visitors and educate them about national history, it does not demonstrate an equally strong focus on functioning as a transnational representation of the history of slavery. The institution's permanent collection does include a section on African art. In a departure from its otherwise novel approach to history telling through visuals, here the museum reverts to the national tendency to highlight cultural and aesthetic aspects.

Despite Brazil's considerable African-descendent population, the dissemination of information to the public about Africa and its presence in Brazil was not a national focus until rather recently. In-depth knowledge of Africa was largely limited to certain academic and Afro-Brazilian religious communities. Perhaps due to Brazilians' overall lack of familiarity with the African continent, including its diverse peoples and artistic production, the only information provided for the African artworks in the AfroBrazil Museum are minimal labels containing the title, cultural group, country, and approximate date. Although no more or less information is given for these pieces than any other works in the permanent collection, visitors seeking to educate themselves about the African heritage of a good part of the Brazilian population have little to glean here. Additionally, the museum's director asserts that the institution is not only a Brazilian museum, but also a "museum of the African Diaspora in the New World," as Brazil was only one of several countries indelibly affected by the arrival of enslaved Africans.[21] References to African-influenced production in other countries, however, are limited to a few works by twentieth-century artists, including George Nelson Preston and Rotimi Fani-Kayode.

Even as the AfroBrazil Museum's distance from Bahia and Rio de Janeiro precludes it as a stop on the regional ethnic tourism circuit, its

location outside these "black" states facilitates the institution's novel approach to introducing the public to black Brazilian history. In Bahia, for example, the resonances of slavery relevant to sites such as the downtown neighborhood Pelourinho (literally "pillory" or "whipping post") and the Museum of Modern Art of Bahia, which is housed in the buildings of a former plantation, have been glossed over for touristic purposes.[22] The AfroBrazil Museum takes a more direct approach, but one that also has limits. For example, the museum has several nineteenth-century prints in its permanent collection by the French artist Jean-Baptiste Debret, which show enslaved Africans in Brazil being physically abused. These works appear in the museum as blown-up, illustrative reproductions, rather than in their original form. The modification of size, despite the content, fosters a decorative effect. Like the model slave ship, their appearance suggests a move toward recognizing the past but circumventing a head-on confrontation. Visual allusions and illusions are both preferable and safer in certain instances than visual accuracies.

Although the AfroBrazil Museum has some weaknesses, it excels in both its accessibility and educational offerings. Because so many Brazilians, both blacks and whites, are reluctant to actively engage with the memory of slavery, the institution will only successfully provide a space where that process can begin if it can at least attract a significant part of São Paulo city's population to visit. One important way to make this happen is that there is no admission charge. This is noteworthy given that the vast majority of museums in Brazil, including the Museum of Modern Art, just a few minutes away, have entry fees. For most economically challenged members of the population, museums are cost-prohibitive. Indeed, even a nominal admission charge can make a museum visit an experience that is out of reach.

Equally important to realizing a public impact is the AfroBrazil Museum's Education Department. Like similar departments in other institutions around the globe, the AfroBrazil Museum's Education Department is primarily responsible for educational activities, including guided thematic tours. Schoolchildren from both private and public schools comprise perhaps the most important groups who come to the museum for these visits. Reflecting on the significance of these tours, Araújo states:

> When I see school groups in the museum, I think that such visits must have some effect on the memory of these children, who are the future of the country because the museum was built to seduce whoever visits it. Children are far more vulnerable and sensitive than adults. They are still in their formative years when images have an immediate power. For this very reason, an accumulation of objects reinforces the remembrance of our heritage.[23]

In his plan to educate the Brazilian public about largely disregarded peoples and periods of national history, Araújo has not overlooked the individuals

who are often some of the most marginalized members of the population—Afro-Brazilian children. Although the museum functions as a heuristic tool for making blacks' role in Brazil's history public for all segments of the population, its commitment to "reflect an inheritance in which . . . the [Afro-Brazilian] can recognize himself, reinforcing the self-esteem of an excluded people with a splintered identity" is especially pertinent for African-descendent visitors of all ages.[24]

MAKING THE MEMORY OF SLAVERY PUBLIC: DICHOTOMIES ON DISPLAY

In making the memory of slavery in Brazil public, the AfroBrazil Museum draws from a number of dichotomies. There is the factor of the private collection in a public space upon which the institution is physically composed. The museum exemplifies the technique of revealing and concealing information through its objects. The institution, however, also engages with a number of more abstract issues that play upon the convergence of intellect and emotion. Foremost is the concept of slavery itself. As a construct of domination and negation, it can be counterbalanced with the ideas of liberation and affirmation. Historian Ira Berlin summarizes the complex nature of understanding slavery in US history as a set of opposing concepts:

> What makes slavery so difficult for Americans, both black and white, to come to terms with is that slavery encompasses two conflicting ideas—both with equal validity and equal truth, but with radically different implications. One says that slavery is one of the greatest crimes in human history; the other says that most men and women dealt with the crime and survived it and even grew stronger because of it. One says slavery is our great nightmare; the other says slavery left a valuable legacy. One says death, the other life.[25]

These same ideas can be applied to slavery in Brazil. It is one of the darkest periods of the country's history. At the same time, bringing enslaved Africans to Brazil paved the way for the subsequent mixture of European, Amerindian, and African influences that became a point of national pride for future generations of Brazilians. In the process of enslavement, Africans were ripped from their homelands and forced to adopt the foreign, European religion of their owners. From this fissure, slaves syncretized African gods and Catholic saints as a subversive way to maintain their sacred beliefs. The enslaved and their descendants gave Brazil the religions of Candomblé and Umbanda, spiritual forces that guide and empower.

Just as Berlin suggests that slavery can be approached and understood as a series of negatives and positives, the AfroBrazil Museum demonstrates a curatorial counterbalancing. Of the different sections in the permanent

collection exhibition, Work and Slavery provides information in the form of objects such as slave shackles and sugar loaf molds, historical photographs of miners and coffee plantation workers, and reproductions of nineteenth-century prints of slaves laboring and receiving corporal punishment. The section does not provide data on individual slaves. However, it teaches its visitors about different kinds of physical labor, as well as important but overlooked historical actors such as wet nurses. Still, the overarching theme of this area is deprivation and captivity. This "negative" is counterbalanced by couching the section between two "positives"—Africa: Diversity and Persistence and Afro-Brazilian Religions, both of which communicate ideas about religious fulfillment and spiritual liberation. This framing underscores the point that blacks' contributions to Brazil should not be measured by their physical labor alone.

Lastly, understanding the AfroBrazil Museum as a space for remembering raises the question if memory, itself, is an active or passive act. In addressing what are often hegemonic undertones implicit in institutional spaces, scholar Patricia Davison underscores how museums are not simply latent receptacles for memory: "museums give material form to authorized versions of the past, which in time become institutionalized as public memory. In this way, museums anchor official memory. Ironically, the process involves both remembering and forgetting, inclusion and exclusion."[26] As Davison suggests, although the public may perceive the museum to be presenting the official and, therefore, authentic version of the past, the story that the museum tells is, in actuality, subjective by the mere fact that museum professionals, and especially curators, decide what will be included and excluded. As the director and head curator for the AfroBrazil Museum, Araújo's "alternative Brazilian history" is as active a construction as the long-standing attitude toward the memory of slavery in Brazil that he wants to correct.

In formalizing the process of remembering and forgetting, institutions are no different than individuals. They, too, showcase individual preferences, interpretations, and sentiments. By interviewing Afro-Brazilians, sociologist France Winddance Twine and anthropologist Robin Sheriff have found that forgetting the unpleasant aspects of slavery, as well as more recent acts of racial discrimination, is an active process.[27] Much in the same way that museums shape public memory by "including" and "excluding" in their collecting and exhibition practices, individuals also demonstrate a counteragency in their control over forgetting.

MUSEUM AS MICROCOSM OF THE RESONANCES OF SLAVERY

Relatively soon after the AfroBrazil Museum opened, the partnership of public and private upon which the museum was built, collapsed. When the institution opened in 2004, it counted Petrobras among its main financial

supporters.[28] Just one short year later, however, as the end of that agreed-upon-period of support drew closer, and without any new major patronage in sight, the museum faced a financial crisis. The situation was compounded by the fact that during Mayor José Serra's administration (2005–2006), São Paulo's municipal cultural secretary, Carlos Augusto Calil, argued that the city was not responsible for providing funds for AfroBrazil Museum employee salaries.[29] As the institution was created by a 2004 special decree of former mayor Marta Suplicy, Calil asserted the museum had sidestepped the proper procedures, including obtaining approval from the Chamber of Commerce. He also argued that to continue to fund the museum with Araújo's commodatum in place rather than a donation would be "creating a permanent framework for a precarious situation."[30] The cultural secretary only conceded to continue to pay the museum's security staff and utilities because the institution is housed in a public building. Araújo began to cover the rest of the employees' salaries by pooling his own personal resources with support from unspecified private businesses.[31] This was only a stop-gap measure, however. On Black Awareness Day 2005, two years to the day that the community came together to celebrate the creation of the AfroBrazil Museum, Araújo strategically closed its doors in protest over the financial issues.

During the 22-day period that the museum remained closed, a political tug-of-war ensued. The municipal government suggested that the museum formally become one of two types of entities: a Private Foundation or a Civil Society Organization of Public Interest (Organização da Sociedade Civil de Interesse Público).[32] Becoming an OSCIP would legally allow the museum to receive support from several governmental sources. Initially, Araújo resisted this option, pointing out that other local museums, including the São Paulo Art Museum and the Museum of Modern Art, both of which are private institutions, receive annual funds from the municipal government.[33] While in the process of debating the situation, the director continued to try to gather financial support for his museum, including by taking out personal bank loans. The Special Secretary for Participation and Partnerships (Secretaria Especial para a Participação e Parcerias) also contributed 220,000 *reais*.[34] Ultimately, Araújo conceded to convert the museum into an OSCIP. In the meantime, Petrobras had agreed to additional, short-term support. With a new plan and more finances, the museum reopened to the public.

More than simply a point of contention between past and present administrations, the financial troubles plaguing the museum were also, if not even more so, about personal politics. In 2005, at the same time that Araújo was director of the AfroBrazil Museum, he also occupied the post of Municipal Secretariat of Culture of São Paulo under José Serra's administration. A little over three months after taking that position, he resigned in a highly public fashion—in an open letter to the mayor, which appeared in the newspaper *A Folha de São Paulo*. Carlos Augusto

Calil succeeded him—the same Carlos Augusto Calil who, soon after occupying the position of Municipal Secretariat of Culture, refused to continue to use city funds for the museum.[35] Ultimately, both Araújo and Calil expressed their sentiments to the magazine *Raiz: Cultura do Brasil* in separate articles, recording their respective arguments in the pages of a popular magazine.[36]

Even though these developments can be easily dismissed as the casualties of opposing political personalities and shortage of governmental funds, I suggest that this series of events are microcosmic of the larger politics of the public memory of slavery in Brazil. The AfroBrazil Museum was a groundbreaking institution poised to teach the public about black history. Rather than supporting the dissemination of that vital information, Calil, as the Secretariat of Culture, was more focused on chastising the museum for not following the rules and identifying loopholes that would allow the government to divert funds away from the institution. Araújo characterized such actions "bureaucratic proselytism," whereas Calil called them "responsible cultural politics."[37] In his position of authority, this municipal official was acting or reenacting the hegemonic role in the historical play of the powerless versus the powerful. This administrative enforcement of forgetting or eliminating black history dates as far back as 1890, when Rui Barbosa ordered the federal archives of slave registration books burned.[38] Highlighting how historical stereotypes and racial discrimination continue to plague contemporary black Brazilians in their social relations, Araújo likens it to a "silent guillotine over our heads ready to enter into action every time one catches a glimpse of some achievement that represents change."[39] In applying different financial rules to the AfroBrazil Museum than those of its peer institutions, which feature "mainstream" (white or European-influenced) cultural production, the secretary was perpetuating this pattern of marginalization.

By taking the analogy of the museum as a microcosm of the larger public memory of slavery one step further, Emanoel Araújo is representative of the black population. Those who are familiar with the history and cultural institutions of Brazil realize the significance of having Araújo serve as the first director of the AfroBrazil Museum. As a black, homosexual man, he has firsthand knowledge of the politics of social exclusion that are so rampant in his country. When Araújo says that the museum provides a reflection of the world "from the black point of view and experience," he is speaking in general terms about giving voice to a part of the population that isn't often articulated in museums, or frequently affiliated with cultural institutions, if at all. His words can also be understood literally, however, as the works that *he* collected over the years through *his* experiences now fill the museum and constitute the core of the institution's permanent collection. Underscoring that sense of ownership, he

still sometimes rightfully refers to the pieces as "my collection," as, per the commodatum, they will be returned to him.[40] Moreover, he believes he is justified in loaning rather than donating his works to the museum because he "doubts that the collection would be adequately cared for and preserved by the public sector," adding, "I want to have control over it while I'm alive."[41] Although his self-assured territorialism may be difficult for individuals such as Calil to accept, it exemplifies both Araújo's dedication to making sure his collection is available to the public and the drive that has made him the first Afro-Brazilian director of a major museum. Just as Brazil is now in the process of reevaluating the role of blacks in national history, because of this unique relationship between man and museum, future studies of the institution will inherently have to include consideration of Araújo, himself an example of the valuable contributions blacks have made to Brazilian society and culture.

CONCLUSION

Despite its challenges, the AfroBrazil Museum has continued to thrive. By 2007, it had tripled the number of works in its permanent collection, and in its first four years it had received approximately 600,000 national and international visitors.[42] As an institution that represents black history from the Afro-Brazilian point of view, it is poised to succeed in its director's mission to raise the "self-esteem of many Afro-Brazilians who do not know who they are."[43] As a testament to this undertaking, despite the museum's economic challenges, it never changed its policy of free admission.

The AfroBrazil Museum is an institution that reflects a forward-thinking shift in national attitudes, at the same time that it exposes some of the social issues that still divide Brazilian society. As the closest thing Brazil currently has to a national museum of slavery, it aims to surpass other institutions that solely focus on cultural contributions. In making the memory of slavery public, the museum brings a difficult and painful part of the nation's past to the surface.

NOTES

1. Quoted in "Hans Belting Interview with Emanoel Araújo," Global Art and the Museum, http://www.globalartmuseum.de/site/guest_author/214.
2. *Racismo cordial* or cordial racism is a term related to informal acts of racial discrimination that occur on a day-to-day basis.
3. "Hans Belting Interview with Emanoel Araújo."
4. In Scots Law, a commodate loan or commodatum is a loan made free of charge for a certain period of time with the condition that the object(s) will be returned to the owner. Araújo's first such loan was made for a two-year period, ending in October 2006. It has since been renewed. Alexandre Bandeira, "O Museu de

Emanoel," *Raiz: Cultura do Brasil*, no. 3 (2005): 77; "Museu AfroBrasil história e conceito," http://www.museuafrobrasil.org.br.
5. See the rubric "Institucional" and "Quem Somos," in "Museu AfroBrasil," (AfroBrazil Museum) http://www.museuafrobrasil.org.br.
6. Though Brazil does not have a national slavery museum, it has several regional museums that address the country's history of slavery. The Slave Museum in Belo Vale, Minas Gerais was created in 1977. Many Brazilians are unaware that this rather obscure institution, located in a relatively remote part of the country, exists. The Museu do Negro (Black Museum), in the Our Lady of the Rosary and Saint Benedict of Black Men Church in Rio de Janeiro is better known, though its reputation is still largely regional. This small museum is a space to promote worship of the slave Anastácia. More Brazilians are familiar with the widely reproduced image of the black woman whose mouth is covered by an iron mask, however, than they are with the museum dedicated to her memory.
7. George Reid Andrews, *Blacks and Whites in São Paulo, Brazil, 1888–1988* (Madison, WI: University of Wisconsin Press, 1991), 185.
8. "Fundação Cultural Palmares Legislação Institucional," (Palmares Cultural Foundation), http://www.palmares.gov.br; Carlos Alberto Medeiros, *Na lei e na raça: legislação e relações raciais, Brasil-Estados Unidos* (Rio de Janeiro: DP&A, 2004), 116–122.
9. Sérgio da Silva Martins, Carlos Alberto Medeiros, and Elisa Larkin Nascimento, "Paving Paradise: The Road from 'Racial Democracy' to Affirmative Action in Brazil," *Journal of Black Studies* 34 (2004): 804–805.
10. See Gilberto Freyre, *Casa-grande e senzala : a formação da família brasileira sob o regime patriarcal* (Rio de Janeiro : Livraria J. Olimpio, 1933), and Gilberto Freyre, *The Masters and the Slaves : A Study in the Development of Brazilian Civilization* (New York: Knopf, 1946).
11. Andrews, *Blacks and Whites in São Paulo*, 7–10.
12. Livio Sansone, "Remembering Slavery from Nearby: Heritage Brazilian Style," in *Facing up to the Past: Perspectives on the Commemoration of Slavery from Africa, the Americas and Europe*, ed. Gert Oostindie (Kingston: Ian Randle Publishers, 2001), 87.
13. Sansone, "Remembering Slavery," 87.
14. Quoted in "Hans Belting Interview with Emanoel Araújo," Global Art and the Museum, http://www.globalartmuseum.de/site/guest_author/214.
15. Emanoel Araújo, "The Museu AfroBrasil in São Paulo: A New Museum Concept," in *The Global Art World: Audiences, Markets, and Museums*, ed. Hans Belting, Andrea Buddensieg, and Emanoel Araújo (Ostfildern: Hatje Cantz, 2009), 183.
16. For an overview of the study, and related essays on "cordial racism," see Cleusa Turra and Gustavo Venturi, *Racismo Cordial: a mais completa análise sobre o proconceito de cor no Brasil* (São Paulo: Editora Ática, 1995).
17. I take the notion of artwork that reveals and conceals from the Museum for African Art's 1993 exhibition, *Secrecy: African Art that Conceals and Reveals*, and the essays in the corresponding exhibition catalog. Though the curators demonstrate how artworks can simultaneously demonstrate these opposing and yet complementary ideas, I use the idea of revealing and concealing with regard to a curatorial technique. See Mary H. Nooter and Wande Abimbola, eds., *Secrecy: African Art that Conceals and Reveals* (New York: Museum for African Art, 1993).
18. Thomas E. Skidmore, *Brazil Five Centuries of Change* (New York: Oxford University Press, 2010), 32–33.
19. Skidmore, *Brazil Five Centuries of Change*, 56–60.

20. Barbara Weinstein, "Racializing Regional Difference São Paulo versus Brazil, 1932," in *Race and Nation in Modern Latin America*, ed. Nancy P. Appelbaum, Anne S. Macpherson, and Karin Alejandra Rosemblatt (Chapel Hill, NC: The University of North Carolina Press, 2003), 237–238, 240.
21. Emanoel Araújo, "Museu AfroBrasil: Um conceito em perspectiva," in *Museu AfroBrasil: Um conceito em perspectiva* (São Paulo: Museu AfroBrasil, 2006), 21.
22. Paula Straile, "The Pillory/Pelourinho in Open-Air Museums in the U.S. and Brazil: A Site of Racism and Racial Reconciliation," in *Erasing Public Memory: Race, Aesthetics, and Cultural Amnesia in the Americas*, ed. Joseph A. Young and Jana Evans Braziel (Macon, GA: Mercer University Press, 2007), 209–242; Patricia de Santana Pinho, *Mama Africa: Reinventing Blackness in Bahia* (Durham, NC, and London: Duke University Press, 2010), 192; Sansone, "Remembering Slavery from Nearby," 86.
23. Quoted in "Hans Belting Interview with Emanoel Araújo," Global Art and the Museum, http://www.globalartmuseum.de/site/guest_author/214.
24. Araújo, "The Museu AfroBrasil in São Paulo," 182.
25. Ira Berlin, "Coming to Terms with Slavery in Twenty-First-Century America," in *Slavery and Public History: The Tough Stuff of American Memory*, ed. James Oliver Horton and Lois E. Horton (New York: The New Press, 2006), 7.
26. Patricia Davison, "Museums and the Reshaping of Memory," in *Negotiating the Past: The Making of Memory in South Africa*, ed. Sarah Nuttall and Carli Coetzee (Cape Town: Oxford University Press, 1998), 145.
27. See France Winddance Twine, "Memory: White Inflation and Willful Forgetting," in *Racism in a Racial Democracy: The Maintenance of White Supremacy in Brazil* (New Brunswick, NJ: Rutgers University Press, 1998), 111–133; Robin E. Sheriff, "Silence: Racism and Cultural Censorship," in *Dreaming Equality: Color, Race, and Racism in Urban Brazil* (New Brunswick, NJ: Rutgers University Press, 2001), 59–83.
28. Petrobras is a multinational company headquartered in Rio de Janeiro. Founded in 1953, this semipublic energy company is a chief producer of oil and distributor of oil products. It also provides major financial support for the arts in Brazil.
29. This is with the exception of two individuals, who were considered city employees. Bandeira, "O Museu," 76. Carlos Augusto Calil is a film professor in the School of Communications and Arts (ECA) at the University of São Paulo.
30. Carlos Augusto Calil, "Lições de maquiavel," *Raíz: cultura do Brasil*, no. 5 (2006), 19.
31. Bandeira, "O Museu," 75.
32. Bandeira, "O Museu," 75.
33. Bandeira, "O Museu," 76.
34. Bandeira, "O Museu," 76.
35. Importantly, Araújo has indicated that it was Calil who challenged the museum funding, and not the entire municipal government under José Serra. Bandeira, "O Museu de Emanoel," 76.
36. See Bandeira, "O Museu," 74–77; Calil, "Lições de maquiavel," 19–20.
37. Bandeira, "O Museu," 76; Calil, "Lições de maquiavel," 19.
38. Robert Brent Toplin, *The Abolition of Slavery in Brazil* (New York: Atheneum, 1972), 253. Today this event is contested. See Robert Slenes, "O que Rui Barbosa não queimou: novas fontes para o estudo da escravidão no século XIX," *Estudos Econômicos*, no. 13 (1983): 117–149.

39. Araújo, "Museu AfroBrasil," 12.
40. Both the São Paulo Art Museum and the city's Museum of Modern Art are public museums that house private collections. However, as with most other museums, in these institutions there is a certain level of distance between the director and the collection, which one does not find with the AfroBrazil Museum. Bandeira, "O Museu," 76.
41. Quoted in Bandeira, "O Museu," 77.
42. Araújo, "The Museu AfroBrasil," 187.
43. Araújo quoted in "Hans Belting Interview with Emanoel Araújo," Global Art and the Museum, http://www.globalartmuseum.de/site/guest_author/214.

12 Afro-Brazilian Heritage and Slavery in Rio de Janeiro Community Museums

Francine Saillant and Pedro Simonard

The city of Rio de Janeiro is characterized by a highly diverse tangible and intangible cultural heritage, which reflects the legacies of the various populations that have contributed to the formation of Brazilian culture. Such multiple cultural heritage is not surprising in a country where more than two hundred languages are spoken and European, Amerindian, and African cultures coexist.

Rio de Janeiro was the capital of Brazil from 1763 to 1960, before losing its place to Brasília.[1] The city is also one of the most important centers in Afro-Brazilian history. Between 1540 and 1866, more than five million Africans came to the country on slave ships, and of this number more than one million arrived in the port of Rio de Janeiro.[2] In 1849, the slave population of the city totaled 78,885 individuals (excluding the freed population estimated at 19,885), whereas the African-born population comprised 116,319 individuals.[3] This historical backdrop raises several questions: How does Rio, the former political capital of the country, present this part of its past? How do heritage policies contribute to preserving and showing the Afro-Brazilian cultural component, as well as its links with the history of slavery?

This chapter has two aims. The first is to survey and review the initiatives recognizing and highlighting Afro-Brazilian heritage, particularly the most recent initiatives, including those devoted to the memory of slavery. The second is to examine the specific case of Rio de Janeiro. In addition to examining national programs the chapter looks at the policies and programs of the state and the municipality of Rio de Janeiro. The observation of a paucity of large museums of civilization[4] directly concerning Afro-Brazilian culture and promoting the memory of slavery in Rio de Janeiro has also led us to study some community museums—small museums that are initiatives of their respective milieus—over the course of a fieldwork carried out in 2009 and 2010.[5] This chapter examines the extent to which a city as important to international heritage as Rio de Janeiro, one of the largest slave ports in Brazil and the Americas, has been able to recognize and then integrate this part of its identity by highlighting its "wounded" heritage.[6]

Several federal institutions with various missions are in charge of identifying, preserving, and promoting Brazilian heritage in terms of its European Amerindian and African contributions.[7] Highlighting Brazilian and Afro-Brazilian heritage is foremost the responsibility of the Ministry of Culture (MinC), the National Historical and Artistic Heritage Institute (IPHAN), and the Palmares Cultural Foundation (FCP).[8]

Afro-Brazilians and the black movement in particular are closely interested in the cultural heritage left by the former enslaved population.[9] These groups have denounced the way Brazilian culture is conveyed by the national elites who have historically undervalued Afro-Brazilian culture and dedicated to it only a very small place in national institutions. Various Afro-Brazilian lobbies seek to influence policies or institutions to enable public recognition of the specific contribution of Afro-Brazilians to national culture, as well as its history and African roots. Since the approval of the 1988 constitution, the actions of the black movement have been increasingly visible: marches and public declarations have brought together various movements associating political, economic, and religious issues, as well as cultural memory. Among these initiatives is "The Zumbi March Against Racism" launched in Brasília in November 1995, which has been followed by a number of other marches.[10] The black movement thus promotes recognition of Afro-Brazilians within the nation and their contribution to both the country's tangible and intangible cultural heritage.[11] As part of this concern, there is a growing discussion of the right to memory. As a result, recognition acts—as a form of symbolic reparation for past wrongs resulting from slavery[12]—are gaining ground within the federal government. However, such recognition is not a simple matter, as Brazil has a troubled relationship with its history of slavery, and the formation of Afro-Brazilian culture is closely bound up with that of slavery. Indeed, Brazil was the last country of the Americas to outlaw slavery, as it did not do so until 1888. For the nation of Brazil, many questions remain. What should be done with the memory of slavery? How can the promotion of Afro-Brazilian culture also specifically address the memory of slavery? To whom should this promotion be entrusted? Should this question be a concern today? For the black movement, the question of slavery is also complex because Afro-Brazilians themselves do not necessarily wish to bring slavery to the fore and emphasize an image of themselves as victims in this dehumanizing economic system.[13] The black movement, for example, seeks instead to highlight the victories and struggles of enslaved, fugitives, and freed individuals in the slavery system. Afro-Brazilians also prefer to show the central role they played in the abolition process, as well as in the elaboration of their own culture, which has largely been incorporated into so-called "national" traditions.[14] The integration of the African contribution into national culture is in fact a source of both pride and frustration, as it carries a dual message. How can one speak of Afro-Brazilian specificity in a context in which the national narrative eliminates this singularity?[15] The

same question arises concerning Afro-Brazilian culture, which is itself a product of an extensive mixing process and whose contours are not always easy to trace.[16]

This paradox is closely related to the myth of racial democracy, which is well anchored in Brazilian society but has weakened in the past ten or so years. This myth suggests a national narrative that values the fusion of identities in favor a single figure, that of the Brazilian as a product of mixing—biological-somatic and historical-cultural miscegenation, an encounter not only consisting of violence and suffering but also of cordiality and exchanges.[17] For a very long time, this vision favored an overall view of a national culture composed of singular contributions rather than highlighting the singularities of each one of them, which inevitably reflected in the long privileged approach to heritage. The choice of this view certainly explains why institutions for the promotion of heritage, especially large museums of civilization, have taken so long to explicitly integrate Afro-Brazilian culture, at least under this name. This vision also explains why specific major institutions entirely dedicated to Afro-Brazilian culture are still rare today and have only been recently established. There are nevertheless indications that the situation is changing, as this chapter attempts to show.

AFRO-BRAZILIAN HERITAGE AND NATIONAL POLICIES

Since the approval of the constitution of 1988—100 years after the official abolition of slavery—numerous initiatives were developed by the federal government to promote Afro-Brazilian heritage in various parts of the country. Recent statistics and programs developed by the MinC (from 2003 to 2010)[18] show that the approval of certain laws[19] over the past ten years increased funding to the initiatives highlighting Afro-Brazilian culture and heritage. In some sectors funding has tripled during this period and led to the explosion of civil society initiatives.[20] As a result, Afro-Brazilian heritage has been supported in recent years in the spirit of affirmative action policies developed in all sectors and concerning the Afro-descendant populations of the country.[21] Since 2003 the MinC has developed a policy called Plural Brazil (*Brasil plural*) meant to reflect cultural diversity and a fairer representation of various cultures in its programs and policies. All minority or minoritized groups are targeted—native peoples, Afro-Brazilians, and gypsies, for example, as well as other carriers of difference with no ethnic label, including gays and disabled persons. This policy is a consequence of the country's adherence to UNESCO's 2005 Convention on the Protection and Promotion of the Diversity of Cultural Expressions.[22] The MinC has devoted particular attention to Afro-Brazilian culture, by asserting that it has offered up resistance "despite the fact that it was a victim of four centuries of slavery and numerous attempts at rendering it invisible."[23] To understand this new focus on Afro-Brazilian culture it is important to examine

current programs, especially those developed by the MinC, the FCP, and IPHAN, the three organizations most directly tied to this valorization.

The MinC website presents the most important information on these programs, which are developed in connection with the FCP and IPHAN. It should be noted however that the FCP, a body of the MinC, was founded in 1988 with the specific mission of promoting Afro-Brazilian cultural, social, and economic values in the frame of national culture, in order to favor the participation of Afro-Brazilians in national development.[24] The mission of IPHAN, another body of the MinC, is to promote and coordinate the process of preserving Brazilian cultural heritage to reinforce identities, ensure the right to memory, and contribute to the country's economic development. Unlike the FCP, it is not specifically devoted to Afro-Brazilian culture.

One of the programs of the MinC related to Afro-Brazilian heritage is named Traditional Communities and Afro-Brazilian Culture (*Comunidades tradicionais e cultura afro-brasileira*). This program seeks to support traditional communities, in this case remnant *quilombos* (former runaway slave communities) and *terreiros* (Afro-Brazilian religious temples) by ensuring ethno-development consistent with their historical, religious, and cultural needs.[25] Among others, these programs develop community training workshops to encourage the preservation and transmission of specific culinary and artisanal traditions. The FCP is responsible for the implementation of these actions with the support of several partners including INCRA (National Institute of Colonization and Agrarian Reform), the Ministry of Agrarian Development, FUNASA (National Health Foundation), the Ministry of Health, the Ministry of Cities, the Ministry of Education, the Ministry of Social Development, the SEPPIR (Special Secretariat for the Promotion of Racial Equality), as well as universities and NGOs.

Another MinC program, Afro-Brazilian Culture (*Cultura Afro-Brasileira*), under the responsibility of IPHAN, supports and promotes thematic projects that enable greater Afro-Brazilian cultural production (dance, theater, and music companies) as well as its national and international dissemination.[26] In addition to several federal ministries and institutions mentioned above—with the exception of INCRA and FUNASA—this program is also supported by the FAT (Worker's Aid Fund), Ministry of Labor and Employment, the CNPq (National Council of Scientific Research), and UNESCO.

The actions of the two above-mentioned programs are intended to help finance specific cultural activities held by communities and groups. This financial assistance can be provided in different forms: awards and distinctions, but also activities that generate income for members of the poorest communities. In this last case, there is also another program, Living Culture (*Cultura Viva*)—actually an umbrella program for a series of community microprograms such as Point of Culture (*Ponto de Cultura*)—which ensures income for all members of a given community involved in a

specific activity, such as artisanal production (arts and crafts). Moreover, these types of initiatives provide support for *jongo* groups of the state of Rio de Janeiro, like the group Pedra do Sal, which has been seeking recognition as an urban *quilombo* for some time.[27] The regular income from the Point of Culture program offers individuals the possibility of making a living with their activity, which was very difficult to imagine in the past. This highly popular program encompasses an extraordinary diversity of activities. For instance, the microprogram Griot Action (*Ação Griô*), allows elderly persons to visit schools and pass on oral traditions to youth in workshops. Like other groups, Afro-Brazilians largely benefit from this initiative, as in the case of certain *jongo* communities in Rio de Janeiro.[28] It is also important to understand that for Afro-Brazilians, heritage and cultural policy are also closely linked to economic autonomy. In 2009, in the state of Rio de Janeiro alone, 150 projects were financed by Point of Culture (though not exclusively devoted to Afro-Brazilian culture), allowing *jongo, afoxé, samba, folia de reis,* and *capoeira* groups to gain renewed vitality.[29]

The IPHAN program for intangible heritage, which dates back to 2000, sustains projects in line with identification, recognition, and safekeeping. It works in partnership with other institutions by involving all levels of governments, universities, NGOs, development agencies, and certain private organizations devoted to culture, research, and funding. The program allowed the recognition of several forms of intangible Afro-Brazilian heritage such as the *samba de roda* of Bahian Recôncavo, several ancient forms of samba from Rio de Janeiro, the profession of Baiana of *acarajé*, the *jongo* of southeast, the northern *Tambor de crioula,* and *capoeira*.[30] The inventories of IPHAN also include other Afro-Brazilian cultural practices likely to attain official recognition in the near future.

The MinC and IPHAN foresee the promotion of built heritage including the renovation of historic buildings, monuments, and support for historic towns or cities. The cities of Salvador, Olinda, Ouro Preto, and São Luís—which are listed as World Heritage Sites by UNESCO, are acknowledged as having both Brazilian and Afro-Brazilian heritage. It is therefore striking to observe that the Afro-Brazilian built heritage that is recognized includes those cities whose history is intertwined with slavery in coffee production and mining areas. However, this heritage is recognized mainly because it represents a typical colonial architecture, not because it was built by the hands of slaves.

When it comes to museums, Brazil is undergoing great transformation. First, the federal government has just adopted a modernization program for museum facilities and in 2009 created the IBRAM (Brazilian Museum Institute).[31] Second, the policy of diversity has been integrated into the broader museum policy by asserting the right to memory in the name of democracy. Perhaps in the future there will be a growing tendency toward recognition of Afro-Brazilian culture and the memory of slavery?

TANGIBLE AND INTANGIBLE AFRO-BRAZILIAN HERITAGE IN RIO DE JANEIRO

The Cultural Secretariat of the state of Rio de Janeiro includes a heritage institute patterned after the model of the federal government, named INEPAC (State Institute of Cultural Heritage), which is in charge of government policy on tangible and intangible heritage throughout the state.[32] The INEPAC website provides a long list of preserved historic properties, including also a list of natural assets.[33] The INEPAC webpage on intangible heritage provides the calendar of popular celebrations and manifestations in the state of Rio de Janeiro. The calendar presents religious ceremonies in which one can find elements of popular Catholicism enriched with Afro-Brazilian rhythms and dances. The list does not necessarily constitute an explicit reference to Afro-Brazilian culture, which is encompassed in the idea of popular culture. This same page contains a calendar of municipal celebrations for each city, including feasts of patron saints, anniversaries, and festivals. It nevertheless mentions events with Afro-Brazilian components, such as the *folias de reis* ("feast of kings"), strongly marked by the presence of Afro-Brazilian rhythms and dances, and the *jongo* practitioners meeting, which every year brings together all the communities that practice *jongo* in the state of Rio de Janeiro and beyond.[34] Finally, the same website offers a variety of information on arts and crafts, cooking, folk medicine, myths, and legends. A few of these popular traditions are of Afro-Brazilian origin, particularly folk medicine, as well as myths and legends. The website also presents a description of festivals, dances, and rhythms, almost all originating from or influenced by Afro-Brazilian culture, such as the Carnival and the *cavalhada*.[35] The format chosen is often similar everywhere: valuing popular culture and implicitly equating popular culture with Afro-Brazilian culture, as this is how interrelations are shown between Brazilian and Afro-Brazilian cultures. This association conceals the singularity of the Afro-Brazilian culture or at least of its own historicity, suggesting that all Afro-Brazilian culture is popular, which is not the case. With regard to the question of slavery, the heritage policies of the state of Rio de Janeiro contributed to the development of historic site inventories such as the former coffee *fazendas* or the promotion of certain "routes," including the gold and sugar routes.

"Popular culture," historic buildings (built by enslaved workers),[36] dances and rhythms, and religious or pagan celebrations come to mind immediately when one thinks of Afro-Brazilian culture. It is precisely in the spirit of promoting recognition of this culture that local movements are born and exert intense political pressure, often at the heart of controversies because they address this gap. In a context of long-standing pressure, a monument was erected in 1986 not far from the neighborhood of Little Africa[37] to honor Zumbi,[38] the leader of the famous Palmares *quilombo*.[39] The bust of Zumbi was the first monument to be erected in the center of

Rio de Janeiro to honor Afro-Brazilian culture and resistance to slavery. It was only in 2009 that a second monument was erected, this time in honor of João Candido, hero of the Chibata revolt of 1910.[40] Since then Pedra do Sal, the mythical place where samba was born and where slaves were disembarked at Rio de Janeiro,[41] was recognized as an urban *quilombo*,[42] a Point of Culture, and a city heritage site. In 2010, in a context of revitalization of the port area, the IPCN (Institute for Research in Black Cultures) proposed to erect in this same neighborhood a Memorial of African Diaspora Ancient Knowledge, a memorial to acknowledge the culture, philosophy, and values of the African diaspora.[43]

Pressure in this direction also came from organizations outside the area of heritage, including the various secretariats for the promotion of racial equality[44] and human rights organizations[45] that act on the federal, state, and municipal levels by encouraging state organizations to apply the values of affirmative action policies. The results of these actions are often disappointing even though Afro-Brazilian culture is overflowing and permeates all spheres of society. The undifferentiated integration of Afro-Brazilian figures and models into African national culture is so great that several aberrations occur, such as the creation of programs to ensure the presence of Afro blocs in the official parade of the Carnival and the interdiction of holding an important Umbanda and Candomblé religious ritual on December 31 in Copacabana to avoid bothering tourists. These initiatives have prompted the black movement and the Afro-Brazilian community to claim that Carnival is more than ever "white" or that the celebration of Afro-Brazilian religions has been "stolen" by the government. It should, however, be mentioned that the process of "whitening" the Brazilian carnival began long before these recent events, actually since the 1930s.[46]

National Museums

Rio de Janeiro boasts a variety of museums of civilization, the most important of which are undoubtedly the Museu Histórico Nacional (National History Museum), the Museu Nacional (National Museum), the Museu da República (Museum of the Republic), and the Centro Nacional de Folclore e Cultura Popular (National Center of Folklore and Popular Culture). These four museums of outstanding quality, which hold national collections, receive several forms of public support and funding and are internationally renowned.

Created in 1922, the National History Museum depends on the MinC.[47] The museum holds treasures dating back to the earliest colonial times, covering all national regions and historical periods. It houses furniture, paintings, everyday items, and numismatic collections; the museum also includes photo archives and a sizable library. In addition, it holds major collections illustrating the links between Portugal and Brazil.

The Nacional Museum was founded in 1818 and is the largest museum of anthropology and natural history of Latin America.[48] Focusing on natural and cultural environments (and native populations in particular), it draws on geology, zoology, archaeology, cultural and biological anthropology, and ethnology. As part of the Ministry of Education and the Federal University of Rio de Janeiro, it also offers internationally known higher education programs in related disciplines. Its collections also contain valuable African objects, which unfortunately remain scarcely highlighted.

The Museum of Republic concentrates on the country's recent history and the development of the Brazilian nation, from the formation of the first Republic in 1889 to the present. Created in 1960, this museum focuses on cultural diversity and is presented as a space for citizens. The museum's website refers to the "preservation of cultural diversity and the promotion of human dignity and universal access."[49] It sporadically organizes events involving minoritized groups, including book launches, exhibitions, and cultural demonstrations, such as dance and music performances, to highlight Afro-Brazilian culture and its roots.

The National Center of Folklore and Popular Culture was created in 1968.[50] It highlights Brazilian popular culture and its tangible and intangible heritage; it is also called the Edison Carneiro Folklore Museum, after one of the first Afro-Brazilian scholars to study Afro-Brazilian culture. This museum has been a pioneer in exhibiting Afro-Brazilian culture and although not labeled "Afro-Brazilian" it is named after a worthy representative of Afro-Brazilian intellectuals. Although the presence of Afro-Brazilian culture is strong in the museum, it is, once again, more generally encompassed under the heading of popular culture. The museum presents collections of artistic and artisanal traditions, as well as exhibitions on typical traditions of the Northeast masquerade *bumba meu boi*, and *jongo*. It also develops educational activities, and houses archives related to these traditions.

Rio de Janeiro is in fact remarkably well equipped with national institutions when compared for instance with São Paulo, which is more geared toward art museums. Cities such as Salvador and São Paulo have also developed museums exclusively devoted to Afro-Brazilian culture. One of them, the Museu Afro-Brasileiro (Afro-Brazilian Museum), was created in 1982.[51] The institution is supported by the MinC, the Ministry of Foreign Relations, the state of Bahia, and the Federal University of Bahia. In São Paulo, the Museu AfroBrasil (AfroBrazil Museum) was created in 2004; it is supported by the federal government and the city of São Paulo.[52] In both museums the presence of slavery is not the primary focus of exhibitions, although the formation of Brazilian culture does draw attention. This is particularly the case for the AfroBrazil Museum, spectacular for its extensive display of collections illustrating the contribution of Afro-Brazilians to art and social struggles, as well as their place in cultural imagination. In spite of serious difficulties in the past as well as their difference in scale,

these two museums are now better established.[53] In Rio de Janeiro, despite numerous government initiatives to promote Afro-Brazilian heritage in its broader sense, there are no comparable initiatives of this kind, excepting the Edison Carneiro Museum, devoted to the folkloric dimension of Afro-Brazilian culture.

Because of these shortcomings, it is worth examining some Rio de Janeiro community museums where Afro-Brazilian heritage and the memory of slavery are given a distinguished place.

Community Museums

The Museu do Negro (Black Museum)

In the middle of the eighteenth century, brotherhoods of slaves and former slaves were able to build their own churches to worship their black patron saints—including Santa Ifigênia, Santo Antonio, São Benedito, Santo Gonçalo, and Santo Onofre—and to bury their deceased members. On Uruguaiana Street in the downtown of Rio de Janeiro, there is a historic church entirely built by enslaved individuals, the church of Nossa Senhora do Rosário e São Benedito dos Homens Pretos (Our Lady of the Rosary and Saint Benedict of Black Men). Adjoining this church is the Catholic brotherhood by the same name, created in 1640. It is well known that the various brotherhoods formed during the period of slavery since the seventeenth century played a central role in giving legitimacy to the enslaved, freed, and free black population, providing them the possibility to act through religion and support their members.[54] The Black Museum was created in 1960, and since then has been maintained by the brotherhood of Saint Benedict.[55] The mission of this museum is to preserve the specific memory of the origin of this church, created by enslaved men and women. The museum is considered to have been an initiative of the first black marshal in Brazil, João Baptista de Mattos, a former director of the brotherhood and of the church. The members of the brotherhood, which has met since ancient times in the basement of the church, brought together various objects owned by slaves who were able to buy their freedom with the support of the brotherhood. The museum displays several torture instruments and also certain work-related objects such as kitchen tools employed by slaves who worked in the plantations. The museum had several other names ("Abolition Museum," "Slavery Museum") before receiving its current name of Black Museum. The church above it, which burned down in 1967, has been partially restored by the brotherhood and its Catholic devotees. Since its creation, the Catholic Church has never provided financial resources to maintain this museum, which was always maintained by the brotherhood, despite the close connection between the brotherhood and the Catholic institution. It was only since very recently that the museum has been of interest to IPHAN, which is currently restoring the historic church where the museum

is located. However, the museum is not visible. Situated behind the church, it remains hidden from the tourists who visit the area, and it is not easy to find the poster indicating its presence. Even though it is a small museum consisting of two rooms, the scarcity of mentions of its existence in tourist guides can explain why tourists rarely visit it. Initially, the museum gives the impression of a sort of jumble of things that are not adequately displayed. Most of the objects displayed are related to the history of slavery and that of the brotherhood. Nevertheless, a visit to this place of memory reveals the meanings given to it by its creators and those individuals who maintain the museum.

In the museum, slavery is represented by torture objects, by the famous engraving representing the hold of a slave ship by the traveler and painter Johann Moritz Rugendas, and by various representations (portraits, sculptures, drawings) of Anastácia, one of the most famous Brazilian slave saints, who is known for the way she was tortured with an iron mask applied to her mouth. It should be noted that the church to which the museum is annexed does not display any portrait of this saint, who each year is venerated on May 13, date of the abolition of slavery.

The narrative of slavery provided by this museum is the narrative of the emancipation process. The idea of emancipation is visible through the importance given to the Brazil's royal family. The museum displays the statues of the royal couple—the emperor Dom Pedro II and the empress Teresa Cristina—and a statue of the imperial heiress Princess Isabel, who signed the 1888 abolition act. The emphasis on emancipation is also visible in the portraits and paintings of Brazilian abolitionists including André Rebouças, Joaquim Nabuco, José do Patrocínio, Luis Gama, and Castro Alves. Through photographs and newspapers clippings, the museum also shows the black struggle for emancipation. A collection of paintings representing colonial churches built by blacks, the sculptures of the most venerated black patron saints, and the ceremonial garments of various black brotherhoods highlight their importance as support structures for slaves and former slaves. Although more discreet, Afro-Brazilian religions—which also played an important role in supporting enslaved, freed, and free blacks—are also represented in the museum. These representations include that of a mother-of-saint and that of Preto Velho ("Old Black"), the spirit of a slave in Umbanda religion publicly celebrated by its followers on May 13. Finally, the museum also presents the history of the church, including the 1967 fire that unfortunately destroyed many objects. The contemporary period is depicted through a collection of portraits, photographs, and paintings of famous figures and black political personalities that are the object of pride for the black community: first, the legendary Zumbi, leader of the Palmares *quilombo*, in whose honor Black Awareness Day is currently celebrated in Brazil on November 20; second, people who joined the political arena of power, such as Afro-Brazilian senators Benedita da Silva and Abdias Nascimento. In addition, one can find a sculpture of Mãe Preta,

a black mother breastfeeding her child, a figure conveying an interpretation of the origin of the Brazilian nation, under the heading of Africa. Although the museum is not a museum of Afro-Brazilian culture, this culture is nevertheless an important part of the museum's memory and origins.

The Pretos Novos Research Institute

The Pretos Novos Research Institute (IPN) is located in the port neighborhood of the Gamboa district of "Little Africa," located near the Guanabara Bay district where thousands of enslaved Africans disembarked during the period of the Atlantic slave trade.[56] Today, the region is a working-class neighborhood, which is even less visible to the ordinary tourist than the downtown region of Uruguaiana Street. Usually, Africans deceased shortly after their disembarkation were buried in cemeteries near the place of arrival, or thrown into mass graves. The lands near the Santa Rita and Santa Casa da Misericórdia churches were used as burial places. The institute, which is the initiative of a couple, is in fact a modest space with a café, a small theater room, and a gallery with a permanent exhibition. In 1990, when the couple purchased a house, they were not aware of the link between their newly adopted neighborhood and the history of slavery. As the wife of the couple explained, "our house is a sort of train: 5 meters high, 30 long, a traditional Portuguese house."[57] A few years after moving in, the couple carried out major renovations and found skeletal remains in the foundations. They wondered if their new acquisition had in the past been the theater of a massacre, as according to them, there were many bones in the house's basement. The couple learned that the house was located very close to Valongo, the region of the former slave market, and near a cemetery. They decided to notify the municipality, which sent to the site archaeologists from the Department of Cultural Heritage. Excavations began, and over five consecutive years the house was transformed into an archaeological site. The modest couple found out that twenty-eight men between 18 and 25 years old had been buried under the house. The city sought to reclaim the site while the excavation was in progress, but the couple refused the expropriation. They did not want to leave their house without a guarantee that the place would be preserved and promoted as a cultural heritage site. Then they invited the media to call their attention to this strange situation of "people living in the middle of an archaeological site."[58] Throughout the excavation, there was a sense of mystery, and specialists refrained from comment. At the time, the couple was not close to the black movement and was not familiar with the fate of "pretos novos" ("new blacks"), the enslaved Africans who perished upon their arrival and were thrown into mass graves in Rio de Janeiro. When the couple became closer to certain black movement activists, they understood that their house was associated with the "pretos novos," whose story is, still today, rarely mentioned outside academic circles. Eventually, once the excavations were finished, the

archaeologists officially left the site, entrusting it to the couple. On November 20, 2001, anniversary of Zumbi, at the beginning of an intense decade for the Brazilian black movement, a first in situ exhibition of the excavated site was opened to the general public in a large celebration. This initiative was supported by Rio de Janeiro municipality and its Archaeology Service, and Secretariat of Culture, as well as activists and people from the neighborhood. Following the celebration, the couple opened their home to visitors who wanted to know more about the site, which was becoming known by word of mouth. Since then, the couple has sought to promote the area by seeking external assistance, but the promotion of the site remains extremely difficult. To allow the project to move forward, the husband and wife decided in 2005, with the help of a group of researchers and activists, to transform the institute into a small NGO. The couple deplores the fact that the institutions that finance Afro-Brazilian culture seem uninterested in the case of this institute. As previously mentioned, the neighborhood is far from the view of tourists. The institute is frequently visited in November (Black Awareness month) and also during events involving Afro-Brazilian culture. Moreover, the house is increasingly visited by Afro-Brazilians and tourists of the African diaspora who are interested in places of remembrance of slavery all over the world.

The narrative presented in this institution and exhibition focuses on two issues: the neighborhood and its historical link with the creation of the city and the history of slavery, and the history of "pretos novos" and the process of archaeological excavations. The institution asserts the history of slavery itself by emphasizing the importance of making this history public, in order to avoid negationism through silence. To achieve this goal, the institute proposes a series of strong statements aimed at raising awareness of the wrongs of slavery. It also provides general information on the more global history of slavery in the context of the Atlantic slave trade. The exhibition primarily consists of explanatory panels and photographs. It features only one artifact: an iron for branding slaves, which was given to the owners. This space can be considered a place of transmission of Afro-Brazilian culture, because it leads the visitors to the memory of the formation of this culture in the context of the Atlantic slave trade and slavery, an aspect the individuals who contribute to maintain this space seek to preserve.

Since 2010 the institute has become a Point of Culture and hence has been receiving federal funding for the development of the Pretos Novos Memorial project under the slogan "Rediscovering the memory of a people, preserving the culture of a country." The promoters of this project—the couple as well as Candomblé leaders and Afro-Brazilian intellectuals—seek to offer courses and workshops on the history of the place, by also maintaining the permanent exhibition, all of which is primarily geared toward primary and high school teachers. They also offer a cultural space for the exhibition of African and Afro-Brazilian works and develop cultural activities, notably music- and theater-related activities. Finally, the space also

contains an art gallery, which is the first to be located on an archaeological site in Rio de Janeiro's port area.

The Maré Museum

The *favelas* of Rio de Janeiro are part of its social and cultural landscape. Inhabited by a mostly black and mixed population, over time these slums were formed by the populations from the country's northeast who migrated to the cities, and also by those groups who were constantly driven back from the center to the fringes of the city. Endemic poverty, a consequence of the conditions that marked the period following the official abolition of slavery, is still rampant. Therefore, the existence of the first community museum created in such a space deserves particular attention. The Maré Musem was unveiled in 2006.[59] It is the first museum created in a Brazilian *favela* and, apparently, one of the first museums in the world to be born in the middle of a shantytown, another one being the Hector Pieterson Museum located in Soweto, South Africa. Maré is also referred to as the Maré Complex, to designate one of the major peripheries of Rio, an area considered to be high-risk because of the insecurity caused by battles between police and drug dealers, social marginality, poverty, and violence. Situated near the international airport Galeão-Antônio Carlos Jobim, the museum derives from a community initiative. The Association of Maré Inhabitants sought to preserve the memory of the traditional way of life that prevailed in the *favela* at the end of the 1990s, the time of its foundation, when the wooden houses were built on piles laid directly on the Guanabara Bay. The museum project began with an initiative of a community television, Maré TV, associated with a project led by local inhabitants aiming to represent themselves and their memory, notably using video, photography, and collection of life stories. Several themes emerged from this process: the history of the way the *favela*'s social environment was formed, the occupation of the *favela*, the difficulty of preserving the site in the face of constant threats of expulsion by military police, and the community's first associations. Other themes also include ecology as well as shrimp and crab fishing. As a result, the idea of creating a perennial initiative began to take shape. Eventually, the association of inhabitants and the Maré TV obtained recognition of their project by the federal government, which made it a Point of Culture. Hence, other partners joined the initiative, notably the Oswaldo Cruz Foundation and its Life Museum,[60] important institutions located on the same territory and which held certain archives on the Maré milieu. The first project identified as a Point of Culture was an exhibition of objects brought by the Maré inhabitants. Held in 2004, the exhibition titled *A força da Maré (The Force of the Tide)* had a double concrete-symbolic value because at Maré the tide was a constant source of life and death, conquest and survival. Inhabitants of Maré largely associate this natural element with their social and cultural identity.

The launch of an exhibition titled *Maré Cidade* (*Maré City*) was also the occasion for a seminar held at the Museum of Republic, to which one of the eldest leaders of Maré was invited: Dona Orosina Vieira, a black healer and midwife who was one of the first residents of the favela. During the government of Getúlio Vargas in the 1950s, Dona Orosina denounced the military intervention in the favela. At the time Vargas agreed to receive her and listened to her grievances. He also listened to her account of bad treatment suffered by the general and the fishing communities. These activities were followed by the establishment of an NGO. The inhabitants started searching for a suitable place to install the museum and collecting new material for the exhibitions. Eventually, an old factory was chosen and the project finally took shape. The collective process moved forward with the constant addition of new objects brought by the residents and the introduction of new themes into the permanent exhibition. Intended to be a lively museum, new social activities were planned, including workshops of hip-hop, percussion, theater, and storytelling. Maré inhabitants intended to present their community life in a dignified way by showcasing aspects other than violence and criminality, thus destigmatizing a community that was highly marginalized. Rather than presenting police raids and chases with drug dealers, as is done in the major Brazilian media, the intent was to show the history of the formation of the territory including the transition from a fishing community to another way of life, everyday activities, struggles for existence, and celebrations. Three general themes mark the museum's exhibition today: water, the household, and fear. The water represents the community's strength and resilience in its perseverance in a difficult environment. The household evokes affects in line with attachment to a settlement, and hence the shanty of shantytowns acquires a new value, that of resistance. When it comes to fear, the intent is to give it meaning and history, by bringing visitors to understand that it has an origin. Indeed, fear has been a part of the history of the community. Fear is not only associated with natural elements but also with past and current police repression. Fear also has a present dimension related to the fighting between drug dealers and police, deaths and assassinations, whether selective or not. Finally, fear has also a future that requires its eradication. There is a wish to use the power of memory to support the community by projecting an image that allows it to regain its power to act, hence supplanting the immobility represented by stigmatization and marginalization.

Though most of its inhabitants come from the northeast and arrived in the Maré context of the migrations and poverty that followed the end of slavery, no reference is made to this migratory origin, even if it is known that there was a sugar plantation on Maré territory. The Afro-Brazilian culture is nevertheless manifest in the exhibition through music, certain religious rituals, and popular celebrations. This museum leads us to Afro-Brazilian culture, and a link can be established among the inhabitants of this area, the intentions of the promoters, and the project, which is quite unique. The

perspective chosen is to focus on social problems related to poverty rather than developing memory issues specific to a group that defines itself by ethnic-racial characteristics. As a result, the memory of favela da Maré is open and plural. In this context, it is understandable that the accent is placed on the conditions in which populations find themselves today, including the people of Maré, who have inherited the inequalities that persist between Afro-Brazilians and the population of Rio de Janeiro with greater financial means. Beyond this fact, it must be said that the museum is a success: 20,000 visitors since 2006, 60 percent from Maré and 40 percent from outside the area. The museum benefits from institutional support through the Point of Culture program and IPHAN as well as through other MinC initiatives such as ceremonies, awards, and documentaries.

CONCLUSION

During the two terms of Luiz Inácio Lula da Silva, the federal government favored affirmative action policies highlighting and promoting Afro-Brazilian culture, especially in Rio de Janeiro. The Brazilian black movement might say that these policies are not enough, but it is certainly a tremendous step forward when contrasted with the situation in the past. First, national policies favoring pluralism and affirmative action in the cultural sector have given greater visibility to Afro-Brazilian culture and heritage in general, without necessarily underscoring the memory of slavery. The large museums of civilization have benefited from this focus and have thus been able to reinforce their actions and initiatives. Second, programs supporting intangible heritage provide economic support to historically marginalized communities, and through the multiplication of initiatives they promote activities of exceptional creativity. Now more than ever, Afro-Brazilian culture and heritage are highlighted in institutions, particularly in museums of civilization. As a result, it is possible in this case to speak of a budding recognition of this heritage in its specificity, and not restricted to a part of national or popular culture. Built heritage is also supported, undoubtedly because the heritage of the slaves contributed to building the most significant buildings during the colonial period and the Empire, including churches, sites of political power, fazendas, and many others. However, this heritage is rarely presented as the contribution of Afro-Brazilians to the nation. How can this recognition be attained? It is hard to imagine the idea of the state valorizing the work of slaves after having dismissed it for centuries. Such denial had led the black movement to focus on monuments honoring the heroes who resisted slavery and oppression, including those of Zumbi and João Candido. At the same time, some community museums are emerging, and one of them indeed has existed since the nineteenth century. The large national museums and museums of civilization are more inclined to present Afro-Brazilian culture and heritage than the memory of slavery.

In community museums part of this memory can be found under the label of the traditionally valued heritage. These museums have struggled greatly and more recently the MinC program Point of Culture has given hope to two communities museums examined in this chapter. The case of the Black Museum is probably more complex, as it is related to a religious institution and part of a church that only now has become a subject of concern for IPHAN. In terms of heritage, the recognition of Afro-Brazilian culture is growing when one considers the dynamism of national actions, but also of other initiatives at the state level in Rio de Janeiro. In addition, there is an unprecedented multiplication of community initiatives of all kinds.

The question of the memory of slavery and its explicit presence in this process of recognition is however more problematic. Of course, the many aspects of tangible and intangible heritage refer to the memory of slavery in one way or another. Nevertheless, the existence of an institution specifically devoted to slavery could contribute to a more complete recognition of Afro-Brazilian culture, whose roots can in no way be detached from this part of Brazilian history.

NOTES

1. Mauricio de A. Abreu, *Evolução urbana do Rio de Janeiro* (Rio de Janeiro: IPP- Instituto Municipal de Urbanismo Pereira Passos, 2008).
2. See David Eltis et al., *The Trans-Atlantic Slave Trade Database: Voyages*, http://www.slavevoyages.org .
3. Mary C. Karash, *A vida dos escravos no Rio de Janeiro* (Rio de Janeiro: Companhia das Letras, 2000).
4. We use the term "museum of civilization" here in reference to national museums of human history; the term refers to museums that deal with history and society.
5. We examined published documents and websites of ministries concerning policies and programs. We visited heritage sites and conducted interviews with museum officials and directors. The analysis revealed how the particularities of Afro-Brazilian culture and the memory of slavery are taken into account.
6. On the notion of heritage, see among others Laurier Turgeon, *Territoires: L'esprit du lieu; Entre le patrimoine matériel et immatériel* (Québec: Presses de l'Université Laval, 2009). On the idea of wounded heritage see Vincent Auzas and Bogumil Jewsiewicki, eds. *Traumatisme collectif pour patrimoine : regards croisés sur un mouvement transnational* (Québec: Presses de l'Université Laval, 2008).
7. Ministério da Cultura, *Cultura em três dimensões* (Brasília: Ministério da Cultura, 2010).
8. The websites are Ministério da Cultura (Ministry of Culture, MinC), http://www.cultura.gov.br/site/, the Instituto Nacional do Patrimônio Histórico e Artístico Nacional (National Historical and Artistic Heritage Institute, IPHAN), http://portal.iphan.gov.br, and the Fundação Cultural Palmares (Palmares Cultural Foundation, FCP), http://www.palmares.gov.br/.
9. Francine Saillant and Ana Lùcia Araujo, "L'esclavage au Brésil: Le travail du mouvement noir," *Ethnologie française* 37, no. 3 (2007), 457–466; Verena

Alberti and Amilcar Araujo, eds. *Histórias do movimento negro no Brasil: Depoimentos ao CPDOC* (Rio de Janeiro: CPDOC, Pallas Editora, 2007).
10. The site of the Palmares *quilombo* located in Serra da Barriga in the state of Alagoas was declared by the IPHAN a national monument. The site is not a museum, but a memorial park.
11. Maria Aparecida Ferreira de Andrade Salgueiro, *A República e a questão do negro no Brasil* (Rio de Janeiro: Museu da República, 2005).
12. Francine Saillant, "Droits, citoyenneté et réparations des torts du passé de l'esclavage: Perspectives du Mouvement noir au Brésil," *Anthropologie et Sociétés* 33, no. 2 (2008): 141–165.
13. See Myrian S. dos Santos, "Representations of Black People in Brazilian Museums," *Museum and Society* 3, no. 1 (2005): 55–65.
14. Pedro Simonard, "'Je me présente' : Comment les membres des communautés *jongueiras* du Brésil contrôlent-ils leur propre image?" *Ethnologies* 31, no. 2 (2010): 99–130.
15. Jacques D'Adesky, *Pluralismo Étnico e Multiculturalsmo: Racismos e Antiracismos no Brasil* (Rio de Janeiro: Pallas, 2005).
16. Kabenguele Munanga, *Rediscutindo a mestiçagem no Brasil: Identidade nacional versus Identidade negra* (São Paulo: Autêntica, 2004).
17. Gilberto Freyre, *Maîtres et esclaves, la formation de la société brésilienne* (Paris: Plon, 1974).
18. Ministério da Cultura, *Cultura em três dimensões* (Brasília, 2010).
19. These laws include successive recognition of remnant *quilombo* communities (Article 68 of the Ato das Disposições Constitucionais Transitórias, Constituição da República Federativa do Brasil de 1988), the law for the mandatory teaching of African history and culture in primary and secondary school (Law 10.639/03), and finally the Statute on Racial Equality approved in 2010.
20. This chapter is part of a five-year research about Rio de Janeiro's black movement and the demands for reparations in Brazil. Culture and heritage are one aspect of this research among many others. The research has been funded by the Social Sciences and Humanities Research Council of Canada since 2005.
21. Marilene De Paula and Rosana Heringer, *Caminhos convergentes: Estado e sociedade na superação das desigualdades raciais no Brasil* (Rio de Janeiro: Heinrich Böll Stiftung, 2009).
22. UNESCO, "Convention on the Protection and Promotion of the Diversity of Cultural Expressions" (Paris: UNESCO, 2005).
23. Ministério da Cultura, *Cultura em três dimensões*, 48, our translation.
24. Ministério da Cultura, *Cultura em três dimensões*, 48.
25. See Ministry of Culture, MinC: http://www.cultura.gov.br/site/2007/09/25/comunidades-de-tradicao-afro-brasileira.
26. See Ministry of Culture, MinC: See http://www.cultura.gov.br/site/2007/09/25/cultura-afro-brasileira.
27. *Jongo* is an Afro-Brazilian cultural manifestation of poor, black, and mixed communities consisting of dance and music. Its origins lie in the knowledge, rituals, and myths of African peoples, especially those from Bantu-speaking regions, and results from the interaction of various cultures. *Jongo* was declared intangible heritage of Brazil in 2005.
28. Pedro Simonard "Le *jongo* et la nouvelle performativité afrobrésilienne," *Anthropologie et sociétés* 34, no. 1 (2010): 33–54.
29. *Afoxé* is a playful kind of carnival developed in the temples of Candomblé, which is an Afro-Brazilian religion; *folia dos reis* is an Afro-Brazilian festivity that brings together dance, masquerades, and celebrations of the Kings

of the Catholic religion; and finally *capoeira* is an Afro-Brazilian martial art combining dance, fighting, and music.
30. *Tambor de Crioula* is an Afro-Brazilian religion found in Maranhão. Baianas of *acarajé* are black women street vendors who still today sell *acarajé*—deep-fried bread made with peeled black-eyed peas—in the streets of Bahia.
31. Ministério da Cultura, *Cultura em três dimensões*, 55.
32. Instituto Estadual do Patrimônio Cultural (State Institute of Cultural Heritage, INEPAC): http://www.inepac.rj.gov.br/ .
33. The *Mata Atlântica* or Atlantic Forest covered the entire Brazilian coastline from the state of Rio Grande do Norte to the state of Rio Grande do Sul.
34. For information on *jongo*, see Pedro Simonard, "A construção da tradição no 'Jongo da Serrinha': uma etnografia visual do seu processo de espetacularização" (PhD diss., Universidade do Estado do Rio de Janeiro, 2005); "Le *jongo* et la nouvelle performativité afro-brésilienne," 33–54; "'Je me présente,'", 99–130. See also Instituto do Patrimônio Histórico e Artístico Nacional. "Jongo no Sudeste." *Dossiê Iphan n° 5* (Brasília: Instituto do Patrimônio Histórico e Cultural, 2008).
35. Reenactment of wars between Catholics and Moors that took place in the Middle Ages on the Iberian Peninsula.
36. For example, in the Paço Imperial, where Princess Isabel signed the abolition act. In this place, which has become an art center, there is only a 7 cm x 7 cm plaque, difficult to find, commemorating the act.
37. See Roberto Moura, *Tia Ciata e a Pequena África no Rio de Janeiro* (Rio de Janeiro: Secretaria Municipal da Cultura, 2005).
38. See Francine Saillant and Ana Lucia Araujo, "Zumbi: mort, mémoire et résistance," *Frontières* 19, no. 1 (2006): 37–42.
39. See Flávio dos Santos Gomes, *Palmares: Escravidão e liberdade no Atlântico Sul* (Rio de Janeiro: Editora Contexto, 2005).
40. According to oral tradition a monument to Preto Velho (a slave spirit in Umbanda) may have existed in this place, but its exact location has not yet been discovered.
41. Initial study on the true birthplace of samba exists, but exceeds the scope of this article. A commemorative plaque signals its importance in this place.
42. *Quilombos* are usually found in rural areas, but some are established in urban areas in various Brazilian cities. Their existence is often called into question by the Brazilian elites.
43. Instituto de Pesquisa das Culturas Negras (Institute for Research in Black Cultures, PCN): http://institutodepesquisadasculturasnegras.blogspot.com/.
44. At the federal level Secretaria de Políticas de Promoção da Igualdade Racial (Secretariat of Policies of Promotion of Racial Equality, SEPPIR), http://www.portaldaigualdade.gov.br/. This secretariat can be found in the state and the city of Rio de Janeiro.
45. At the state level, Conselho Estadual dos Direitos do Negro (State Council for Black Rights), http://www.cedine.rj.gov.br/; at the municipal level, Conselho Municipal de Defesa dos Direitos do Negro (Council for the Defence of Black Rights), http://www0.rio.rj.gov.br/comdedine/carta_pres.htm.
46. See Edward Pablo de Sa Sauerbruun, "Samba, Capoeira, Malandragem, and National Identity: The Contradictions of a Racial Democracy" (PhD diss., Southern Illinois University, Carbondale, 2003).
47. See Museu Histórico Nacional (National History Museum), http://www.museuhistoriconacional.com.br/.
48. See Museu Nacional (National Museum), http://www.museunacional.ufrj.br/.
49. See Museu da República (Museum of Republic), http://www.museudarepublica.org.br/.

Afro-Brazilian Heritage and Slavery 231

50. See Centro Nacional de Folclore e Cultura Popular (National Center of Folklore and Popular Culture), http://www.cnfcp.gov.br/.
51. See Museu Afro-Brasileiro (Afro-Brazilian Museum), http://www.ceao.ufba.br/mafro/.
52. Museu AfroBrasil (AfroBrazil Museum), http://www.museuafrobrasil.com.br.
53. In Bahia, the institution was long closed and left in a state of relative dilapidation; in São Paulo the institution's establishment proved very complex in terms of recognition and financing.
54. Quintão Antonia Aparecida, *Lá vem o meu parente: As irmandades de pretos e pardos no Rio de Janeiro e em Pernambuco (século XVIII)* (São Paulo: Annablume Editora, 2002).
55. Museu do Negro (Black Museum), http://www.irmandadedoshomenspretos.org.br/museu_do_negro.htm.
56. See the Portal Arqueológico dos Pretos Novos (Pretos Novos Archaeological Portal), http://www.pretosnovos.com.br.
57. Interview with the couple Merced and Pettrucio.
58. About Cemetery of Pretos Novos, see Júlio César Medeiros da Silva Pereira Medeiros, *À flor da terra: o cemitério dos pretos novos no Rio de Janeiro* (Rio de Janeiro: Garamond Universitaria, 2007).
59. Museu da Maré (Maré Museum), http://www.museudamare.org.br/joomla/.
60. See Museu da Vida (Life Museum), http://www.museudavida.fiocruz.br/cgi/cgilua.exe/sys/start.htm?tpl=home&UserActiveTemplate=mvida.

13 Exhibiting Slavery at the New-York Historical Society

Kathleen Hulser

"For Americans, a people who see their history as a freedom story and themselves as defenders of freedom, the integration of slavery into their national narratives is embarrassing and can be guilt-producing and disillusioning. It can also provoke defensiveness, anger and confrontation," wrote James Oliver Horton, the chief historian for the *Slavery in New York* exhibition held in the New-York Historical Society (N-YHS).[1] With that groundbreaking exhibition held in 2005, the N-YHS plunged into the contested arena of interpretation of slavery. The result has been change in museum's practices, which since then have had an enduring impact on what is collected, how it is organized, and what visitors see both in person and on the Internet. These initiatives in exhibitions, collections development, public programs, electronic new media, and education have made the history of slavery in the North much more visible in the public space, anchoring public debates and legitimizing curriculum changes, as well as altering the way the history of the city is viewed.

This chapter argues that the N-YHS seized an opportune moment to explore what had been a "forgotten history" of northern slavery in response to changes in the political climate of the 1960s and 1970s that opened the door to new interpretations of African American history, and changes in the self-image of New York City as a major city drawing strength from its multicultural traditions. The chapter suggests that the manner of exhibiting the historical topic of slavery was born of a particular historical moment when attitudes toward museum presentation no longer assumed a passive spectator and a simple written didactic approach. The result of these changed assumptions was a more complicated relationship between audiences and museum presentations. Finally the chapter argues that not only the N-YHS addressed the historical topic of northern slavery, but also that this presentation engaged modern modes of perception and solicited modern audience engagement with its twenty-first century package of interactive audio elements, dramatized historical incidents, media pieces, touch objects, and critical exercises for visitors. Examples discussed in this chapter show that this series was not simply a set of exhibitions, but rather a transformational engagement with the memory of slavery that motivated

the institution to rethink its presentations, its relationship to audiences, its outreach to schools, its public programs, and its collecting.

THE NEW-YORK HISTORICAL SOCIETY

The N-YHS was founded in 1804. The institution collects documents, paintings, and objects related to the United States seen through the prism of New York, with particular focus on the eighteenth and nineteenth centuries. A series of exhibitions and related public programs and educational projects exploring the history of slavery and racial prejudice began in 1997 and has continued under three different presidents to the present day. For a long time the N-YHS has held records, artworks, and objects that can tell the story of slavery, in particular in the North of the United States. But it has taken a combination of a changing social climate, a new generation of curators, and visionary museum leadership to spark serious interpretation of existing resources, and firm commitments to pursuing new types of collecting and programming to render these collections visible.[2] The building of dedicated websites, electronic dissemination of teacher's guides, use of podcasts and iTunes University, creation of cell phone tours, and incorporation of new media into all phases of interpretation have made slavery content accessible globally and catalyzed both academic exploration and sampling by general audiences.[3] Changes in handling content include looking at how the business of slavery tied the North to the South, uncovering the decades-long-agitation of free African Americans in the antislavery movement, the role of black abolitionists, and tracing the legacy and aftermath of slavery.

Why did the N-YHS focus its attention on slavery and its aftermath in the North? The changing social climate of the 1960s and 1970s meant that the history of African Americans in the United States became more central to understanding national histories, and slavery study grew enormously. The work of university historians in underlining how Northern business helped to fund and strengthen the slave system in the Southern states slowly began to reach the general public by the 1980s. A related surge of interest in civil rights led to much scholarship on abolitionism in the 1960s and 1970s; however, the role of African Americans in creating communities of struggle, international sympathy, and a rhetoric of empowerment and justice that spanned the period of enslavement and emancipation was to surface more decisively in the 1980s and onward. Although people know Harlem in the 1920s as a mecca for African American arts and identity, the formative role the free people of color played in the area now known as Tribeca in the period before the Civil War is much less known, as is the nineteenth-century history of free black communities. Early African American New Yorkers forged institutions, nurtured a generation of black political activists, and shaped the origins of black political thought. The

probe into the origins of slavery in the North has rendered these questions visible, providing the scholarly and public foundations of knowledge that is spearheading a reconceptualization of the meaning of downtown Manhattan as a locus of early freedom struggles.

In 1991, during the term of New York City's first black mayor, David Dinkins, the construction of a new federal building uncovered a long-forgotten African burial ground. From the late 1600s until its closing in 1794, the more-than-six-acre African Burial Ground received the bodies of an estimated 20,000 persons of African heritage, both free and enslaved.[4] A huge outcry ensued from concerned New Yorkers, especially New Yorkers of African descent, as bulldozers threatened to disturb graves, and a public movement to preserve the site focused attention on the presence of African Americans in the city from colonial times. Meanwhile, the city's premier collection of documents on black history, the Schomburg Center for the Study of Black Culture, a division of the New York Public Library, organized many important small exhibitions about people of African descent. As a result of this surge of public interest, researchers, authors, and curators such as Howard Dodson, Christopher Paul Moore, and Julia Hotton developed groundbreaking exhibitions from the 1990s to the present at the Schomburg Center in Harlem that deal with different aspects of the Atlantic slave trade and black presence in the United States.[5]

ENGAGING PUBLIC DEBATE

The N-YHS could plausibly date its initial efforts to reckon with the legacy of the slavery in the North and its aftermath to an acclaimed exhibition of 1997 *Before Central Park: The Life and Death of Seneca Village* and accompanying teacher's guide.[6] Based on exhaustive investigation of sparse sources, the highly original exhibition probed the founding of a free African American community in the 1820s in an area of the West Side that later became Central Park. The exhibition *Before Central Park* curated by Grady Turner, L. J. Krizner and Cynthia Copeland, was a model of investigative history and creative design to show how a community formed, established its own religious and educational institutions, and then was swept away by eminent domain when the city wanted the land for Central Park.

The success of the Seneca Village project was continued in 2000 when then president Betsy Gotbaum invited a small photography exhibition of sixty images called *Witness*, which was drawing packed crowds to the Roth-Horowitz Gallery, to move to the N-YHS exhibition space in March 2000. *Without Sanctuary: Lynching Photography in America* displayed photographs and postcards of horrendous racial crimes assembled by James Allen. When the original ensemble was moved to the larger space, the N-YHS expanded the interpretation with historical materials on the antilynching movement, which was particularly active in New York. The

exhibition thrust the issues of postemancipation racial violence into a national and international spotlight, and had particular resonance as it appeared directly after the February 2000 trial and acquittal of four policemen for the shooting of an unarmed African immigrant, Amadou Diallo.[7] Allen had previously offered the show to many major New York museums, which all turned it down, so the exhibition at N-YHS seemed a bold step away from long-standing cautious attitudes about exhibiting controversial and disturbing subjects. Scholar Bettina M. Carbonell asked, "What happens to the 'facts' pertaining to victims and perpetrators, when they are subjected to the aegis and decorum of well-composed and carefully formulated history?"[8] Indeed, the subject matter was so gruesome—asking visitors to see images of people hung and mutilated in front of cheering crowds—that a psychologist was brought in for staff training sessions, and public discussions were facilitated by the N-YHS public historian to encourage feedback and response, rather than a voyeuristic experience.[9]

NORTHERN SLAVERY

Although *Before Central Park* and *Without Sanctuary* were small, low-budget exhibitions, they demonstrated that N-YHS saw itself as a history institution responsive to a multicultural city curious about histories of the African American experience and willing to display emotionally difficult material on topics that were not obviously aesthetically "exhibitable." Thus, the two exhibitions laid the groundwork for taking a big step away from the museum convention of planning history exhibitions on the basis of existing collections and precertified national narratives. The exhibition *Slavery in New York* (October 2005 to March 2006), curated by Richard Rabinowitz and Lynda Kaplan, offered a glimpse of a world of urban slavery that few outside the academic community knew.[10] In the absence of a wealth of physical remainders of slavery—the customary artifacts that comprise most museum shows—the exhibition demanded innovative thinking about how to convey its themes. To most New Yorkers, it was a revelation to learn how deeply rooted slavery was in local history, arriving with the Dutch in the New Amsterdam (1609–1664), as the colonial trading post scrambled for labor to carve a city out of the rocky terrain of downtown Manhattan. Indeed, it was probably slave labor that built the wall for which Wall Street is named, dug the ditches that drained the swamps in the choice low-lying areas near the rivers, and laid the earliest foundations of Broadway. In this early time period, visual sources were relatively sparse, so the most creative techniques were required to tell the story of the enslaved people. In the Dutch era gallery, a document detailing the strategy of using slave labor for the Dutch West Indies Company was complemented by wire figures doing work. Made by Brooklyn sculptor Deryck Fraser with David Geiger, these figures suggested that enslaved people of African descent were a large presence, but scholars did not

know what they looked like or much about their stories. An intriguing aspect of enslaved life under the Dutch was represented in an artful manner in the accompanying catalog: Schomburg Library historian Christopher P. Moore created a collage photograph, layering historical information about farms belonging to "half-free slaves" atop a modern photograph of a well-known New York City location.[11] After enslaved people worked for twenty years for the Dutch West India Company they petitioned for their freedom and, surprisingly, were granted a limited form of liberty in the 1640s and some land around what is today known as Washington Square. In Moore's modern collage photograph these "free negro plots" (Figure 13.1) were depicted on top of today's handsome public park, elegant historic buildings, and busy New York University campus, offering not just a map that layered past and present but also offering an interesting thrust in reparations thinking. It once was their land, the image suggested, what happened later?

Often the key historical items of the exhibition were documents, which required creative treatment to engage an audience. One example from N-YHS collections was an extraordinary rare legal paper, the indictment for participants in a slave conspiracy of 1712 that involved people born in West and West Central Africa (including Coromantee, Angola, and Yoruba) and some "Spanish Negroes" who were probably free sailors who had been illegally

Figure 13.1 Free Negro Plots in Washington Square. Photograph by Christopher P. Moore in *Slavery in New York*, edited by Ira Berlin and Leslie M. Harris (New York: New Press, 2005). Courtesy of Christopher P. Moore.

sold by privateers into slavery in New York.[12] Next to the indictment for the conspiracy, which was a rather small and in itself unimpressive piece of paper with a wax seal, a small theatre piece ran which imagined the conspirators talking of how they could set fires to distract the city watch, and then kill their owners and escape. The shadowy figures speaking from a projection behind a scrim conveyed the clandestine atmosphere, use of traditional magic, and high stakes of such a slave uprising in a white society where even minor slave rule-breaking carried the death penalty. The combination of the acted scenes, posted laws with draconian punishments for infractions of the slave codes, and scenes from daily life offered varied ways to understand the experiences of enslaved people.[13] Visitor reactions to this installation showed a great hunger for detailed explorations of the brutal regime of slavery, and satisfaction in seeing evidence that, despite the odds, resistance can be documented throughout nearly four hundred years of slavery in the region.[14]

Another device that served to carry an important narrative theme in a compelling visual manner was The Well, an exhibition prop that featured enslaved women's voices, talking about their daily lives in eighteenth-century New York, emanating from the shaft of a well. The visitor was thus put in the position of eavesdropping on conversations of women going about their daily tasks. Throughout the exhibition, the curators attempted to probe the experience of a slave society from the inside, insofar as possible. Sources tell us that increasingly severe laws in the eighteenth century forbade gatherings of enslaved people to prevent conspiracy and uprisings. However, because so many African New Yorkers worked as domestics and laborers their presence on the street was significant, and they did congregate in groups to fetch water.[15] Thus the well installation attempted to give visitors a window into life lived under a system of harsh laws, where people still managed to trade news and critical commentary in public space. Visitors could look down into a projection, seeing faces and hearing voices with African accents telling stories and commenting on the fate of their brethren. In a visit to the exhibition, M. Eloi Coly, the curator of Maison des Esclaves on Gorée Island (Senegal), was fascinated with this spot because it reminded him of how communication operates in Africa at the most basic human level, despite systems of repression, state censorship, and even language barriers in an urban setting that gathered many ethnic groups.[16]

A display called the Merchant's House (Figure 13.2) near The Well offered a strategy for using collections objects that do not have a specific slave provenance to carry a historical narrative about the nature of a slave society.[17] A tea set and various serving vessels used by a wealthy slave-owning New York family were interpreted from the point of view of the hands that poured the tea and proffered the sugar bowl. The video interpretation of the objects asked viewers to adopt the perspective of those doing the work of serving, rather than imagining themselves just as the possessors of what in the eighteenth century would have been great luxuries. Around the corner from this exercise in class relations

238 *Kathleen Hulser*

Figure 13.2 Merchant's House Installation. Exhibit *Slavery in New York*, New-York Historical Society, 2005. Photograph by Glenn Castellano. Courtesy of New-York Historical Society.

was a set of vernacular implements of daily life that would have been the tools used by many of the enslaved in domestic service. This area featured buckets with weights, simulating the burden of hauling water, which was often done by small children. That sort of tangible exercise intrigued both adults and school visitors, and stimulated many conversations about child labor both in the past and in the present. Interestingly, relatively few people seemed to grasp that the series on slavery ought to be seen as a project in labor history—a field which has perhaps foundered as union membership in the United States has dropped. However, a class visit of adult students from Joseph S. Murphy Institute for Worker Education and Labor Studies, an adult learning division associated with the City University of New York, allowed N-YHS staff to hear important questions. An adult woman, for example, asked with horror, "You mean there was really no end to the working day at all, no time you could be sure of rest?"—to which the staff reply was "yes." This group consisted of union members, people of African, Latino, Southeast Asian, and Caucasian ancestry, and a lively exchange about working conditions ensued. Initially it seemed that popular culture images of the horrors of the Middle Passage had crowded out the details of the endless daily grind

in most people's minds. But as union members this group was particularly responsive to the exhibition's presentation of abuse of the body, overwork, and early death.

By the time of the American Revolution, one in five inhabitants of New York City was enslaved.[18] This contradictory composition of a population whose claims for freedom clashed with the actual social system in effect in the colony made a big impact on visitors to the exhibition. As New York City was largely occupied by the British during the Revolution, and the English offered freedom to those who fought against the American patriots, the story of slavery in this locale forced members of the general public to rethink a well-worn narrative of national liberation. In the context of remarks about her book, *The Whites of Their Eyes: The Tea Party's Revolution and the Battle over American History*, historian Jill Lepore, whose public history writings for the *New Yorker* engage the general public in issues of perceptions of the past, recently commented "I teach slavery as part of the American Revolution because my commitment as a teacher is to desegregate history."[19] This point was forcefully made in the exhibition by a display that featured an excerpt from "The Book of Negroes," a British ledger that showed which African colonials had fought for the British Crown and thus merited freedom and passage abroad when the British withdrew from America in 1783. One person on the black loyalist list, named Deborah Squash, was threatened by a demand from her owner that she be returned. But the British Commander Sir Guy Carleton refused to allow General George Washington to repossess his former slave, because Squash had, according to the British records, served King George faithfully and thus won her freedom.[20]

A large, handsome portrait of a clergyman identified as Peter Williams, Senior, reminded visitors of the early story of African American churches.[21] Williams worked as a tobacconist and as sexton at the John St. Methodist church, before gaining his freedom. But discrimination in that denomination motivated him to form a breakaway church, the African Methodist Episcopal Church of Zion, which became a leading institution in the early-nineteenth-century African American community. The congregation helped fugitive slaves, and Sojourner Truth and other prominent people worshipped there at the first meetinghouse built at Church St. and Leonard. The struggle against slavery arrived early on in the guise of spiritual warfare, something that was easy to understand for audiences brought up on television images of Reverend Martin Luther King, Jr. and other clergy leading the civil rights struggles of the 1950s and 1960s. The exhibitions installed video feedback stations where visitors could record comments, and one such comment explicitly underlined these linkages between the early religious attack on slavery and the continuing battle for justice today. "We have gone from the cotton fields to the board rooms in terms of struggling. Although we have made some strides, it seems that we are engaged in spiritual as well as professional

warfare," said one African American woman, stressing regrettable historical continuity.[22]

AFTERMATH OF SLAVERY—BUILDING FREE COMMUNITIES

A sequel to the first large exhibition, *New York Divided*—curated by Richard Rabinowitz and Lynda Kaplan—ran from November 2006 to September 2007.[23] This second exhibition in the series presented the period after slavery was abolished in New York State in 1827, showing how the aftermath left the city still deeply tied to the expanding southern slave system. Based again on much original research developed by the American History Workshop and the N-YHS curatorial team, the exhibition reveals how an important new voice for change emerges in New York as a free black community establishes institutions and grooms leaders. The exhibition also contributed to changing the discourse on the history of slavery by showing how the relationship between the South and the North, and that between rural areas and cities, reveals the way political destinies of the region were interwoven with practical networks of business and pleasure. The exhibit also reminded visitors that slaves were visible as the servants and travelling companions of Southern slaveholders, as they visited other regions where slavery had been earlier abolished. The exhibition emphasized the role of African Americans in helping fugitives from slavery, and calling Colored Conventions to advocate for the equality and justice, which failed to accompany emancipation in the North. For many, Danny Glover playing the character of Dr. James McCune Smith was the most memorable video in the section on black abolitionists. His persuasive voice and commanding persona lent power to the depiction of someone whose activities were remarkable in the antebellum period, spanning political essays, scientific writing, aid to fugitives, and an active role in the African American Episcopal denomination, which was fighting for recognition from the central church authorities.[24]

The texture of racial relations in the city in the antebellum period was revealed in items dug up and displayed for the first time. One such item was a cache of letters written during the Riot of 1834 when white mobs targeted African Americans and abolitionists over fears of racial mixing after a preacher gave a sermon to an integrated audience and had even described Jesus as "a dark-skinned man."[25] These unusual notes written to New York Mayor Cornelius Lawrence reveal a city in which antiblack violence was so well planned that mob targets appealed for protection before the rioters came to attack their houses. One such missive came from African American Thomas Downing, a prominent owner of an oyster house serving businessmen in the financial district, who may have been targeted by the antiabolitionist mob due to his support of fugitives on the Underground Railroad. "Tho. Downing of 5 Broad Street states that he has been inform'd that an attack will be made on his house and requests the authority to interfere if it should be necessary." [26] Visitors reading this handwritten note—notice the

hint that if the mayor does nothing, this African American citizen will take up arms in his own defense—may well hear fascinating resonances in a city with a long history of racial conflict and official one-sidedness.[27]

In New York's largest outbreak of violence, the Draft Riots of 1863, Civil War era opponents of conscription took control of the city for four days, targeting African Americans, both random and selected individuals. One family chosen for a mob attack, the Lyons, ran a colored seaman's boarding house on Vandewater Street. The later memoir by the then 13-year-old daughter, Maritcha, tells how the boarders threw the stones of the mob back through the windows at the rioters.[28] These pungent, detailed stories from individuals whose stories also appeared on the exhibit's companion website revised the standard Northern narrative of Union solidarity against a pro-slavery South, documenting the dissent that pitted white working class against African Americans during the war.[29] This sentiment intensified after the Emancipation Proclamation enlarged Lincoln's stated war aims from preserving the union.

The exhibition series and the historical documents and artifacts it revealed dramatically showed audiences the endemic racial conflict of the nineteenth century that erupted after slavery's demise in the US North. By presenting historical exhibitions, contemporary artworks, public programs, websites, and new collections over the course of many years, the slavery interpretive projects forged a portrait of American slavery that insisted that slavery, its aftermath of racial injustice, and the birth of African American political thought and leadership were all integral parts of a narrative that wove past and present into a textured historical experience necessary to ground a true understanding of American history, democracy, and its vicissitudes

The public programs developed in relation to the exhibition underlined this larger integrated message, inviting writers, historians, journalists, civil rights experts, legal analysts, and artists to speak and perform, enormously enlarging the scope of interpretation beyond the already rich set of artifacts on display. For example, historian David W. Blight came repeatedly to the N-YHS in the course of the various slavery exhibitions to give different public programs exploring the history of slavery and changing public perceptions of the process of gaining freedom.[30] Annette Gordon-Reed spoke to overflow crowds about her research on Thomas Jefferson and the Sally Hemmings family.[31] These ongoing public programs, which featured very lively question and answer sessions and chances to talk with the participants at receptions, fulfilled a public appetite for connecting presentations of the past with political concerns of the present.

CONTEMPORARY ARTISTS REFLECT ON SLAVERY

If the history of slavery has interested some of the public for at least a generation, it is well worth asking what significance slavery holds for

those indifferent to history. Approaching the history of slavery from a different angle, the N-YHS sampled living artists' responses to the history of slavery. The 2006 exhibition *Legacies: Contemporary Artists Reflect on Slavery,* curated by Cynthia R. Copeland, Kathleen Hulser, and Lowery Stokes Sims, addressed an art audience, rather than its customary history-oriented one.[32] The N-YHS curators found an enormous array of existing artworks engaged in the impact and experience of slavery. Sculptures, paintings, installation, and photography works were borrowed from US and international artists such as Kara Walker, Carrie Mae Weems, Faith Ringgold, Maria Magdalena Campos-Pons, Betye Saar, Glen Ligon, Melvin Edwards, Marc Latamie, and Kerry James Marshall. However, it was perhaps in the arena of the six commissions generously created by artists working on short deadlines that the dialogue between past and present was most pungently revealed. "Mammy-Daddy," the first ever performance art piece filmed at the N-YHS, interpreted the strange story of Topsy-Turvy dolls which joined a Caucasian doll and an African American one at the waist, hiding one from the other under a skirt until the doll was flipped. This popular nineteenth-century toy persisted well into the twentieth century, and became a target of curiosity for interracial artist duo Bradley McCallum and Jacqueline Tarry. McCallum and Tarry are known for their collaborations on multimedia pieces that explore history and politics, and also incorporating elements of their personal lives.[33] They staged a live reenactment of the doll-dualism by strapping themselves into a giant turning mechanism and filming the solemn turns. The installation piece projected that film above a sculpted version with the artists' heads attached in a coffin-like setting underneath.

Another original piece was created by a modern activist organization. The American Anti-Slavery Society linked classic slave narratives with modern ones by installing first editions of Frederick Douglass's *Narrative* and Harriet Jacobs' fictionalized account of her captivity under contemporary video stories from survivors of slavery from Darfur, Lebanon, and Mauritania. Artist Fred Wilson made a bold foray into the meanings of freedom in the early republic, by juxtaposing George Washington, Napoléon Bonaparte, and Toussaint Louverture with images of the enslaved, as well as shackles and slave badges. In addition, the image of a tobacco worker holding a jaunty modern edition of a Phrygian cap was also added to the piece entitled Liberty/Liberté. His impressive ensemble traced the persistence of slavery from the founding of the republic to the Louisiana Purchase, a sale made attractive to Napoléon Bonaparte when he lost an entire army in the slave uprising in Haiti. "American history is related to all these different subjects, all these different places," said Wilson in *The New York Times,* when explaining that he ransacked the N-YHS collections for ways to highlight the contrast of liberty and slavery in the revolutionary era.[34] As Wilson's work won such acclaim it is

Figure 13.3 Liberty/Liberté, Fred Wilson. Exhibit *Legacies*: *Contemporary Artists Reflect on Slavery*, New-York Historical Society, 2006. Photograph by Glenn Castellano. Courtesy of New-York Historical Society.

being returned for permanent installation in the N-YHS Great Hall after renovations are completed in fall 2011.

These artworks have courageously inscribed tragic history into the contemporary canon, demonstrating how slavery's ugly traces could not be erased. The memory of slavery has come roaring back in these pieces replete with historical insights and fraught with the aesthetic anxiety generated in the politics of portraying pain. The range and quality of work available, of which only thirty pieces could fit in N-YHS galleries, suggest that major institutions in the United States did not lack ways to convey this difficult aspect of American history. Moreover, it is fascinating to speculate how the engagement with slavery has pried an opening for engagement with history in an art scene fiercely devoted to the present moment. The *Legacies* opening attracted an overflow crowd, which included basketball star Patrick Ewing, quite visibly towering over the throng, and many young African American men. This continued to form a substantial portion of visitors, which was new for the N-YHS, which had been accustomed to serving a traditional core audience of mostly college-educated, Caucasian viewers.

CONTINUING IMPACT OF EXHIBITION INITIATIVES

Once the N-YHS had begun exploring slavery, the subject could not be simply reshelved. So when a major exhibition titled *Lincoln in New York*—curated by Richard Rabinowitz and Linda Kaplan—opened in 2009, the narrative had to examine the impact of his views on slavery in a northern city that both supplied the Union with many soldiers and rioted against the draft and African-Americans in 1863. The most startling items exhibited in that context were the rash of stereotyped images of African-Americans printed in New York in the wake of the Emancipation Proclamation and an outpouring of racist caricatures of Lincoln. One such caricature was produced by the New York-based Society for the Diffusion of Political Knowledge, to influence the contested 1864 presidential election. Copperheads and disgruntled northern democrats during the war deemed Lincoln a threat to civil liberties and mounted the first race-baiting national political campaign, printing a booklet with a cover image of a faked "King Abraham Africanus." This rare piece of ephemera shows fear of black voters emerging a mere year after the Emancipation Proclamation. Visitor reactions to these vitriolic drawings in the service of race-hatred ranged from "[t]hey didn't even wait till everyone was free to start stomping people in the newspapers," to the comment, "[t]hese political dirty tricks remind me of Swift Boat."[35] These audience comments on controversial racist publications show that active and engaged visitors are alert to the implications of historical materials, which at first glance may seem to be just another documentation of early racism. Visitors might interpret the faked pamphlet on Lincoln as evidence that race could be a convenient tool in elections, or to explore the origins of prejudice along the volatile borders of slavery and freedom, but at the very least the comments cited above demonstrate lively, thoughtful engagement.

The N-YHS slavery projects provoked commentary in public space as well. Although the long existence of slavery in the North is well known in academia, this was not widely known to the general public. The advertising campaign played up this aspect that could hardly fail to resonate with a New York public constantly exposed to incidents that evoke the legacy of racism. Thus, for example, one ad in the subway entrances read "Slavery—It Happened Here." The public reacted to these advertisements by connecting the past with the present. One passer-by scrawled graffiti in large sharpie below the tagline, commenting: " . . . and it's still happening." Even the giant New York City school system, which serves nearly a million pupils, sat up and took notice: educational management sent curriculum specialists, teachers, and hundreds of schools groups to the exhibition. One memorable special session addressed several dozen principals from across the five boroughs, encouraging them to integrate the topic of slavery in the north into their regular sequence of learning.

Meanwhile, the financial district, which appears in iconic shots of Wall Street on the nightly news, suddenly assumed a new historic meaning, as

the place where the city practiced the commerce of slavery, selling human beings, trading in sugar, insuring cargoes—living ones and those in bales and barrels—building ships to carry those goods, and financing the expansion of cotton lands in the New South, which gave new life to slavery after the Louisiana Purchase. This function in bankrolling the system of slavery and its expansion tied New York City tightly to the transatlantic system, and thus has imbued the narrow streets of the tip of Manhattan with new, ominous meanings. These became clear as the sites identified on maps in the slavery exhibitions started showing up on all kinds of walking tours, and were even mentioned by the better-informed tour guides on buses. The Professional Guides Association of New York City enthusiastically embraced this new knowledge of the city, and many of them incorporated it into their historical interpretations of downtown neighborhoods, talking of architecture one moment, and of human suffering in the heart of the early republic in the very next breath.[36] This form of making slavery visible outside museum walls proved to be a particularly long-lasting effect of the slavery shows, and the ingenious use of story maps created by Albert Lorenz Studio within those exhibitions helped city history buffs visualize how slavery mapped onto familiar cityscapes, even though the physical reminders were gone.

MUSEUMS AND COLLECTING

The museum and library of the N-YHS both would ideally like to enhance the collection's representation of the history of more diverse groups. However, the reality of collections policies means that these efforts must be envisioned not as startling new endeavors, but as building out existing collections in a thoughtful manner. The N-YHS is clearly in a good position to do so, as its powerful collections in abolitionism and the business of slavery both provide a basis for reaching toward modern-day civil rights struggles, and tracing the free community and the growth of African American political thought. In the Henry Luce III Center for the Study of American Culture, selected objects associated with slavery are grouped in the permanent display area, which is handled as visible storage space. There, since the end of the slavery exhibition series in 2007, one has been able to view a set of slave shackles paired with figurines from the famed 1852 antislavery novel *Uncle Tom's Cabin*. A grouping of silver objects, a teapot, and sugar tongs suggest contrast between the luxury of a fine silver tea service and the bondage of those in domestic service whose hands poured the tea. The sugar tongs direct attention to the Caribbean's major slave-produced commodity produced on cane plantations at the cost of untold suffering and human life. This ensemble of objects provides a discussion point for school groups touring the Luce Center, and has allowed the N-YHS to respond to the 1990s call for an "Amistad curriculum" that would ensure that this

generation of schoolchildren would learn about slavery, North and South, as an integral feature of their American history studies.

As the N-YHS experience with *Legacies: Contemporary Artists Reflect on Slavery* demonstrated, the memory of slavery and the recurrent encounters with that history have stimulated an extensive twentieth-century body of artworks. Offering a layer of reflection on the history of slavery, these newer works of art also offer museums a chance to stage vigorous dialogues between past and present. The sculpture of Sojourner Truth by Barbara Chase-Riboud, an artist based in Paris, is a small-scale bronze figure that resonates with the substantial institutional holdings of nineteenth-century portrait bronzes, including a large collection of Rogers groups. John Rogers (1829–1904) was a sculptor whose popular bronze groups were purchased by many middle-class Americans in the nineteenth century. The New-York Historical Society owns many of these sculptural groups, several of which illustrate anti-slavery themes. The Sojourner figure, according to Chase-Riboud, was conceptualized to speak to some of the portrait conventions of the nineteenth century—a period which is characterized by its omission of significant depictions of the great nineteenth-century women who fought to end slavery. The artist explained, "typically the nineteenth-century public bronze was a man on a horse. I wanted Sojourner to have a horse, but it did not seem right to have her actually riding the horse."[37] So, Chase-Riboud gave Sojourner her horse, but as a companion, and depicts her leading the horse with a lantern, a seeker after truth, bringing spiritual light into the wilderness of a benighted slave-holding nineteenth century. The figure stood for over a year as the centerpiece of the slavery display in the Luce Center, until 2008 when the first African-American governor of New York state, David Paterson, requested it as a loan for the governor's mansion where it remained until 2011.

Having established the precedent with that acquisition of a modern bronze, the first sculpture by a living African-American woman to enter the collections of the N-YHS, the museum staff was emboldened to seek more. As curators noticed, a landscape of civil rights was blossoming in Harlem, and with Frederick Douglass adorning an intersection near Central Park, it seemed a natural second step to inquire if a maquette was available of the new 13-foot figure of Harriet Tubman, installed in 2009 on West 122nd St. and St. Nicholas Avenue (an avenue slated to be renamed Harriet Tubman Boulevard). California-based artist Alison Saar had finished her commission for the public sculpture, and her gallery Phyllis Kind had an example available from a limited edition of small-scale versions of the figure. Saar's Tubman research had revealed her activity as a scout and nurse during the Civil War, as well as her celebrated role leading fugitive slaves out of her native Maryland in the antebellum period. Based on this research, Saar emphasized Tubman's sturdy form, a physique she had honed working in the lumber operations on the Delmarva Peninsula where she was enslaved. "I wanted people to see how strong and young Harriet was," explained

sculptor Saar. "I see her as fit and determined, so, I left a furrow in her brow to show her intensity and I made her shoulders muscled."[38] The acquisition was tempting, but the N-YHS like so many historical institutions lacks the funds to compete with art world prices. However, the display of the work in a public program for adult learners called Run for Your Life, about the Underground Railroad, proved its popularity with the sold-out audience.[39] Once the figure had been viewed on loan for a time in the N-YHS context, support was mustered, and the purchase/partial gift was made. These two examples illustrate how small steps can begin to move an institution forward: in 2004 *Slavery in New York* debuted, and by 2009 the N-YHS had added two sculptures by major living African American women artists to its collections. The exhibition initiatives had changed ideas about what was important to collect: now African American artists were wooed and museum gatekeepers saw the centrality of African American voices.

As the institution has integrated an interpretation of slavery into its core mission of telling both the national story and New York's history, it has expanded its narrative relating to the aftermath and legacy of slavery. In this spirit, the N-YHS plans to dedicate a new civil rights gallery upon its reopening in 2011. Although no firm roster of exhibitions has been set, research is underway for a 2012 exhibition dealing with Elizabeth Jennings who legally challenged streetcar segregation in New York in 1854, and won. The contemporary photographer Platon, who recently generously donated a group of photographs to the Print Room Collections, will be the subject of an exhibition in the civil rights gallery on his project to follow up on the narratives of the early leaders of the civil rights movements. This photography project took him across the nation to find people both famous and obscure who are now in their senior years, and have witnessed enormous societal changes since the days of eager Northern activists joining Southern grass-roots protestors at lunch counter sit-ins, freedom bus rides, and voter registration efforts.[40] The inauguration of the civil rights gallery with its plans for exhibitions on African American experiences of seeking justice in the 1850s and the 1950s show how the institution is now serving audiences that have shown a hunger to trace the impact of slavery on subsequent generations.

CONCLUSION

This chapter underlined how a generation of museum staffers raised in the atmosphere of civil rights was able to see that audiences in a city newly aware and proud of its African-American heritage wanted to understand the history of slavery. As the rediscovery of slavery at the African Burial Ground and in the records of the N-YHS demonstrates, the history was there, but it took the social and political motivation of memory to stimulate institutional changes that fostered the large slavery projects. Slavery and its consequences have now

been woven into the fabric of museum historical interpretation so thoroughly that they cannot be forgotten again. The power of memory meant that the slavery project at N-YHS could not be contained in just the original three-part series. Grappling with the history of slavery means that objects in the N-YHS that relate to sugar are interpreted in relation to the slave trade that made the sugar economy function. Likewise, the quest to fully interpret the history of slave society has tied New York history to a global perspective, forcing other exhibitions to situate themselves in a transatlantic world. For example, the exhibition "Nueva York" done in 2010–2011 in partnership with El Museo del Barrio in New York City, interpreted slavery, sugar, and Caribbean trade in a deeper fashion as a result of the research and staff involvement in the various slavery projects over the years. Truly as James Oliver Horton has said: "Slavery is not African American history, it is American history."[41] Fragmentary evidence and scattered sources have been drawn together in frameworks of significance that are the scaffolding for new interpretations, and this has revitalized the study of the colonial period in New York, and given great historical depth to contemporary debates on the origins and meanings of racial prejudice in our society. The tone and syntax of exhibition itself has shifted, as the heretofore prevailing flat informational aura of the museum label could not be maintained with contents that spoke of atrocity and lifelong bondage.

The language of displays in the exhibition of this difficult and tragic history has furthered a process of layering in the relationship of museum and audience. Displays such as the Merchant's House/Slave Lives duo in *Slavery in New York* demonstrate how objects can be recruited into historical arrangements that speak to the irony of contingent historical circumstances. This sort of layered interpretation dealing with the history of violence and abuse was new for the N-YHS, and has pushed the institution to acknowledge the tradition of the factual "value-free" history, even as it began to move into a terrain where passionate debate is the norm. The lovely silver teapot in the Merchant's House is still a handsome artifact of the eighteenth century, but few will forget its juxtaposition with the Slave Lives so eloquently evoked around the corner from the elegance of the "master's quarters." The way objects have been offered to the public embraces dialogue with current events, situating collections and museum objects in the context of debates about the meaning of the past, rather than the narrow confines of connoisseurship. Overall, the work of over a decade in connecting the public with the primary sources long dormant at the Society has been a success story in public history that demonstrates how controversy and difficult history themes motivate presenters and audiences, giving history an urgent meaning in our contemporary world.

NOTES

1. James Oliver Horton and Johanna C. Kardux, "Slavery and Public Memory in the United States and the Netherlands," in "Slavery and Its Legacies," special issue, *New-York Journal of American History* 66, no. 2 (2005): 35.

2. Inspired leadership from New-York Historical Society presidents including Betsy Gotbaum and Kenneth T. Jackson created a climate in which research for the slavery series could get underway, an effort begun by N-YHS staffers Kathleen Hulser, Steven Jaffee, and Cynthia R. Copeland. But it was under the presidency of Louise Mirrer that major corporate sponsorships were secured, which permitted substantial staff time to be devoted to the projects since 2004.
3. See Kathleen Hulser and Steve Bull, "Click History: Wherever, Whenever," in *Creativity and Technology: Social Media, Mobiles and Museums*, ed. James Katz, Wayne LaBar, and Ellen Lynch (Edinburgh, UK: MuseumsEtc, 2011), 204–213.
4. African Burial Ground National Monument (New York: African Burial Ground, 2003), http://www.africanburialground.gov/Documents/ABG_Brochure_2003_10.pdf
5. Howard Dodson, Christopher Paul Moore, and Roberta Yancey, *The Black New Yorkers: The Schomburg Illustrated Chronology 400 Years of African American History*, (New York: John Wiley & Sons, 2000).
6. See The Seneca Village website: http://projects.ilt.columbia.edu/seneca/start.html.
7. The Guinean immigrant Diallo was a student and an applicant for political asylum. He was shot by plainclothes policemen in the Bronx in February 1999. Large protests at City Hall attended by former Mayor David Dinkins, Bronx Borough President Fernando Ferrer and other city notables drew national attention to the case. It was widely interpreted as an incident of race-based, excessive use of force. New York City later settled a wrongful death suit for $3 million with Diallo's family.
8. Bettina M. Carbonell, "The Afterlife of Lynching: Exhibitions and the Recomposition of Human Suffering," *Mississippi Quarterly*, 2008: 197.
9. James Allen, Hilton Als, John Lewis, and Leon F. Litwack, *Without Sanctuary: Lynching Photography in America* (Santa Fe, NM: Twin Palms, 2000)
10. Ira Berlin and Leslie M. Harris, eds. *Slavery in New York* (New York: New Press, 2005). Major essays commissioned for this volume diverged from the museum custom of publishing lavishly illustrated catalogues. Instead the anthology concentrated on distilling a generation's scholarship into accessible short essays appealing to the general public and students. This publication marked the beginning of a new publication program that has emphasized readable but scholarly history in short forms with select historical visual material presented as evidence rather than illustration.
11. Christopher P. Moore, "A World of Possibilities: Slavery and Freedom in Dutch New Amsterdam," in *Slavery in New York*, ed. Ira Berlin and Leslie M. Harris (New York: New Press, 2005), 44.
12. Graham Russell Gao Hodges, *Root & Branch: African Americans in New York and East Jersey, 1613–1863* (Chapel Hill, NC: University of North Carolina Press, 1999), 64–66.
13. Exhibition materials on New York's worsening slaves codes were drawn from Hodges, *Root & Branch*, 47–53, and Jill Lepore, *New York Burning: Liberty, Slavery and Conspiracy in Eighteenth-Century Manhattan* (New York: Knopf, 2005), 80–81.
14. See Leslie M. Harris, *In the Shadow of Slavery: African Americans in New York City, 1626–1863* (Chicago, IL: University of Chicago Press, 2003), 11–71, and Graham Russell Gao Hodges and Alan Edward Brown, eds., *"Pretends to be Free": Runaway Slave Advertisements from Colonial and Revolutionary New York and New Jersey* (New York: Garland, 1994).
15. Jill Lepore, "The Tightening Vise: Slavery and Freedom in British New York," in *Slavery in New York*, 75.

250 Kathleen Hulser

16. Compare the evolution of the institutional presentation of slavery and its aftermath with the international perspective on presenting slavery to the public by visiting some of the African sites that tell the transatlantic history of slavery. Gorée Island in Senegal and Elmina Castle in Ghana are both members of the International Coalition of Sites of Conscience. http://www.sitesofconscience.org/en/.
17. See a particularly sophisticated discussion of irony, viewpoint, and the museum effect in this display in Bettina M. Carbonell, "The Syntax of Objects and the Representation of History: Speaking of *Slavery in New York*," *History and Theory*, no. 47 (2009): 122–137.
18. Graham Russell Gao Hodges, "Liberty and Constraint: The Limits of Revolution," in *Slavery in New York*, 94.
19. Jill Lepore, Lecture, December 6, 2010, Eugene Lang College of the New School for Social Research. See Jill Lepore, *The Whites of Their Eyes: The Tea Party's Revolution and the Battle over American History* (Princeton, NJ: Princeton University Press, 2010).
20. Deborah Squash, described as "20, a stout wench, formerly slave to General Washington," can be found in the "Book of Negroes" list of black loyalists who left on British ships from New York in November 1783. She boarded the ship *Polly* bound for Port Roseway, Nova Scotia (Canada), with her husband Harry, http://www.blackloyalist.com/canadiandigitalcollection/documents/official/book_of_negroes.htm.
21. Anonymous, oil painting, N-YHS. Acc. X.173.
22. Anonymous comment from "Telling Lives," Visitor video comment booth, American History Workshop, 2005.
23. Graham Russell Gao Hodges, *Root & Branch*.
24. John Stauffer, *The Black Hearts of Men: Radical Abolitionists and the Transformation of Race* (Cambridge, MA: Harvard University Press, 2001); Craig D. Townsend, *Faith in Their Own Color: Black Episcopalians in Antebellum New York City* (New York: Columbia University Press, 2005).
25. New-York Historical Society Library, Misc. Manuscripts "Riots of 1834," "Letters to Mayor Cornelius Lawrence," 1834.
26. Harris, *In the Shadow of Slavery*, 194–199.
27. Harris, *In the Shadow of Slavery*, 194–199. Leslie M. Alexander, *African or American? Black Identity and Political Activism in New York City, 1784–1861* (Urbana, IL: University of Illinois Press, 2008).
28. Tonya Bolden, *Maritcha: A Nineteenth-Century American Girl* (New York: Harry Abrams, 2005). This illustrated volume is a children's book, but is the only existing full-length treatment of Maritcha Remond Lyons' memoir. Its handsome display of visual sources coupled with a simple but accurate exposition of a fascinating chapter of Civil War history from the perspective of an African American teen actually involved in the Underground Railroad make it a valuable source. That it exists as children's literature offers an interesting insight into author and publisher views of the marketplace for history based on primary sources.
29. See *New York Divided*, http://www.nydivided.org.
30. David Blight, *A Slave No More: Two Men who Escaped to Freedom, Including Their Own Narratives* (New York: Houghton Mifflin, 2007). This tale emphasized how the Civil War itself provided an enormous opening for fugitive slaves to escape, and showed how freedom did not necessarily entail full equality in a prejudiced postemancipation society.
31. Annette Gordon-Reed, *The Hemmingses of Monticello: An American Family* (New York: W.W. Norton, 2008).

Exhibiting Slavery at the New-York Historical Society 251

32. Lowery Stokes Sims, Kathleen Hulser, and Cynthia R. Copeland, *Legacies: Contemporary Artists Reflect on Slavery* (New York: New-York Historical Society, 2006).
33. Bradley McCallum and Jacqueline Tarry, *Bearing Witness: Work by Bradley McCallum & Jacqueline Tarry* (Baltimore, MD: Contemporary Museum of Art & Maryland Institute of Contemporary Art, 2010).
34. Felicia R. Lee, "Slavery's Legacy Seen through Art," June 13, 2006, C1, C7. Arts Section, 1.
35. I collected these comments from visitors to galleries in December 2009 and February 15, 2010.
36. Hardy Phippen, president GANYC.
37. Kathleen Hulser, "Sojourner Truth Maquette by Barbara Chase-Riboud, " Acquisition Report (New York: New-York Historical Society, February 2007).
38. Alison Saar, telephone interview by Kathleen Hulser, November 20, 2008.
39. These initiatives were supported by the US Department of Education Underground Railroad Educational and Cultural Program.
40. Some of the photographs can be viewed online in the *New Yorker* magazine archive at http://www.newyorker.com/reporting/2010/02/15/100215fa_fact_remnick#ixzz17vj8L400. David Remnick, Portfolio by Platon, "The Promise," *The New Yorker*, February 15, 2010, 95.
41. James Oliver Horton and Lois E. Horton, eds. *Slavery and Public History: The Tough Stuff of Memory* (New York: New Press, 2006).

14 Museums and the Story of Slavery
The Challenge of Language

Regina Faden

Despite the passage of nearly 150 years since its legal end, many North Americans are reluctant to talk about slavery. Fundamentally, the history of slavery and its legacy pose particular problems because this history contradicts the national narrative of freedom, independence, self-reliance, equality, and justice. The hundreds of years of suffering, brutality, exploitation, and domination inflicted by enslavement belie the image North Americans want to see and project to themselves and to others. James Oliver Horton and Lois E. Horton describe this dilemma as "the nation's most enduring contradiction."[1]

For some white North Americans, addressing slavery is problematic for several reasons. Race has been perceived as something that belongs to others. Some are afraid of speaking for fear of being perceived as racist or being told they have no right to speak. Whites are also wary about an implied complicity in the shameful institution. Some whites still hold racist beliefs that contribute to their reluctance—and defensiveness.[2] At the same time, African Americans do not always wish to talk about slavery. The pain and weight of slavery can still be a heavy burden. Typically, the stories about slavery portray African Americans as victims, denying them any agency and ignoring the strength and endurance necessary to survive their ordeal. As historian Ira Berlin contends, "Although the playing field was never level, the master-slave relationship was nevertheless subject to continual negotiation."[3]

One of the public forums where North Americans have begun to explore slavery is in museums. As research indicates, however, many museums continue to present narratives that "reinforce traditional views of reality."[4] Like other North Americans, some museum staff are reluctant to take on the story of slavery. They are not entirely irrational in their misgivings. When Colonial Williamsburg critically evaluated its interpretation of the eighteenth century, the museum decided to incorporate the story of slavery, in part, by reenacting a slave auction. One interpreter who portrayed a slave "explained that many of his friends and members of his family would not talk to him about his job once they understood what he did."[5]

Difficult stories and possible negative reactions do not free museums from their obligation to present an objective history. For those who undertake an effort to present a more realistic story, there will be obstacles but

obstacles that can be overcome. This chapter will examine two museums dealing with the challenge of language as it relates to museums and presenting the story of slavery. The Mark Twain Boyhood Home & Museum in Hannibal, Missouri, will serve as an example of a museum that struggles with racial language of the nineteenth century. Historic St. Mary's City in St. Mary's City, Maryland, serves as an example of how language of the past can obscure the whole story.

MUSEUMS AND THE HERITAGE OF LANGUAGE

Before he died, Sam Clemens (Mark Twain) was world famous. Just after his death in 1910, one of Hannibal's wealthy philanthropists purchased and donated the boyhood home of Sam Clemens to the city, establishing the Mark Twain Boyhood Home & Museum. Visitors toured the home, itself the main artifact itself remaining of the Clemens' life there. In the 1930s the Works Progress Administration (WPA) built a simple stone structure to house the museum. Eventually the city also acquired several other buildings on the same city block. At that time, the museum's interpretation focused on the white characters of Tom Sawyer, Becky Thatcher, and Huckleberry Finn. The buildings, both facilities and artifacts, were used as interpretive spaces for episodes from Twain's books. The museum embodied a nostalgic story of childhood in a time of simplicity and innocent fun.

Nostalgia was the lens through which the museum told its stories of Twain's white characters until approximately 2002. Scholars began to sharply criticize the museum for propagating a myth of an idyllic nineteenth-century America. For those, scholars and admirers of Twain, who see him as an advocate for peace and social justice because of his later works condemning war, such as "The War Prayer," the museum's focus on the white characters of Tom Sawyer, Becky Thatcher, and the mischievous Huck Finn was a disservice to Twain and his beliefs. The character of Jim, a slave, and the story of slavery in Hannibal and Twain's youth were entirely absent from the museum. Such scholars as Shelley Fishkin rightly criticized the museum for its whitewashed version of Twain's experience in Hannibal.[6] As Fishkin explains,

> Hannibal—the lies it told itself, the truths it denied—would serve as an emblem for Twain of the wider "civilized world."' Twain's Hannibal, in turn would become an emblem of America itself. To the extent that one could mask the betrayals and depravities at the heart of Hannibal, one could deny the dark underside of the nation.[7]

Like the "civilized world," Fishkin saw that the museum avoided telling the uglier part of Hannibal's and Twain's history. The museum owed it to Twain to match his commitment to looking deeply at this "underside" and help visitors understand his message of compassion and equality (Figure 14.1).

Figure 14.1 Mark Twain and John Lewis at Quarry Farm, Elmira, New York, July, 1903. Photograph courtesy of the Mark Twain Boyhood Home and Museum, Hannibal, MO.

The board, composed of white local residents, was willing to reevaluate the museum's interpretation. In 2003, the museum hired Dr. Jay Rounds from the University of Missouri-St. Louis to develop a new master plan for interpretation. During the drafting of a new Master Plan in 2003–2004, some board directors and staff resisted the topic of slavery, specifically the suggestion of installing a slave pallet in the kitchen of the boyhood home to represent where a slave probably slept. The board and many in the community saw the boyhood home as sacred; it should not be tainted by the story of slavery. In their eyes, including the slave pallet as an exhibit would indict not only Twain as a racist but Hannibal as well.

In 2005, as the executive director of the museum, I conducted interviews, formal and informal, with members of the community. Although the interviews were meant to gauge the feasibility of a capital campaign, residents of Hannibal, African American and white, reacted strongly to proposed changes at the museum. Whites were angry about introducing the story of slavery. They were very clear that it would make them look racist. African Americans were clear that the Mark Twain Museum had nothing to offer them and dared the executive director to do something to make good on promises of change. Despite restrictions in Twain's house, the first

phase of the plan, updating the Interpretive Center, included several text panels addressing Twain's experience with slavery in Hannibal.

At this time, the museum was reconstructing the Huckleberry Finn House, a special project funded entirely by a major donor. The reconstructed house represented the home of Tom Blankenship, the real-life friend of Twain and model for Huck Finn. The proposed exhibit discussed the different social and economic levels in which white society ignored Jim and the central message of Jim's humanity in the novel. Alternatively, staff and some board members felt the project offered an opportunity to talk about Twain's novel, *Adventures of Huckleberry Finn*.[8] This proposal caused anxiety among some board directors. They asked: Do African Americans want us to talk about slavery and race? Do we want to create controversy in the city? When the designer of the exhibit about social and economic strata failed to submit a plan, the board approved the exhibit that discussed the novel and its legacy of controversy.[9]

The decision to install the exhibit cost the museum the goodwill of its largest donor, who had funded the reconstruction of the house. Funds for exhibit design were not in the budget, and no artifacts existed that supported the story. Despite their trepidation about offending their donor, the lack of budget, and the storm the exhibit might cause, the board and staff forged ahead.

What the board understood was that at the heart of the long controversy over *Huck Finn* is language. In the nineteenth century, the novel was famously banned by the public library in Concord, Massachusetts, as "the veriest trash. Suitable only for the slums."[10] The character of Huck Finn with his "vulgar" speech, fondness for smoking, and lack of education was offensive to genteel audiences. The Brooklyn Public Library followed Concord's example and banned the book in 1905 with this explanation: 'Huck not only itched but scratched, and that he said sweat when he should have said perspiration.'"[11] Huck was rejected because critics did not see how he could elevate or improve his readers.

Although the fire over *Huck Finn's* lack of refinement has died out, the controversy over the novel's racial language is still burning hot. Since the 1950s, critics react strongly to Twain's use of the word "nigger" more than two hundred times in the novel. The many efforts to ban Huck Finn have focused on the novel's racially charged language and often on Twain's depiction of the character of Jim, an enslaved man and Huck's companion down the Mississippi River. In 1957,

> the NAACP charged that *Huck Finn* contained "racial slurs" and "belittling racial designations." Since then, the book has been called "racist" for both the pervasive use of the word "n_____" and a portrayal of blacks that some people consider stereotypical and demeaning. It has been removed from reading lists in schools ranging from Texas to Pennsylvania (including, ironically, the Mark Twain Intermediate School in

Fairfax, Virginia). Public libraries also continue to deal with requests that the book be removed, although the focus of the controversy has shifted to the classroom.[12]

Although *Huck Finn* was published more than one hundred years ago, it still provokes strong reactions. In 2007, the novel was the fifth-most-challenged book in the country and Twain the third–most-challenged author.[13]

Each year in the United States, school systems consider banning and some eventually ban the novel from their classrooms. For example, in 2007 a black student, Ibrahim Mohamed at Richland High School in North Richland Hills, Texas, complained about the assignment to read the novel for his class. Ellen Bell, associate superintendent for the school district, explained that the purpose of the assignment was to educate students about "literature and history by discussing the controversial word [nigger]. 'The purpose was to talk to students about language that could be hurtful and see it in the historical context in which it was written,' Bell said. 'The teacher was trying to be sensitive to students' feelings and not to be hurtful.'"[14] Students' complaints and hurt feelings are typical of reports about banning *Huck Finn* in schools. Students and their parents object to the language.

Recent incidents of very public racial slurs by public figures show us that the power of the word "nigger" to offend and demean has not dimished. It is understandable that students and parents might question assigning *Huck Finn*. Twain's use of "nigger" can offend people's sensibilities today. Even some teachers who believe the novel to be worth discussing find it difficult to assign. John Foley, a teacher in Ridgefield, Washington, explains, "'I have a lot of passion for 'Huck Finn,' and my enthusiasm usually carries the book. But I have kids come up to me, very smart kids, who say, 'Mr. Foley, I hate this book.'"[15] Foley recommends choosing something more modern to promote classroom dialogue about race.

Given the ongoing controversy over Huck Finn and the frequent damning of Twain as a racist because he penned the work,[16] would it be best for the museum to slip *Huck* under the rug and forget about him? What is the responsibility of the museum to Twain and the community where he lived? The museum could demonstrate Twain's commitment to social justice, by focusing on other works that more clearly demonstrate his belief in social justice, such as "King Leopold's Soliloquy" about Belgian colonialism.[17] In this way, the museum could escape the quagmire of *Huck Finn*'s language. Yet, by not addressing the controversy over *Huck*'s language, the museum would tacitly concur with critics that Twain was racist. Visitors from all over the world could return home thinking this. Allowing this to happen would be cowardice, and the museum would deserve the scorn of Twain himself.

In developing the exhibit for the "Huckleberry Finn House," staff understood that they needed to address the charges of racist language directly. For the museum in Hannibal, where Twain absorbed the racism of the period and place, it was particularly important to put the language in its historical and cultural context. Jocelyn Chadwick, the author of *The Jim Dilemma:*

Reading Race in the Adventures of Huckleberry Finn, believes in the value of Twain's fiction and his personal story. She explains that the novel should be taught "to students because it is an important work by one of America's most prominent writers. It not only deals with a difficult time in American history, it marks an important transformation for Twain himself. Starting with '*Huckleberry Finn*,' Chadwick said, Twain's writings stopped being just stories and began to reflect his social conscience."[18] Iris Ford, professor of anthropology, agrees that Twain's work should be taught. She argues that Twain "push[es] the boundaries of public discourse to help us address prejudices and fears by exposing raw truths that underlie our espoused values and beliefs. *Adventures of Huckleberry Finn* is a cultural artifact from which there is much to learn about who we are and who we can be."[19]

Supported and strengthened by the work of scholars such as Chadwick and Fishkin, the museum's exhibit discussing the novel of *Huck Finn* opened in 2005 without controversy. The exhibit' story, told through text panels, places the work in its historical context; it urges visitors to read it and decide for themselves whether it is a racist novel or a novel about racism. Bringing the story up to date, the final panel text presents a brief story of modern-day slavery; Twain's message of compassion and equality are as relevant today as in the nineteenth century.

In 2010, the museum, under the guidance of a more racially diverse board, introduced the once unacceptable slave pallet in the kitchen of the Clemens' home. Having overcome objections raised during the 2003 master planning, the museum was ready to offer a more objective story of Twain and his early life. The museum's executive director, Cindy Lovell, talks about the new exhibit and its intention:

> We wanted to tell the most complete story about everyone who lived in the house, not just the Clemenses. So, we installed a slave pallet—a handmade rug on the kitchen floor by the fireplace because this is the most likely place for [the family's slave] Sandy to have slept. He would have arisen, tended the fire, and begun his day of chores.[20]

The board's reaction in 2010 was markedly different to the addition than it had been in 2003. Lovell explains, "When I suggested this humble 'installation' The museum staff and board members were enthusiastic from the outset, and visitors have been visibly moved when viewing this exhibit. Suddenly the nostalgia of whitewashed fences gives way to the reality that "the good ol' days" weren't good for all concerned."[21]

In July 2010, the museum joined with other organizations to host a public forum about racism. The program was organized and sponsored by the Community Partnership for Reconciliation (CPR), "a diverse group of citizens working to eliminate racism and its residual destructive impact."[22] Cindy Lovell, a member of CPR, explains, "we believe [Twain] would support any effort to reduce racism and promote harmony, especially here in his hometown."[23]

Lovell describes the museum's efforts to address racism and Twain's use of racially charged language. "Every time that word appears we cringe, we feel it, and we feel the absurdity of the racism that was encouraged to perpetuate slavery." She further explains:

> When Mark Twain wrote in his autobiography, "In religion and politics people's beliefs and convictions are in almost every case gotten at secondhand, and without examination" he was reminding us that our loving parents and role models tell us how to vote, how to worship, and whom to hate. And what child is going to question his superiors? Huck did.[24]

Like Sam Clemens, Hannibal and the museum have had to work to unlearn lessons from its slave-holding past in order to bring about change within. A core aim of the museum now is to help the community exorcise its ghosts by providing a safe forum for discussion. The new exhibits and programs carried out by the museum have made a difference. As Joe Miller, an African American community partner, explains:

> For people to be interested in your life, your history, and your community, it gives you a new feeling of inclusiveness, because in many instances the Black community has felt left out . . . and for someone to take the time to want to know about you, it makes you proud and gives you a new perspective about the attitude of your community as a whole.[25]

In helping the community look at its past and discuss the difficult topic of race and the legacy of slavery, the museum has helped build bridges among the city's people. Language has been a challenge as well as a springboard for discussion and change.

In October 2010, the Mark Twain Boyhood Home & Museum received the Martin Luther King, Jr. Award from the local chapter of the National Association for the Advancement of Colored People (NAACP). When its president, Annie Dixon, presented the award, she explained that it recognized the museum "for its proactive endeavors, such as the anti-racism workshop, an after-school program for at-risk youth, participation in Juneteenth, and performances by Gladys Coggswell, [African American] storyteller-in-residence."[26] As the powerful example of Twain himself demonstrates, it is possible to shed one's worldview. Finding a new direction requires sometimes painful change, but museums, as trusted institutions of education, are obligated to tell the whole story.

MUSEUMS AND DECIPHERING THE CODE OF LANGUAGE

As demonstrated by the story of the Twain museum, language can be a challenge to interpreting the history of slavery for the public today. Historic

St. Mary's City (HSMC) faces similar challenges in presenting the story of the early days of slavery in the Chesapeake. One can follow the evolution of slavery in Maryland through law and court cases, but the laws alone do not provide access to the thoughts and beliefs that supported changing from a society with slaves to a slave society. Historian Ira Berlin uses this phrase to describe a transition from a society of free, indentured, and slave labor to a society with legalized, lifelong slavery for blacks.

Historic St. Mary's City is a state agency charged with the preservation and interpretation of Maryland's first capital, St. Mary's City. For more than forty years, its research department of archaeologists and historians has studied artifacts and documents to reconstruct the city and the experience of its people. Today, the museum has a number of reconstructed buildings and living history exhibits that tell the story of life in early Maryland. The central themes of the exhibits are the site's significant firsts: the first place to establish the separation of church and state in the English-speaking world, the first woman to request the vote in the state legislature, and the first person of African descent, Matthias de Sousa, to participate in a colonial legislature. Of course, the stories of the separation of church and state and of de Sousa are appealing, making Maryland an example of virtue and tolerance. Yet the laws that would institutionalize slavery were also passed in St. Mary's City.

Scholars have sought for more than one hundred years to understand how the slave system in the Chesapeake developed. How did it change from a society where slavery was one among different forms of labor as compared to a society "where slavery stood at the center of economic production"?[27] They have approached this question from multiple angles. Historians have studied the economic, cultural, and geopolitical reasons for the emergence of a heritable enslavement designated only for "negroes." They have examined such fundamental issues as the economic role of slavery in the American colonies, the development of the Chesapeake's plantation economy, and the development of a codified system of slavery. More recently work has focused on the origin and agency of Africans and enslaved people, the understanding of the term "race" in the seventeenth century, and the prejudice against Africans prior to the development of slavery in the United States. Over the years, scholars have agreed on a number of factors that influenced the growth of lifelong slavery: its precedence in the Atlantic world, a shortage of indentured labor, and the shifting economy of the Chesapeake.

Still, scholars have not yet agreed why and how the people of the American colonies justified slavery to themselves. Unlike those in the nineteenth century who left behind published and private works justifying and defending slavery, we do not have tracts, diaries, or other records from the seventeenth century that allow us to understand the rapid advancement of the slavery system. As Julia King and Edward Chaney explain, language describing race is unclear, and terms used today, such as black, white, or

mulatto had different meanings in the seventeenth century.[28] Thus historians still seek to understand the back story of laws and practices that supported the legal and social institutionalization of lifelong black enslavement.[29]

This is of particular concern to Historic St. Mary's City (HSMC). It is the task of the research staff, as at all museums, to consider all artifacts from the site and the work of historians and anthropologists in order to develop exhibits interpreting this information for the public. The staff at HSMC sees the history of the origins of slavery in the Chesapeake both as contributing to a more objective history and a unique contribution to the museum field; this is a topic not yet adequately addressed at any seventeenth-century English site. Typically visitors understand slavery as it was in the nineteenth century, as a fully formed system. General perceptions have been shaped by popular culture, such as *Gone with the Wind*. The term "slavery" conjures images of a big house with many slaves in the fields and a slave quarter. The interpretation of the early years helps visitors understand that the American system of slavery did not arrive full-blown from Europe or Africa but developed out of a particular context.

St. Mary's City was part of the tobacco coast and from its first days made its wealth from the "sotweed," but in the seventeenth century the slave population was relatively small.[30]

At HSMC when we refer to the "Plantation" (Figure 14.2), we mean a modest, middling home of the 1660s with a kitchen garden and indentured servants. First-person interpreters explain to visitors that the master and mistress of the house worked, ate, and slept alongside their indentured servants. This proximity among landowner and servants would have been the same for slaves. Documents tell us that there were American Indian and African enslaved people in small numbers during the seventeenth century. St. Mary's City was abandoned after the capital was moved to Annapolis in 1695. After 1700, however, the enslaved black population increased exponentially and racial divides solidified.[31] By the early eighteenth century, laws defined servitude as a lifelong status for blacks, made interracial marriage illegal, and eliminated many of the legal protections for slaves.

Currently representing this story are several exhibits across the museum's campus about slavery. These exhibits include buildings where enslaved people labored, archaeological artifacts, and legal documents to tell these stories. The museum plans to continue to develop this narrative in the future. Staff are also currently working together to interpret a nineteenth-century slave quarter. A new visitors' center will offer an opportunity to discuss about slavery through its exhibits and lead visitors to other sites about the theme. In the case of how slavery developed, artifacts are of limited use. Research staff must turn to documents to tell the full story.

The challenge for the museum is language—what is not available and what is available, but difficult to penetrate. For example, the museum does not have seventeenth-century documents, such as diaries, letters, or journals, that help today's scholars understand the beliefs and values that supported and promoted the growth of slavery. Laws document changes over time in what concerns the

Figure 14.2 Historical Interpreter and Visitor at the Godiah Spray Plantation, Historic St. Mary's City, 2007. Photograph courtesy of Historic St. Mary's City Commission.

legal status of "negroes" or "slaves," but they do not reveal the justification for such changes. Archives preserve the legislation that institutionalized slavery in Maryland, but the language of the seventeenth century is difficult to interpret and to convey; one cannot apply the contemporary meaning of words, including "slave," "servant," "race," "negro," and "slave," because these words were used inconsistently.[32]

Historian Jonathan Alpert attempted to trace the development of slavery through colonial and state law.[33] His work exposes the ambiguity of the legal language and the shifting scope of enslavement. Although it is hard to penetrate the meaning of seventeenth-century language related to race, the end is clear; by the eighteenth century those designated as "negroes" were slaves for life. Given the ambiguity of seventeenth-century language related to race and language within Maryland law, the following cases exemplify the difficulty in developing a coherent story about the development of slavery for museum visitors.

In 1639 "An Act for the liberties of the people" guaranteed all Christian inhabitants, "slaves excepted," the full rights of all Englishmen. The term "slaves" does not distinguish between racial or ethnic groups but makes clear the divide between nonslaves and Englishmen. Indeed, in the 1630s, slaves could be American Indians; there were a small number of black slaves as well as black indentured servants who were not slaves.[34] Therefore, in the early seventeenth century, a slave was not always an African or a person of African descent.

The law is also unclear as to whether slavery for blacks was a status for life or of limited duration. Alpert explains, "[p]robably 'slave' as a matter of law simply meant someone who was obligated to serve his master for life,"[35] but there were some cases where the status of slave was for a limited term. In 1653, the case of John Babtista, a "moore of Barbary," was brought before the provincial court. Babtista sued for his freedom, arguing that his owner, Simon Overzee, did not buy him for his lifetime. One may infer from the case that Babtista was likely black and moreover whites were not sold for a lifetime.[36] Further supporting this inference is the case of Charles Cabe in 1679, a black man, who argued that he had been purchased only for a 21-year term. Since he could not produce any witnesses to support his story, Cabe was declared a slave.[37]

In 1658, the intriguing case of Antonio demonstrates the as yet undetermined status of blacks in Maryland. Antonio was the first African slave to be mentioned by name in colonial records. He is described as a "Negro servant" during a court case against his owner, Simon Overzee. Antonio was first brought to St. Mary's for treatment of an infected hand. At some point, he became the property of Simon Overzee, a Dutch merchant. When he was healed, Antonio refused to work and was punished. Overzee beat him and poured hot lard over his back. He then hung Antonio against a building by his wrists; Antonio died before he was let down. Overzee was indicted for murder but acquitted because the punishment of Antonio was within the prescribed bounds of the law.[38]

Antonio's was not the only such case. Thirty years later in 1688, Richard and Susan Harris were brought before the court on charges in Somerset upon "a Suspition of their Shortning the daies of a Negroe girle Called Nan aged about 13 yeares who as slave to the said Richard harris dureing the Naturall Life of his said wife by violent ill & barbarous usage it being

reported aMong the Neighbors."[39] On November 13, the Harrises were formally acquitted. This case illustrates that whereas slavery was becoming a condition for life, slaves were not to be abused beyond the bounds of acceptable practice by law. This is different from later years when the death of a slave would be entirely unremarkable.

Despite certain protections as late as 1688, the 1699 "An Act relateing to Servants and Slaves" changed the nature of slavery and distinguished "Negros" from other groups. The law asserted that if a free woman married an enslaved man, the children of the union would follow the man's condition. Maryland law stipulated that "all Children now borne or hereafter to be borne of Such Negros or Slaves shall be Slaves dureing their Naturall lives."[40] Although the title of the law suggests that there are slaves who are not "negroes," it seems to imply that all "Negros" were slaves. The next phrase indicates that even at this late date, slavery was not solely a status for "Negros," but race-mixing was already strongly discouraged. "[A]ny white woman either free or Servant that shall Suffer herselfe to be begott with Child by a Negro or other Slave or ffree Negroe such woman so begott with Child as aforesaid if free shall become a Servant for and dureing the terme of Seaven Years."[41]

By 1715 slavery is codified as a heritable and permanent status. "And be itt alsoe Enacted by the Authority af[d] that all Negroes and other Slaves Already Imported or hereafter imported in this province and all Children now born or hereafter born of such Negroes and Slaves shall be Slaves dureing their naturall lives."[42] Furthermore, the law prohibits marriage between whites and slaves of color. "[B]e it further Eancted that all Ministers pastors and Magistrates or other person whatsoever who According to the Laws of this province doe Usually Joyne people in Maryage shall not upon any pretense Joyne in Maryage Any Negroe whatsoever or Molatto Slave with any white person."[43] In this case, race is designated.

Through the law, it is possible to see that as slavery developed, it moved gradually toward designating a status for "Negroes." De Sousa's status as a free man contrasted with Antonio's and Nan's deaths and the subsequent court cases exemplify the fluid and rapidly evolving status of blacks in early Chesapeake society. These histories also help demonstrate the transition from a mix of indentured servitude and slavery for Native and African peoples to the heritable enslavement designated exclusively for Africans and African Americans.

Research staff at HSMC will continue to work with historians and archaeologists to look for evidence of the beliefs and values that supported the transition from a society with slaves to a slave society. It might well be that the museum will pose a question in its exhibits rather than provide a succinct historical answer. It might be more productive to ask visitors, how was it possible for people to institutionalize slavery in a colony dedicated to equality? It is a question easily asked of the United States as a whole.

The important story here is that lifetime slavery for blacks did not arrive in America fully formed. The system of slavery in the Chesapeake was a product of the conditions, beliefs, and choices within an international web of politics, prejudice, colonization, and trade.

As Historic St. Mary's City moves forward with its exhibit planning, staff will turn to the community, specifically the descendants of slaves, to help tell the stories they want to share and hear. This will likely entail public meetings and discussions, blogs or wiki sites to share information, and opportunities for talking in smaller groups about the community's history. Many museums currently carry out programs which promote community history but the majority does not. As museums and their communities work through their own preconceptions and let go of the guilt and anger, anxiety and fearfulness, they come ever-closer to the goal of accepting the past for what it was and moving North Americans forward together.

ADDRESSING RACE IN THE TWENTY-FIRST CENTURY

Herein lies the power of the museum: to be a forum for discussing the past and helping communities, local and national, leave behind the ghosts of shame and silence that have haunted them. As Henry Louis Gates, Jr. explains, ignoring the history of slavery and race in the United States has not freed us from the past at all. We have behaved "as if silence about [slavery's] horrors—and its significance to American prosperity and the shaping of our institutions—would make it go away. But the past can't be ignored; it can only be processed, digested and represented, again and again."[44] For museums, as institutions of education in their communities, presenting and discussing the past as objectively and inclusively as possible can make all the difference.

Although some museums have made progress in incorporating African American history into their interpretation, Lonnie Bunch, founding director of the National Museum of African American History and Culture, cautions that "[f]ar too frequently, African American culture is segregated from the other more 'mainstream' stories that museums explore."[45] He sends out a challenge and raises the bar for museums. "What is missing is a new synthesis—a 'new integration'—that encourages visitors to see that exploring issues of race is essential to their understanding of American culture."[46] Museums can help people find the place and the words to talk about slavery and race. Exhibits are an excellent beginning. Programs, like the antiracism workshop at the Twain Museum, can help create dialogue in a safe environment. As Cindy Lovell explains, the museum wanted to host the workshop, "to reiterate to our local community—both black and white—that the museum is active in embracing the past while moving into the future. No doubt our country has come a long way since slave traders

auctioned human souls in this very town, but we recognize that we still have work to do."[47]

NOTES

1. James Oliver Horton and Lois E. Horton, "Introduction," in *Slavery and Public History: The Tough Stuff of American History*, ed. James Oliver Horton and Louis E. Horton (New York: New Press: 2006), vii.
2. Jennifer L. Eichstadt and Stephen Small, *Representations of Slavery: Race and Ideology in Southern Plantation Museums* (Washington, DC: Smithsonian Institution, 2002), 15.
3. Ira Berlin, *Many Thousands Gone: The First Two Centuries in American Slavery* (Cambridge, MA: Belknap Press of Harvard University Press, 1998).
4. Edward A. Chappell, "Social Responsibility and the American History Museum" *Winterthur Portfolio* 24 (1989): 248.
5. James Oliver Horton, "Slavery in American History," in *Slavery and Public History*, 53.
6. Shelley Fisher Fishkin, *Lighting Out for the Territory: Reflections on Mark Twain and American Culture* (New York: Oxford University Press, 1997).
7. Fishkin, *Lighting Out for the Territory*, 49.
8. Mark Twain, *Adventures of Huckleberry Finn* (London: Chatto & Windus, 1884).
9. In other articles, I discuss the story of the Huck Finn House in greater detail. See Regina Faden, "Changing Old Institutions: Race in the Mark Twain Museum," *Arkansas Review: A Journal of Delta Studies* (Spring 2009): 5–17; and Regina Faden "Presenting Mark Twain: Keeping the Edge Sharp," *The Mark Twain Annual* 6, no. 1 (2008): 23–30.
10. "'Huckleberry Finn' in Concord," *University of Virginia Library*, http://etext.virginia.edu/railton/huckfinn/nyherald.html.
11. Culture Shock: Huck Finn Teachers Guide, http://www.pbs.org/wgbh/cultureshock/teachers/huck/aboutbook.html.
12. Culture Shock: Huck Finn Teachers Guide.
13. "Most Frequently Challenged Authors of the 21st Century," *American Library Association*, http://www.ala.org/ala/issuesadvocacy/banned/frequentlychallenged/challengedauthors/index.cfm.
14. "Lesson Prompts Call for 'Huckleberry' Ban," *United Press International*, http://www.upi.com/Top_News/2007/10/31/Lesson-prompts-call-for-Huckleberry-ban/UPI-66841193869958/.
15. "Wash. Teacher Calls for 'Huck Finn' Ban" *United Press International*, January 19, 2009, http://www.upi.com/Top_News/2009/01/19/Wash-teacher-calls-for-Huck-Finn-ban/UP39901232395760.
16. Russell Smith, "The Legend of Mark Twain," *Mark Twain Forum* (1994), http://www.twainweb.net/filelist/legend.html.
17. Mark Twain, *King Leopold's Soliloquy* (Boston: P.R. Warren Co., 1905).
18. Alvin Powell, Fight over Huck Finn Continues: Ed School Professor Wages Battle for Twain Classic," *The Harvard University Gazette*, September 28, 2008, http://www.news.harvard.edu/gazette/2000/09.28/huckfinn.html.
19. Iris Ford, "The Anthropology of Miss Watson's Big Jim," *River Gazette* 10 (2010): 8.
20. Cindy Lovell, email message to author, November 2, 2010.
21. Lovell, email message to author, November 2, 2010.

22. "Mark Twain Museum to Sponsor Anti-Racism Workshop," October 1, 2010, http://www.marktwainmuseum.org/index.php/press-room/recent-press-releases?start=20.
23. Lovell, email message to author, November 2, 2010.
24. Lovell, email message to author, November 2, 2010.
25. Dana Forde, "Missouri Exhibit Recognizes Black Ancestors of 'Huck Finn' Era," June 2, 2008, http://diverseeducation.com/article/11230/.
26. Lovell, email message to author, March 2, 2010.
27. Ira Berlin, *Many Thousands Gone*, 8.
28. Julia A. King and Edward E. Chaney, "Passing for Black in Seventeenth Century Maryland," in *Interpreting the Early Modern World: Transatlantic Perspectives*, ed. Mary C. Beaudry and James Symonds (New York: Springer: 2011), 87–111.
29. Donald R. Wright, "Recent Literature on Slavery in Colonial North America," *OAH Magazine of History* 17 (2003): 5–9.
30. Allan Kulikoff, *Tobacco and Slaves: The Development of Southern Cultures in the Chesapeake, 1680–1800* (Chapel Hill, NC: University of North Carolina Press, 1986), 40.
31. Jonathan L. Alpert, "The Origin of Slavery in the United States—The Maryland Precedent," *The American Journal of Legal History* 14 (1970): 189–221.
32. King and Chaney, "Passing for Black in Seventeenth Century Maryland."
33. Alpert, "The Origin of Slavery in the United States."
34. Alpert, "The Origin of Slavery in the United States," 191.
35. Alpert, "The Origin of Slavery in the United States," 191.
36. See Winthrop D. Jordan, *White Over Black: American Attitudes Toward the Negro, 1550–1812* (Chapel Hill, NC: University of North Carolina Press, 1968), and Alpert, "The Origin of Slavery in the United States," 192.
37. Alpert, "The Origin of Slavery in the United States," 192.
38. Maryland State Archives, vol. 41, 205. Proceedings of the Provincial Court, 1658–1662, http://aomol.net/000001/000041/html/am41—205.html.
39. Maryland State Archives, vol. 91, 86. Proceedings of the General Assembly March 1697/8–July 1699, http://aomol.net/000001.00001/html/am91–86.html.
40. Maryland State Archives, vol. 22, 552. Proceedings of the General Assembly March 1697/8–July 1699, http://aomol.net/000001/000022/html/am22—552.html.
41. Maryland State Archives, vol. 22, 552. Proceedings of the General Assembly March 1697/8–July 1699.
42. Maryland State Archives, vol. 30, 289. Proceedings and Acts of the General Assembly, April 26, 1715–August 10, 1716, http://aomol.net/000001/000030/html/am30—289.html.
43. Maryland State Archives, vol. 30, 289. Proceedings and Acts of the General Assembly, April 26, 1715–August 10, 1716, http://aomol.net/000001/000030/html/am30—289.html.
44. Henry Louis Gates Jr., "Not Gone with the Wind: Voices of Slavery," *The New York Times*, February 9, 2003, http://query.nytimes.com/gst/fullpage.html?res=9C00E1D61E38F93AA35751C0A9659C8B63.
45. Lonnie Bunch, "Embracing Ambiguity: The Challenge of Interpreting African American History in Museums," *Museums & Social Issues* 2, no. 1 (2007): 54.
46. Bunch, "Embracing Ambiguity," 54.
47. Lovell, email message to author, November 2, 2010.

Contributors

Ana Lucia Araujo is an associate professor in the Department of History at Howard University. She published *Romantisme tropical: l'aventure illustrée d'un peintre français au Brésil* (2008) and *Public Memory of Slavery: Victims and Perpetrators in the South Atlantic Laval* (2010). She also edited *Living History: Encountering the Memory of the Heirs of Slavery* (2009) and *Paths of the Atlantic Slave Trade: Interactions, Identities, and Images* (2011). In addition she coedited *Crossing Memories: Slavery and African Diaspora* (2011).

Renée Ater is an associate professor in the Department of Art History and Archaeology at the University of Maryland. Her scholarship and teaching focus on American art of the nineteenth and twentieth centuries. Ater was awarded a 2004–05 National Endowment for Humanities Fellowship for University Teachers and a 2006 General Research Board Summer Research Award from the Graduate School of the University of Maryland for her book, *Remaking Race and History: The Sculpture of Meta Warrick Fuller* (2011). Her next book project is entitled *Unsettling Memory: Public Monuments to Slavery in the United States*.

Alice Bellagamba is an associate professor of political anthropology and African studies at the University of Milan-Bicocca. She has been carrying out fieldwork in The Gambia and neighboring Senegalese regions since 1992, and currently she is completing a research project based on oral and archival sources on slavery and its aftermath in colonial Gambia.

Richard Benjamin gained a degree in community and race relations at Edge Hill College and then went on to complete an MA and a PhD in archaeology at the University of Liverpool. He was a visiting research scholar at the W.E.B. DuBois Institute of African and African American Research, Harvard University, in 2002 and was appointed as head of the International Slavery Museum in 2006.

Mathieu Claveyrolas is a research associate at the CNRS (Centre National de la Recherche Scientifique, France) and a member of the CEIAS (Centre

d'études de l'Inde et de l'Asie du sud). As an anthropologist, he focused his first field researches on India and Hinduism and has published books and articles on Hindu temples and on the interactions of patrimonial constructions, nationalism, and religion, including *Quand le temple prend vie* (2003) and "Les temples de Mère Inde, musées de la nation" *Gradhiva* (2008). He recently conducted long-term fieldwork in Mauritius on the relations between Indianness and Creoleness.

Kimberly Cleveland is an assistant professor of art history in the Welch School of Art & Design at Georgia State University (Atlanta, GA). She is interested in examining questions of race, identity, and artistic production in modern and contemporary Afro-Brazilian art. She has published in the *Journal of Black Studies* and authored the essay, "Kehinde Wiley's Brazil: The Past against the Future," for the exhibition catalog *Kehinde Wiley: The World Stage; Brazil* (2009).

Geoffrey Cubitt is a senior lecturer in history at the University of York, UK. He is the author of *The Jesuit Myth: Conspiracy Theory and Politics in Nineteenth-Century France* (1993) and *History and Memory* (2007). He edited *Imagining Nations* (1998) and coedited *Heroic Reputations and Exemplary Lives* (2000) and *Representing Enslavement and Abolition in Museums: Ambiguous Engagements* (2011). He was coinvestigator on the "1807 Commemorated" project, which analyzed responses to the Bicentenary of the 1807 Act of Abolition in British museums.

Regina Faden received a PhD in American studies from Saint Louis University. She joined Historic St. Mary's City (HSMC) as executive director in October 2008. At HSMC Faden has been engaged with fundraising, research, and developing new program and marketing initiatives. Previously Regina served as executive director of the Mark Twain Boyhood Home & Museum in Hannibal, Missouri, from 2004 to 2008 where she helped created its successful series of Teachers Workshops. For the past fifteen years, Faden has taught Museum Studies, American Literature and History at such schools as Boston College, St. Louis University, and St. Mary's College of Maryland.

Renaud Hourcade is a PhD candidate and teaching assistant in political science at Sciences Po Rennes (France). A member of the Centre de Recherches sur l'Action Publique en Europe, he was also a visiting fellow with the Centre for the Study of International Slavery, University of Liverpool. His doctoral thesis proposes a comparative perspective on the politics of memory developed in the former slave trade cities of Nantes, Bordeaux, and Liverpool. His research and publication topics include local and national public policies of memory, race relations, and the production of local identity.

Kathleen Hulser is a public historian, senior history curator, and education curator at the New-York Historical Society (N-YHS). She worked on the curatorial teams for *Slavery in New York* and *New York Divided*, and was a cocurator of *Legacies: Contemporary Artists Reflect on Slavery*. Hulser has also curated numerous other major history exhibitions, including *Grant and Lee in War and Peace* and *The Rosenbergs Reconsidered: The Death Penalty in the Cold War Era*. In addition, she is an adjunct professor at the New School (New York) and the New York University.

Margot Minardi is an assistant professor of history and humanities at Reed College in Portland, Oregon. A historian of social reform movements in eighteenth- and nineteenth-century North America, she is the author of *Making Slavery History: Abolitionism and the Politics of Memory in Massachusetts* (2010). Her current work explores the development of national and cosmopolitan allegiances in the context of the nineteenth-century pacifist movement in the United States and the broader Atlantic world.

Francine Saillant is a professor in the Department of Anthropology at Université Laval (Canada) and director of CELAT (Centre de recherches sur les lettres, les arts et les traditions). Her research interests are human rights, reparations of slavery in Brazil, and Afro-Brazilian culture. She is the author of numerous articles and book chapters. Her book *Identités et Handicaps* (2007) examines Brazilian NGOs and their approach of handicap through cultural initiatives. She also coedited *Pour une Anthropologie non-hégémonique: Le manifeste de Lausanne* (2011). With Pedro Simonard she directed three documentary films about the memory of slavery in the Candomblé, including *Axé dignidade* (2010).

Nelly Schmidt is a professor and research director at the CNRS (Centre National de la Recherche Scientifique, France) at the University of Paris IV-Sorbonne. She is a member of the International Scientific Committee of The Slave Route Project, UNESCO, and the author of several books about Victor Schœlcher and French and international abolitionist movements, including *Victor Schœlcher* (1994), *L'engrenage de la liberté—Caraïbes, XIXe siècle* (1995), *Abolitionnistes de l'esclavage et réformateurs des colonies* (2000), and *L'abolition de l'esclavage: Cinq siècles de combats, XVIe–XXe siècles* (2005). She also edited *La France a-t-elle aboli l'esclavage? 1830–1935* (2009).

Pedro Simonard received a PhD in social sciences from the Universidade do Estado do Rio de Janeiro. He was postdoctoral fellow of CELAT (Centre de recherches sur les lettres, les arts et les traditions) at Université Laval (Canada) between 2008 and 2010. His research deals with the renewal

of jongo in the state of Rio de Janeiro in Brazil. She directed several documentary films, including *Salve jongo* (2005) and *Eu venho de longe* (2010).

Quito Swan is an associate professor of African diaspora history at Howard University. He currently teaches courses on the global African diaspora. His primary research interests include international black protest movements, Black Power as an international phenomenon, marronage, and African resistance to slavery, Garveyism, diasporic protest music, Pan-Africanism, and sociocultural movements in the modern African Diaspora. He is faculty advisor of *Cimarrones*, a student organization at Howard that builds relationships with African descended communities across the Americas. His first book, *Black Power in Bermuda and the Struggle for Decolonization*, was published in 2009.

Bibliography

Abreu, Mauricio de A. *Evolução urbana do Rio de Janeiro*. Rio de Janeiro: IPP-Instituto Municipal de Urbanismo Pereira Passos, 2008.
Alberti, Verena, and Amilcar Araujo, eds. *Histórias do movimento negro no Brasil: Histórias do movimento negro no Brasil: Depoimentos ao CPDOC*. Rio de Janeiro: Pallas Editora, 2007.
Alexander, Leslie M. *African or American? Black Identity and Political Activism in New York City, 1784–1861*. Urbana, IL: University of Illinois Press, 2008.
Allen, James, Hilton Als, John Lewis, and Leon F. Litwack. *Without Sanctuary: Lynching Photography in America*. Santa Fe, NM: Twin Palms, 2000.
Allen, Richard. "Licentious and Unbridled Proceedings: The Illegal Slave Trade to Mauritius and the Seychelles during the Early Nineteenth Century." *Journal of African History* 42 (2001): 91–117.
Allen, Richard. *Slaves, Freedmen and Indentured Laborers in Colonial Mauritius*. Cambridge: Cambridge University Press, 1999.
Allison, David K., and Tom Gwaltney. "How People Use Electronic Interactives: Information Age—People, Information & Technology." In *Hypermedia & Interactivity in Museums: Proceedings of an International Conference*, edited by David Bearman, 62–73. Pittsburgh: Archives & Museum Informatics, 1991.
Alpert, Jonathan L. "The Origin of Slavery in the United States—The Maryland Precedent." *The American Journal of Legal History* 14 (July 1970): 189–221.
Andrews, George Reid. *Blacks and Whites in São Paulo, Brazil, 1888–1988*. Madison, WI: University of Wisconsin Press, 1991.
Aparecida, Quintão Antonia. *Lá vem o meu parente: As irmandades de pretos e pardos no Rio de Janeiro e em Pernambuco (século XVIII)*. São Paulo: Annablume Editora, 2002.
Appanah, Nathacha. *Les Rochers de Poudre d'Or*. Paris: Folio, 2003.
Araujo, Ana Lucia. "Caminhos atlânticos: memória e representações da escravidão nos monumentos e memoriais da Rota dos escravos." *Varia História* 25, no. 41 (2009): 129–148.
Araujo, Ana Lucia. "De victime à résistant: mémoires et représentations de l'esclavage dans les monuments publics de la Route des esclaves." *Les Cahiers des Anneaux de la Mémoire* 12 (2009): 84–102.
Araujo, Ana Lucia "Enjeux politiques de la mémoire de l'esclavage dans l'Atlantique Sud: La reconstruction de la biographie de Francisco Félix de Souza." *Lusotopie* XVI, no. 2 (2009): 107–131.
Araujo, Ana Lucia. *Public Memory of Slavery: Victims and Perpetrators in the South Atlantic*. Amherst, NY: Cambria Press, 2010.
Araujo, Ana Lucia. "Renouer avec le passé brésilien: la reconstruction du patrimoine post-traumatique chez la famille De Souza au Bénin." In *Traumatisme*

collectif pour patrimoine : regards croisés, edited by Vincent Auzas and Bogumil Jewsiewicki, 305–330. Québec: Presses de l'Université Laval, 2008.

Araujo, Ana Lucia. "Slavery, Royalty and Racism: Representations of Africa in Brazilian Carnaval." *Ethnologies* 31, no. 2 (2010): 131–167.

Araujo, Ana Lucia. "Welcome the Diaspora: Slave Trade Heritage Tourism and the Public Memory of Slavery." *Ethnologies* 33 no. 1 (2011): 145–178.

Araújo, Emanoel. "Museu AfroBrasil: Um conceito em perspectiva." In *Museu AfroBrasil: Um conceito em perspectiva*. São Paulo: Museu AfroBrasil, 2006.

Araújo, Emanoel. "The Museu AfroBrasil in São Paulo: A New Museum Concept." In *The Global Art World: Audiences, Markets, and Museums*, edited by Hans Belting, Andrea Buddensieg, and Emanoel Araújo, 180–188. Ostfildern: Hatje Cantz, 2009.

Archibald, Robert R. *The New Town Square: Museums and Communities in Transition*. Lanham, MD: Alta Mira Press, 2004.

Assemblée nationale. *Cent cinquantenaire de la Révolution de 1848 Actes du colloque de la Société d'histoire de la Révolution de 1848 et des révolutions du XIXe siècle*. Paris: Créaphis, 2002.

Assemblée Nationale (France). Société d'Histoire de la Révolution de 1848 et des Révolutions du XIXe siècle (Paris). *Cent cinquantenaire de la révolution de 1848: Colloque international organisé par la Société d'histoire de la révolution de 1848 et des révolutions du XIXe siècle*. Paris: Assemblée Nationale, 1998.

Auzas, Vincent, and Bogumil Jewsiewicki, eds. *Traumatisme collectif pour patrimoine : regards croisés sur un mouvement transnational*. Québec: Presses de l'Université Laval, 2008.

Bailey, C. Anne. *African Voices of the Atlantic Slave Trade: Beyond the Silence and The Shame*. Boston, MA: Beacon Press, 2005.

Bako-Arifari, Nassirou. "La Mémoire de la traite négrière dans le débat politique au Bénin dans les années 1990." *Journal des Africanistes* 70, nos. 1–2 (2000): 221–231.

Ball, Edward. *Slaves in the Family*. New York: Ballantine Press, 1998.

Bandeira, Alexandre. "O Museu de Emanoel." *Raiz: Cultura do Brasil*, no. 3 (2005): 74–77.

Barreiro-Meiro, Roberto. *Las Islas Bermudas y Juan Bermudez*. Madrid: Instituto Histórico de Marina, 1970.

Barry, Boubacar. *Senegambia and the Atlantic Slave Trade*. Cambridge: Cambridge University Press, 1998.

Baude, Pierre. *Centenaire de l'abolition de l'esclavage dans les colonies françaises et la Seconde République française, 1848–1948: L'affranchissement des esclaves aux Antilles françaises, principalement à la Martinique*. Fort-de-France: Imprimerie Officielle, 1948.

Bazin, Jean. "La production d'un récit historique." *Cahiers d'études africaines* XIX, 73–76, nos. 1–4 (1979): 435–585.

Becker, Howard. *Outsiders*. Paris: Métailié, 1985.

Beech, John. "The Marketing of Slavery Heritage in the United Kingdom." In *Slavery, Contested Heritage, and Thanatourism*, edited by Graham Dann and A.V. Seaton, 85–105. New York: Haworth Press, 2001.

Bellagamba, Alice. "Back to the Land of Roots: African American Tourism and the Cultural Heritage of the River Gambia." *Cahiers d'études africaines* XLIX, 1–2, nos. 193–194 (2009): 453–476.

Bellagamba, Alice. "After Abolition: Metaphors of Slavery in the Political History of the Gambia." In *Reconfiguring Slavery: West African Trajectories*, edited by Benedetta Rossi, 63–84. Liverpool: Liverpool University Press, 2009.

Bellagamba, Alice. "'The Little Things that Would Please Your Heart . . .': Enslavement and Slavery in the Narrative of Al Hahh Bakoyo Suso (The Gambia)." In

African Voices on Slavery and the Slave Trade, edited by Alice Bellagamba, Sandra Greene, and Martin Klein. New York: Cambridge University Press, forthcoming.

Bellagamba, Alice. "Slavery and Emancipation in the Colonial Archives: British Officials, Slave Owners, and Slaves in the Protectorate of the Gambia (1890–1936)." *Canadian Journal of African Studies* 39, no. 1 (2005): 5–41.

Benedict, Burton. *Indians in a Plural Society: A Report on Mauritius*. London: Her Majesty's Stationery Office, 1961.

Benoist, Jean. "De l'Inde à Maurice et de Maurice à l'Inde, ou la réincarnation d'une société." *Carbet* 9 (1989): 185–201.

Berlin, Ira. "Coming to Terms with Slavery in Twenty-First-Century America." In *Slavery and Public History: The Tough Stuff of American Memory*, edited by James Oliver Horton and Lois E. Horton, 1–17. New York: New Press, 2006.

Berlin, Ira. "Coming to Terms with Slavery in the Twenty-First Century," in *Slavery and Public History: The Tough Stuff of American Memory*, ed. James Oliver Horton and Lois E. Horton, 1–17. Chapel Hill, NC: University of North Carolina Press, 2008.

Berlin, Ira. *Many Thousands Gone: The First Two Centuries of Slavery in North America*. Cambridge, MA: Belknap Press of Harvard University Press, 1998.

Berlin, Ira, and Leslie M. Harris, eds. *Slavery in New York*. New York: The New Press, 2005.

Berliner, David. "An 'Impossible' Transmission: Youth Religious Memories in Guinea-Conakry." *American Ethnologist* 32 (2005): 576–592.

Bernabé, Jean, Patrick Chamoiseau, and Raphaël Confiant. *Éloge de la créolité*. Paris: Gallimard, 1989.

Bernhard, Virginia. *Slaves and Slaveholders in Bermuda, 1616–1782*. Columbia, MO: University of Misssouri Press, 1999.

Bernier, Celeste-Marie. "'Speculation and the Imagination': History, Story-Telling and the Body in Godfried Donkor's 'Financial Times' (2007)." *Slavery and Abolition* 29, no. 2 (2008): 203–217.

Bernier, Celeste-Marie, and Judie Newman. "Public Art, Artefacts and Atlantic Slavery: Introduction." *Slavery and Abolition* 29, no. 2 (2008): 135–150.

Bicentenary of the Abolition of the Slave Trade Act, 1807–2007. London: Department for Communities and Local Government, 2007.

Blackmar, Elizabeth, and Roy Rosenzweig. *The Park and the People: A History of Central Park*. Ithaca, NY: Cornell University Press, 1991.

Blight, David W. "If You Don't Tell It Like It Was, It Can Never Be as It Ought to Be." In *Slavery and Public History: The Tough Stuff of American Memory*, edited by James Oliver Horton and Lois E. Horton, 19–34. New York: New Press, 2006.

Blight, David. *A Slave No More: Two Men who Escaped to Freedom, Including Their Own Narratives*. New York: Houghton Mifflin, 2007.

Blight, David, Anna Mae Duane, Thomas Thurston, and James O. Horton. *"Hope is the First Great Blessing:" Leaves from the African Free School Presentation Book, 1812–1826*. New York: New-York Historical Society, 2008.

Bodnar, John. *Remaking America: Public Memory, Commemoration, and Patriotism in the Twentieth Century*. Princeton, NJ: Princeton University Press, 1992.

Bogat, Raoul. "Commémoration du Centenaire de l'abolition de l'esclavage." Lecture given on April 27, 1948, Basse-Terre, in Guadeloupe. Basse-Terre: Imprimerie officielle, 1949.

Bolden, Tonya. *Maritcha: A Nineteenth-Century American Girl*. New York: Harry Abrams, 2005.

Bonder, Julian. "On Memory, Trauma, Public Space, Monuments, and Memorials." *Places: Forum of Design for the Public Realm* 21, no. 1 (May 2009): 62–69.

Bonniol, Jean-Luc. "Echos politiques de l'esclavage colonial, des départements d'outre-mer au cœur de l'État." In *Politiques du passé: Usages du passé dans la France contemporaine,* edited by Claire Andrieu, Marie-Claire Lavabre, and Danielle Tartakowsky, 59–69. Aix-en-Provence: Publications de l'Université de Provence, 2006.

Booth, James. *Communities of Memory: On Witness, Identity and Justice.* New York: Cornell University Press, 2006.

Booth, James. "The Unforgotten: Memories of Justice." *American Political Science Review* 95, no. 4 (2001): 779–791.

Boswell, Rosabelle. *Le Malaise Créole: Ethnic Identity in Mauritius.* New York: Berghahn Books, 2006.

Bouchet, Ghislaine. Archives Départementales de Guadeloupe et al. *1848: une aube de liberté: l'abolition de l'esclavage à la Guadeloupe: Archives départementales, Bisdary-Gourbeyre, 27 avril–28 juin 1998: catalogue de l'exposition.* Basse-Terre: Direction des Archives départementales de la Guadeloupe, 1998.

Boudet, Catherine, and Julie Peghini. "Les enjeux politiques de la mémoire du passé colonial à l'île Maurice." *Transcontinentales* 6 (2008): 13–36.

Boym, Svetlana. *The Future of Nostalgia.* New York: Basic Books, 2001.

Breen, T. H. "Making History: The Force of Public Opinion and the Last Years of Slavery in Revolutionary Massachusetts." In *Through a Glass Darkly: Reflections on Personal Identity in Early America,* edited by Ronald Hoffman, Mechal Sobel, and Fredrika J. Teute, 67–95. Chapel Hill, NC: University of North Carolina Press, 1997.

Bulletin d'information et de documentation du Comité français de la Libération Nationale. Algiers, May 30–July 3, 1943.

Bunch, Lonnie. "Embracing Ambiguity: The Challenge of Interpreting African American History in Museums," *Museums & Social Issues* 2, no. 1 (2007): 45–56.

Burchall, Colwyn. *Freedom's Flames: Slavery in Bermuda and the True Story of Sally Bassett.* Hamilton: Mazi Publications, 2010.

Burton, Richard D. E. "Vichyisme et vichyistes à la Martinique." *Cahiers du Cerag,* no. 34 (1978): 1–107.

Candido, Mariana P. *Fronteras de Esclavización: Esclavitud, Comercio e Identidade en Benguela, 1780–1850.* México: El Colégio de Mexico, 2011.

Carbonell, Bettina M. "The Afterlife of Lynching: Exhibitions and the Re-composition of Human Suffering." *Mississippi Quarterly,* 2008, 197–215.

Carbonell, Bettina M. "The Syntax of Objects and the Representation of History: Speaking of *Slavery in New York.*" *History and Theory,* no. 47 (2009): 122–137.

Cardoso, Carlos Alberto Lopes. "Dona Ana Joaquina dos Santos Silva Industrial Angolana da Segunda Metade do Século XIX." *Boletim Cultural da Câmara Municipal de Luanda* 37 (1972): 4–14.

Carlisle, Nancy. *Cherished Possessions: A New England Legacy.* Boston, MA: Society for the Preservation of New England Antiquities, 2003.

Carmignani, Sandra. "Une montagne en jeu: figures identitaires créoles et patrimoine à Maurice." *Journal des Anthropologues* 104 (2006): 265–286.

Carrithers, Michael. "Anthropology as a Moral Science of Possibilities." *Current Anthropology* 46, no. 3 (2005): 433–456.

Carter, Marina. *Servants, Sirdars and Settlers. Indians in Mauritius, 1834–1874.* Delhi: Oxford University Press, 1995.

Carter, Marina, and Torabully, Khal. *Coolitude: An Anthology of the Indian Labour Diaspora.* London: Anthem Press, 2002.

Castillo, Lisa Earl. "Between Memory, Myth and History: Transatlantic Voyagers of the Casa Branca Temple (Bahia, Brazil, 1800s)." In *Paths of the Atlantic*

Slave Trade: Interactions, Identities, and Images, edited by Ana Lucia Araujo, 203–238. Amherst, NY: Cambria Press, 2011.

Célius, Carlo Avierl. "L'esclavage au musée: récit d'un refoulement." *L'Homme* 145 (1998): 249–261.

Césaire, Aimé. "Hommage à Victor Schœlcher (I)." *Tropiques* (1945): 229–235.

Chan Low, Jocelyn. "Une perspective historique du processus de construction identitaire à l'île Maurice." In *Interethnicité et Interculturalité à l'île Maurice*, edited by Yu-Sion Live and Jean-François Hamon, 13–26. Île de la Réunion: Kabaro, 2008.

Chan Low, Jocelyn. "Les enjeux actuels des débats sur la mémoire et la réparation pour l'esclavage à l'île Maurice." *Cahiers d'études africaines* 44, nos. 173–174 (2004): 401–418.

Chapman, Malcom, ed. *Edwin Ardener: The Voice of Prophecy and Other Essays*. Oxford: Basil Blackwell, 1989.

Chappell, Edward A. "Social Responsibility and the American History Museum." *Winterthur Portfolio* 24 (1989): 247–265.

Charlton, John. *Hidden Chains: The Slavery Business and North East England, 1600–1865*. Newcastle: Tyne Bridge, 2008.

Charlton, John. *Remembering Slavery 2007: A Brief Guide to the Archive Mapping and Research Project*. Newcastle: Literary and Philosophical Society, 2007.

Charmet, Auguste. "Césaire et le Parti progressiste martiniquais: le nationalisme progressiste." *Nouvelle Optique, Recherches haïtiennes et caraïbéennes* 1, no. 2 (1971): 57–84.

Chatwin, Bruce. *The Vice-Roy of Ouidah*. London: Jonathan Cape, 1980.

Chaban-Delmas, Jacques. "Préface." *Bordeaux, le rhum et les Antilles*. Bordeaux: Musée d'Aquitaine, 1991, 5.

Chazan, Suzanne, and Ramhota, Pavitranand. *L'hindouisme mauricien dans la mondialisation*. Paris, Karthala, 2009.

Chazan, Suzanne, and Widmer, Isabelle. "Circulation migratoire et délocalisations industrielles à l'île Maurice." *Sociétés contemporaines* 43 (2001): 81–120.

Chivallon, Christine. "Bristol and the Eruption of Memory: Making the Slave-Trading Past Visible." *Social and Cultural Geography* 2, no. 3 (2001): 347–363.

Chivallon, Christine. "Construction d'une mémoire relative à l'esclavage et instrumentalisation politique: le cas des anciens ports négriers de Bordeaux et Bristol." *Cahier des Anneaux de la Mémoire* 4 (2002): 177–203.

Chivallon, Christine. "L'émergence récente de la mémoire de l'esclavage dans l'espace public: enjeux et significations." *Revue d'histoire moderne et contemporaine* 52, no. 4 (2005): 54–81.

Chivallon, Christine. "Mémoires antillaises de l'esclavage." *Ethnologie française* 32, no. 4 (2002): 601–612.

Chivallon, Christine. "Mémoires de l'esclavage à la Martinique." *Cahiers d'études africaines* 1, no. 197 (2010): 235–261.

Chivallon, Christine. "Resurgence of the Memory of Slavery in France: Issues and Significations of a Public and Academic Debate." In *Living History: Encountering the Memory of the Heirs of Slavery*, edited by Ana Lucia Araujo, 83–97. Newcastle: Cambridge Scholars Publishing, 2009.

Ciarcia, Gaetano. "Restaurer le Futur: Sur la Route de l'Esclave à Ouidah (Bénin)." *Cahiers d'études africaines* 192, no. 4 (2008): 687–706.

Claveyrolas, Mathieu. "L'ancrage de l'hindouisme dans le paysage mauricien: transfert et appropriation." *Autrepart* 4, no. 56 (2010): 17–37.

Cobra Verde. DVD. Directed by Werner Herzog. West Germany, 1987.

Colley, Linda. *Britons: Forging the Nation, 1707–1837*. New Haven, CT: Yale University Press, 2005.

Comité pour la mémoire de l'esclavage. *Mémoires de la traite négrière, de l'esclavage et de leurs abolitions.* Paris: La Découverte, 2005.

Connerton, Paul. *How Societies Remember.* New York: Cambridge University Press, 1989.

Constant, Fred. "La politique française de l'immigration antillaise de 1946 à 1987." *Revue européenne des migrations internationales* 3, no. 3 (1987): 9–30.

Cooper, Frederick. "Introduction." In *Beyond Slavery: Explorations of Race, Labor, and Citizenship in Postemancipation Societies*, edited by Frederick Cooper, Thomas C. Holt, and Rebecca J. Scott, 1–32. Chapel Hill, NC, and London: University of North Carolina Press, 2000.

Costa e Silva, Alberto da. *Francisco Félix de Souza, mercador de escravos.* Rio de Janeiro: Nova Fronteira, 2004.

Costello, Ray. *Black Liverpool: The Early History of Britain's Oldest Black Community, 1730–1918.* Liverpool: Picton Press, 2001.

Cottias, Myriam. "L'oubli du passé contre la citoyenneté: troc est ressentiment à la Martinique (1848–1946)." In *1946–1996: Cinquante ans de départementalisation outre-mer*, edited by Fred Constant and Justin Daniel, 293–313. Paris: Harmattan, 1997.

Cubitt, Geoffrey. "Atrocity Materials and the Representation of Transatlantic Slavery: Problems, Strategies and Reactions." In *Representing Enslavement and Abolition in Museums*, edited by Laurajane Smith, Geoffrey Cubitt, Kalliopi Fouseki, and Ross Wilson, 237–240. New York: Routledge, 2011.

Cubitt, Geoffrey. "Bringing It Home: Making Local Meaning in 2007 Bicentenary Exhibitions." *Slavery and Abolition* 30, no. 2 (2009): 259–275.

Cubitt, Geoffrey. "Lines of Resistance: Evoking and Configuring the Theme of Resistance in Museum Displays in Britain around the Bicentenary of 1807." *Museum and Society* 8, no. 3 (2010): 143–164.

Cubitt, Geoff, Laurajane Smith, and Ross Wilson. "Introduction: Anxiety and Ambiguity in the Representation of Dissonant History." In *Representing Enslavement and Abolition in Museums*, edited by Laurajane Smith, Geoffrey Cubitt, Kalliopi Fouseki, and Ross Wilson, 1–19. New York: Routledge, 2011.

D'Adesky, Jacques. *Pluralismo Étnico e Multiculturalsmo: Racismos e Anti-racismos no Brasil.* Rio de Janeiro: Pallas, 2005.

David, Philippe. *Les navétanes: histoire des migrants saisonniers de l'arachide en Sénégambie des origines à nos jours.* Dakar: Nouvelles Editions Africaines, 1980.

Davies, Peter N. *The Trade Makers: Elder Dempster in West Africa, 1852–1972.* London: George Allen & Unwin, 1973.

Davison, Patricia. "Museums and the Reshaping of Memory." In *Negotiating the Past: The Making of Memory in South Africa*, edited by Sarah Nuttall and Carli Coetzee, 143–160. Cape Town: Oxford University Press, 1998.

Decoudun-Gallimard, Frédérique, ed. *Île de La Réunion, regards croisés sur l'esclavage: 1794–1848: Musée Léon-Dierx à Saint-Denis de La Réunion du 13 novembre 1998 au 25 avril 1999.* Paris: Somogy, 1998.

Diawara, Mamadou. *L'empire du verbe et l'éloquence du silence.* Cologne: Rüdiger Köppe Verlag, 2003.

Dodson, Howard, Christopher Paul Moore, and Roberta Yancy. *The Black New Yorkers: The Schomburg Illustrated Chronology.* New York: John Wiley, 2000.

Doezema, Marianne, and June Hargrove. *The Public Monument and its Audience.* Cleveland, OH: Cleveland Museum of Art, 1977.

Dorigny, Marcel, ed. *Esclavage, résistance et abolitions: Actes du 123e congrès des sociétés historiques et scientifiques, Fort-de-France, avril 1998.* Paris: Éditions du CTHS, 1999.

Dorigny, Marcel, ed. *Les abolitions de l'esclavage: de L. F. Sonthonax à V. Schoelcher: 1793, 1794, 1848*. Saint-Denis: Presses Universitaires de Vincennes and UNESCO, 1995.
Dorigny, Marcel, and Yves Bénot, eds. *Rétablissement de l'esclavage dans les colonies françaises: 1802, aux origines d'Haïti*. Paris: Maisonneuve et Larose, 2003.
Dresser, Madge. "Remembering Slavery and Abolition in Bristol." *Slavery and Abolition* 30, no. 2 (2009): 223–246.
Dresser, Madge. "Set in Stone? Statues and Slavery in London." *History Workshop Journal* 64, no. 1 (2007): 162–199.
Dubois, Laurent. *A Colony of Citizens: Revolution and Slave Emancipation in the French Caribbean, 1787–1804*. Chapel Hill, NC: University of North Carolina Press, 2004.
Dubois, Laurent. *Les esclaves de la République: l'histoire oubliée de la première émancipation (1789–1794)*. Paris: Calmann-Lévy, 1998.
Duncan, John. *Travels in Western Africa in 1845 & 1846: Comprising a Journey from Whydah, through the Kingdom of Dahomey, to Adofoodia in the Interior*, vol. 1. London: Frank Cass, 1968 [1847].
Early, Gerald. "Adventures in the Colored Museum: Afrocentrism, Memory, and the Construction of Race." *American Anthropologist* 100 (1998): 703–711.
Eichstadt, Jennifer L. and Stephen Small, *Representations of Slavery: Race and Ideology in Southern Plantation Museums*. Washington, DC: Smithsonian Institution, 2002.
Eisenlohr, Patrick. *Little India: Diaspora, Time, and Ethnolinguistic Belonging in Hindu Mauritius*. Berkeley, CA: University of California Press, 2006.
Esclavage: Le devoir de mémoire, l'impératif de vigilance. Paris: Sénat, 1998.
Faden, Regina. "Changing Old Institutions: Race in the Mark Twain Museum." *Arkansas Review: A Journal of Delta Studies* (Spring 2009): 5–17.
Faden, Regina. "Presenting Mark Twain: Keeping the Edge Sharp." *The Mark Twain Annual* 6, no. 1 (2008): 23–30.
Fanon, Frantz. *Peau noire, masques blancs*. Paris: Le Seuil, 1952.
Fick, Carolyn E. *The Making of Haiti: The Saint Domingue Revolution From Below*. Knoxville, TN: University of Tennessee Press, 1990.
Fisher-Blanchet, Inez. "L'affaire Sénécal en Guadeloupe, 1848–1851." *Cimarrons* I, 1981, 93–111.
Fishkin, Shelley Fisher. *Lighting Out for the Territory: Reflections on Mark Twain and American Culture*. New York: Oxford University Press, 1997.
Fitts, Robert K. *Inventing New England's Slave Paradise: Master/Slave Relations in Eighteenth-Century Narragansett, Rhode Island*. New York: Garland, 1998.
Fleming, David. "Liverpool: European Capital of the Transatlantic Slave Trade." Paper presented at the annual conference of International Association of City Museums, Amsterdam, November 3, 2005.
Foner, Eric. *Who Owns History? Rethinking the Past in a Changing World*. New York: Hill and Wang, 2002.
Foote, Thelma Wills. *Black and White Manhattan: The History of Racial Formation in Colonial New York City*. New York: Oxford University Press, 2004.
Forbes, Frederick E. *Dahomey and the Dahomans: Being the Journals of Two Missions to the King of Dahomey and Residence at his Capital in the Years 1849 and 1850*, vol. 1. London: Frank Cass. 1966 [1851].
Forte, Jung Ran. "'Marketing Vodun': Cultural Tourism and Dreams of Sucesss in Contemporary Benin." *Cahiers d'études africaines*, 193–194 (1–2): 429–452.
Fouseki, Kalliopi. "'Community Voices, Curatorial Choices': Community Consultation for the 1807 Exhibitions." *Museum and Society* 8, no. 3 (2010): 180–192.

Freyre, Gilberto. *Maîtres et esclaves, la formation de la société brésilienne*. Paris: Plon, 1974.
Freyre, Gilberto. *Casa-grande e senzala : a formação da família brasileira sob o regime patriarcal*. Rio de Janeiro : Livraria J. Olimpio, 1933.
Freyre, Gilberto. *The Masters and the Slaves : A Study in the Development of Brazilian Civilization*. New York: Knopf, 1946.
Gaibazzi, Paolo. "Two Soninke 'Slave' Descendants and Their Family Biographies." In *African Voices on Slavery and the Slave Trade*, edited by Alice Bellagamba, Sandra Greene, Martin Klein. New York: Cambridge University Press, forthcoming.
Gamble, David. *Economic Conditions in Two Mandinka Villages. Kerewan and Keneba (Gambia)*. London: Her Majesty's Stationary Office, 1953.
Geggus, David, ed. *The Impact of the Haitian Revolution in the Atlantic World*. Columbia, SC: University of South Carolina Press, 2001.
Genovese, Eugene D. *Roll Jordan Roll: The World the Slaves Made*. New York: Pantheon Books, 1974.
Gifford, Anthony, Wally Brown, and Ruth Bundey. *Loosen The Shackles: First Report of the Liverpool 8 Inquiry into Race Relations in Liverpool*. London: Karia Press, 1989.
Giraud, Michel. "Les enjeux présents de la mémoire de l'esclavage." In *L'esclavage, la colonisation et après*, edited by Patrick Weil and Stéphane Dufoix, 533–558. Paris: Presses Universitaires de France, 2005.
Glissant, Édouard. *Le discours antillais*. Paris: Le Seuil, 1981.
Glissant, Édouard. *Poétique de la relation*. Paris: Gallimard, 1990.
Gomes, Flávio dos Santos. *Palmares: Escravidão e liberdade no Atlântico Sul*. Rio de Janeiro: Editora Contexto, 2005.
Gordon-Reed, Annette. *The Hemmingses of Monticello: An American Family*. New York: W.W. Norton, 2008.
Gramsci, Antonio. *Quaderni dal Carcere*, Vol. 3 (Quaderni 12–29; 1923–1935), Edizione critica dell'Istituto Gramsci, edited by Valentino Gerratana. Torino: Einaudi, 2007.
Gray, John. *A History of The Gambia*. London: Frank Cass & Co, Ltd, 1966.
Green, Andy. "Remembering Slavery in Birmingham: Sculpture, Paintings and Installations." *Slavery and Abolition* 29, no. 2 (2008): 189–201.
Greene, Lorenzo Johnston. *The Negro in Colonial New England*. New York: Atheneum, 1969.
Greene, Sandra. "Whispers and Silences. Explorations in African Oral History." *Africa Today* 50, no. 2 (2003): 40–53.
Guide des sources de la traite négrière, de l'esclavage et de leurs abolitions. Paris: Archives nationales, La Documentation française, 2007.
Guyer, Jane. "Postscript: From Memory to Conviction and Action." *Africa* 75, no. 1 (2005): 119–123.
Halbwachs, Maurice. *La mémoire collective*. Paris: Presses Universitaires de France, 1950.
Halbwachs, Maurice. *Les cadres sociaux de la mémoire*. Paris: F. Alcan, 1925.
Hall, Catherine. "Afterword: Britain 2007: Problematising History." In *Imagining Transatlantic Slavery*, edited by Cora Kaplan and John Oldfield, 191–201. Basingstoke: Palgrave Macmillan, 2010.
Hall, Catherine. "Introduction." *History Workshop Journal* 64, no. 1 (2007): 1–5.
Hamdy, F. Sherine. "Islam, Fatalism, and Medical Intervention: Lessons from Egypt on the Cultivation of Forbearance (*Sabr*) and Reliance on God *(Tawakkul)*." *Anthropological Quarterly* 82, no. 1 (2009): 173–196
Hamilton, Douglas. "Representing Slavery in British Museums: the Challenges of 2007." In *Imagining Transatlantic Slavery*, edited by Cora Kaplan and John Oldfield, 127–144. Basingstoke: Palgrave Macmillan, 2010.

Hardung, Christine. "Everyday Life of Slaves in Northern Dahomey: The Process of Remembering." *Journal of African Cultural Studies* 15, no. 1 (2002): 35–44.
Harris, Leslie M. *In the Shadow of Slavery: African Americans in New York City, 1626–1863*. Chicago, IL: University of Chicago Press, 2003.
Haswell, Margaret. *Economics of Agriculture in a Savannah Village*. London: Her Majesty's Stationary Office, 1953.
Hayward, Walter. *Bermuda Past and Present*. New York: Dodd, Mead & Company, 1911.
Hazareesingh, Kissoonsingh. *Histoire des Indiens à l'Île Maurice*. Paris: Maisonneuve, 1973.
Heywood, Linda, and John K. Thornton. *Central Africans, Atlantic Creoles, and the Foundation of the Americas, 1585–1660*. New York: Cambridge University Press, 2007.
Hine, D. Clark, Trica Danielle Keaton, and Stephen Small, eds. *Black Europe and the African Diaspora*. Urbana and Chicago, IL: University of Illinois Press, 2009.
Hodges, Graham Russell Gao, and Alan Edward Brown, eds. *"Pretends to be Free": Runaway Slave Advertisements from Colonial and Revolutionary New York and New Jersey*. New York: Garland, 1994.
Hodges, Graham Russell Gao. "Liberty and Constraint: The Limits of Revolution." In *Slavery in New York*, edited by Ira Berlin and Leslie M. Harris, 91–110. New York: New Press, 2005.
Hodges, Graham Russell Gao. *Root & Branch: African Americans in New York and East Jersey: 1612–1863*. Chapel Hill, NC: University of North Carolina Press, 1999.
Hodges, Graham Russell Gao, and Alan Edward Brown, eds. *"Pretends to be Free": Runaway Slave Advertisements from Colonial and Revolutionary New York and New Jersey*. New York: Garland, 1994.
Holsey, Bayo. *Routes of Remembrance: Refashioning the Slave Trade in Ghana*. Chicago, IL: University of Chicago Press, 2008.
Horton, James Oliver, and Johanna C. Kardux. "Slavery and Public Memory in the United States and the Netherlands." In "Slavery and Its Legacies." Special issue, *New-York Journal of American History* 66, no. 2 (2005): 35–52.
Horton, James Oliver, and Johanna C. Kardux. "Slavery and the Contest for National Heritage in the United States and the Netherlands." *American Studies International* 42, nos. 2–3 (2004): 51–74.
Horton, James Oliver, and Lois E. Horton, eds. *Slavery and Public History: The Tough Stuff of American Memory*. Chapel Hill, NC: University of North Carolina Press, 2008.
Horton, James Oliver, and Lois E. Horton, eds. *Slavery and Public History: The Tough Stuff of American Memory*. New York: New Press, 2006.
Howard-Hassman, Rhoda. "Reparations to Africa and the Group of Eminent Persons." *Cahiers d'études africaines* 173–174 (2004): 81–97.
Hulser, Kathleen. "Sojourner Truth Maquette by Barbara Chase-Riboud." Acquisition Report. New York: New-York Historical Society, February 2007.
Hulser, Kathleen, and Steve Bull. "Click History: Wherever, Whenever." In *Creativity and Technology: Social Media, Mobiles and Museums*, edited by James Katz, Wayne LaBar, and Ellen Lynch, 204–213. Edinburgh: MuseumsEtc., 2011.
Huyssen, Andreas. *Twilight Memories: Marking Time in a Culture of Amnesia*. New York and London: Routledge, 1995.
Innes, Gordon. *Sunjata: Three Mandinka Versions*. London: School of Oriental and African Studies, 1974.
Instituto do Patrimônio Histórico e Artístico Nacional. "Jongo no Sudeste." *Dossiê Iphan n° 5*. Brasília: Instituto do Patrimônio Histórico e Cultural, 2008.

Isaacman, Allen, and Barbara Isaacman. *Slavery and Beyond: The Making of Men and Chikunda Ethnic Identities in the Unstable World of South-Central Africa, 1750–1920*. Portsmouth, NH: Heinemann, 2004.
Jarvis, Michael. *In the Eye of All Trade: Bermuda, Bermudians and the Maritime Atlantic World, 1680–1783*. Chapel Hill, NC: University of North Carolina Press, 2010.
Jawara, Dawda. *Kairaba*. Burgess Hill, West Sussex: Domtom Publishing Ltd, 2009.
Jordan, Winthrop D. *White Over Black: American Attitudes Toward the Negro, 1550–1812*. Chapel Hill, NC: University of North Carolina Press, 1968.
Joubert, Louis. "Les conséquences géographiques de l'émancipation des Noirs aux Antilles, 1848." *Cahiers d'outre-mer: Revue de Géographie de Bordeaux et de l'Atlantique* 1 (1948): 105–118.
Julien, Charles-André. "Notice biographique sur Victor Schœlcher." *Larousse Mensuel Illustré: Revue encyclopédique Larousse*, no. 405, May 1948, n pag.
Kachun, Mitch. *Festivals of Freedom: Memory and Meaning in African American Emancipation Celebrations, 1808–1915*. Amherst, MA: University of Massachusetts Press, 2003.
Kachun, Mitch. "From Forgotten Founder to Indispensable Icon: Crispus Attucks, Black Citizenship, and Collective Memory, 1770–1865." *Journal of the Early Republic* 29, no. 2 (2009): 249–286.
Kantrowitz, Stephen. "A Place for 'Colored Patriots': Crispus Attucks among the Abolitionists, 1842–1863." *Massachusetts Historical Review* 11 (2009): 96–117.
Kaplan, Cora. "Commemorative History without Guarantees." *History Workshop Journal* 64, no. 1 (2007): 389–397.
Kaplan, Cora, and John Oldfield, eds. *Imagining Transatlantic Slavery*. Basingstoke: Palgrave Macmillan, 2010.
Karash, Mary C. *A vida dos escravos no Rio de Janeiro*. Rio de Janeiro: Companhia das Letras, 2000.
King, Julia A., and Edward E. Chaney. "Passing for Black in Seventeenth Century Maryland." In *Interpreting the Early Modern World: Transatlantic Perspectives*, edited by Mary C. Beaudry and James Symonds, 87–111. New York: Springer, 2011.
Klein, Martin. "Slave Descent and Social Status in Sahara and the Sudan." In *Reconfiguring Slavery: West African Trajectories*, edited by Benedetta Rossi, 45–84. Liverpool: Liverpool University Press, 2009.
Klein, Martin. *Slavery and Colonial Rule in French West Africa*. Cambridge: Cambridge University Press, 1998.
Klein, Martin. "Studying the History of Those Who Would Rather Forget: Oral History and The Experience of Slavery." *History in Africa*, no. 16 (1989): 209–217.
Kratz, A. Corinne. "Conversations and Lives." In *African Words, African Voices: Critical Practices in Oral History*, edited by Luise White, Stephan Miescher, and David William Cohen, 127–161. Bloomington, IN: Indiana University Press, 2001.
Krizner, L. J., Cynthia R. Copeland, and Grady Turner. *Seneca Village: A Teacher's Guide to Using Primary Sources in the Classroom*. New York: New-York Historical Society, 2010.
Kulikoff, Allan. *Tobacco and Slaves: The Development of Southern Cultures in the Chesapeake, 1680–1800*. Chapel Hill, NC: University of North Carolina Press, 1986.
La traite négrière, l'esclavage et leurs abolitions: mémoire et histoire: séminaire national organisé le 10 mai 2006, Carré des sciences, Paris. SCEREN, CRDP Académie de Versailles, 2007.
"Lady of Boston, A" [Mary Webb]. *Memoir of Mrs. Chloe Spear*. Boston, MA, 1832.

Lara, Oruno D. *Breve Historia del Caribe*. Caracas: Academia Nacional de la Historia, 2001.
Lara, Oruno D. *Caraïbes entre Liberté et Indépendance: Réflexions critiques autour d'un bicentenaire, 1802–2002*. Paris: Harmattan, 2002.
Lara, Oruno D. *De l'Oubli à l'Histoire: Espace et identité caraïbes*. Paris: Maisonneuve et Larose, 1998.
Lara, Oruno D. *Guadeloupe: faire face à l'Histoire*. Paris: Harmattan, 2009.
Lara, Oruno D. *La liberté assassinée: Guadeloupe, Guyane, Martinique et La Réunion, 1848–1856*. Paris: Harmattan, 2005.
Lara, Oruno D. *Space and History in the Caribbean*. Princeton, NJ: Markus Wiener Publications, 2006.
Lara, Oruno D., and Inez Fisher-Blanchet. *Propriétaires d'esclaves en 1848: Martinique, Guyane, Saint-Barthélemy, Sénégal*, vol. 2. Paris: Harmattan, 2011.
Lara, Oruno D., and Inez Lara. *Guadeloupe, Propriétaires d'esclaves en 1848*, vol. 1. Paris: Harmattan, 2010.
Larson, Pier. "Horrid Journeying: Narrative of Enslavement and the Global African Diaspora." *Journal of World History* 19, no. 4 (2008): 434–436.
Lastrucci, Marc. "L'évocation publique à Nantes de la traite négrière et de l'esclavage de 'Nantes 85' aux 'Anneaux de la Mémoire,' 1983–1994." MA diss., Université de Nantes, 1996.
Law, Robin. "A carreira de Francisco Félix de Souza na África Ocidental (1800–1849)." *Topoi*, 2001: 9–39.
Law, Robin. "The Atlantic Slave Trade in Local History Writing in Ouidah." In *Africa and Trans-Atlantic Memories: Literary and Aesthetic Manifestations of Diaspora and History*, edited by Naana Opoku-Agyemang, Paul E. Lovejoy, and David V. Trotman, 257–274. Trenton, NJ: Africa World Press, 2008.
Law, Robin. "The Evolution of the Brazilian Community in Ouidah." *Slavery and Abolition* 22, no. 1 (2001): 3–21.
Law, Robin. "Francisco Félix de Souza in West Africa: 1820–1849." In *Enslaving Connections: Western Africa and Brazil during the Era of Slavery*, edited by José C. Curto and Paul E. Lovejoy, 189–213. Amherst, NY: Prometheus/Humanity Books, 2003.
Law, Robin. *Ouidah: The Social History of a West African Slaving "Port," 1727–1892*. Athens, OH: Ohio University Press, 2004.
"Le Centenaire de la liberté." *Revue d'histoire des colonies*, no. 81 (1948).
Lepore, Jill. *New York Burning: Liberty, Slavery and Conspiracy in Eighteenth-Century Manhattan*. New York: Alfred Knopf, 2005.
Lepore, Jill. "The Tightening Vise: Slavery and Freedom in British New York." In *Slavery in New York*, edited by Ira Berlin and Leslie M. Harris, 57–90. New York: New Press, 2005.
Lepore, Jill. *The Whites of Their Eyes: The Tea Party's Revolution and the Battle over American History*. Princeton, NJ: Princeton University Press, 2010.
Lloyd, Suzette. *Sketches of Bermuda*. London: James Cochran, 1835.
Lonnie, Bunch. "Embracing Ambiguity: The Challenge of Interpreting African American History in Museums." *Museums & Social Issues* 2, no. 1 (2007): 45–55.
Lopo, Júlio de Castro. "Uma Rica Dona de Luanda." *Portucale* 3 (1948): 129–138.
Lowenthal, David. *The Past is a Foreign Country*. Cambridge: Cambridge University Press, 2003.
Lozère, Christelle. *Bordeaux colonial. 1850–1940*. Bordeaux: Sud Ouest, 2007.
Lynch, Bernadette, and Samuel Alberti. "Legacies of Prejudice: Racism, Co-Production and Radical Trust in the Museum." *Museum Management and Curatorship* 25, no. 1 (2010): 13–35.
Madeiros, Carlos Alberto. *Na lei e na raça: legislação e relações raciais, Brasil-Estados Unidos*. Rio de Janeiro: DP&A, 2004.

Marstine, Janet. *New Museum Theory and Practice*. Oxford: Blackwell Publishing, 2006.
Martin, Gaston. *L'abolition de l'esclavage: 27 avril 1848*. Paris: Presses Universitaires de France, 1948.
Martins, Sérgio da Silva, Carlos Alberto Medeiros, and Elisa Larkin Nascimento. "Paving Paradise: The Road from 'Racial Democracy' to Affirmative Action in Brazil." *Journal of Black Studies* 34 (2004): 787–816.
Maxwell, Clarence. "'The Horrid Villainy': Sarah Bassett and the Poisoning Conspiracies in Bermuda, 1727–1730." *Bermuda Journal of Archaeology and Maritime History* 12 (2001): 38–66.
Maxwell, Clarence. "Race and Servitude: The Birth of a Social and Political Order in Bermuda, 1619–1669." *Bermuda Journal of Archaeology and Maritime History* 11 (1999): 39–65.
Mbembe, Achille. "La République et l'impensé de la 'race'." In *La fracture coloniale : La société française au prisme de l'héritage colonial*, edited by Pascal Blanchard et al., 139–153. Paris: La Découverte, 2005.
McCallum, Bradley, and Jacqueline Tarry. *Bearing Witness: Work by Bradley McCallum & Jacqueline Tarry*. Baltimore, MD: Contemporary Museum of Art & Maryland Institute of Contemporary Art, 2010.
McCarthy Thomas. "Coming to Terms with Our Past, Part II: On the Morality and Politics of Reparations for Slavery." *Political Theory* 32 (2004): 750–772.
Medeiros, Júlio César Medeiros da Silva Pereira. *À flor da terra: o cemitério dos pretos novos no Rio de Janeiro*. Rio de Janeiro: Garamond Universitaria, 2007.
Melish, Joanne Pope. *Disowning Slavery: Gradual Emancipation and "Race" in New England, 1780–1860*. Ithaca, NY: Cornell University Press, 1998.
Menschel, David. "Abolition Without Deliverance: The Law of Connecticut Slavery, 1784–1848." *Yale Law Journal* 111, no. 1 (2001): 183–222.
Miller, Christopher L. *The French Atlantic Triangle: Literature and Culture of the Slave Trade*. Durham, NC: Duke University Press, 2008.
Milne, Seumas. "Réhabilitation du colonialisme." *Le Monde Diplomatique*, Paris (May 2005): 4–5.
Minardi, Margot. *Making Slavery History: Abolitionism and the Politics of Memory in Massachusetts*. New York: Oxford University Press, 2010.
Ministério da Cultura. *Cultura em três dimensões*. Brasília, 2010.
Monteiro, Tânia P. "Portugueses na Bahia na Segunda Metade do Século XIX—Imigração e Comércio." MA diss., Universidade Federal da Bahia, 1982.
Moore, Christopher P. "A World of Possibilities: Slavery and Freedom in Dutch New Amsterdam." In *Slavery in New York*, edited by Ira Berlin and Leslie M. Harris, 29–56. New York: New Press, 2005.
Moura, Roberto. *Tia Ciata e a Pequena África no Rio de Janeiro*. Rio de Janeiro: Secretaria Municipal da Cultura, 2005.
Munanga, Kabenguele. *Rediscutindo a mestiçagem no Brasil: Identidade nacional versus Identidade negra*. São Paulo: Autêntica, 2004.
Murray, Freeman Henry Morris. *Emancipation and the Freed in American Sculpture: A Study in Interpretation*. Washington, DC: Murray Brothers, 1916.
Musée national des arts et traditions populaires (France). *Tropiques métis: mémoires et cultures de Guadeloupe, Guyane, Martinique, Réunion: Musée national des arts et traditions populaires, 5 novembre 1998–12 avril 1999*. Paris: Réunion des musées nationaux, 1998.
Musson, Nellie. *Mind the Onion Seed: Black "Roots" Bermuda*. Nashville, TN: Parthenon Press, 1979.
Naidoo, Roshi. "High Anxiety: 2007 and Institutional Neuroses." In *Representing Enslavement and Abolition in Museums*, edited by Laurajane Smith, Geoffrey Cubitt, Kalliopi Fouseki, and Ross Wilson, 44–60. New York: Routledge, 2011.

National Museums Liverpool. "Liverpool Slavery Remembrance Initiative (LSRI) Business Plan 2006–2008." Liverpool, 2006.
Nell, William Cooper. *The Colored Patriots of the American Revolution*. Boston, MA, 1855.
Nelson, Charmaine A. *The Color of Stone: Sculpting the Black Female Subject in Nineteenth-Century America*. Minneapolis, MN, and London: University of Minnesota Press, 2007.
Nooter, Mary H., and Wande Abimbola, eds. *Secrecy: African Art that Conceals and Reveals*. New York: Museum for African Art, 1993.
Nora, Pierre. "Between Memory and History: Les Lieux de Mémoire." *Representations* 26 (Spring 1989): 7–24.
Noret, Joel. "Memories of Slavery in Southern Benin: Between Public Commemorations and Lineage Intimacy." Paper presented at the workshop "Politics of Memory: Making Slavery Visible in the Public Space," 125th Annual Meeting of the American Historical Association, Boston, January 6–9, 2011.
Norridge, Zoe. "Finding a Home in Hackney? Reimagining Narratives of Slavery through a Multicultural Community Museum Space." *African and Black Diaspora* 2, no. 2 (2009): 167–179.
Odell, Margaretta Matilda. *Memoir and Poems of Phillis Wheatley, A Native African and a Slave*. Boston, 1834.
Uduku, Ola, and Gideon Ben-Tovim. *Social Infrastructure in Granby/Toxteth: A Contemporary Socio-Cultural and Historical Study of the Built Environment and Community in L8*. Liverpool: University of Liverpool Press, 1998.
Oldfield, J. R. *"Chords of Freedom": Commemoration, Ritual and British Transatlantic Slavery*. Manchester: Manchester University Press, 2007.
Olick, Jeffrey. *The Politics of Regret: On Collective Memory and Historical Responsibility*, New York: Routledge, 2007.
Packwood, Cyril. *Chained on the Rock: Slavery in Bermuda*. Hamilton: Island Press Ltd, 1975.
Paton, Diana. "Interpreting the Bicentenary in Britain." *Slavery and Abolition* 30, no. 2 (2009): 277–289.
Paula, Marilene de, and Rosana Heringer. *Caminhos convergentes: Estado e sociedade na superação das desigualdades raciais no Brasil*. Rio de Janeiro: Heinrich Böll Stiftung, 2009.
Pétré-Grenouilleau, Olivier. *Nantes et la traite négrière*. Nantes: RMN-Chateau des Ducs de Bretagne, 2007.
Piersen, William D. *Black Yankees: The Development of an Afro-American Subculture in Eighteenth-Century New England*. Amherst, MA: University of Massachusetts Press, 1988.
Pinho, Patricia de Santana. *Mama Africa: Reinventing Blackness in Bahia*. Durham, NC: Duke University Press, 2010.
Pollak, Michael. *L'Expérience concentrationnaire. Essai sur le maintien de l'identité sociale*. Paris: Métailié, 1990.
Pope, James. "A Dangerous Spirit of Liberty: The Spread of Slave Resistance in the Atlantic, 1729–1745." Paper presented at University of West Indies at Cave Hill, Barbados, October 15, 2010.
Prince, Linda. "White Community, Black Compromise: Blacks and the Experience of Interraciality in Boston from Slavery Freedom, 1693–1815." PhD diss., Harvard University, 2002.
Prince, Mary. *The History of Mary Prince: A West Indian Slave*, edited by Moira Ferguson. Ann Arbor, MI: Michigan University Press, 1997.
Prior, Katherine. "Commemorating Slavery 2007: A Personal View from Inside the Museums." *History Workshop Journal* 64, no. 1 (2007): 200–211.

Quel enseignement de la traite négrière, de l'esclavage et des abolitions: Séminaire du Réseau national des écoles associées à l'UNESCO, 4, 5 et 6 novembre 2004. Champigny: SCEREN-CRDP de l'Académie de Créteil, 2008.

"Quelques considérations sur l'état actuel de nos colonies et leur avenir." *Revue Coloniale*. Ministère de la Marine et des Colonies, 1850.

"Queries Respecting the Slavery and Emancipation of Negroes in Massachusetts, Proposed by the Hon. Judge Tucker of Virginia, and Answered by the Rev. Dr. Belknap." *Collections of the Massachusetts Historical Society*, 1st ser., 4 (1795): 192.

Quinn, Charlotte. *Mandinko Kingdoms of the Senegambia: Traditionalism, Islam and European Expansion*. Evanston, IL: Northwestern University Press, 1972.

Quinn, Charlotte. "A Nineteenth Century Fulbe State." *Journal of African History* 12, no. 3 (1971): 427–440.

Reflecting on the Past and Looking to the Future: The 2007 Bicentenary of the Abolition of the Slave Trade in the British Empire. London: Department for Culture, Media and Sport, 2007.

Régent, Frédéric. *Esclavage, Métissage, Liberté: La Révolution française en Guadeloupe, 1789–1802*. Paris: Grasset, 2004.

Reinhardt, Catherine A. *Claims to Memory: Beyond Slavery and Emancipation in the French Caribbean*. New York, Oxford: Berghahn Books, 2006.

Rice, Alan. "From Ships on the Head to Stone-Markers on the Shore." In *Radical Narratives of the Black Atlantic*, edited by Alan Rice, 201–217. London and New York: Continuum, 2003.

Rice, Alan. "Naming the Money and Unveiling the Crime: Contemporary British Artists and the Memorialization of Slavery and Abolition." *Patterns of Prejudice* 41, nos. 3–4 (2007): 321–343.

Rice, Alan. "Revealing Histories, Dialogising Collections: Museums and Galleries in North West England Commemorating the Abolition of the Slave Trade." *Slavery and Abolition* 30, no. 2 (2009): 291–309.

Richards, Sandra. "What Is to Be Remembered? Tourism to Ghana's Slave Castle Dungeons." *Theatre Journal* 57, no. 4 (2005): 617–637.

Richardson, David. "Liverpool and the English Slave Trade." In *Transatlantic Slavery: Against Human Dignity*, edited by Anthony Tibbles, 67–72. Liverpool: Liverpool University Press, 1995.

Ricketson, Daniel. *History of New Bedford*. New Bedford, MA, 1858.

Ricoeur, Paul. *Memory, History, Forgetting*. Chicago, IL: University of Chicago Press, 2006.

Roberto, R. V. "A Critical Look at Online Exhibitions and Online Collections: When Creating One Resource is More Effective than the Other." *DESIDOC Journal of Library and Information Technology* 28, no. 4 (2008): 63–71.

Rôche, Christian. *Histoire de la Casamance: Conquête et résistances: 1850–1920*. Paris: Karthala, 1985.

Ross, David A. "The Career of Domingo Martinez in the Bight of Benin, 1833–1864." *Journal of African History* 6, no. 1 (1965): 79–90.

Rush, Dana. "Contemporary Vodun of Ouidah, Benin." *African Arts* 34, no. 4 (2001): 32–47.

Russell-Wood, A. J. R. *Fidalgos and Philanthropists: The Santa Casa da Misericórdia of Bahia (1550–1755)*. Berkeley, CA: University of California Press, 1968.

Saillant, Francine. "Droits, citoyenneté et réparations des torts du passé de l'esclavage: Perspectives du Mouvement noir au Brésil." *Anthropologie et Sociétés* 33, no. 2 (2008): 141–165.

Saillant, Francine, and Ana Lucia Araujo. "L'esclavage au Brésil: Le travail du mouvement noir." *Ethnologie française* 37, no. 3 (2007): 457–466.

Saillant, Francine, and Ana Lucia Araujo. "Zumbi: mort, mémoire et résistance." *Frontières* 19, no. 1 (2006): 37–42.

Saillant, John. *Black Puritan, Black Republican: The Life and Thought of Lemuel Haynes, 1753–1833.* New York: Oxford University Press, 2003.
Salgueiro, Maria Aparecida Ferreira de Andrade. *A República e a questão do negro no Brasil.* Rio de Janeiro: Museu da República, 2005.
Sandage, Scott A. "A Marble House Divided: The Lincoln Memorial, the Civil Rights Movement, and the Politics of Memory, 1939–1963." *Journal of American History* 80, no. 1 (June 1993): 135–167.
Sansone, Livio. "Remembering Slavery from Nearby: Heritage Brazilian Style." In *Facing up to the Past: Perspectives on the Commemoration of Slavery from Africa, the Americas and Europe,* edited by Gert Oostindie, 83–89. Kingston: Ian Randle Publishers, 2001.
Santos, Myrian S. dos. "Representations of Black People in Brazilian Museums." *Museum and Society* 3, no. 1 (2005): 55–65.
Santos, Myrian Sepúlveda dos. "The Repressed Memory of Brazilian Slavery." *International Journal of Cultural Studies* 11, no 2 (2008): 157–175.
Sauerbruun, Edward Pablo de Sa. "Samba, Capoeira, Malandragem, and National Identity: The Contradictions of a Racial Democracy." PhD diss., Southern Illinois University, Carbondale, 2003.
Saugera, Eric. *Bordeaux port négrier.* Paris: Karthala, 1995.
Savage, Kirk. *Standing Soldiers, Kneeling Slaves: Race, War, and Monument in Nineteenth-Century America.* Princeton, NJ: Princeton University Press, 1997.
Schmidt, Nelly. *Abolitionnistes de l'esclavage et réformateurs des colonies: Analyse et documents, 1820–1851.* Paris: Karthala, 2000.
Schmidt, Nelly. "Asservir: Fiches Bilans de Connaissance: Dossier d'accompagnement du film Routes de l'Esclave; Une vision globale." Paris: UNESCO, 2010.
Schmidt, Nelly. *Combats pour une abolition: sur les pas de Victor Schoelcher.* Versailles: Conseil général des Yvelines, 2010.
Schmidt, Nelly. "La commémoration du centenaire de l'abolition de l'esclavage dans les colonies françaises, 1848–1948." In "Histoire des centenaires, ou le devenir des revolutions, 1848: Révolutions et mutations au XIXe siècle." Special issue, *Revue d'histoire du XIXe siècle: Société d'histoire de la Révolution de 1848 et des révolutions du XIXe siècle,* 5 (1989): 31–54.
Schmidt, Nelly. *La France a-t-elle aboli l'esclavage? Guadeloupe, Martinique, Guyane, 1830–1935.* Paris: Perrin, 2009.
Schmidt, Nelly. *Victor Schœlcher.* Paris: Fayard, 1994.
Schmidt, Nelly. "Victor Schœlcher, mythe et réalité." *Revue d'histoire du XIXe siècle: Société d'histoire de la Révolution de 1848 et des révolutions du XIXe siècle* 4 (1988): 51–73.
Schœlcher, Victor. *L'arrêté Gueydon à la Martinique, l'arrêté Husson à la Guadeloupe.* Paris: Le Chevalier, 1872.
Schœlcher, Victor, and Emile Tersen. *Esclavage et colonisation.* Paris: Presses Universitaires de France, 1948.
Searing, James. *"God Alone is King!" Islam and Emancipation in Senegal: The Wolof Kingdoms of Kajoor and Bawol, 1859–1914.* Oxford: James Currey, 2002.
Servan-Schreiber, Catherine. *Histoire d'une musique métisse à l'île Maurice: Chutney indien et séga Bollywood.* Paris: Riveneuve Éditions, 2010.
Sheriff, Robin E. "The Muzzled Saint: Racism, Cultural Censorship, and Religion in Urban Brazil." In *Silence: The Currency of Power,* edited by Maria-Luisa Achino-Loeb, 113–137. New York: Berghahn Books, 2006.
Sheriff, Robin E. "Silence: Racism and Cultural Censorship." In *Dreaming Equality: Color, Race, and Racism in Urban Brazil.* New Brunswick, NJ: Rutgers University Press, 2001.
Sherwood, Marika. *After Abolition: Britain and the Slave Trade since 1807.* London and New York: I.B. Tauris, 2007.

Sims, Lowery Stokes, Kathleen Hulser, and Cynthia R. Copeland. *Legacies: Contemporary Artists Reflect on Slavery*. New York: New-York Historical Society, 2006.
Simonard, Pedro. "A construção da tradição no 'Jongo da Serrinha': uma etnografia visual do seu processo de espetacularização." PhD diss., Universidade do Estado do Rio de Janeiro, 2005.
Simonard, Pedro. "'Je me présente': Comment les membres des communautés jongueiras du Brésil contrôlent-ils leur propre image?" *Ethnologies* 31, no. 2 (2010): 99–130.
Simonard, Pedro. "Le *jongo* et la nouvelle performativité afrobrésilienne." *Anthropologie et sociétés* 34, no. 1 (2010): 33–54.
Sims, Lowery Stokes, Kathleen Hulser, and Cynthia R. Copeland. *Legacies: Contemporary Artists Reflect on Slavery*. New York: New-York Historical Society, 2006.
Skidmore, Thomas E. *Brazil Five Centuries of Change*. New York: Oxford University Press, 2010.
Slenes, Robert. "O que Rui Barbosa não queimou: novas fontes para o estudo da escravidão no século XIX." *Estudos Econômicos*, no. 13 (1983): 117–149.
Small, Stephen. "Contextualizing the Black Presence in British Museums: Representations, Resources and Response." In *Museums and Multiculturalism in Britain*, edited by Eilean Hooper-Greenhill, 50–66. Leicester: Leicester University Press, 1997.
Smith, Clifford, and Clarence Maxwell. "A Bermuda Smuggling-Slave Trade: The Manila Wreck' Opens Pandora's Box." *Bermuda Journal of Archaeology and Maritime History* 13 (2002): 57–87.
Smith, James. *Slavery in Bermuda*. New York: Vantage Press, 1976.
Smith, Laurajane. "Affect and Registers of Engagement: Navigating Emotional Responses to Dissonant Heritages." In *Representing Enslavement and Abolition in Museums*, edited by Laurajane Smith, Geoffrey Cubitt, Kalliopi Fouseki, and Ross Wilson, 260–323. New York: Routledge, 2011.
Smith, Laurajane. "Man's Inhumanity to Man and other Platitudes of Avoidance and Misrecognition: An Analysis of Visitor Responses to Exhibitions Marking the 1807 Bicentenary." *Museum and Society* 8, no. 3 (2010): 193–214.
Smith, Laurajane, and Geoffrey Cubitt. "1807 Commemorated Project Report: International Slavery Museum." York: University of York, 2009.
Smith, Laurajane, Geoff Cubitt, Ross Wilson, and Kalliopi Fouseki, eds. *Representing Enslavement and Abolition in Museums*. New York and London: Routledge, 2011.
Smith, Laurajane, and Kalliopi Fouseki. "The Role of Museums as "Places of Social Justice': Community Consultation and the 1807 Bicentenary." In *Representing Enslavement and Abolition in Museums*, edited by Laurajane Smith, Geoffrey Cubitt, Kalliopi Fouseki, and Ross Wilson, 97–115. New York: Routledge, 2011.
Smith, Tracy-Ann. "Science and Slavery, 2007: Public Consultation." In *Representing Enslavement and Abolition in Museums*, edited by Laurajane Smith, Geoffrey Cubitt, Kalliopi Fouseki, and Ross Wilson, 116–130. New York: Routledge, 2011.
Spence, David. "Making the London, Sugar and Slavery Gallery at Museum of London Docklands." In *Representing Enslavement and Abolition in Museums*, edited by Laurajane Smith, Geoffrey Cubitt, Kalliopi Fouseki, and Ross Wilson, 149–163. New York: Routledge, 2011.
Spring, Christopher, "Art, Resistance and Remembrance: A Bicentenary at the British Museum." In *Representing Enslavement and Abolition in Museums*, edited by Laurajane Smith, Geoffrey Cubitt, Kalliopi Fouseki, and Ross Wilson, 193–212. New York: Routledge, 2011.
Stauffer, John. *The Black Hearts of Men: Radical Abolitionists and the Transformation of Race*. Cambridge, MA: Harvard University Press, 2001.
Stewart, James Brewer. "The Emergence of Racial Modernity and the Rise of the White North, 1790–1840." *Journal of the Early Republic* 18 (1998): 181–217.

Straile, Paula. "The Pillory/Pelourinho in Open-Air Museums in the U.S. and Brazil: A Site of Racism and Racial Reconciliation." In *Erasing Public Memory: Race, Aesthetics, and Cultural Amnesia in the Americas*, edited by Joseph A. Young and Jana Evans Braziel, 209–242. Macon, GA: Mercer University Press, 2007.
Swan, Quito. *Black Power in Bermuda: The Struggle for Decolonization*. New York: Palgrave Macmillan, 2009.
Swindell, Kenneth, and Alieu Jeng. *Migrants, Credit and Climate: The Gambian Groundnut Trade, 1834–1934*. Leiden: Brill, 2006.
Tabili, Laura. *"We Ask For Justice" Workers and Racial Difference in Late Imperial Britain*. Ithaca, NY, and London: Cornell University Press, 1994.
Taussig, Michael. *Defacement: Public Secrecy and the Labor of the Negative*. Stanford, CA: Stanford University Press, 1999.
Tersen, Emile. *Esclavage et colonisation*. Paris: Presses Universitaires de France, 1948.
The Slave Routes: A Global Vision. DVD. UNESCO, 2010.
Thomas, Émile. *Rapport à M. le Ministre de la Marine et des Colonies sur l'organisation du travail libre aux Antilles françaises et sur les améliorations à apporter aux institutions coloniales*, 15 avril 1849. Paris: Imprimerie nationale, 1849.
Thompson, Alvin. *Flight to Freedom: African Runaways and Maroons in the Americas*. Jamaica: University of the West Indies Press, 2006.
Tibbles, Anthony. "Against Human Dignity: The Development of the Transatlantic Slavery Gallery at Merseyside Maritime Museum." In *Proceedings, IXth International Congress of Maritime Museums*, edited by Adrian Jarvis, Roger Knight, and Michael Stammers, 95–96. Greenwich and Liverpool: National Maritime Museum, Merseyside Maritime Museum, 1996.
Tibbles, Anthony. "Facing Slavery's Past: The Bicentenary of the Abolition of the British Slave Trade." *Slavery and Abolition* 29, no. 2 (2008): 293–303.
Tinker, Hugh. *A New System of Slavery: The Export of Indian Labour Overseas*. London: Hansib Educational Books, 1973.
Tonkin, Elisabeth. *Narrating Our Past: The Social Construction of Oral History*. Cambridge: Cambridge University Press, 1992.
Toplin, Robert Brent. *The Abolition of Slavery in Brazil*. New York: Atheneum, 1972.
Townsend, Craig D. *Faith in Their Own Color: Black Episcopalians in Antebellum New York City*. New York: Columbia University Press, 2005.
Trouillot, Michel-Rolph. *Silencing the Past: Power and the Production of History*. Boston, MA: Beacon Press, 1995.
Tucker, Terry. *Bermuda's Story*. Hamilton: Island Press Ltd, 1980.
Turgeon, Laurier. *Territoires: L'esprit du lieu; Entre le patrimoine matériel et immatériel*. Québec: Presses de l'Université Laval, 2009.
Turra, Cleusa, and Gustavo Venturi, *Racismo Cordial: a mais completa análise sobre o proconceito de cor no Brasil*. São Paulo: Editora Ática, 1995.
Twain, Mark. *Adventures of Huckleberry Finn*. London: Chatto & Windus, 1884.
Twain, Mark. *King Leopold's Soliloquy*. Boston, MA: P.R. Warren Co., 1905.
Twine, France Winddance. "Memory: White Inflation and Willful Forgetting." In *Racism in a Racial Democracy: The Maintenance of White Supremacy in Brazil*. New Brunswick, NJ: Rutgers University Press, 1998.
Ulrich, Laurel Thatcher. "Hannah Barnard's Cupboard: Female Property and Identity in Eighteenth-Century New England." In *Through a Glass Darkly: Reflections on Personal Identity in Early America*, edited by Ronald Hoffman, Mechal Sobel, and Fredrika J. Teute, 238–273. Chapel Hill, NC: University of North Carolina Press, 1997.
UNESCO. "Convention on the Protection and Promotion of the Diversity of Cultural Expressions." Paris: UNESCO, 2005.

UNESCO. *UNESCO-Madanjeet Singh Prize for the Promotion of Tolerance and Non-Violence* (brochure). Paris: UNESCO, 2009.
Unnuth, Abhimanyu. *Sueurs de sang*. Paris: Stock, 1977.
Van Hoven, Eduard. *L'oncle maternel est roi: La formation d'alliances hiérarchiques chez les Mandingues du Wuli (Sénégal)*. Leiden: Research School CNWS, 1997.
Vaughan, Megan. *Creating the Creole Island: Slavery in Eighteenth-Century Mauritius*. Durham, NC, London: Duke University Press, 2005.
Verger, Pierre. *Fluxo e refluxo do tráfico de escravos entre o Golfo do Benin e a Bahia de Todos os Santos dos séculos XVII a XIX*. Salvador: Corrupio, 2002.
Vergès, Françoise. *La mémoire enchaînée : Questions sur l'esclavage*. Paris: Albin Michel, 2006.
Vinitzky-Seroussi, Vered. "Commemorating a Difficult Past: Yitzhak Rabin's Memorials." *American Sociological Review* 67 (2002): 30–51.
Wagner-Pacifici, Robin, and Barry Schwartz. "The Vietnam Veterans Memorial: Commemorating a Difficult Past." *American Journal of Sociology* 97 (1991): 376–420.
Walker, David. *No More, No More: Slavery and Cultural Resistance in Havana and New Orleans*. Minneapolis, MN: University of Minnesota Press, 2004.
Wallace, Elizabeth Kowaleski. *The British Slave Trade and Public Memory*. New York: Columbia University Press, 2006.
Wallace, Elizabeth Kowaleski. "Uncomfortable Commemorations." *History Workshop Journal* 68, no. 1 (2008): 223–233.
Walvin, James. "The Slave Trade, Abolition and Public Memory." *Transactions of the Royal Historical Society* 19 (2009): 139–149.
Walvin, James, and Alex Tyrrell. "Whose History Is It? Memorialising Britain's Involvement in Slavery." In *Contested Sites: Commemoration, Memorial and Popular Politics in Nineteenth-Century Britain,* edited by Paul A. Pickering and Alex Tyrrell, 147–169. Aldershot: Ashgate, 2004.
Waterton, Emma. "The Burden of Knowing Versus the Privilege of Unknowing." In *Representing Enslavement and Abolition in Museums,* edited by Laurajane Smith, Geoffrey Cubitt, Kalliopi Fouseki, and Ross Wilson, 23–43. New York: Routledge, 2011.
Waterton, Emma. "Humiliated Silence: Multiculturalism, Blame and the Trope of Moving On." *Museum and Society* 8, no. 3 (2010): 128–157.
Waterton, Emma, and Ross Wilson. "Talking the Talk: Policy, Popular and Media Responses to the Bicentenary of the Abolition of the Slave Trade Using the 'Abolition Discourse'." *Discourse and Society* 20, no. 3 (2009): 381–399.
Weinstein, Barbara. "Racializing Regional Difference São Paulo versus Brazil, 1932." In *Race and Nation in Modern Latin America,* edited by Nancy P. Appelbaum, Anne S. Macpherson, and Karin Alejandra Rosemblatt, 237–261. Chapel Hill, NC: University of North Carolina Press, 2003.
Weinstein, Helen. "The Making of the 1807 Bicentenary in the Media: Commissioning, Production, and Content." Paper presented at the conference "Remembering Slave Trade Abolitions: Commemorations of the Abolition of the Slave Trade in International Perspective," Newcastle University, November 2007.
Welke, Barbara Y. "When All the Women Were White, and All the Blacks Were Men: Gender, Class, Race, and the Road to Plessy, 1855–1914." *Law and History Review* 13 (1995): 261–316.
Wemyss, Georgie. *The Invisible Empire: White Discourse, Tolerance and Belonging*. Farham and Burlington: Ashgate, 2009.
Wheeler, Douglas Lanphier. "Angolan Woman of Means: D. Ana Joaquina dos Santos e Silva, Mid-Nineteenth Century Luso-African Merchant-Capitalist of Luanda." *Santa Barbara Portuguese Studies Review* 3 (1996): 284–297.
Wilson, Ross. "The Curatorial Complex: Marking the Bicentenary of the Abolition of the Slave Trade." In *Representing Enslavement and Abolition in Museums,*

edited by Laurajane Smith, Geoffrey Cubitt, Kalliopi Fouseki, and Ross Wilson, 131–146. New York: Routledge, 2011.
Wilson, Ross. "Remembering to Forget? The BBC Abolition Season and Media Memory of Britain's Transatlantic Slave Trade." *Historical Journal of Film, Radio and Television* 28, no. 3 (2008): 391–403.
Wilson, Ross. "Rethinking 1807: Museums, Knowledge and Expertise." *Museum and Society* 8, no. 3 (2010): 165–179.
Wirth, Laurent, Benoît Falaize, Nelly Dejean, Jean-Marc Bassaget, Nelly Schmidt, and Jacques Desquenes. "Quelles solutions pour enseigner les questions sensibles aujourd'hui et demain?" In *Quelles pratiques pour enseigner des questions sensibles dans une société en évolution? Actes du séminaire européen, Paris, les 14 et 15 décembre 2005*, 47–62. Paris : Ministère de l'Education Nationale, de l'Enseignement Supérieur et de la Recherche, EduSCOL, Formation continue.
Wood, Marcus. *Blind Memory: Visual Representations of Slavery in England and America*. New York: Routledge, 2000.
Wood, Marcus. "The Horrible Gift of Freedom and the 1807/2007 Bicentennial." In *The Horrible Gift of Freedom*, edited by Marcus Wood, 296–353. Athens, GA, and London: University of Georgia Press, 2010.
Wood, Marcus, ed. *The Horrible Gift of Freedom: Atlantic Slavery and the Representation of Emancipation*. Athens, GA, and London: University of Georgia Press, 2010.
Wood, Marcus. "Packaging Liberty and Marketing the Gift of Freedom: 1807 and the Legacy of Clarkson's Chest." In *The British Slave Trade: Abolition, Parliament and People*, edited by Stephen Farrell, Melanie Unwin, and James Walvin, 203–223. Edinburgh: Edinburgh University Press, 2007.
Wood, Marcus. *Slavery, Empathy and Pornography*. Oxford: Oxford University Press, 2002.
Wright, Donald R. "Recent Literature on Slavery in Colonial North America." *OAH Magazine of History* 17 (2003): 5–9.
Ximenes, Cristiana Ferreira Lyrio. "Joaquim Pereira Marinho: Perfil de um contrabandista de escravos na Bahia (1828–1887)." MA dissertation, Universidade Federal da Bahia, 1998.
Young, James E. "Memory/Monument." In *Critical Terms for Art History*, edited by Robert S. Nelson and Richard Shiff, 234–247. Chicago and London: University of Chicago Press, 2003.
Young, James E. *At Memory's Edge: After-Images of the Holocaust in Contemporary Art and Architecture*. New Haven, CT, and London: Yale University Press, 2000.
Young, James E. *The Texture of Memory: Holocaust Memorials and Meaning*. New Haven, CT, and London: Yale University Press, 1993.
Zepherin, Wesley. *Connecting with the Bicentenary of the Abolition of the Transatlantic Slave Trade: A Toolkit for Developing Projects*. Dewsbury: Arts Council England, Yorkshire, 2007.
Zilversmit, Arthur. *The First Emancipation: The Abolition of Slavery in the North*. Chicago, IL: University of Chicago Press, 1967.

WEB SITES AND ELECTRONIC JOURNALS

BellsUnbound.com. A World Wide Ring of Freedom, http://www.bells-unbound.com/.
Carsignol, Anouck. "La diaspora, instrument de la politique de puissance et de rayonnement de l'Inde à l'île Maurice et dans le monde," *EchoGeo* [online journal] number 10 (2009), http://echogeo.revues.org/11329.

Centro Nacional de Folclore e Cultura Popular (National Center of Folklore and Popular Culture), http://www.cnfcp.gov.br/.
Conselho Estadual dos Direitos do Negro (State Council for Black Rights), http://www.cedine.rj.gov.br
Conselho Municipal de Defesa dos Direitos do Negro (Council for the Defense of Black Rights), http://www0.rio.rj.gov.br/comdedine/carta_pres.htm.
Eltis, David et al. *The Trans-Atlantic Slave Trade Database: Voyages*, http://www.slavevoyages.org.
Fundação Cultural Palmares (Palmares Cultural Foundation), http://www.palmares.gov.br/.
Insituto de Pesquisa das Culturas Negras (Institute for Research in Black Cultures), http://institutodepesquisadasculturasnegras.blogspot.com/.
Instituto do Patrimônio Histórico e Artístico Nacional (National Historical and Artistic Heritage Institute), http://portal.iphan.gov.br.
Instituto Estadual do Patrimônio Cultural (State Institute of Cultural Heritage, INEPAC), http://www.inepac.rj.gov.br/.
International Coalition of Sites of Conscience, http://www.sitesofconscience.org/en/.
Fundação Cultural Palmares (Palmares Cultural Foundation), http://www.palmares.gov.br/.
Little, Barbara J. "Introduction." *CRM: The Journal of Heritage Stewardship* 7, no. 1 (2010), http://crmjournal.cr.nps.gov/print.cfm?type=Introduction.
Ministério da Cultura (Ministry of Culture, MinC), http://www.cultura.gov.br/.
Museu Afro-Brasileiro (Afro-Brazilian Museum), http://www.ceao.ufba.br/mafro/.
Museu AfroBrasil (AfroBrazil Museum), http://www.museuafrobrasil.com.br.
Museu da Maré (Maré Museum), http://www.museudamare.org.br/joomla/.
Museu da República (Museum of Republic), http://www.museudarepublica.org.br/.
Museu da Vida (Life Museum), http://www.museudavida.fiocruz.br/cgi/cgilua.exe/sys/start.htm?tpl=home&UserActiveTemplate=mvida.
Museu do Negro (Black Museum), http://www.irmandadedoshomenspretos.org.br/museu_do_negro.htm.
Museu Histórico Nacional (National History Museum), http://www.museuhistoriconacional.com.br/.
Museu Nacional (National Museum), http://www.museunacional.ufrj.br/.
Museum of London Docklands, http://www.museumindocklands.org.uk/.
New York Divided, http://www.nydivided.org.
New-York Historical Library. "Slavery Related Collection Guide," https://www.nyhistory.org/slaverycollections/.
Norfolks Hidden Heritage, http://www.norfolkshiddenheritage.org.uk/.
Portal Arqueológico dos Pretos Novos (Pretos Novos Archaeological Portal), http://www.pretosnovos.com.br.
Progressive Labour Party, http://www.plp.bm.
Revealing Histories: Remembering Slavery, http://www.revealinghistories.org.uk.
Secretaria de Políticas de Promoção da Igualdade Racial (Special Secretariat for Racial Equality, SEPPIR), http://www.portaldaigualdade.gov.br/.
Slavery and the Making of the University. Online exhibition. Manuscripts Department, University of North Carolina at Chapel Hill, http://www.lib.unc.edu/mss/exhibits/slavery/index.html.
The Seneca Village website, http://projects.ilt.columbia.edu/seneca/start.html
Virtual Tour of the University of North Carolina at Chapel Hill, http://www.unc.edu/tour/index.html.

Index

A
Aapravasi Ghat, 63, 66
abolition of slavery, 5, 6, 42, 45, 55, 66, 103, 106, 108, 112, 114, 116, 118, 122n33, 125, 128, 131, 135, 162, 197, 199, 200, 215, 222, 225
abolition of the slave trade
British, 5, 25, 30, 180
Abolition of the Slave Trade Act (1807), 159, 163, 164, 178, 179, 183
abolitionism, 8, 93, 100, 160, 161, 162, 163, 165, 167, 168, 170, 171, 172, 173, 233, 245
abolitionist(s 20, 23, 80, 96, 97, 100, 108, 109, 110, 111, 114, 115, 161, 162, 163, 164, 165, 167, 168, 169, 170, 175, 222, 233, 240
Adventures of Huckleberry Finn, 255, 257
affirmative action, 200, 215, 219, 227
African Burial Ground, 9, 234, 247, 249n4
African Diaspora Heritage Trail, 83, 87
Afro-Brazilian
art, 198, 199
history, 199, 200, 225
populations, 9, 209
Afro-Brazilians, 20, 197, 215, 216, 224, 217, 227
AfroBrazil Museum, 9, 198, 199, 200, 201, 202, 203, 204, 205, 206, 207, 208, 209, 210n5, 212n40, 220, 231
agency, 44, 52n43, 99, 100, 135, 159, 163, 168, 188, 197, 202, 252, 259

American History Workshop, 240
Araújo, Emanoel, , 198, 201, 204, 206, 207, 208, 209
artwork(s), 30, 87, 136, 191, 198, 199, 201, 203, 222n17, 233, 241, 242, 243, 246

B
Bahia, ix, 5, 16, 20, 22, 24, 33n17, 198, 199, 203, 204, 220, 230n30, 231n53
Bassett, Sally, 7, 71, 72, 73, 74, 78, 80, 81, 82, 83, 84, 85, 86, 87, 88
Bermuda, 7, 71, 72, 74, 75, 77, 78, 79, 80, 81, 82, 83, 84, 85, 87
Bermuda Sun, 73, 84, 85, 88
Bicentenary (British abolition of slave trade), 8, 11, 25, 159, 160, 161, 162, 163, 164, 165, 166, 168, 170, 172, 173, 174, 177n33, 178, 179, 183, 184, 185, 193
Birmingham Museum and Art Gallery, 160, 166, 168
black history, 4, 9, 86, 136, 137, 164, 188, 198, 208, 209, 234
black movement, 5, 214, 219, 223, 224, 227
blacks, 21, 71, 72, 74, 75, 76, 77, 78, 79, 80, 81, 82, 84, 85, 86, 87, 88, 98, 99, 101, 110, 182, 200, 204, 205, 206, 209, 222, 223, 255, 259, 260, 262, 263, 264,
Bordeaux, 8, 124, 125, 127, 129, 130, 131, 132, 133, 134, 135, 136, 137, 138
Brazil, ix, 3, 5, 6, 8, 9, 15, 16, 18, 19, 20, 24, 30, 31, 197, 198, 199, 200, 201, 202, 203, 204, 205, 206, 208, 209, 211n28, 210n6,

213, 214, 217, 219, 221, 222, 229n20, 270, 274
British Caribbean, 7, 27, 115, 163, 179
Brown, Ewart, 85

C

Calil, Carlos Augusto, 207, 208, 209, 211n29
Chase-Riboud, Barbara, 246
Chesapeake, 259, 260, 263, 264
Clarkson, Thomas, 167, 168, 172, 177n35
collections, 25, 92, 102, 120, 171, 178, 180, 185, 190, 191, 192, 193, 194, 201, 212, 219, 220, 232, 233, 235, 236, 237, 241, 242, 245, 246, 247, 248
collective identity, 145, 173
Colonial Exhibition of 1931, 133
colonial policy, 106, 108
commemoration(s), 3, 4, 5, 6, 7, 8, 10, 25, 30, 66, 68, 69n19, 71, 92, 98, 106, 112, 113, 114, 116, 117, 118, 119, 124, 127, 128, 131, 132, 134, 135, 137, 141, 164, 165
Committee for the Memory of Slavery, 116, 117
communalism, 63, 64, 68
community, 8, 30, 40, 54, 62, 68, 128, 130, 134, 135, 136, 147, 151, 159, 165, 166, 171, 173, 181, 182, 183, 184, 185, 187, 193, 194, 195, 207, 216, 225, 226, 234, 254, 256, 258, 264
 African American, 234, 239
 Afro-Brazilian, 219
 Afro-Luso-Brazilian, 16, 18
 Aguda, 32
 black, 131, 186, 191, 222
 consultation, 188
 Creole, 56, 57, 66
 free, 245
 Indian, 65
 local, 172
 memory, 63
 political, 137
 university, 143, 146, 148, 153
community museums, 9, 213, 221, 227, 228
countermonument, 30, 147, 149
Creoleness, 54, 56, 62, 65, 68, 69n36
crimes against humanity, 3, 5, 6, 15, 116, 118, 124, 131, 192
Crow Lane, 73, 76, 77, 78, 83, 84
culture, 62, 64, 117, 171, 188, 199, 203, 223, 229n20
 African, 229n19
 African American, 264
 African Caribbean, 184
 Afro-Brazilian, 9, 215, 216, 217, 218, 219, 220, 221, 223, 224, 225, 226, 227, 228
 American, 264
 bourgeois, 136
 Brazilian, 197, 209, 213, 214
 commemorative, 104, 162
 Creole, 133
 "Indian", 60
 "Indo-Mauritian", 57
 material, 103, 199, 201
 Mauritian, 65
 national, 61, 216, 220
 popular, 218, 220, 238, 260

D

deference politics, 100, 104n20
Downing, Thomas, 240
Draft Riots of 1863, 241

E

Equiano, Olaudah, 11, 168
exhibition(s), 3, 6, 8, 9, 10, 25, 31, 34n37, 35, 122n34, 125, 127, 128, 129, 132, 146, 150, 159, 160, 161, 163, 164, 166, 167, 168, 169, 170, 171, 172, 173, 174, 177n39, 178, 179, 180, 181, 184, 186, 187, 191, 193, 194, 197, 198, 199, 201, 206, 210n17, 220, 223, 224, 225, 226, 232, 233, 234, 235, 236, 237, 239, 240, 241, 242, 244, 245, 247, 248

F

Finn, Huck, 253, 255, 256, 257
forgetfulness, 2, 8, 106, 108, 109, 111, 115, 119
France, 3, 4, 5, 6, 8, 11n11, 36, 49n6, 106, 109, 110, 111, 113, 116, 117, 118, 119, 124, 125, 126, 127, 129, 130, 133, 134, 135, 138n5
freedom(s), 21, 37, 39, 43, 50n15, 66, 71, 75, 79, 80, 82, 85, 88, 93, 95, 96, 102, 106, 107, 108, 110, 112, 115, 116, 131, 141, 142,

Index

143, 150, 151, 152, 153, 179, 221, 232, 234, 236, 239, 241, 242, 244, 247, 252, 262
French Caribbean colonies, 7, 106, 109, 115, 136
Freyre, Gilberto, 200

G
Guadeloupe, 107, 108, 109, 110, 111, 112, 113, 114, 115, 116, 119, 125

H
Hannibal, x, 253, 254, 255, 256, 258
heritage, 15, 20, 60, 119, 166, 194, 204, 215, 218, 219, 228, 253
 African, 203, 234
 African-American, 247
 Afro-Brazilian, 214, 215, 216, 221, 225, 227
 African-Caribbean, 167
 Brazilian, 214
 Creole, 56
 cultural, 5, 213, 214, 216, 223
 Indian, 67
 institutions, 159, 164, 165
 intangible, 64, 217, 220, 229n27
 monuments, 62
 national, 33n18, 71, 170
 policies, 9
 projects, 58
 regional, 148
 slave-trade, 25
Heritage Lottery Fund (HLF), 159, 165
 myth(s), 7, 8, 57, 58, 66, 74, 78, 85, 88, 106, 108, 114, 116, 148, 119, 188, 200, 215, 218, 229n27, 253
Houses of Parliament, Westminster, 160, 168
Huckleberry Finn House, 255, 256

I
indenture system, 55, 58, 61, 63
Indentured labourer(s), 55, 57, 61, 62, 63, 65, 66
Indentured labor, 55, 57, 58, 63, 64, 65
India, 54, 55, 57, 59, 60, 61, 65, 69n22
Indianness, 60
International Slavery Museum (ISM), ix, 9, 25, 136, 160, 169, 177n37, 178, 179, 180, 181, 183, 184, 185, 186, 187, 188, 189, 190, 192, 193, 194, 195

J
James McCune Smith, 240

L
language, 9, 10, 56, 69n35, 248, 252, 253, 255, 256, 258, 259, 261, 262
 policies, 64, 67
Le Morne, 65, 66
legacy, 88, 149, 168, 172, 179, 252, 255
 of internal slavery, 35, 36, 46, 47, 48
 of slavery, 9, 85, 126, 147, 173, 205, 233, 247, 258
 of the slave past, 151, 153
 of the colonial era, 191
 of racism, , 244
Liverpool, 5, 9, 25, 131, 135, 136, 159, 160, 169, 170, 171, 172, 178, 179, 180, 181, 183, 186, 190, 191, 192, 193, 268
Liverpool City Council, 186
Logan, Juan, ix, 144, 151, 152
London, ix, 25, 29, 30, 80, 161, 170, 173, 180, 184, 190, 192
London, Sugar and Slavery (exhibition), 26, 27, 160
Louverture, Toussaint, 116, 130, 132, 242

M
Marginality, 44, 225
Marinho, Joaquim Pereira, ix, 6, 15, 19, 21, 22, 23, 24, 30
Mark Twain, x, 81, 253, 254, 255, 256, 257, 258
Mark Twain Boyhood Home & Museum, 10, 81, 253, 264
Maroon, 57, 60, 65, 66, 74, 169
Maroonage, 75
Martinique, 107, 108, 109, 110, 11, 113, 114, 116, 119, 125
Maryland, 10, 246, 253, 259, 261, 262, 263
Mauritius, 7, 54, 55, 56, 57, 58, 59, 60, 61, 62, 63, 64, 65, 66, 67, 68n1
McCallum, Bradley, 242
McCorkle Place, ix, 143, 146, 148, 149, 153
memorial(s), 3, 8, 18, 19, 65, 128, 129, 132, 142, 145, 146, 147, 148, 149, 150, 161, 219, 155n24 and n25
 Holocaust, 142

Index

memorialization, 1, 3, 6, 7, 15, 18, 62, 133
memory, 3, 8, 15, 18, 19, 20, 31, 44, 46, 57, 64, 65, 67, 72, 92, 93, 97, 102, 109, 11, 112, 119, 124, 126, 128, 129, 131, 132, 133, 134, 135, 136, 137, 142, 143, 147, 150, 164, 167, 169, 172, 197, 199, 201, 206, 210n6, 216, 217, 221, 222, 223, 224, 226, 227, 228, 247
 collective, 1, 2, 87, 110, 127
 community, 63
 cultural, 101, 214
 entrepreneurs, 8, 125, 127, 129 130, 131, 133, 134, 135, 137, 138
 historical, 95, 101
 place of, 64, 222
 of indentured labor, 54, 66
 of slavery, 1, 2, 4, 7, 8, 9, 10, 54, 66, 96, 118, 126, 130, 131, 137, 142, 204, 205, 206, 208, 213, 214, 217, 225, 232, 243, 246, 248
 site(s) of, 8, 143, 145, 148, 153
 work, 149
Middle Passage, 59, 142, 136, 161, 167, 187, 201, 238
migration, 15, 57, 59, 60, 61, 125
Milligan, Robert, ix, 6, 15, 25, 27, 28, 29, 30, 34n41
monument(s), 30, 32, 87, 142, 143, 147, 149, 155n24, 164, 202
museum(s)
museums of civilization, 213, 215, 219, 227, 228n4
Museum of London Docklands, 25, 26, 27, 30, 160, 169, 172
museum visitors, 172, 253, 262

N

Nantes, 8, 110, 124, 125, 127, 128, 129, 130, 131, 133, 134, 135, 136, 137, 138, 268
narrative genres, 40, 43
narratives, 44, 54, 61, 96, 99, 138, 161, 164, 169, 247, 252
 historical, 40, 41, 42, 48, 50, 124
 national, 4, 6, 124, 232, 235
 slave, 4, 136, 150, 242
nation, 2, 22, 54, 56, 62, 64, 65, 67, 68, 85, 86, 93, 99, 117, 124, 126, 142, 145, 147, 164, 191, 198, 214, 162, 200, 209, 220, 223, 227, 247, 252, 253, 268

National Museums of Liverpool, 181, 182, 183, 184
National Service of Commemoration, Westminster Abbey, 164
New-York Historical Society, ix, x, 9, 232, 233, 238, 249n2, 243, 246
North Carolina Freedom Monument Project, ix, 8, 141, 142, 143, 144, 150, 151, 152, 153

O

okomfo, 73
oral sources, 39, 48, 49n12
Ouidah, 15, 16, 17, 18, 19

P

perpetrators, 2, 3, 6, 15, 16, 19, 31, 125, 128, 134, 135, 137, 172, 235
pluralism, 227
poison, 73, 88
politics, xi, 8, 9, 58, 61, 71, 101, 102, 103, 124, 130, 141, 176n25, 207, 208, 242, 243, 258, 264
Prince, Mary, 74, 80
Progressive Labor Party (PLP), 71, 83, 84, 85, 87
public history, 92, 150, 239, 248
public memory, 1, 6, 7, 10, 15, 16, 17, 18, 19, 20, 21, 22, 23, 30, 31, 112, 124, 125, 126, 127, 131, 132, 133n9, 137, 141, 142, 175, 179, 206, 208
public secret, 42
public space, 1, 2, 4, 5, 6, 7, 9, 10, 15, 17, 20, 22, 30, 31, 48, 54, 62, 67, 125, 126, 135, 141, 146, 147, 151, 205, 232, 237, 244

R

race relations, 87, 88, 97, 133, 136, 137, 142, 148, 200, 268
racism, 2, 4, 7, 71, 78, 86, 134, 137, 149, 172, 182, 186, 187, 191, 197, 202, 209, 210n16, 244, 256, 257, 258
reparation, 107, 204
resistance, 7, 8, 68, 72, 73, 74, 77, 78, 82, 83, 87, 88, 96, 98, 109, 111, 115, 116, 130, 135, 142, 161, 163, 167, 168, 169, 170, 184, 187, 188, 190, 193, 215, 219, 226, 237, 270
Rio de Janeiro, 9, 199, 203, 210, 211n28, 213, 217, 218, 219,

220, 221, 223, 224, 225, 227, 228, 270
River Gambia, 7, 35, 36, 37, 38, 44
roots, 3, 5, 20, 45, 54, 62, 68, 92, 96, 97, 126, 146, 214, 220, 228
Roots (Alex Haley), 4

S

Saar, Alison, 246, 247
Salvador (Bahia), ix, 20, 21, 22, 217, 220
São Paulo, 9, 197, 198, 202, 203, 204, 207, 220, 231n53
school curriculum, 6, 116, 220
Seneca Village, 234
silence, 2, 35, 36, 40, 42, 44, 48, 51n27, 81, 97, 109, 111, 125, 128, 129, 131, 137, 224, 264
Silent Sam (Confederate soldier monument), 145, 148, 149
sites of memory, 143, 145, 153
slave-holding, 35, 36, 37, 38, 42, 79, 246, 258
slave-dealing, 35, 36, 37, 38, 42, 45
slave descendant(s), 35, 36, 38, 39, 41, 42, 43, 45, 46, 47, 48, 49, 50, 51, 56, 58, 132
slave conspiracy, 236
slave revolt, 77
Slave Route project, 4, 5, 17, 19, 30, 58, 116, 131
slave trade, 1, 2, 3, 4, 5, 6, 7, 8, 9, 10, 15, 16, 17, 18, 19, 20, 21, 23, 26, 27, 30, 31, 33n16, 35, 36, 37, 38, 39, 40, 41, 42, 44, 45, 46, 48, 49n6, 51n37, 54, 55, 57, 59, 60, 61, 62, 64, 67, 68, 73, 74, 75, 78, 80, 81, 84, 85, 86, 88, 92, 93, 97, 99, 102, 106, 107, 108, 110, 111, 112, 113, 114, 115, 116, 117, 118, 119, 124, 125, 125, 126, 127, 128, 129, 130, 131, 132, 133, 134, 135, 136, 137, 138, 138n6, 139, 139n30, 140n30, 141, 143, 146, 149, 150, 151, 159, 162, 163, 164, 165, 166, 167, 169, 170, 171, 178, 179, 180, 181, 182, 183, 184, 185, 186, 187, 188, 190, 191, 193, 194, 199, 200, 202, 203, 204, 206, 208, 209, 213, 215, 217, 218, 219, 220, 221, 222, 223, 224, 225, 226, 227, 228, 234, 237, 238, 248, 253, 254, 255, 257, 258, 261, 262, 264, 268

British, 5, 25, 26, 30, 178, 179, 180
slave merchant(s), 6, 16, 17, 18, 19, 21, 22, 23, 27, 30, 33n19, 74, 75, 138, 200, 264
slave trader(s), *see* slave merchant(s)
slavery, 2, 3, 4, 5, 6, 7, 8, 9, 10, 11n9, 20, 32, 35, 46, 47, 54, 58, 66, 71, 72, 79, 87, 93, 94, 95, 96, 104n12, 106, 109, 116, 117, 118, 124, 126, 127, 128, 129, 134, 135, 136, 141, 142, 145, 147, 153, 160, 161, 162, 163, 168, 170, 171, 172, 173, 174, 175n14, 175n15, 178, 181, 184, 186, 191, 192, 197, 201, 205, 210n6, 214, 224, 232, 233, 235, 239, 240, 241, 242, 243, 245, 246, 247, 248, 249, 250, 252, 259, 260, 263
Souza, Francisco Félix de Souza, 6, 15, 16, 17, 18, 19, 21, 22, 30, 32n6
Spirit of Bermuda, 83
Spirit of Freedom, ix, 71, 72, 83, 84, 85, 87, 88
St. Mary's City, x, 10, 253, 259, 260, 261, 264
sugar, 25, 30, 54, 55, 56, 58, 107, 115, 119, 125, 160, 180, 206, 218, 226, 237, 245, 246
Suh, Do-Ho, 145, 146, 147, 149, 153
Swanson, David, ix, 144, 151

T

Tarry, Jacqueline, 242
Taubira Law, 5, 124, 131
teaching, 8, 84, 106, 116, 118, 119, 181, 184, 186, 187, 200, 201, 229
transatlantic slave trade, *see* slave trade
transatlantic trade, *see* slave trade
Truth, Sojourner, 239, 246
Tubman, Harriet, 74, 246

U

Underground Railroad, 240, 247, 250n28
UNESCO, 4, 5, 15, 17, 20, 30, 58, 63, 65, 116, 131, 179, 186, 215, 216, 217, 219
University of North Carolina at Chapel Hill, ix, 8, 142, 143, 145, 148, 155n25
Unsung Founders Memorial, 8, 141, 143, 145, 146, 147, 148, 149, 150, 153

W

West India Dock (Quay), 26, 27, 29, 161, 180
white toade, 73
whites, 61, 71, 72, 73, 75, 77, 80, 81, 82, 85, 86, 87, 88, 93, 95, 98, 99, 100, 101, 103, 110, 135, 163, 197, 202, 204, 252, 254, 262, 263
Wilberforce House Museum, 160, 169, 181
Wilberforce, William, 162, 164, 167, 168, 169, 172, 181
Wilberforce, Rachel, 191, 192
Williams, Lyneise, 151
Williams, Peter, 239
women, 19, 23, 36, 37, 38, 39, 40, 42, 43, 44, 45, 47, 48, 51n36, 77, 79, 80, 95, 96, 97, 98, 100, 142, 145, 146, 149, 153, 166, 167, 168, 205, 237, 246, 247
 black, 3, 17, 20, 74, 81, 230n30
 enslaved, 16, 17, 38, 74, 77, 80, 135, 221, 237
 white, 75, 98, 167
working memorial, 152
World Heritage List, 20, 63, 64, 65